EXHIBITING AUTHENTICITY

MANCHESTER
UNIVERSITY PRESS

EXHIBITING
AUTHENTICITY

e

DAVID PHILLIPS

MANCHESTER UNIVERSITY PRESS

MANCHESTER AND NEW YORK

distributed exclusively in the USA by St. Martin's Press

Published by Manchester University Press
Oxford Road, Manchester M13 9NR, UK
and Room 400, 175 Fifth Avenue, New York, NY 10010, USA

Distributed exclusively in the USA by
St. Martin's Press, Inc., 175 Fifth Avenue, New York,
NY 10010, USA

Distributed exclusively in Canada by
UBC Press, University of British Columbia, 6344 Memorial Road,
Vancouver, BC, Canada V6T 1Z2

British Library Cataloguing-in-Publication Data
A catalogue record for this book is available from the British Library

Library of Congress Cataloging-in-Publication Data
Phillips, David, 1946–
 Exhibiting authenticity / David Phillips.
 p. cm.
 Includes bibliographical references.
 ISBN 0-7190-4796-X (cl).—ISBN 0-7190-4797-8 (pb)
 1. Art—Expertising. I. Title.
 N8558.P55 1997
 702'.8'8—dc21 97-12648

ISBN 0 7190 4796 X *hardback*

 0 7190 4797 8 *paperback*

First published 1997

01 00 99 98 97 10 9 8 7 6 5 4 3 2 1

Typeset by Servis Filmsetting Limited, Manchester, England
Printed in Great Britain
by Redwood Books, Trowbridge

9455 A (PHI)

CONTENTS

FIGURES

ACKNOWLEDGMENTS

For such a broad topic I have called at some point on the expertise of virtually everyone in the department of Art History and Archaeology in Manchester University, but I am particularly indebted to Stacey Boldrick, Suzie Butters, Christa Grössinger, Axel Lapp and Tom Rasmussen. Paul Binski, now in Cambridge, and Richard Thomson, now in Edinburgh, likewise provided vital leads. Ian Wolfenden, who teaches with me on the programmes in art gallery and museum studies, has, as always, made his uniquely extensive contribution as both a mine of information and a tower of strength, commenting to great effect on the manuscript at an early stage. The illustrations in the book have required a lot of special processing of various kinds, which would have been quite impossible without the enthusiasm, expertise and resourcefulness in photography and computing of Peter Burton, Andy Fairhurst and Mike Pollard.

A variety of technical and curatorial specialists in the field devoted a good deal of time, sometimes repeatedly, each of them also generously commenting on some draft text. The technical issues in each case could not have been introduced without their involvement, though the specialists are, of course, not to blame for the naiveties that are bound to remain. Caroline Carr-Whitworth of Brodsworth Hall briefed me and commented in connection with technicalities there. Velsen Horie of the conservation department of the Manchester Museum helped with scientific background, and Eos Kyprianou of the department of Mathematics at Manchester University did the same for the foray into statistics; Caroline Villers of the Courtauld Institute both commented on a draft of chapter 6 and provided indispensable insights at other points mentioned in the text.

A special technical investigation was required in pursuing the identity of the painting of St Jerome introduced in chapter 3, and I am indebted to Neil Walker of Nottingham Castle for kind permission for the painting to travel to the laboratories of the MA Conservation of Fine Art Programme in the University of Northumbria at Newcastle, where Anne Bacon and her colleagues generously carried out the inspections and analyses and took the specialised images on which the investigation depended.

I am particularly indebted to Stephen Lloyd, Janice Slater and colleagues in the Scottish National Portrait Gallery and to Alex Kidson and the handlers in the Lady Lever Art Gallery at Port Sunlight, who fitted into their tight schedules the considerable inconvenience of allowing me to examine and photograph their portraits of Nelson by Abbott.

A number of colleagues and friends went to special lengths in answering queries and pointing out interesting material, notably Oliver Garnet of the National Trust; Peter Hartley of the conservation studios of Manchester City Art Galleries; Lucy Till of Dulwich Picture

Gallery on their Rubens; Elisabeth Taburet Delahaye of the Louvre on Marcy; Ken Levine of Nottingham University on framing; Anthony Luttrell; Adrienne Quarles van Ufford of the Rembrandt Research Project; Janet Yapp on art market technicalities; and Peter Yapp on a variety of points. Pat Halfpenny, now of the Winterthur Museum, Delaware, provided an invaluable insight into the recent Staffordshire earthenware forgery case. Caroline Hull and Andrew Jotischky were indipsensable guides to the cult of saints.

In obtaining photographs, I have by chance made repeated calls on the Prussian State Museums in Berlin, where Ina Tautorat of the Junior-Museum in the Museum of Ethnography, Hartmut Krohm of the Kaiser Friedrich Museum, and Lothar Lambacher and Ingeborg Hagedorn of the Decorative Arts Museum all went to much appreciated special trouble on my behalf.

Any academic book relies upon the dedication of library and archive staff, and those who have made most unknowing contributions to this project are in the John Rylands University Library of Manchester, the National Art Library in the Victoria and Albert Museum, the British Library, the Witt Library and, most of all, the London Library, to whom I am grateful not only for permission to reproduce a number of images, but for sustaining the most delightful of all the institutions through whose labyrinth of stacks the threads of research for a project of this general kind can be pursued.

Vanessa Graham and Carolyn Hand of Manchester University Press have been most forbearing and encouraging editors, and to their anonymous peer review reader I am grateful too both for encouragement and for some quite indispensible pointers in reordering my argument.

A key helper made her contribution about twenty years ago, and sadly has since died. Josephine Parry, conservator for the Midlands Area Museum Service, kindly made a special trip to London to try to explain to me how age and treatment had introduced such remarkable variation into the appearance of paintings in a definitive show of the work of Sir Peter Lely, an artist from whose studio a fairly homogeneous-looking product emerged. If this book had a single starting-point, it was in the mismatch between that puzzling variety in appearance, explained for me by Josephine, and in the extent to which it was passed over in silence within the exhibition.

INTRODUCTION

I HAVE a recurring nightmare fantasy. Time-travel is possible, and I am the courier on a coach taking a group of artists from the past to a major art museum, to see how faithfully their achievements are being cherished in the present. It is not an easy trip from the start, because they keep fighting one another, and Rubens, though remaining aloof from that kind of thing, gets really upset when we stop to let some women on. Then they all start, about what they say are savages amongst the artists we stop to pick up later on the way. But it's when we get there, and they all crowd expectantly into the gallery, that all hell breaks loose. A handful of painters, mostly fifteenth- and-sixteenth century fellows, seem happy enough, but otherwise the air is thick with angry cries and hollow laughter. 'That's not mine!', 'What have they *done* to it?', 'Where's the rest of it?' and 'It wasn't meant to be seen like that' echo through the galleries again and again.

Just a baseless fantasy? If time-travel were possible, could we be sure that the scrupulous scholarship of attribution, the science that can now be brought to bear in the conservation of artefacts, the care of curators in devising displays, extending sometimes to the authentic details of reconstructed historical contexts, would on the whole win admiring compliments from the gratified artists on their trip from the past? The key word is authenticity, in attribution, conservation or display. If good practice is followed in the name of authenticity in these specialities, then supposedly the experience of the museum visitor should be authentically of the intentions of the artist or of the past.

But a less trusting view of the objects that are displayed with such authority in art museums readily uncovers a host of instances that would surely provoke the protesting cries of my fantasy. A more critical view of the idea of authenticity reveals it too as a shifting sand on which to base practice. However, if authenticity is not a basis for the practices of art historians, conservators and curators, then what are we up to? That is what this book is about.

Chapter 1, 'The cult of saints and the cult of art', takes a long view of the role

of institutions in policing supposedly authentic, transcendent religious or aesthetic experiences. Church and museum purport only to validate spiritual dimensions of relics and artefacts, intruding into the market-place reluctantly, as spiritual weights and measures inspectors, and raising the artefact or relic that attains the object heaven of shrine or art museum free from the associations with money and status that may have been a regrettable part of its earlier social life. But behind the scenes church and museum officials are mired in cash and politics, and busily at work setting the supposedly transcendental values that they police. Their parallel roles lend support to Walter Benjamin's celebrated charge that religious and aesthetic experience, and the aura and authenticity of objects associated with them, are transient social contrivances. They had their parts to play, in his view, as successive forms of political empowerment in the past, but are only anachronistic leftovers in the modern world. That challenge sets the scene for what follows. There remain grounds for a more positive view of what art history and museums have to offer, but ones we will only discover in the things that art historians, conservators and curators do that offer an escape from authenticity.

The next four chapters look at what art historians do in the name of authenticity in attribution. Chapter 2, 'The connoisseurs' paradox', sets out the conundrum that though connoisseurial judgement is brought to bear in the interests of transcendent experience, it is not evaluation of experience that establishes consensus in attributions, but assessment of physical properties of objects. Increasingly, too, the evidence that matters has less to do with features even associated with aesthetic effect, and more to do with scientific characteristics of materials or with documentary evidence about accidents of the history of ownership of artefacts. Chapter 3, 'The evidence', considers these kinds of research in more detail, noting that they too remain open to problems in interpretation.

How hard those problems of evidence make escape from the compromising associations of authenticity becomes apparent when it comes to the crunch of drawing the strands of evidence together in a decision. Chapter 4, 'Verdicts', draws on experience of decisions in court and on recent research into judgement under uncertainty. Decisions are usually, in the end, matters of probability, and art-historical identifications can come anywhere on a very broad spectrum of degrees of confidence. Yet oddly little of that uncertainty is reflected in the conventions of art attribution. There is one place though where it is reflected, with considerable sensitivity, and that is in pricing in the market-place.

Chapter 5, 'The judges in the dock', therefore turns the tables on the art historian, and considers the case that conventions of art attribution and classification make a lot more sense in the market-place than they do as art history. The art historian, in this view, hiding behind a smokescreen of concern

with technical clues to a nebulous notion of authenticity, homogenises all the historical complexity of art production and consumption under an apparently objective classificatory scheme, that in practice makes of the art of the past a coded classification of social and political power in the present. However, that does not invalidate attribution research completely, since it is, after all, what the colour-coding and conventions of any map also tend to do, and yet it can still be a faithful map of selected features of the landscape. Art historians are guilty as charged, but can be dismissed with a caution. What they have done over the last century of scientific classification is to plot for us a map of the production of artefacts, and one of unrivalled precision, so long as we always remember that it is bound to be selective in what it shows, and to reveal as much about the society that produced the map as it does about the societies that produced the artefacts.

The next two chapters consider conservation, once again starting by looking at the issues that turn up in good practice, and then seeing how they reflect problems with the whole concept of authenticity. Chapter 6, 'Condition', notes that the twin goals of much conservation, to respect both the intentions of the original maker of an object and the signs of its historical life, are often irreconcilable. Surveying practice in variety of object types, and then in easel paintings as a detailed case-study, it becomes apparent that the decisions involved cannot be based just on technical considerations. The interventions of treatment are bound to involve interpretative assumptions. They therefore give the lie to the way that conservation can seem to lift the object out of historical time, either restoring it to 'original' condition, or freezing it as a 'time-capsule', for both of these approaches can only be just as much a part of social process within historical time as any other intervention in the life of the object.

Chapter 7, 'Intention', traces the source of these difficulties to the notion that authentic condition in an artwork implies an authentic experience for the viewer. Intention and meanings of an artwork are not fixed but change, rooted in the mental and social lives of the ages through which it passes, not in its physical fabric. A better focus for conservation is not authentic meaning, but instead the perceptual devices in artefacts that are the source of their changing meanings. Chief amongst these are the contrivances that make artworks perceptually unusual and puzzling, such as the ambiguities involved in any illusionistic representation. However, these contrivances can change physically with time and treatment too, accompanying major shifts in meaning, as when the illusionistic effect of a polychrome sculpture is transformed in a later presentation of the object, stripped of all colour. Making artefacts fit for their successive re-presentations has more in common with performance of plays or music than with respect for integrity of the first realisation of an object. The conservator, far from lifting the object out of this kind of social life, is often its agent.

The final chapter, 'Curators and authenticity', turns to curators, and our experience as museum visitors. Art historians may be cartographers of the past, and conservation performance upon its objects, but museum visiting does not feel like that. We feel we are in the presence of the real thing. Semiotics offers one account of how the illusion of the real arises, but another metaphor to add to mapping, that of framing, seems to match experience better. It is a term very widespread in social and psychological studies of the last half century, as well as in postmodern cultural studies, and a sociological account due to Erwin Goffman fits museum experience well. Art within museums is very much a framed affair in these terms, but when understood too in the context of framing in ritual, it emerges as much more than just a device in modern political history. It regains its more ancient status within the variety of ritual devices that seem to help us come to terms with social life. Authenticity is a very recent invention by comparison. If we are brave enough, we can escape from it.

<div style="text-align: center;">**1**</div>

THE CULT OF SAINTS
AND THE CULT OF ART

WHAT DISTINGUISHES art museums, fairly obviously, is art: the objects in them, whatever other meanings and values they carry, are characterised at least in theory by physical properties which give rise to states of mind unavailable in other objects. They are objects endowed with transcendent values, and the values seem guaranteed if the artefacts are authenticated in terms of identification and condition, and appropriately displayed in a museum.

The guarantee begins to look less solid, however, if we subject the word 'authenticity', instead of the artefact, to a little scrutiny. It is an odd-ball, hovering on the edges of a group whose established members would include 'real', 'ideal', 'perfect', 'essential', 'true', 'natural', 'normal', 'pure', proper', 'original', 'honest', 'sincere', 'right', 'basic' and 'absolute'. 'Authentic' very much wants to join this club, but does not quite qualify for membership. Several of those established members, when used as adverbs, 'really!', for example, or 'honestly!', are little more than expletives. They express emphasis over and above their role in description. 'Honestly,' we might say, 'I've basically just got a perfectly normal hangover.' 'Originally' can be used in this kind of way, but 'authentically' itself would not usually be. Yet like the others, 'authentic', used as an attribute, seems to refer to properties which are not merely discriminating, like 'big' or 'blue', but which identify the subject as in some way expressive of an abstract, universal truth. Any anthropologist will insist now that these words are all used, in different societies, in ways just as various and socially loaded as those already suggested for authenticity, though always in association with supposedly transcendent and absolute values.

So why can 'authentically' not be used with quite the same general emphasis as all the others? It seems more at home, instead, in a different club, with reference to whatever is not authentic, but on the contrary is pseudo, sham, make-believe, mock, false, fake, semi- , or synthetic.[1] These are terms that gained currency particularly in the first half of this century, in response to some of the alienating aspects of modern culture. As will emerge further on, that

reflects only one phase in the evolution of current notions of authenticity, but it alerts us to how recent an invention authenticity in the sense that we know it seems to be. Already it is beginning to look a bit too much of an upstart to be the rationale for quite so much art-historical and museum practice. We would be also be wise to beware of 'true' or 'honest' or 'real', but authenticity is certainly not entitled to the absolute status to which these pretend – not really.

The trend of much of recent anthropological and critical writing is to insist that all such supposedly transcendent values are vehicles of social empowerment, facilitated through the rituals and institutions of societies. The art historian becomes a shaman. To enthusiasts for cultural theory art history is a conspiracy. If we follow the trend of Marxist aesthetics, the trick of authenticity is merely one of those notions whereby objects become fetishes, bearers of values far exceeding the cost of producing them, which endow their makers and possessors with a mysterious status denied to those who lack the capital which is the key to the magic loop. Those familiar with the more recent literature of museums will know the theses which have emerged in this tradition, from writers by no means all Marxist, particularly in the surge of dissenting theory provoked in the 1960s and 1970s by the strength of tradition in French academic and educational life. The villains in each case are supposedly universal truths, especially truths of beauty and of historical or scientific fact. Through their selection and institutionalisation, power is exercised, according to Foucault, distinctions between classes are sustained, according to Bourdieu, and financial capital and cultural knowledge and status are exchanged, in a dance of complicated equations, according to Baudrillard. In each scheme, museums play a vital, but duplicitous role. Curators seem merely to assess evidence, but in practice are deeply involved in setting the values that they police.

Not many people go into art history or museums because they aspire to a career of covert social oppression, and many would find it hard to recognise much association at all between these intellectually intricate theorisings and the pressing imperatives of daily academic or curatorial life. Many, indeed, would defend the transcendent properties of the artefacts they study or curate. We need therefore to confront the evidence that, even if we reject the sometimes mechanistic social roles proposed for us by some critical commentators, we are deluding ourselves if we imagine that we can make decisions about attribution, condition or display without reference to particular notions of authenticity, which are far from innocent of association with all manner of other social values and status.

Aesthetic values and money values

The first problem is the association between quality and money value. Art museum curators and colleagues in cultural heritage sites might like to see

themselves as inspectors of quality, who, like any good weights and measures inspectors, enter the market only in order to bring to bear scholarship and science in the interests of a well-regulated art market and of a world of learning ever adding to its stock. Yet curators are not mere inspectors and scholars, since they are just as intimately involved in setting market values as in assessing artistic ones. How is it that one role is so prominent, and the other so covert?

The secret lies in a taboo on association of values of art and of money in museum presentations, a taboo which the historical record shows to be directly related to the museums' role. It is hard to believe, if we visit an art gallery, and then if later we pick up a copy of *The Art Newspaper*, or one of the reports produced by the International Foundation for Art Research, that we can be concerned with the same world. It is not just that if we take an object to the museum for identification, we will be admonished that the museum can indeed identify, but of course cannot value. In the gallery, any suggestion that financial values ever even entered into the history of art at all seems to be taboo, save for discreet, grateful references to the donors and funds which have on occasions made acquisitions possible. The tradition is sustained in those most up-to-date productions, CD ROM guides. Consult the National Gallery Microsoft CD ROM, the Louvre CD ROM or the Corning Museum of Glass CD ROM, incorporated into the Victoria and Albert Museum's new display of glass. Only in the last, concealed with other matters under the curious heading of 'Short stories', is there any suggestion that the glass, when new, was a commodity which was bought and sold. In the other cases, we may be told for whom a work of art was made, but there is rarely any reference to what the purchaser paid for it, what it cost to make it, and above all what the gallery had to pay to get it.

The taboo is upheld by clear distinctions between the way cash is used in different spaces within the museum. On the one hand are the cafes and the shop, places where cash can be exchanged for food, or for goods, such as reproductions and copies. On the other hand are the displays, exchange-free zones, for the re-presentation of the authentic and the pure. In between there is a threshold, where you may exchange cash for admission, but once in the galleries themselves only occasional and trivial exchanges happen, for example of cash for leaflets. Sometimes you can make an offering of money too, as you might in throwing it into a sacred well, but in that case it is not exchanged for anything palpable. Donors, whether paying for admission, contributing to upkeep, or as major patrons attending special functions, do get something in exchange for their cash, of course. They don't just get let in. They get a feeling of belonging, and the social status which goes with that. Pilgrims to mediaeval shrines often got indulgences, relief from time in purgatory, into the bargain. But still, as long as you are in the reserved space marked by authenticity of the

objects and experiences within it, you don't exchange cash for goods. What all this conceals is that outside the museum, of course, authenticity does get exchanged for cash, much more cash than is required for those copies and reproductions, and that both authenticity and cash are also tied in with social position, all part of a system of exchange. That is not to rule out a transcendent dimension as well to the qualities and experiences associated with authenticity (though it does for some), but it is to admit that if such values are, for lack of a better word, 'real', they are mighty hard to disentangle from their social context.

The symmetry between the museum as a place where financial values have no place in the meanings of art as expressed in displays, and the museum as champion of authenticity, is illuminated by one curious historical exception to the rule. In the South Kensington Museum (the predecessor of the Victoria and Albert Museum), in the later nineteenth century, it was the practice that the prices paid by the museum for contemporary artefacts were displayed on their labels.[2] This came in for comment from commissioners during famously stormy hearings of a parliamentary select committee inquiry in 1897, which followed much press criticism of the museum. It was clearly quite long-established practice, since we find the prices, for example, in the museum's catalogue of antique and modern furniture and woodwork of 1874.[3] It was justified by some curators on the ground that the South Kensington Museum was unlike others, in being a museum of fine workmanship for contemporary practitioners, in which costs were simply a question of professional interest, rather than a shrine to cultures of the past. The same justification was cited for displaying some of the forgeries the museum had acquired, whose unfortunate recent acquisition had provoked some of the unfavourable comment. Defending themselves before the committee on the subject of the forgeries, both C. Purdon Clarke, the Director, and Armstrong, the Director of Art, insisted that it did not matter to a museum of workmanship when the work was done, if it was fine. 'I would buy any kind of modern object that was beautiful as a work of art,' Armstrong insisted, 'it does not matter to me if it was made last week or made in the fourteenth century.'[4] So what qualified the object as fit to have a place in the South Kensington Museum was very different from the requirements of authenticity in the sense of 'not forgery' defended by most museums. The prices vanished in due course, and the relaxed attitude to forgery was abandoned too, along with the recognition that works of art do have costs and values, as the museum lost its founders' aspirations to offer an example to the manufacturing classes in the hope of stimulating British industry and became, like other museums, more of a cultural shrine.

The taboo forbidding curators to enter the market except as inspectors of purity was at the heart of a spectacularly sordid court case in 1912. George Donaldson, a dealer, sought to ward off an action by Alfred George Temple,

curator of the Guildhall Art Gallery. Even the Lord Chief Justice, presiding, apologised that he had not examined the papers in the case early enough to arrange a substitute, since he was aquainted with both parties. Donaldson had donated collections both to the museum of the Royal College of Music and to the Victoria and Albert Museum and was a friend of Edward VII. Alfred George Temple, shown in figure 1, Knight Commander of the Orders of the Danenborg and Alfonso XII of Spain, Officier de l'Instruction Publique de France, Chairman of the Executive Committee of the National Trust, Councillor of the Royal Drawing Society, etc. etc., was involved in organising major shows abroad, as well as in the Guildhall Gallery. His own taste was resolutely conservative, bitterly hostile to Impressionism, for example, and he was a painter himself, of an ethereal world through which drift damsels. He described his curatorial career in a volume of memoirs,[5] which does reveal a notable preoccupation with art prices (which, though, we may be sure never intruded into exhibition), but no hint, not a whiff, that he was himself involved in the trade.

The eruption of the court case, therefore, was like the overturning of a stone to reveal a world of teeming, naked competition. Temple's case was based on

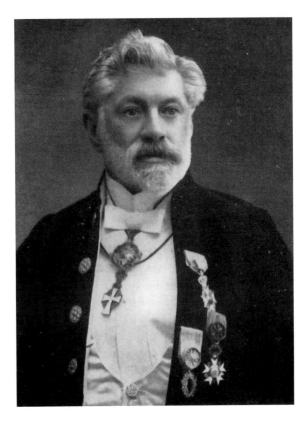

1
Alfred G. Temple

entitlement to a share of proceeds, in recognition of his role in introducing to Donaldson a senator, the millionaire railway magnate senator Clark, who became a substantial client. For all three men, art was just part of an elevated social position. The interest of the case for this discussion is that Donaldson sought to defend himself by discrediting Temple, through the revelation that Temple had been covertly dealing at the same time as being a curator in the public sector. Donaldson only lost, perhaps, because Temple's breach of taboo was not a legal one, and in threatening to ruin Temple by revealing it Donaldson could be made to appear to have broken even greater taboos. He might still have got away with it but for the sordidness of the details of his machinations, which Sir Edward Carson for Temple's defence was able to dig up. Even improper enquiries to Temple's employers as to his freedom to deal under his contract might have been excused but for such tit-bits as this quotation from a letter suggesting Donaldson's approach to business: 'Wait till your hare is in the field and then start your dogs. Oh! You innocent lamb.' Even worse than this mixture of animal metaphors, Donaldson's threats to Temple had been uttered to a mutual acquaintance, a Miss Brough, a skin-specialist with a club in Soho, a lady with whom both men had long been aquainted, had often lunched. We need not dwell on just how the complicated history of financial dealings between the three became involved in the case, or even speculate that perhaps Donaldson's true offence, unspoken in a world of men keen to keep one part of a fellow's life separate from another, was to have brought such a possibly dubious connection into the case at all. The point is to notice that Donaldson believed all this would be outweighed by Temple's breach of art world convention, and indeed it emerged during the case that the American artist Edwin Austin Abbey had sustained the convention, in resolutely refusing Donaldson's attempts to pay him for a first link in the chain of introduction to the senator, even outwitting Temple and Donaldson's attempt to persuade his wife to accept some cash.[6]

There is often a *frisson* of surprise if the taboo is relaxed and the signs of financial interest show through. It even applies in the private sector. Note the dealer René Gimpel in 1918 on the discretion with which the dominant expert on Italian painting, Bernard Berenson, took care to disguise his commercial involvement, well known to insiders: 'He doesn't do business or accept commissions, but he shares in the profits. "Here are twenty-five thousand francs, M. Berenson." "Thanks, Gimpel."'[7]

Nevertheless, there is still a clear distinction between the public museum and the dealer. The sense that a hidden border has been crossed when anyone transfers from one to the other is there even when not a breath of impropriety is suggested, for example when the unimpeachably art-establishment figure of Sir Peter Wakefield, former director of the National Art Collections Fund, was recently reported to be involved in the sale of Rembrandt's *Rape of Europa* to

the J. Paul Getty Museum for between $25m and $40m dollars, not just as an adviser, but on a two-year contract to negotiate a deal.[8] 'Gamekeeper turned poacher', declared a headline in the *Independent on Sunday* in the same spirit, reporting the appointment of Richard Oldenburg, previously director of the Museum of Modern Art in new York, as Chairman of Sotheby's America in the Summer of 1995.[9]

In practice any half-decent curator or scholar is in constant touch with the market, and by no means as a neutral inspector. Regrettably often, the contact has even extended to dubious practice. The tradition is doubtless as old as collections, and erupted into the light of day a couple of centuries ago with the precipitous flight of the magnificently disreputable Baron Raspe, creative geologist, schemer, and almost certainly author of the *Adventures of Baron Munchausen,* whose brief curatorial career ended when he was about to be found out pawning specimens of medals from the ducal collections he was appointed to curate. Though very much alive, for example recently in the Chester Beatty Library in Dublin, quite such a sharp curatorial feel for the financial value of collections is of course the exception. It is an ever-present possibility, though, because curators must remain in the market, with an eye to acquisitions or simply to the passage of important specimens, and must know about prices in order to value collection items, to purchase and to advise potential donors. Curators are not there just as observers or as independent experts on identification. They are actively involved in setting values. Often this is just because a museum show or acquisition affects market values. Lawrence Alloway describes how, curating a show of Morris Louis 'veil' paintings in 1963, he was obliged to scale down his catalogue revelation of quite how many of these paintings there were, or else face the withdrawal of collaboration from the artist's dealer and estate, which at the time was carefully restricting supply of the paintings on the market. They were shrewdly holding back until the consensus valuation of the painter was more secure, thanks, of course, to exhibitions in not-for-profit galleries such as the venue for Alloway's show, the Guggenheim.[10]

Curators can be involved in much more technical ways too. So much so that the tax authorities in the USA, the IRS, had to step in during the 1980s to ban a role for museums in valuing when objects were offered as donations, with tax incentives to the donor which increased with the values of the donations. The most celebrated instance, involving the distinguished but exotic curator of antiquities at the J. Paul Getty Museum, Jiri Frel,[11] was only the tip of the iceberg. The regulations published by the IRS in 1988 in order to distance museums from just these issues do not remove the requirement for curators to be expert in these and many other technicalities.[12] British curators must know their way around comparable thickets of rules, involving intricate financial maths and a terminology so arcane that it is hard even to pronounce except in

the muttered tones appropriate to elite negotiations, of *private treaty* sales, *in lieu* acceptances, or the technicalities of the levels of the *douceur* intended as an inducement to owners to take advantage of provisions reducing tax, where works are not sold on the open market.

Some of the problems arising in the USA were considered by a panel at an evening seminar in New York in 1983 (organised, of course, not by a museum but by the *Art Research News*). What should a museum do, a questioner from the floor asked, when a donor proposes, rather than sell a museum a set of six chairs, to sell them two at a very high price, in return for a secret agreement to donate the other four in a subsequent year, claiming tax concessions on their valuation? The museum would still gain – even highly priced, the two chairs cost less than the six would – but the tax authorities would lose. That would be a manifest scam, the panel replied, and probably a museum crime, but other issues were trickier. What should the museum do, for example, in the case of a gift accepted in good faith, and valued fairly according to its current attribution for tax concession purposes, but which the curators later identify as a fake, and therefore as of less value? Alerting the IRS will hardly please the donor, yet to fail to do is to enter uncertain legal territory.[13] Transcendent aesthetic values cannot be kept distinct from cash values.

Aesthetic quality and social status

Nor from social values. The next point to note is that these values are not merely financial. Few values are. Even in a subsistence economy a market is the arena for trading of goods in exchange not just for the cost of making them, but for their survival value. In any more relaxed economic circumstances, market values reflect status and power more symbolically. Consider the rise in value, in the 1920s and 1930s, of British or American art of the eighteenth century, following the taste established by the Arts and Crafts Movement, in relation to a little book of 1933 by Margaret Bulley called *Have you good taste?*.[14] Miss Bulley was associated with art education and its research in the London County Council in the first half of the twentieth century, and had already in 1925 published *Art and counterfeit,* – not, as one might suppose, a study of forgery, but of 'true art' as opposed to 'false'. *Art and counterfeit* included a report, from 1923, of children's preferences as expressed to pairs of reproductions shown to them on cards.[15] *Have you good taste?* was an exercise on the same lines, but based around the fine arts, reproducing the picture pairs and responses collected from adults during a survey organised by the journal *The Listener*.

Margaret Bulley's starting-point in *Have you good taste?* was to emphasise that authentic art does not lie in photographic realism. More generally, her comparisons reflect a loosely Arts and Crafts derived set of principles, spelled

out more explicitly in her text. She was reserved about then current notions of functionalism, which she associated with Le Corbusier, wondering if it was not too materialistic, but was quite clear that Art Nouveau had been 'a misfortune and perverted taste'. Her preference was for principles of form derived from Ruskin and confirmed in her own time by Roger Fry. The judgements are all ostensibly of formal properties. Thus of the first of the two chests of drawers in figure 2 (which actually belonged to Roger Fry), 'plastic sense of form has so shaped the whole that the ornament becomes an integral part of the structure . . .' and so forth, whilst of the second 'the ornament might be cut out of cheese'.[16] Margaret Bulley is quite clear that 'beauty exists . . . it is something "objective", as the philosophers would say, and is not "just a matter of taste"', and that therefore in her picture pairs she could contrast 'objects . . . of the same type, but whereas one is exhibited as a work of art . . . the opposed example is shown as a poorer work, or else as a counterfeit, downright ugly'.

But in the details of Bulley's discussion class and culture are constantly breaking through. 'Only a great artist-craftsman could have conceived the design' of the first chest of drawers, whereas the second is inspired by the thought of profit – not something, of course, for which true artists spare a moment's thought – with mouldings costed by the yard. Another of the 'counterfeit' specimens is a piece of printed textile which 'looks like cheap linoleum'. Elsewhere she disapproves of the furnishings put by a department store for an advertisement into a large house 'on a housing estate'.[17] Are we not hearing a faithful echo of Ruskin's detestation of mechanised ornament in the new furnishings displayed in the Great Exhibition, maybe an echo too of his conviction

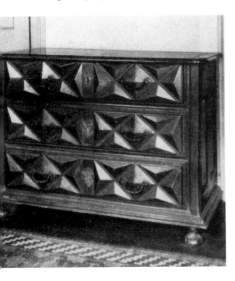
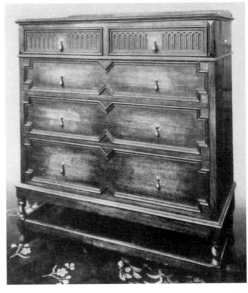

2 Chests of drawers in good and bad taste

that the loss of pleasure in traditional labour, visible in traditional artefacts but only parodied by the machined ornament of factory manufactures, was leading the working classes to seek relief in false notions of liberty? Small surprise that Miss Bulley's academic psychological adviser should turn out to be none other than the established, but still quite young, Cyril Burt, who later, after the Second World War, almost certainly invented data to justify his findings about the relationship between genetic background and intelligence. In an appendix to *Have you good taste?*, he warns that the samples are too small to be more than indications, but still has no hesitation in finding that 'men of the highest eminence . . . no matter what their sphere of work, sent in replies that are inevitably superior to the replies of others following the same calling'. By contrast, those 'whose occupations are of a humbler sort' gather at the other end of the scale.[18] Men, reassuringly, perform better than women on such substantial items as chairs and bookcases, but: 'For both sexes the voiles and embroideries were the hardest of all; and here, as might be expected, the women were distinctly better.'[19]

So taste is variable, for Margaret Bulley, but beauty is essentially absolute, and overall good judgement of truth as opposed to counterfeit in art correlates with class, gender and intelligence. Burt and Bulley's eminent experimental subjects include the art critic Clive Bell, sculptors Frank Dobson and Eric Gill, scientists James Jeans, Julian Huxley and Oliver Lodge, as well as the writer Walter de la Mare and Earl Russell.[20] As a group they might just as easily have been cited by Pierre Bourdieu in his sociological mirror-image version of things, in which Margaret Bulley's notion of beauty is seen as arbitrarily defined, her truth as counterfeit, whilst the training to recognise such supposed beauties and truths gives access not to spiritual realms, but to a code qualifying those who understand it as members of dominant social groups.[21] On what authority, we can imagine Bourdieu asking, did Miss Bulley call for calibration of beauty in her specimen picture pairs? The answer is a committee, representing an opinion-forming circuit in which value accrues to works of art: two academics, Constable from the Courtauld Institute and Jowett from the Central School of Arts and Crafts; a journalist, Tatlock, editor of the Burlington Magazine; the critic Roger Fry; and, of course, the directors of the National Gallery and the Victoria and Albert Museum.[22] But this is another group which Bourdieu might have cited just as readily as Bulley.

Art museums and the cycle of values

Margaret Bulley's authenticity, associated with 'true' artistic quality, is certainly involved with social values, just as the more usual association between authenticity and attribution is associated with money values. It is apparent too that the association of the supposedly transcendental properties of art with financial and social values involves a large cast of people: artists, dealers,

publishers, collectors, critics and art historians as well as museum curators – indeed everyone concerned with art at all. Both the reputations of works of art and their money value are ever on the move, as subjects of discussion even when not in the form of physical transactions, such as sales or exhibitions. In every transaction between members of the cast making up the art world, between the critic making a comment and the public, between a curator and visitors to a show, between a dealer or publisher and buyers, the financial and social values attached to the works of art involved, including assessment of their supposedly transcendent aesthetic dimension, change. Over time, the values can go down as well as up, but as long as an artistic stock is rising, everyone gains just by association with it. The identity of each participant is invested in a different aspect of the business, the artist in creativity, the critic in shrewd commentary, the dealer in promotion of talent, the client, public or private, in a collection. Each transaction involves the participants in an exchange, as cash, social status and the supposedly transcendent values of the object are translated into one another.

That is where museum display and aquisition plays a special role. It seems to lift the object out of the cycle of exchanges, finally severing it from the social and financial distractions from aesthetic value that inevitably compromised the work as it cycled from transaction to transaction in its hazardous social life, *en route* to Nirvana in the art museum. Through aquisition, or even in a provisional way just through temporary museum exhibition, the work crosses a threshold, usually from private into public ownership, but always into 'not for profit' display, in which it becomes an object only of transcendent values. Not only the work attains a new status in this rite of passage. As the work is incorporated into exhibition programme or collection, both the identities and cash value of stock in hand of everyone who bought into that particular merry-go-round go up a notch. This adjusting of social values by ritual endorsement of transcendent ones is, of course, the sleight of hand at the heart of the conjuring trick, since the museum is just as much the source of all the kinds of value associated with objects as are their makers.

The role has been fundamental to museums from their origins, as is delightfully illustrated in the small picture in figure 3. From 1615 the Augsburg painter Anton Mozart has left us a record of the handing over of the Pomeranian Art Shrine, or Kunstschrank, to the local duke, Philipp II.[23] These elaborate pieces of furniture were little museums in themselves, their outsides shrines to art, their cupboards and drawers filled with curiosities of both art and nature as well as necessities of the toilet and entertainments. The Kunstschrank, typically, would be the centrepiece of the Kunstkammer, a chamber devoted to collections of the same kind. Philipp II's Pomeranian example of the Kunstschrank, sadly destroyed by bombing in the last days of the Second World War, was probably the most famous example of its type, requiring seven years to make, by two dozen artists and craftsmen. To be a contractor for the

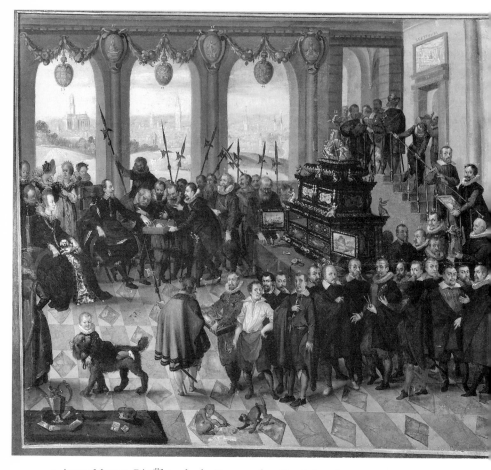

3 Anton Mozart, *Die Übergabe des Pommerschen Kunstschranks*

Pomeranian Kunstschrank was, of course, a matter of commerce, but at the same time to be involved, for a craftsman or artist of Augsburg, was to be inscribed in the canon of excellence, a local canon perhaps, but one solemnised in the formal and public transfer that the painting celebrates. To be on the safe side, and for maximum effect, Mozart made his record of the event and published it as a print two years before it happened. No wonder the locksmith Jois Muller turns his head, no doubt to show off his preferred profile.

The cult of art and the cult of saints

The Kunstschrank, however, not only looks forward to the museum. The term means 'art shrine', and the ancestors of these cabinets were the cases in which

relics were kept and displayed. They make one small, direct link between the cult of art and the cult of saints. That small link is only a tiny part of a much larger parallel between the roles of the guardians of museum and church collections. The role of the museum in masking the political and social lives of artefacts through the policing of authenticity and the canon jumps into relief when it is noted how closely it parallels the very comparable role of church authorities in relation to relics of the saints. We should still beware of seeing the parallels as more than suggestive. The greatest difference to bear in mind is that the nearly 2,000-year-old role of church authorities in policing Christian belief dwarfs the puny two centuries or so which museums have so far put in on the art beat. We are comparing quite a fine-grained set of changes in the meanings of authenticity in museums with what must be decidedly simplistic glimpses of often remote devotional practice. Nor should we imagine museums as the heirs to a role, as if the cult of saints had evolved neatly into the cult of art. Kunstschranks were one avenue in which just that happened, but they comprise only one small strand in the history of museums or relics. The analogies we will consider extend far more widely, and come right up to date.

The first point that the parallel suggests is the extent to which aquisition and display are matters of ritual, for shrine or museum. As Sue Pearce relates in discussing relics in her study of collecting, their rite of passage into the shrine was a transformation of the spiritual status of the donor of the relic too.[24] The physical translation of the objects was also ritualised. The movement of relics was marked by procedures of *translatio* and *elevatio,* whose meanings changed with time, but covered the actual transfer of relics from site to site and often from one owner to another, as well as their disinterment if necessary, and later their ritual display to the public in a new site. The rites of passage, especially prior to the twelfth century or so, were very often represented as rebirths of the objects after a period of danger and confusion, expressed in legends of acquisition, and of the prowess of noted aquirers. Where this process, as was often the case, involved removal of the relics without the authority of previous guardians, the process was dignified with another solemn term, *furta sacra,* 'sacred theft'. It was the norm in earlier centuries, from shrines sometimes in utter ruins, sometimes merely a bit neglected, on occasions with the consent of demoralised locals, often furiously pursued by them. Such episodes were so integral to the implication of rebirth through transfer of the object that they were often invented for relics whose provenance did not include one. Within the museum world the traditions of *translatio* and *elevatio* are reflected only weakly in the tradition of the private view, however glitzy, but *furta sacra* flourishes virtually unchanged.

Ambitious abbots resemble nothing so much as aggressively acquisitive curators. The early eleventh-century Abbott Richard of St Vanne in Verdun reminds us of Thomas Hoving's account of his career at the Metropolitan

Museum.[25] Each took over an institution with a reputation for a certain austerity, but left behind him a much rebuilt institution whose high profile had attracted great wealth in gifts. One of the clerical critics of Richard's building programmes saw him building in Hell in a vision, and it would come as no surprise to hear opponents of Hoving's extensions of the Metropolitan Museum of Art into Central Park express similar sentiments. Both were protected by their record in acquisition. Richard's prize coup was the arm of St Pantaleon, which he secured through courageous *furta sacra* in the ruins of Commercy, even as it was being sacked by Odo of Champagne. Not even Richard, however, matched the aquisitive passion of Bishop Hugh of Lincoln, later himself canonised, who, once allowed to handle the relics of the arm of Mary Magdalene at Fécamp, tried to sever a finger delicately with his incisors, but had to get to work seriously with his molars when he found he was chewing off more than he could bite.[26]

Thomas Hoving may never have had to secure an acquisition by biting it, but his books of reminiscence have endowed some of his acquisitions with troubled passages that saints might envy. Did he and his expert team from the Met really have to jam a chair against the door of a room in Christie's to make a technical examination of Velazquez's *Juan de Pareja* against the auctioneers' wishes?[27] Can duplication really explain why the Euphronios krater, which Hoving acquired for the Metropolitan Museum of Art, was not the same Euphronios krater that the Italian Government believed had reached the clandestine antiquities market after illegal theft from an Etruscan tomb?[28] It sounds little less miraculous than the timely, if startling duplication of the body of St Abbanus, a miracle some millennium and a half earlier, which forestalled fighting between the monks of the monastery in Ireland in which the saint began his career, and those of the one in which he died.[29] From the point of view of ritual, the truth does not matter at all, and such buccaneering adventures on the market certainly make for better mythology than the humbling appeals for cash and beseeching of financial donors against export deadlines that so often mark the dreary rite of passage of major objects in Britain. From the point of view of ritual, the murkier the adventures endured by the object in its public rebirth, the better.

The rituals of translation that mark the rite of passage of the object are matched by those of authentication. In the cult of saints, authentic saintly status is first indicated by a holy life, whereas in the case of art, for reasons that, as we will later see, are intimately involved in the meanings of authenticity, it is an unholy life that helps. Then the status of the relic or artefact itself, as well as of the associated saint or artist, needs to be confirmed by miraculous effect, either curative or aesthetic. In the early days standards for miracles were not stringent, as some might guess from the case of the miraculous duplication of the relics of Saint Abbanus. Over the centuries things were tightened up, with

formal records of testimony by large numbers of named witnesses. If we had been on pilgrimage in Canterbury around Easter in 1171, the year after Becket's murder, we might well have been quizzed by a monk named Benedict, deputed to gather evidence and witnesses of Becket's miracles, to support his candidature and then status as a saint.[30] The evidence remained a matter of assertion by witnesses, but that is, after all, as will also be emphasised later, just the problem too with evaluations of aesthetic effect.

For both church and museum authorities it is much better if miraculous effect is backed up by procedures to confirm convincing provenance. We will look at the provenance of works of art in greater detail later, but any art exhibition visitor will be familiar with the acres of small print in traditional catalogues, seeking to reconstruct the history of ownership and display of objects from the moment they were made. Confirmation of authenticity by provenance of relics was not easy for the Church. It was not a problem in connection with the relics of the very early martyrs, since their followers often witnessed their deaths and the gathering of the remains, but thereafter was almost impossible to ensure for saintly relics. Forgery became a sustained epidemic. By the early fifteenth century, Bernardin of Siena complained that 100 cows could not have produced all the milk which Mary had apparently left as relics, and this kind of joke was endlessly repeated thereafter, particularly in the form of the ever larger feats of carpentry proposed to consume all the fragments of the True Cross.[31] Even where the physical source of relics was fairly reliable, there could be no certainty about just whose bits were whose. Consider the efforts of the relic-merchant Deusdena, of the ninth century, who travelled round the great abbeys of the north, exciting jealous competition and collecting commissions to secure desirable saintly remains, and then systematically worked the catacombs of Rome to fulfil them, employing a whole organisation in the business.[32] What on Earth, literally, could the emissaries very occasionally sent to Rome to check on purveyors of this kind hope to establish about the particular human remains they were offered? No wonder that when Hinckmar of Rheims convened a mid ninth-century synod to confirm the authenticity of the relics of St Helena, it was felt that a better way to test the credentials of her translator was through something more demonstrably rigorous, ordeal by hot water.[33]

The validation conferred by the procedures of authentication is not all one-way. The object once authenticated reciprocates by adding to the lustre of its new home, whether shrine or museum. This is usually unspoken, but objects can become eloquent in this respect when there are question marks over the legitimacy of the act of transfer. Then the object is recruited to bear witness to the superior claims of the new home as custodian. Thus, when the city of Venice stole the body of St Mark from Alexandria in 827, in practice to prop up their case for ecclesiastical independence, along with what Patrick Geary in his

study of *furta sacra* calls a staggering array of falsified documents, the justification was pious: to rescue the remains from the hands of Saracens.[34] That is the standard story, that the new institution, whether shrine or museum, is a better home for the acquisition, because it will be better looked after, or because it was not appreciated where it was. Saintly relics often obligingly signalled their agreement with miracles. Indeed, a saint's agreement was often sought in this way before a *translatio* was undertaken, and woe betide whoever ignored dissent, like the archdeacon of Bishop Rufus of Turin, struck dead when he persisted in trying to remove from its church the finger of John the Baptist.[35] But in account after account – Geary tells us some 100 of them are known between the death of Charlemagne and the Crusades – the saint agrees, sometimes after some agonising, whereupon fragrant aromas accompany the *elevatio*, and miracles follow the enshrinement after the adventures of *translatio*, often confounding the furious protests of the communities from whom the remains have been extracted.

Museum supporters have to speak up to make the same point for their reticent objects, but have done so eloquently in great waves of museological *furta sacra*. Consider the removal, and subsequent reluctant restitution, of treasures brought by Napoleon to France from all over Europe. 'Let them take them, then,' Baron Gross declared, reluctantly conceding after Napoleon's defeat that the acquisitions must be relinquished, 'but they have no eyes to see them with. France will always prove by her superiority in the arts that the masterpieces were better here than elsewhere.'[36] Similar refrains embellish claims to perpetual custody of the materials brought to northern and western Europe and the USA in later waves of acquisition, first from Greece, then from Egypt and the Near East, then, at the end of the nineteenth century, in a great blundering, plundering competition, from the buried cities of the silk road across the Taklamakan desert.[37] The 1816 British Select Committee report on the Elgin marbles speaks for all of them, echoing Baron Gross, though this time it is not artistic superiority and valour but traditions of freedom which made England their natural home: 'no country better adapted . . . honourable asylum . . . secure from further injury . . . serve as models to those who, by knowing how to revere and appreciate them . . .' etc.[38] Similar arguments were until recently still trotted out in respect of objects aquired with little scruple for provenance, under the aggressively aquisitive policies of American museums in the 1970s and 1980s. The Boston Museum of Fine Arts justified retention of a breastplate bought in Sotheby's, but later found to have been stolen from the Lafayette Collection in the late 1970s, on the ground that by the time the connection had been made, study, conservation and publication had enhanced its value.[39] When the history of museums attains a scale which can be reviewed as can that of the cult of saints, how enlightened will these great epidemics of *furta sacra* seem? Will they sound more convincing than the defence of Professor John

Quentin Feller of Scranton University in 1991, a trustee of the Peabody Museum in recognition of his donations, that his theft of 100 pieces of porcelain from numerous museums was justified to rescue them from neglect?[40]

The benefits of aquisition are often a lot more material than mere validation of status. Financial interest is often as much involved. A shrine was an investment, no less than a museum extension, by quite early in the Middle Ages. Charlemagne, trying to bring a little order to life amongst the Franks in 811, ordered an investigation into rampant *translatio* of relics by those who 'then construct new basilicas and vehemently exhort whomever they can that they should donate their goods to them.'[41] No one paid much attention. Pilgrimage became an industry, with guidebooks that can have a remarkably modern touristic ring to them: 'On this same mountain', we read of Mount Carmel in *Les Pelerinages por aler en Jherusalem* of about 1231, 'is St Margaret's, a convent of Greek monks, also occupying a beautiful place. The convent has some good relics, and overlooks the place where St Elijah lived, a chapel cut into the rock. . . .'[42] We owe the cathedrals of Europe and Chaucer's Canterbury Pilgrims to the tradition. Modern-day city fathers build prestige museum developments into their capital programmes with the same aspirations, though Berliners stole a march on rivals just by opening their hearts to Christo and Marie-Claude instead of Christ. In 1995 the wrapping of the Reichstag attracted an estimated five million visitors, before the city has properly begun to catch up with the huge investments of Frankfurt and Cologne in modern museum developments.

Once the pilgrim reaches the shrine or museum, politics can have more to do in practice with just which saints or artists he or she finds canonised there than has all the ostensible evidence emerging from the rituals of authentication. That emerges vividly from a record of the process of canonisation in the archives of Salisbury Cathedral, the residue of the two centuries of lobbying necessary to secure the canonisation of Osmund, Bishop of Sarum in the late eleventh century, but successfully canonised only in 1456.[43] The public case presented by the documents, the 52 miracles attested to by 75 witnesses, not to mention 100 cures of toothache, the reputation, the carefully preserved relics, was the least of it. At a tense late stage in the protracted and expensive negotiations the dean and chapter warn their agents in Rome against 'the double langage of a certein person named in your seid lettre . . .' and recommend that because of 'the gret instaunce made bysily un to his holynesse be messages and writings of diverse kings and princes for saintes to be canonized in their Reames and landes . . . oure said mater wold be best spedde . . . in secret wise, so that sollicitours of other canonizacions shuld not knowe thereof . . .'[44] The petitioners had one card up their sleeve, since the popes knew very well that failure to canonise a candidate with sufficient local credibility was to invite people simply to ignore papal authority. More than that, when the agents spent

more of their desperately short cash on a Roman consistory court advocate (it cost them 4 ducats just to get him to give them back their documents), he advised them to play on papal fears that England might renounce the authority of Rome entirely, three-quarters of a century before Henry VIII did just that. We hear mutterings of internal Church politics too, as cardinals discussing the case are reported to the commissioners to have grumbled that had Osmund been a mendicant – fashionably avant-garde, as we might say – and not a member of an established major order, he would have been canonised long ago. But none of this, of course, could be guessed from the papal bull of canonisation, or the ceremonies which followed it in Salisbury.

In the Western liberal democracies, the cycle of art world opinion from which canonical status emerges is rather more like the ecclesiastical equivalent at an earlier stage, before the papacy had imposed its authority on the process. Canonical status emerges locally, hand in hand with the need to establish or reinforce local identity. At the start of the twentieth century nationalism played a striking role in the development of appreciation of the qualities of vernacular artefact production, both in Europe and the USA. Thus in each country discovery of rugged virtues like those expressed in Roger Fry's Provençal chest of drawers was associated with national folk characteristics. Until late in the nineteenth century such objects were little collected; excluded, in other words, from the canon. Even in 1909 the director of the Metropolitan Museum, Edward Robinson, had reservations about whether people would be interested in the collections of such things included in the celebratory nationalist exhibition commemorating the Hudson Fulton expedition.[45] Yet it was in just such contexts that interest did arise, and as tastes changed dramatically in the first decades of the twentieth century, it was with decidedly nationalistic overtones. Wallace Nutting, in his American book on *Period furniture*, remarks that 'we love the earliest American forms because they embody the strength and beauty in the character of the leaders of American settlement'.[46] No surprise then that across the Atlantic the prolific author of collectors' manuals, Arthur Hayden, in his *Chats on cottage and farmhouse furniture*, assures us that it is only in the last few years that the taste for the 'French insipidities' of Chelsea and Derby porcelain and the like has been replaced by appreciation of the sterling qualities of Toft and Enoch Wood and other such producers, 'as English as the leather blackjack and the home-brewed ale'.[47]

Notoriously, the politics can be those of the state too. The long-rumoured CIA backing for the promotion of the reputations of the New York Abstract Expressionists in the late 1940s and 1950s has recently been put on the record, in the testimony of many of those involved, for a recent UK television programme.[48] The CIA agenda was to support anything that communist governments and sympathisers opposed, especially an art movement demonstrating such rugged macho individualism as did Abstract Expressionism. As in the case

of St Osmund, there were more local political currents too, since the public US establishment at the time, less liberal than the CIA, still associated several of the painters with subversive, leftist sympathies and with degeneracy, and rubbished their work. 'If that's art, then I'm a Hottentot', President Truman remarked. The support was, therefore, factional and covert. Sometimes, the agents now testify on camera, some wealthy fellow would set up a new foundation – the Fairfield Foundation was one of many – often no more than a letter-head in practice, to provide cover for Agency funds on their way to support shows in France and Italy. At other times, it was just old-fashioned cardboard boxes full of cash, surreptitiously moved from car to car.

The economic and political implications of artworks and relics are reflected finally in the tight control of church and museum authorities over not just the presentation of relics and artworks, but even the way they were supposed to be experienced. The first problem is to sustain the spiritual pretensions at all in the face of the manifestly worldly associated interests. Not everyone is convinced, whether by miracles or aesthetic effects. There were some dissenting voices against the cult of relics even in the early Church, and many who doubted their credentials by the high Middle Ages. Klaus Schreiner, in a study of scepticism on this score, remarks how often in the writings of thoughtful ecclesiastics we come to find the phrases 'as the religious believe', 'it is claimed', 'as they say' or 'if ancient belief is true'.[49] Much theological effort went into awkward questions about relics of Christ's umbilical cord and foreskin, let alone the Virgin's milk. On any reckoning they must first have become available at an early stage in His life, and whoever thought to preserve such things at that stage in the game, sceptical folk were inclined to ask? But doubts are not confined to religious belief, and the spinning women in Utrecht market in 1251, warning bystanders that the new martyr discovered by the local Dominicans was just a scam to get money, sound much like opponents of modern art in the local papers.[50]

It was not just a matter of believers versus unbelievers. The authorities of the new Protestant states of the mid-sixteenth century sought to discredit the papal authority they displaced through demonstration of the forgery involved in some miracles. Mechanical forgeries of miracles seem to have been a speciality of the fifteenth and early sixteenth centuries, like the 'certain engines and old wire, with old rotten sticks . . . that did cause the eyes to move and stare in the head' found in a statue by a commissioner dismantling the devotional furnishings of an abbey church in Kent, as a part of the enforcement of Protestant conventions of worship after Henry VIII's renunciation of the authority of the Vatican.[51] No wonder that in response the authorities in Rome became more cautious and have remained so, through centuries of ever more elaborate control of veneration. In the spring of 1995, the Vatican has moved to veto the use of even a copy of the Madonna, which, it is said, has begun to weep tears

of blood to the enormous commercial excitement of enterprising citizens of Sant' Agostino, outside Civitavecchia in Italy, following its translation from Medjugorje in Bosnia.[52] In the routine housekeeping reported in the almanac of the Vatican Media Office for spring 1995, caravans, savings banks, astronauts and television workers all have patron saints, newly authenticated with updated procedures and standards. Meanwhile the Feast of St Thecla is abolished 'since there is no basis for her veneration', whilst of St Symphorosa and her Seven Sons it could only be said that 'the account of their lives is not worthy of belief'.[53]

It is hard for us to be sure of our interpretations of more sophisticated debates about the experiences appropriate in the presence of relics, because of the remoteness for us of the experience of shrines for a less sceptical clientele, at such huge distances and intervals of time. Nevertheless, some experiences were clearly appropriate, others not, and regional and Church politics play a role. In the late tenth century St Bernard of Anger, compiling a book of miracles, set off to check out the statue of the Virgin Mary at the church of St Foy in Conques, enjoying a great reputation following the cure of the blindness of one Witbert, in 980. Bernard is horrified by what he finds, here and elsewhere in the south of France, since there seems no awareness of the distinction by then accepted in the north that objects – such as fragments of the cross – are better subjects of veneration than images, which always offer the risk that the superstitious will worship the image idolatrously, rather than venerate what it represents. The shining statue of St Gerald at Aurillac, for example, looks to Bernard more the kind of thing one might set up to Jove, or Mars. The pilgrims prostrating themselves in such shrines had probably never before seen anything like the jewel-encrusted, gleaming-eyed effigies placed like holy highwaymen to demand their offerings.[54] For appropriate experience of a saint, Bernard insists, a book is OK, perhaps a picture, since shadowy patterns on a wall are not at all the same thing as a statue, but it is clear that the faithful must not mistake the representation for the real presence.[55] The kind of issue Bernard is engaging was of course a huge one for the Church, encompassing the main distinction between the traditions of the Eastern Church, which associated with icons a real sacred presence that the Roman Church accepted in relics, but not in pictures or sculpture. It is an issue so persistent that Graham Greene met his first wife in 1925 only thanks to a letter she sent him, to remonstrate with him for using in a magazine article the word 'worship', rather than 'venerate', to describe devotion to the Virgin Mary.[56] Policing of experience is at the heart of control of authenticity and of the politics of the Church.

For today's museums, Pierre Bourdieu offers us an analogy suggesting as much concern for authenticity of experience as Bernard's at Conques, in spite of the huge gap in time and context. Museums, he says, implicitly emphasise (as, it will be recalled, Margaret Bulley did explicitly) that what is authentically

to be appreciated in a picture is not whatever is represented, but higher properties, such as the formal characteristics of paint or composition. The distinction is one which, according to Bourdieu, helps to define the art appreciation of the educated middle class from the less informed appreciation of less dominant social groups. The latter appreciate a picture for its mimetic qualities, or for what it shows, 'condemned to a perception of a work of art which takes its categories from the experience of daily life and which results in the basic recognition of the object represented'.[57] The distinction is in this case particularly socially divisive because the less educated have no access to the codes that would enable them to experience artworks in the prescribed manner. The museum seems open to all, but is in practice a mechanism of social distinction and exclusion.

The strength of evidence about the social and political dimensions of the role of museums in policing authenticity certainly makes it hard to retain a role for any purely transcendent values in what curators care for. The Marxist Walter Benjamin, in a famous essay, proposed that the day of the museum object, with its 'aura' of uniqueness and authenticity, is as surely over as the credibility of religious experience. We must understand, he insisted, that even our consciousness is politically constructed. The work of art had been, he suggested, the object of a cult of beauty, a kind of socially formed perceptual response appropriate to the age which had to counter the earlier rituals of the Church, but hopelessly outmoded in an age when a new politically formed consciousness had no further need for 'aura' in the age of limitless reproduction and film 'The reactionary attitude towards a Picasso painting changes into the progressive reaction towards a Chaplin movie.'[58]

In that scheme historians and curators of art are exposed as the priesthood of a discredited religion, unless content with a modest role on the sidelines of the cultural present, as explainers of the historical process that has left their objects like religious relics for an unbeliever, as mere husks of vanished authenticity. The problem for anyone who wants to retain a more transcendent and cross-cultural role for aesthetics and artworks is that it is very hard to stand outside the kind of socially conditioning processes that Benjamin or Bourdieu propose, to study art other than as a participant. The approach I shall follow in the chapters to come is to focus down from this brief overview of the institutional control of authenticity, to take a close look at what it is that is done in the name of authenticity, as art historians identify, conservators intervene and curators display. These functions seem straightforward enough, but justifying practice in the name of authenticity will turn out to mask problems that seem to bear out a political analysis of what is going on. Only if the mystique of authenticity that burdens good practice with meanings that are often paradoxical is cast off will scope be found for a more positive view of what art history and its museums do.

Notes

1 M. Orvell, *The real thing: imitation and authenticity in American culture*, 1880–1930 (Chapel Hill, University of North Carolina Press, 1989), pp. 144–6.

2 Select Committee on Museums of the Science and Art Department *Report* (London, House of Commons Parliamentary Papers, 1897), XII, p.287.

3 J. H. Pollen, *Antique and modern furniture and woodwork in the South Kensington Museum* (London, Chapman and Hall, 1874).

4 Select Committee on Museums of the Science and Art Department, *Report*, pp. 185, 289.

5 A. G. Temple, *Guildhall memories* (London, John Murray, 1918).

6 *The Times*, 5, 6 and 7 November 1912, p. 3 of each issue.

7 R. Gimpel, *Diary of an art dealer*, trans. J. Rosenburg (London, Hamish Hamilton, 1986), p. 4.

8 P. Jeromack, 'The inside story of a sale', *The Art Newspaper*, 46 (March 1995), 13, 14.

9 G. Norman, 'Gamekeeper turned poacher', *Independent on Sunday* (11 June 1995), 78, 79.

10 L. Alloway, 'The great curatorial dim-out', in R. Greenberg, B. W. Ferguson and S. Nairne (eds), *Thinking about exhibitions* (London, Routledge, 1996), pp. 220–230, 227.

11 T. Hoving, and G. Norman, 'The Getty scandals', *The Connoisseur* (May 1987), 99–108; and 'It was bigger than they know', *The Connoisseur* (August 1987), 73–81.

12 Thanks to Andy Finch of the American Association of Museums, replying to my query on the internet list Museum-L, 9 February 1996, for information on these rules.

13 *Art Research News*, 2:2–3 (1983), 3, 4.

14 M. Bulley, *Have you good taste?* (London, Methuen, 1933).

15 M. Bulley, *Art and counterfeit* (London, Methuen, 1925), pp. 85–92.

16 Bulley, *Have you good taste?*, figures 1 and 2 and pp. 25, 26.

17 *Ibid.*, p. 2.

18 C. Burt, 'A test in aesthetics', *ibid.*, pp. 44–52.

19 *Ibid.*, p. 50.

20 *Ibid.*, p.46.

21 P. Bourdieu and A. Darbel, *The love of art: European art museums and their public* (Cambridge, Polity Press, 1991).

22 Bulley, *Have you good taste?*, p. 20.

23 Gallery information sheets of the Kunstgewerbemuseum, Berlin: R. Braig, 'Der Pommersche Kunstschrank' (sheet 1473); 'Die Übergabe des Pommerschen Kunstschrankes an Herzog Philipp II von Pommern-Stettin im Stettin im Jahre 1617' (sheet 1474); 'Die Gegenstände aus dem Pommerschen Kunstschrank' (sheet 1475); (Berlin, Pädagogischer Dienst, Staatliche Museen Preussischer Kulturbesitz, 1985).

24 S. Pearce, *On collecting* (London, Routledge, 1995), pp. 98–102.

25 J. P. Geary, *Furta Sacra: thefts of relics in the central Middle Ages* (Princeton, Princeton University Press, 1990), pp. 65–7.

26 P. Binski, *Medieval death: ritual and representation* (London, British Museum Press, 1996), p. 15.

27 T. Hoving, *Making the mummies dance: inside the Metropolitan Museum of Art* (New York, Simon and Schuster, 1993); reviewed by R. Hughes, 'Masterpiece theatre', *New York Review of Books*, XL:5 (4 March 1993), 8–14, 11, 12.

28 Hughes, 'Masterpiece Theatre', 10.

29 Geary, *Furta Sacra*, p. 116.

30 B. Ward, *Miracles and the mediaeval mind: theory, record and event, 1000–1215* (London, Scolar Press, 1982), pp. 89–109.

31 K. Schreiner, ' "Discrimen veri ac falsi": Ansätze und Formen der Kritik in der Heiligen- und Reliquienverechnung des Mittelalters', *Archive fur Kulturgeschichte*, 48:1 (1966), 1–53, 37.

32 Geary, *Furta Sacra*, p. 45, 46.
33 Schreiner, ' "Discrimen veri ac falsi"', 1–53, 9.
34 Geary, *Furta Sacra*, pp. 88–92.
35 *Ibid.*, p. 114.
36 H. and A. Borowitz, *Pawnshop and palaces: the fall and rise of the Campana Museum* (Washington, Smithsonian University Press, 1991), p. 109.
37 P. Hopkirk, *Foreign devils on the Silk Road* (Oxford, Oxford University Press, 1984).
38 I. Jenkins, *Archaeologists and aesthetes in the sculpture galleries of the British Museum* (London, British Museum Press, 1992), p. 19.
39 J. Conklin, *Art crime* (Westport, Conn. and London, Praeger, 1994), p. 33.
40 *Ibid.*, p. 170.
41 Geary, *Furta sacra*, p. 40.
42 A. Jotischky, *The perfection of solitude* (Philadelphia, Pennsylvania State University Press, 1995), p. 140.
43 A. R. Malden (ed.), *The canonisation of St Osmund* (Salisbury,Wiltshire Record Society, 1901), pp. iii–xxxiv.
44 *Ibid.*, p. 115.
45 C. Tomkins, *Merchants and masterpieces* (New York, E. P. Dutton, 1970), p. 175.
46 W. Nutting, *Period furniture* (Framingham, no date – *c.* 1926), p. 5, cited in M. Orvell, *The real thing: imitation and authenticity in American culture, 1880–1940* (Chapel Hill, University of North Carolina Press, 1989), p. 167.
47 A. Hayden, *Chats on cottage and farmhouse furniture* (London, L. T. Fisher Unwin, 1912), p. 31.
48 Tony Cash (director), *Hidden hands: a different history of modernism* (a documentary for ATV, produced by Frances Stonor-Saunders, 1995).
49 Schreiner, ' "Discrimen veri ac falsi" ', pp. 24, 25.
50 *Ibid.*, pp. 1–53, 14.
51 G. H. Cooke, *Letters to Cromwell and others on the suppression of the monasteries* (New York, Hillary House Publishers 1965), p. 145.
52 A. Gumbel, 'Bad Friday as weeping Madonna is locked up', *Independent* (15 April 1995), 11.
53 F. Wheen, 'Francis Wheen adds to the Pope's list of loose canonisations', *Observer*, *'Life'* supplement (21 May 1995), 5.
54 B. Abou-el-Haj, *The mediaeval cult of saints: formations and transformations* (Cambridge, Cambridge University Press, 1994), p. 1.
55 E. Dahl, 'Heavenly images the statue of St Foy of Conques and the signification of the mediaeval "cult-image" in the West', *Acta ad archaeologiam et-artium historiam pertinentia*, 8 (1978), 175–91.
56 D. Lodge, 'Behind the smoke screen', *New York Review of Books*, 42:10, 61–6, 62
57 Bourdieu and Darbel, *The love of art*, p. 44.
58 W. Benjamin, 'The work of art in the age of mechanical reproduction', in H. Arendt (ed.), *Illuminations* (London, Fontana, 1973), pp. 219–53, 236.

2

THE CONNOISSEURS' PARADOX

EVEN PIGEONS, according to researchers at Keio University in Tokyo, can be trained to discriminate between Impressionist and Cubist pictures.[1] As far as was reported, the pigeons neglected to commission any pigment analysis and did no research into provenance, but just relied on judgement by eye. Human judges, on the other hand, relying on the eye alone, can even fail to recognise a painting by a duck rather than a person, to judge from the case of the abstract by Pablo the Muscovy Duck, alias Van Duck, purchased as a human artefact in Liverpool.[2] No wonder that art historians avail themselves of extra aids when possible, but judgements by eye and feel remain the first line of approach, and surprisingly often the only one. It is an approach which tends to be discredited not only by demonstrated error, but by the vagueness of language to which it can give rise, but it can also be startlingly successful. However, though aesthetic judgement is often cited in evidence in proposing attributions, consensus of acceptance depends upon more direct evidence, or even upon legal convention.

The connoisseur is never more exposed than when in court. In 1977 a New York court adjourned to the apartment of Stuart Travis of Investment Corporation Prometheus Fund, to try to establish the authorship of a painting attributed to Sir Joshua Reynolds that he had offered to the Metropolitan Museum, on condition that the valuation was high enough to be advantageous to him for tax purposes. The museum had called in Brenda Auslander of Sotheby's as an appraiser, who had concluded that the painting was not by Reynolds, but was instead an unusually nice Tilly Kettle. Counsel for the defence, Robert Weiner, recalled the scene in the flat at a subsequent seminar. 'If anyone has ever tried to explain to someone who is not familiar with art, and who doesn't have an eye necessarily, as to why something is right, it was an education.' The British art historian Sir Ellis Waterhouse, appearing for the defence, justified his opinion against the attribution to Reynolds partly on the grounds that the expressions of the children in the picture looked silly, whereas

those in Reynolds's paintings always looked intelligent. 'The court looked at me,' Weiner continued in recalling the case, 'I looked at the judge, and basically, the judge said, "Well, he's supposed to be the expert"'.[3]

And yet, week after week, millions of British viewers watch the specialists of the *Antiques Road Show* making judgements which demonstrate how much routine, successful attribution goes on, based only on judgement by simple inspection. There have been documented instances of less routine but even more impressive feats of discrimination, such the letters from the Samuel Palmer specialist David Gould and from the artist Graham Sutherland, denouncing as imitations the pictures attributed to Samuel Palmer, but subsequently revealed to be by Tom Keating, just on the basis of photos reproduced in the *Sunday Times* in 1973.[4] How can judgement by eye be sometimes so penetrating, sometimes fallible and always so hard to communicate?

Projecting knowledge into what we see

The answer is that visual perception is a much less constant business than it appears. Seeing anything at all, resolving the data streaming across the retina into sense, depends on knowledge and expectation as much as on the incoming data. Perception does not seem so fallible from the inside, but a lesson that we do not see what is in front of us, but rather a construction, including a large contribution from the mind, is most vividly demonstrated by the well-known geometric illusions in which shapes which are demonstrably circular are seen as spiral, or parallel lines appear to diverge. Illusions like these probably arise from the economic bundling together of signals into neural channels at quite an early stage in the exceedingly complex progress of the data from the eye into consciousness. The contribution of prior knowledge to more everyday visual experience is better demonstrated by figure 4. It prominently presents three objects, but there is more to it than that.[5] Even if it takes only a moment to see what makes this a more complicated image, there is for most viewers a difference between the image before and after the complication appears.

4
A drawing suggestive of the role of knowledge in perception

However, nothing whatever in the pattern has changed. It is only our knowledge and expectation of what it means that have altered, but what it feels like to look at has quite changed too.

Even in everyday circumstances our ability to recognise objects is mysterious, because it is so hard to define what it is about the objects that we are recognising. It seems so straightforward, when you look, for example, at a chair. In the 1960s computer engineers thought that it would be a fairly simple business to equip a computer with a formalised, generic description of what chairs are like, so that the machines would be able to recognise them in the data captured by a video-camera. Not so. Machines can only reliably recognise objects presented to them one by one, in just the form expected and lit consistently. How is it that our brains can often recognise as a chair even an extraordinarily eccentric example, made, say, out of knarled tree-roots, half in shadow, and perhaps only partially visible amongst other objects? How can we recognise the same chair again when we see it under utterly different conditions? We must be comparing our sensory perceptions of the object with some representation in memory, but what characteristics of the object comprise such a flexible representation, not to mention what physiological form the representation takes in the mind, is utterly mysterious. All we know is that such mental references must play a role in every act of recognition, and presumably be constantly updated. There is no reason to suppose that judgements made in the processes of art attribution, spotting that our chair is not just a chair but a particular kind of rustic one, or the mysterious processes involved in just finding the chair beautiful, are innocent of these constraints on ordinary vision.[6]

The recognition of the characteristics which we apply in making art-historical attributions is in effect a fascinating case-study of these problems. The process, which in everyday life we do continuously and unconsciously, is broken down into discrete experiences – the memory of specific comparative examples – and to some extent translated into verbal terms in looking at art. Each time we come across an unfamiliar work in a recognised style, or see one we know after an interval, we update our impressions of what is special about the style. The serious student of art may well make notes about the experience, though, of course, even in this process much happens which we do not articulate to ourselves. By the end of the seventeenth century, commentators were quite explicit that the judgement of works of art involved matching each new examination with a consciously formed mental representation. The writer and artist Jonathan Richardson remarked, echoing earlier writers, that from study of the aspects of an artist's work which are characteristic we: 'Furnish our minds with as Just and Compleat Ideas of the Masters . . . as we can . . . For when we judge who is the Author of any Picture, or Drawing, we do the same thing as when we say who such a portrait resembles. In That case we find the Picture answers to the Idea we have laid up in our minds of such a Face'.[7]

The mental representation is all the more consciously formed because so much experience of works of art is not gained from objects in the condition and context in which they were made, but from remnants, much transformed by age and adaptation. Sir Joshua Reynolds, writing a few decades after Richardson, made the extent to which this must call for an act of conscious projection very explicit: 'An artist whose judgement is matured by long observation, considers rather what the picture once was, than what it is at present. He has by habit acquired a power of seeing the brilliancy of tints through the cloud by which it is obscured.'[8] Even more commonly, we learn not from objects at all, but from glimpses through another dark glass, that of reproduction. For artists of the past the reproductions were not photographic, but engravings, in other words not just copies, but copies in another medium. The projection of characteristics into perception whenever we try to retrieve the original appearance of a work under circumstances of this kind, bordering at least on conscious projection, is therefore quite a normal part of looking at art.

The projection is not just a matter of visual forms, either. As the team of researchers on the Rembrandt Research Project remark in the introduction to their first volume, it is not just a matter of

> the collecting of a stock of visual memories, but also the 'reconstruction' of an individual . . . One's opinions on authenticity are based a great deal on this reconstructed image of the artist, but every fresh confrontation with paintings seen before causes friction between one's image of the artist and the actual work of his hand. It is as if, time and again, a distortion occurs through one's own mental structure being projected on the imaginary mental structure of the artist.[9]

The same kind of process is also unconsciously involved in looking at art, and indeed in any act of recognition. It is not possible to define how much of any visual experience is consciously formed by the process of projecting into what we see, and how much unconsciously.

How these uncertainties, in the face of problems of display, condition, and reproduction, are compounded by the observer's mood, and indeed food, is described in an account from the late 1930s by Alan Burroughs, a connoisseur, though better known as an American pioneer of the application of X-rays in the study of art. He describes three varying perceptions of a 'small portrait by "Terburg", the first when the painting makes little impression on the connoisseur 'after a distressing meal . . . when the lingering distaste of greasy food tops every subtle reaction of the senses'. On the second occasion poor viewing conditions leave the door open for projection into the painting from previous experience: 'Full of recollections of other pictures by Terburg, one concentrates upon the poorly displayed example . . . in general making the most out of the aesthetic experience of the moment.' It is only later, inspecting a photograph,

that Burroughs wonders whether 'the will to see blinded one to the fact . . . that this is not one of Terburg's best efforts . . . that the background is repainted. In the vague light of the gallery one might have missed these details and unconsciously reconstructed the effect as it was in its original state.'[10]

Evaluating objects or evaluating experience?

Burroughs reflects a sustained confusion about just what the connoisseur is assessing that arises out of these perceptual difficulties. He tells us that the photograph he ends up with was obtained as a reminder of the experience of seeing the picture, yet in the end it is not his experience of which the photograph offers an *aide-mémoire*, but features of the object missed in the earlier examination. Connoisseurs' assessments are sometimes of properties of objects, but at other times of the experience offered by an object. It is often hard to decide which is under discussion, yet clearly these are two very different things. The art historian Richard Offner, in 1927, was one of the very few connoisseurs to be clear that his approach was an evaluation of his experience.[11] However, the confusion between object and experience, combined with our perceptual fallibility, makes the role of the connoisseur a tricky one, and the trend in art-historical and curatorial debate has been away from evaluations of experience and towards identification of characteristics of the object. It makes the role a paradoxical role one, because when the connoisseur, like Burroughs inspecting his photograph, attempts an objective assessment not of experience but of characteristics of the object, rather as we routinely recognise the sender of a letter in the characteristics of handwriting, without necessarily finding the writing beautiful, the process rather begs the question of quality, of transcendental values, since they are surely, for a connoisseur, the only justification for the exercise.

The confusion between properties of the artefact and of the viewer's experience appears early in the literature of connoisseurship, and is very apparent in Jonathan Richardson's *Two discourses* of 1719. Richardson is more concerned with assessment of excellence than mere attribution, and in that context suggests that the critic use a formal scheme to set out how successful the artist has been. Figure 5 shows his example. Each aspect assessed is marked out of eighteen, except drawing, which in Richardson's view cannot aspire to sublimity, confining it to a maximum score of seventeen.[12] The important point for us is that Richardson tries to distinguish those aspects which are inherent in the object, listed from 'composition' to 'colouring', from those aspects that reflect the viewer's experience, added below as 'advantage' and 'pleasure'. We would now, of course, hesitate to accept the first list as properties of the artefact, accessible to objective assessment, but Richardson was, as Carol Gibson-Wood emphasises in a study of connoisseurship,[13] following the lead of his philoso-

pher contemporary Locke in his confidence that sensory perceptions can be reliably divorced from feeling. Once the rules of excellence under these headings are understood, he assures us, 'a man is as certain he sees what he thinks he sees as in any other Case where his own Senses convey the Evidence to his Understanding'. Advantage and pleasure, by contrast, are 'More or Less as my Fancy, Judgement or other circumstances happen to be . . . and every man must judge for himself'. In case we needed a reminder of how remote from our own assumptions all this is, 'advantage' turns out to mean what we might call moral benefit. Richardson explains that the portrait he is considering, being of a widow, inspires in him thoughts of the sadness of widowhood, and thus of the virtues of marriage. So eighteen out of eighteen for advantage, but not perhaps for Richardson's own distinction of objective and subjective.

The beginnings of a shift in focus, away from assessment of experience and towards that of objective properties, is apparent in the last decades of the

(70)

Countess D O W A G E R *of* Exeter. **V. D Y C K.** O C T O B E R *the 16th,* 1717.		FACE.
Composition	10	18
Colouring	17	18
Handling	17	18
Drawing	10	17
Invention	18	18
Expression	18	18
Grace and Greatness	18	18
Advantage 18 *Sublime.*		*Pleasure* 16

5
The table of excellence

The

eighteenth century. The focus moved from the interest of Richardson's generation in excellence, at least as much a property of the viewer's experience as of the object, and towards a much more consistent preoccupation with attribution, still a matter of opinion, but unequivocally about a property of the object. The shift is reflected in the conventions of picture-hanging in galleries. During the century a style of ornamental, symmetrical hanging had become formalised, in which the work of artists of different schools was mixed up, but in balanced arrays to bring out just those comparisons of excellence of interest to Richardson and his contemporaries. We find records of examples now only in archives and engravings, but one revival is currently under way. In the summer of 1996 the collections of the Doria Pamphili family in Rome were on tour in London and Washington whilst their gallery was being prepared for rehanging in just this style, following a scheme devised by Nicoletti in 1760 and preserved in manuscript.[14] The hanging style we are more used to, of paintings arranged by school and artist so as to reveal the characteristics of each in a much more classificatory way, was introduced in the new public galleries of the last decade of the eighteenth century in Düsseldorf, Vienna and Paris, as Andrew McClellan explains in his study of the establishment of the Louvre as a public museum.[15] It proved a remarkably durable convention for paintings. Curiously, in the display of ancient sculpture the advocates of aesthetic against systematic arrangement managed to put up a more successful defence.[16]

The same confusion between the assessment of experience and of properties of objects is reflected too in the history of rather variable suggestions about just what features of a painting a connoisseur should focus upon. Some connoisseurs of the seventeenth century distinguished between those parts of a painting whose execution was hack work, often left to studio assistants, and the parts which could only be done with panache by the master. The commentator Giulio Mancini, for example, in his *Considerazione* of 1620, recommends looking for perfection in 'those parts which demand resolution and cannot be well executed in the process of imitation', such as ringlets of hair. The printmaker Abraham Bosse, a little later, claimed that many painters even specially fashioned particular brushes for different effects, which could never then be imitated by any imitator lacking these tools.[17] But this emphasis on touch was only appropriate for the quite free painting styles favoured at the time – the age of Rubens and Frans Hals – but by no means universal. It is also still unclear whether what the connoisseur evaluates in the touch is some hand-writing-like characteristic of the shape of the paint, or an emotive effect upon the viewer.

The issue remains a theme in contemporary connoisseurship, though the evaluation of connoisseurial experience now plays the minor role. By the end of the nineteenth century there was a clearer awareness of the role that formal properties of the object rather than of experience might play. 'I have wanted to show', the doctor turned art historian Morelli wrote to his British friend Layard

in 1885, 'that the overall impression of a work of art is not sufficient, and that to recognise a great master with certainty in these works it is above all the forms peculiar to that master that must be known . . . The aesthetic . . . has nothing to do with the science of art.'[18] More specifically, it was in those details which an artist forms least consciously, such as ears and hands, that the characteristic forms appear, and which should be the focus of the art historian's attention, according to Morelli. However, Carol Gibson-Wood, who cites this letter of Morelli's in the original French in her study of connoisseurship, warns us that Morelli did not himself apply this scheme with the consistent rigour sometimes attributed to him. It was Bernard Berenson, in the next generation of art historians, who developed his suggestions into the systematic approach attributed to Morelli, complete with a sliding scale of features in Italian painting carried out with more or less attention; ears, hands, folds and landscapes offering the unconsciously painted diagnostic features, whereas structure and movement of figures, architecture, colour and chiaroscuro were more consciously devised.

The same principle was surely being followed by the British physicist Arthur Laurie in the early decades of this century, though he does not say so explicitly himself, in the approach he pioneered using macro-photographs of brush-strokes, like the ones in figure 6–8, enlarged to the point where their role in representation vanished into abstraction. These examples all show hands (though Laurie took his details from every part of paintings), in figure 6 from Rembrandt's portrait of Claes Berchem's wife of 1647, in figure 7 from a portrait by Frans Hals, and in figure 8 from one by Jacob Backer in the Wallace Collection, which has a spurious Rembrandt signature.[19]

But this kind of focus on properties of the object by no means entirely displaced more intuitive assessment of aesthetic experience. Neither Morelli nor Berenson doubted that the overall impression of quality – of their own reactions – was still of vital importance. The scholar of the Northern Renaissance, Max Friedlaender, insisted that the most useful impression was that formed at once, from a glance at the whole picture, and that it was essential to avoid focusing on details at that stage, taking the watch to pieces to the point where it no longer goes.[20] In this tradition, here is Thomas Hoving, nothing if not vivid, on technique for the connoisseur, first when inspecting Velazquez's *Juan de Pareja* for aquisition by the Metropolitan Museum: 'The first impression of a work of art is the whole pedigree, the rush that comes to the experienced art watcher in the first thousandth of a second . . . I motioned Fahy to place a seat in front of the *Juan*, which had been set on an easel. Hubert set up the spotlight . . . 'Hit me!', I said. The light clicked on, and I glanced directly at the picture and then looked away . . .'. He tells us how he contrived something similar when viewing the Euphronios vase in a restorer's garden in Zurich. This time, fortified with a cold bee , 'I turned my eyes to the thing and felt as if I had been punched in the stomach.'[21]

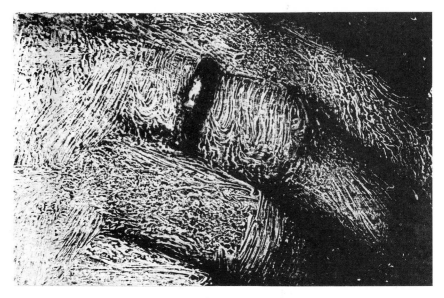

6 Detail of a hand from Rembrandt's *Portrait of Claes Berchem's wife* of 1647

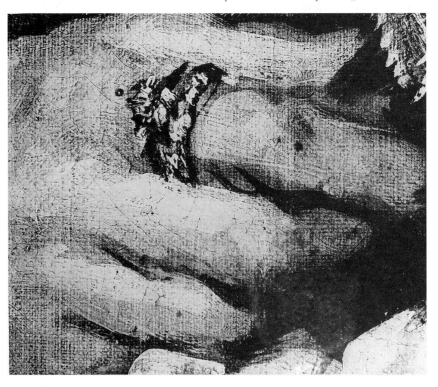

7 Detail of a hand from a portrait by Frans Hals

This kind of James Bond approach to aesthetics would not have cut much ice with Mauritz van Dantzig, a lover of systems, who published his most influential results in the late 1940s and 1950s.[22] He stands a bit outside the mainstream of art history, but he wrote the text for an influential postwar Rijksmuseum exhibition *True or false? (Vals of Echt?)*, which toured to the Corning Museum of Glass in 1953, itself now a centre for the study of forgery.[23] In direct contradiction to Friedlaender, he insisted that anyone who accepts a judgement made at first sight and intuitively is content with only superficial perceptions. Van Dantzig made the most thorough of attempts to systematise the assessment of visual properties of paintings. He analysed them from menus of literally dozens of possible stylistic components, rather as if working with indentikit picture components. Not only of paintings, since he proposed similar systematic methods for character assessment for business recruitment. Van Dantzig also seems to have fallen into the error of middle age which expresses itself in a conviction that fundamental truth in the speciality of a researcher can be boiled down to some key principle, understood only by that great sage who is oneself, like Casaubon's key to all mythologies in George Eliot's *Middlemarch*. The key to quality for van Dantzig, who restricted his interest to representational Western pictures, came to lie increasingly in an

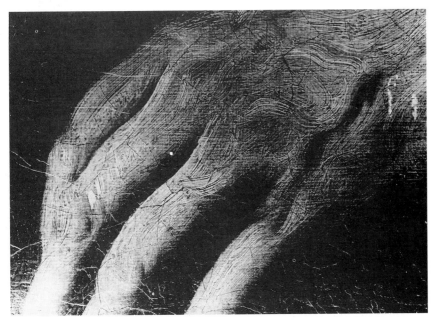

8 Detail of a hand from a portrait by Jacob Backer

insistence that the more that detail in a picture, as well as contrasts of tone and colour, are concentrated in the areas of most emotional significance, and minimised in physically and emotionally peripheral parts, the more pleasing the work appears. Of course, it is easy to find exceptions to this curious rule. It also hints at how hard it was for even van Dantzig to keep the evaluation of characteristics uncompromised by assumptions about quality.[24]

Nevertheless, van Dantzig was an acute observer, whose system offers a fascinatingly radical experiment. His approach differs from Morelli's in two ways. The first was that Morelli proposed only a handful of details for attention, whereas van Dantzig required hundreds. For any picture, he started from a list of twenty subjects from which more detailed characteristics could be derived. The second of his categories, for example, is 'organisation of the picture surface', which in the case of van Gogh expands into some twenty more characteristics: main subject as large as possible; upper parts light and airy; upright lines usually a bit inclined; horizon or eyes of a portrait usually placed between half and two-thirds the way up the canvas, etc. On technique he noted that the artist usually removed his brush at a right angle to the canvas at the end of a stroke; used paint without much oil, preserving the form of the stroke; made strokes which show slight swelling, broadest before the end of the stroke; often flattened his impasto by careless stacking of his canvases, and so forth. In colour, he noted van Gogh's liking for sharply adjacent contrasts of tone and colour, most often in the form of small warm islands of colour on larger cool areas of paint. There are ninety-two of these indicators for characteristics common to all periods of van Gogh's painting, and then others which changed with changes in his style.

The second difference from Morelli's approach was that in van Dantzig's system each of these characteristics is given a mark, and at the end of the exercise the marks are totalled. Not every characteristic applies in every picture; colour, for example, is clearly irrelevant in assessing a monochrome drawing, in which case any colour characteristics are assigned a zero. The scores of totals of characteristics in a picture which are, and are not, in line with expectation are then added and expressed as percentages of the totals of applicable characteristics for the picture (just as characteristics of candidates for jobs are now added up after interview in what many consider good equal opportunities practice). In general, van Dantzig found that in the case of van Gogh, no authentic picture got less than a 76 per cent positive score, and no recognised imitation more than 45 per cent. Any picture in between must be doubtful.[25] Amongst the examples to which he applied his method is a tricky van Gogh, *The Sea at Saintes Maries* (figure 9) which had been bought by the collector Madame Kröller-Müller from a soon-to-become notorious collection sold in 1929 by the dancer turned Berlin dealer Otto Wacker, soon to emerge as a purveyor of forgeries.[26] The *Sea at Saintes Maries* was a particularly problematic

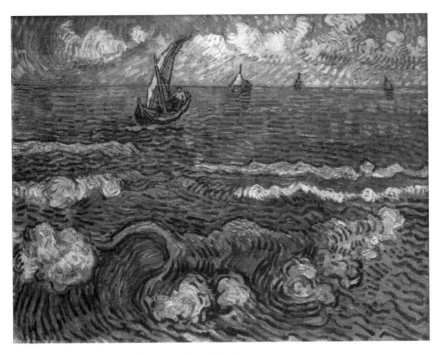

9 Imitator of van Gogh, *The sea at Saintes Maries*

painting, and the leading van Gogh specialist La Faille changed his mind about it no less than four times, remaining puzzled for decades after Wacker's trial in 1932.[27] In van Dantzig's analysis the painting emerges as a fake, with only 44 per cent positive features.[28] La Faille's final verdict, and current opinion, go along with van Dantzig in this case.

There are all sorts of problems with his approach. It is less successful where there is not a huge *œuvre* like that of van Gogh, for example in the case of Leonardo, who van Dantzig admitted gave him problems. He also acknowledged that even assessment of the most down-to-earth characteristics would sometimes vary from person to person, though he insisted that in his method such variation would be random, and cancel out. He did not, however, manage wholly to avoid confusing evaluation of the experience of the observer with assessment of characteristics of the object. Some of his characteristics are clearly subjective, 'tragic atmosphere' for example, for van Gogh, or 'lifelike portrayal of body'.

Van Dantzig's is essentially the approach that in a less formal way anyone attempting a connoisseurial assessment by eye still brings to bear. So we find the art historian Konrad Oberhuber, speaking at a seminar on connoisseurship in New York in 1983, insisting that connoisseurship can be taught, and specifying

very different and specific criteria for different artists, as Van Dantzig did, instead of seeking to specify one type of feature to focus on for judgement, as the seventeenth-century connoisseurs had proposed for touch, or Morelli for the least consciously painted details. In Piero della Francesca, Oberhuber suggested, it is the structure of space for which one looks, in Fouquet the organisation of surface, and so forth.[29] Effective as this kind of approach can be, it still rarely commands consensus by itself. It is compromised by the confusion about just what is being assessed, and the burden of proof has shifted to less equivocally objective evidence. That leaves the connoisseurs' paradox unresolved. If the point of the whole exercise is to identify artefacts that give rise to experiences of a kind that other objects cannot offer, why should identification depend on properties of the artefact that play a minor role in evoking the experiences? The puzzle becomes odder by the end of the next chapter, where it will be seen that the most valuable evidence is scientific and documentary, usually with no direct role in the visual effect of the object at all.

Notes

1 Anon., 'Art is the food of life for pigeons', *Observer* (14 May 1995), 5.

2 W. Barton, '£70 for a van Duck original', *Daily Telegraph* (31 September 1985), 17.

3 *Art Research News*, 2: 2–3 (1983), 4, 5.

4 T. Keating and G. and F. Norman, *The fake's progress* (London, Hutchinson, 1977), p. 229

5 The white shape in the middle is the silhouette of a figure. It is the profile of a classical Greek pedimental figure of one of the sons of Niobe, protecting himself with his cloak above his head, and can just be seen as a plaster cast in the far left-hand corner of the room in figure 27.

6 H. B. Maginnis, 'The role of perceptual learning in scholarship', *Art History*, 13:1 (March 1990), 104–17.

7 F. Junius the Younger, *Painting of the ancients* (London, printed R. Hodgkinson, 1638); and J. Richardson, *Two discourses . . .* (London, [W. Churchill, 1719] Scolar Press, 1972), p.149, both cited in M. Kirby Talley, jun., 'Connoisseurship and the methodology of the Rembrandt Research Project', *International Journal of Museum Management and Curatorship*, 8 (1989), 175–214, 177, 179.

8 J. Reynolds, 'The second discourse', *The Works of Sir Joshua Reynolds*, ed. Edmond Malone (London, T. Cadell, jun. and W. Davies, 1801), vol. II, pp. 33, 34.

9 J. Bruyn, B. Haak, S. H. Levie, P. J. J.van Thiel and E. van de Wetering, *A corpus of Rembrandt paintings* (Amsterdam, Martinus Nijhoff, 1982), vol. I, p. xvi.

10 A. Burroughs, *Art criticism from a laboratory* (London, Allen and Unwin, 1939), pp. 29, 30.

11 R. Offner, 'An outline of a theory of method', in his *Studies in Florentine painting* (New York, Junius Press, [1927] 1972), pp. 127–36.

12 J. Richardson, *Two discourses . . .* p. 70.

13 C. Gibson-Wood, *Studies in the theory of connoisseurship from Vasari to Morelli* (New York, Garland Publishing, 1988), p. 123.

14 J. E. Kauffman, 'Doria Pamphili treasures visit America', *The Art Newspaper*, 61 (July–August 1996), 12.

15 A. McClellan, *Inventing the Louvre* (Cambridge, Cambridge University Press, 1994), esp. pp. 3–5.

16 I. Jenkins, *Archaeologists and aesthetes in the sculpture galleries of the British Museum* (London, British Museum Press, 1992).

17 J. M. Muller, 'Measures of authenticity, the detection of copies in the early literature on connoisseurship', in *Studies in the History of Art*, 20 (1989) (Proceedings of the symposium 'Retaining the original, multiple copies, originals and reproductions', Center for the Advanced Study of the History of Art, National Gallery of Art, Washington, DC, and Johns Hopkins University, Baltimore, 8–9 March 1989), pp. 141–9, pp. 143, 144.

18 Letter from Morelli cited in Gibson-Wood, *Studies in the theory of connoisseurship*, pp. 237–47.

19 A. P. Laurie, *Study of Rembrandt and paintings of his school by means of magnified photographs* (London, Emery Walker, 1930), figures 10, 14 and 42.

20 Kirby Talley, jun, 'Connoisseurship and the methodology of the Rembrandt Research Project', pp. 188, 189.

21 T. Hoving, *Making the mummies dance* (New York, Simon and Schuster, 1993), pp. 256, 311.

22 J. Storm van Leeuwen, 'The concept of pictology and its application to works by Frans Hals,' in H. L. C. Jaffé, S. van Leeuwen and L. H. van der Tweel (eds), *Authentication in the visual arts– a multi-disciplinary symposium* (Amsterdam, B.M. Israel BV, 1978), pp. 57–92.

23 J. J. Denier van de Gon, 'Sponteneity in motor expression and the art of playing the spinal c(h)ord', in Jaffé, van Leeuwen and van der Tweel (eds) *Authentication in the visual arts*, pp. 93–102, 94.

24 M. van Dantzig, *Pictology* (Leiden, E. Brill, 1973), p.10.

25 M. van Dantzig, *Vincent? A new method of identifying the artist and his work and of unmasking the forger and his products* (Amsterdam, Keesing, 1953).

26 F. Arnau, *Three thousand years of deception* (London, Jonathan Cape, 1961), pp. 226–41

27 J. B. de la Faille, *L'œuvre de Vincent van Gogh* (Brussels, G. van Oest, 1928); *Les Faux van Gogh* (Brussels, G. van Oest, 1930); *Vincent van Gogh* (London, Heinemann, 1939); *L'Œuvre de Vincent van Gogh* (Amsterdam, Meulenhoff International, 1970).

28 M. van Dantzig, *Vincent?*, pp. 78–89.

29 *Art Research News*, 2:2–3 (1983), 22.

THE EVIDENCE

THE ODDEST feature of van Dantzig's approach was the contrast between his obsessive search for evidence in the paint and studied neglect of scientific or historical evidence. As the emphasis shifts from assessment of experience on to judgements about properties of the object, the first job is to identify the materials of which an object – any object – is made, and to check whether they are consistent with materials expected in things of that type and age. Next to look at are the ways in which the materials have been applied, once again for checking against the historical record. Then comes the historical record itself. The object may offer two sets of inscriptions, one in the hand of time, in the form of wear, of transformations and decay of materials, of treatments applied by restorers, conservators and adaptors. The other appears as labels, marks and seals. The value of this data is that it should correspond to a quite separate record, for a major object, in documents such as wills, sale catalogues and news reports and letters. We will look at each of these kinds of evidence. The point that emerges is that though they can sometimes be decisive, they can be hard to interpret too, and may only contribute circumstantial evidence to the final decision.

The evidence of science

En route, the difficulty has to be met that many of these questions are best asked using scientific techniques of analysis, or at least it is wise if science provides confirmation of the answers. A background in art history does not always encourage a love of science too. As Laurie suggested, there was quite a widespread resistance amongst connoisseurs of the first half of the twentieth century to admitting that any evidence can match that of the eye. 'The officials who guard our national treasures and the English group of art experts regard me with a cold and fish-like eye', he still claimed in 1934. 'Fish-like' seems an odd term in the context, but Laurie's next claim was more apropos. 'Their days

are numbered. Systematic research is bound to replace empiricism and intuition, and the day will come when people will be astonished to learn that the Trustees of the National Gallery with one accord refused the proposal that a laboratory be added to the resources of that institution.[1] The prejudice against any evidence except that of the eye probably goes back to Richardson and the Lockean insistence on reliance on sensory experience, but that insistence has to be understood as a reaction to earlier emphasis on received authority and reputation. Now it is sensory experience that seems more suspect, and there is very much a laboratory in the National Gallery.

Many art historians still feel that science is best left to scientists, but as will emerge in the next chapter, that turns the people in white coats into little less than oracles, and makes it hard to estimate what weight their evidence should be given in relation to other evidence. It is worth taking on board enough background to be able to ask questions, but it can seem daunting. It is not so bad when scientific inspection involves processes such as microscopy, which even in the case of the scanning electron microscope yields apparently understandable pictures, though the technicalities of how they are made may be opaque. The identities of materials too are commonly indicated by simple chemical reactions, though often the simpler the reaction, the greater, in practice, the experience needed in interpreting it. Numerous metals can be tested with just a drop of chemical. A spot of nitric acid will turn sterling silver-blue, but not affect electroplate. Even some more technical approaches, such as X-ray crystallography, though very complex to carry out, are not too hard to describe. If a material is available in crystal form, the shadow pattern thrown when it is illuminated by a beam of X-rays indicates the arrangement of the array of atoms in the crystal, and so the chemical identity of the crystal. The mathematics involved in the relationship between shadow and structure is complex, but in practice identification is often done by matching the new pattern with previously identified examples.

But there is no question but that the range of less readily understandable scientific tests available for the study of art objects is bewildering. The techniques applicable to materials of different type also vary greatly in kind and number. Scores of possibilities exist for oil-paintings, rather few for ceramic or metalwork. Even for glass, for which science has perhaps the least to offer the researcher, the techniques which have on occasion been tried sound like the stations on a non-scientist's nightmare subway line: auger emission spectroscopy, electron microprobe analysis, secondary ion mass spectroscopy, neutron activation analysis, electron spin resonance, and inductively coupled plasma source spectroscopy would only be a few of the stops.[2] But take the term spectroscopy. It occurs three times on the list. Not all that much background is required to make it possible to ask questions to get an idea about what is going on, and it introduces a principle with very general applications. The issue

hangs on the relationship between matter, for our purposes the stuff that objects are made of, and radiation, such as X-rays, or radioactivity, or light.

Matter seems familiar. Its components can be described in families which assemble at different scales. At the smallest scale sub-atomic particles combine in the atomic nucleus. It is only in recent decades that structure at this scale has impinged on human events, since the forces holding matter together at the level of the nucleus are indifferent to the changes in the materials of everyday life, such as freezing, or magnetisation, or burning. At the next scale up, particles assembled as nuclei combine with anything from one to dozens of entities called electrons, to make up the atoms of the substances known as elements, such as hydrogen, silver or mercury. Next, these elemental atoms and their electrons combine in the reactions of chemistry into the vast variety of configurations known as molecules, whose properties distinguish more complex substances from one another, water from white spirit, bronze from quartz. Finally, the ways in which molecules combine offer structure on a colossal variety of scale, from the fine-grained crystalline patterns typical of metals or snow, through the hugely complex configurations of molecules in the giant substances of life, such as DNA, to glass, which shows no regular large-scale structure at all – a piece of glass is one huge molecule.

Radiation is trickier, though the kinds art historians meet are likely to be familiar at least by name. Gamma rays, X-rays, ultra-violet radiation, visible light, infra-red, microwave and radio waves are all known as electromagnetic radiation. It can, though, come as a surprise to anyone with a British humanities background that the varieties of this radiation all belong to one extended family, so that radio waves are not so different from visible light. Beyond that, however, it is not easy to imagine them intuitively, because language, based on human experience of the world at the scale of objects and stuff, just does not offer terms to describe them. It can be said that they are disturbances which move through space, as waves move through water, but whereas we can readily describe in everyday language the stuff that water waves are made of – water – it is not easy to describe what electromagnetic radiation is a disturbance of, what stuff it is. So hard is it to conceptualise electromagnetic radiation that in pre-twentieth-century theories it was assumed that the waves must be in some mysterious, ultra-fine substance, the ether, permeating all space and matter. But there is no ether, no stuff. All that can be said of electromagnetic radiation is that it consists of moving patterns of variation in the electrical and magnetic properties of space.

Although these variations cannot readily be described verbally, they can be quite precisely measured. They are regular patterns, in which areas of intensity alternate, but unlike the two-dimensional patterns we are familiar with, they are three-dimensional, and moving at the speed of light, which makes them difficult to visualise even in the abstract. However, as with wallpaper patterns,

identical points recur in adjacent repeats of the patterns of radiation, and the distance between these points is the wavelength of the radiation. Variation in wavelength is all that distinguishes the different components of the spectrum of electromagnetic radiation, but the range of wavelength is staggering. The disturbances classified as gamma rays repeat many billions of times in the space of a millimetre, yet radio waves can be hundreds of metres in length. Visible light is somewhere in the middle, with patterns repeating two and a half thousand times in a millimetre for blue light, seventeen hundred for red.

When matter and radiation meet, one of three things may happen. The matter may be transparent to the radiation, as glass is to light, or as soft body tissue is to X-rays. The rays pass through, as radio waves can pass through brick walls. Alternatively radiation may be reflected back from the matter, as the wavelengths of visible light which appear green are reflected back from grass, or as heat in the form of infra-red radiation reflects back from the metal reflector of a fire. The third possibility is that the radiation may be absorbed by the matter, as is the red component of visible light by grass (it looks green because it is the part of the spectrum that is not red that is reflected back), or the infra-red in sunlight by the seat of a car. This absorption requires more attention, since the process very often produces changes in the absorbing matter. The red light absorbed in leaves drives photosynthesis, the physiological processes of plant life. The microwaves absorbed by food cook it. The radio waves absorbed by a metal aerial are translated into electric currents in the metal, which in turn are translated into the sound and images of radio or television.

Now for the key point. For absorption of radiation by matter to happen, there has to be a very exact match in the energy that each brings to their meeting. Recall that matter at each scale is formed by combinations of smaller entities. There is energy in the patterns of bonding and motion characteristic of the component entities of matter at every scale. There is energy in radiation too. Rather contrary to intuition, the smaller the wavelength of the radiation, and the finer the scale of the structures of matter, the greater the energy involved. When matter and radiation meet, there is absorption and exchange of energy only for wavelengths of the radiation involved that happen closely to match the energy that can be accommodated at some scale of bonding or motion within the material. The greater the energy and finer the scale, as a rule, the more drastic the transformation of the material. That is why disturbances of sub-atomic structure in nuclear events give rise to such damaging radiation: the very short wavelength gamma rays react with the chemistry of life at a very deep, small-scale level of atomic structure. On the other hand, this is also why radio waves are believed to be harmless. Especially at longer wavelengths, they can only give rise to transient electric currents in a few materials, without the energy to disrupt their chemistry, their patterns of molecular structure.

Such a brief survey provides a way into those nightmare stations on the subway line, wherever the word spectroscopy turns up. The exact accounting that goes on whenever radiation is absorbed by matter also applies when it is emitted. Measuring the characteristics of radiation absorbed or emitted by matter will in many cases reveal shifts in energy relations within the material so precise that they can be interpreted as the signatures of particular substances. However, it is often necessary to get the materials to emit some tell-tale radiation, to glow a bit in some part of the electromagnetic spectrum, not something a work of art usually does spontaneously. In a variety of techniques, therefore, and over a wide range of scales, energy is actually pumped into the object, or into a sample, for example by heating it, bombarding it with sub-atomic particles, or firing a laser beam at it. In each case the energy pumped in is carefully chosen so that instead of inducing long-term changes, it is only temporarily absorbed, and then re-emitted as radiation that can be measured. But one way or another, the exact accounting of energy exchange in absorption is the basis of any spectroscopic process.

It also helps explain related techniques that are not strictly spectroscopically understandable. We will briefly note the use of just two, both applied in the detection of forgeries; one useful for revealing details of materials used, the other for information about their age. In the first, the specimen is an illuminated manuscript, in the manner of the fifteenth century, but attributed to the most discreetly successful (known) forger of the twentieth century, the so-called Spanish forger. Forgeries from this source, coming on the market from around 1910 to 1930, have been identified in their hundreds, after decades of scholarship, though who was responsible remains tantalisingly mysterious. In this case the energy pumped in took the form of a beam of sub-atomic particles, whose energies destabilised some metal atoms in the pigments, making them radioactive. How long they remained radioactive was measured by leaving the manuscript in contact with a sequence of photographic plates, one for seven to nine days, the next for nine to eleven days, and so forth. As the days went by, some types of atoms settled down again and ceased to emit radiation, so that tell-tale patches of exposure, induced in the photographic emulsion, shrink from plate to plate. From the known characteristic decay times for different atoms, along with measurements of the energy of the radiation, it was possible to identify arsenic in green areas, indicating a pigment commonly manufactured after 1814, present in a number of the forger's works, but believed to be unknown in the fifteenth century.[3]

Thermoluminescence indicates not the identity of materials but the age of fired ceramics. It involves pumped-in and emitted energy in three stages. First, before the pot is even made, radiation within the clay itself from naturally radioactive atoms is converted into energy that gets trapped within irregularities in the crystalline structure of the minerals in the clay. Second, when the

pot is fired and heat is pumped into these irregularities, they are destabilised, and radiate all their added energy in tiny flashes of light. However, those radioactive atoms within the clay, impervious to mere heating, continue to bombard their neighbours, so that from the moment of firing the crystalline structures start to accumulate absorbed energy all over again. The researcher now makes two measurements. The first is made by heating the pot once more, but this time measuring the light emitted as tiny scintillations, to reveal the total amount of energy accumulated from radioactivity within the clay since it was first fired. The second measurement is of the proportions and varieties of radioactive, bombarding atoms within the clay. Since the rates of radiation from radioactive atoms of different kinds are known, dividing the total amount of radiation (indicated in the first measurement) by the rate at which it has been going on (derived from the second measurement) gives an estimate of how long it has been going on since the pot was fired.

In 1986 the British Museum courageously announced the results of a campaign of thermoluminescence testing applied to a wide range of ceramics, which revealed a higher than expected number of forgeries across the range of the collections, from Italian Maiolica to Roman lamps, including one of the latter that had previously been used for the cover illustration of the museum's booklet on the lamps. Twenty of the museum's seventy-three Zapotec Mexican ceramics and the museums' whole collection of five Samian ceramic moulds also gave anomalous results.[4] More positively, when the Cleveland Museum of Fine Art in the USA was considering the $1m dollar purchase of an apparently fifth-century BC Chinese bronze, bird-shaped vessel in 1991, tests on the bronze itself would have revealed little about age. But tiny particles of ceramic from the mould used to cast the bronze, lodged in crevices in its surface and brushed free for analysis, indicated with thermoluminescence a reassuring firing date, some 2,600 years ago.[5]

These are exotic and expensive techniques, and only with a lot of detailed discussion and explanation can a lay observer develop any feel for the extent to which they offer marvellous precision on the one hand, or merely helpful indications on the other. The scope for problems in sampling in the testing procedures, in matching with the record or with interpretation, vanish in pronouncements that can seem oracular. The uncertainties of interpretation of scientific evidence in a difficult case are illustrated by an example for which only more familiar techniques were brought to bear, though even these will be easier to understand with the elementary background outlined above. Figure 10 shows *St Jerome in penitence*. It is a panel painting, but an odd one, and scientific help is needed because it gets odder the more carefully it is looked at. It has traditionally been attributed to the 'German School, early sixteenth century', and indeed some details, like the ripples in the water, are more like those found in Danube School painting than anything else. The drapery, on the

other hand, is much more Italian-looking. The very formal pedestal of drapery on the ground round Jerome's knees, for example, is nothing whatever like the angular conventions of Northern painting. But even for Italian painting that kind of formalism was unusual by the sixteenth century. It had certainly given way to much more naturalistic conventions in both Italian and Northern

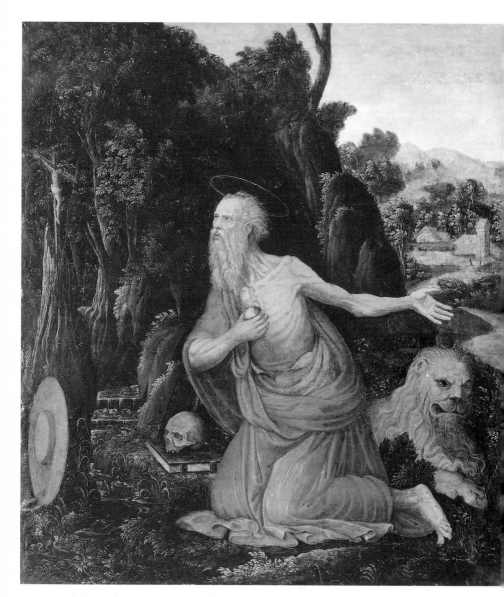

10 *St Jerome in penitence*, sixteenth century

painting by the time artists were interested in anatomical detail like the strange (and in this case quite erroneous and fanciful) forms we see in the saint's neck, which is much more typical of the second half of the century. It is hard, therefore, to place the picture geographically or by date. Dates right through the sixteenth century have been informally suggested by specialists, and locations widespread throughout Germany and Italy. The consensus seems to be that the painting is north Italian, but nobody has been able to point to anything very similar.

In a survey of possible examples for this book, this picture came to seem an ever-better candidate for a forgery, probably from the late nineteenth century. 'Once you find one thing wrong with a work of art,' Joseph Noble of the Metropolitan Museum observed, of what looked like an inappropriate casting seam in an ancient Greek bronze horse that he then mistakenly condemned as a forgery, 'then your eyes are clear and you can see more errors.'[6] So you do, but the errors you see can be your own. The obvious thing wrong with this St Jerome is that he has got the stone in the wrong hand. In most comparable *St Jeromes in penitence* of the period, and there are very many, Jerome holds the stone in one hand and gestures to his bruised chest with the other. In the instances when one arm is outflung, it holds the stone, the better to whack his chest with. An example in a woodcut by Hans Baldung Grien, also incidentally showing typical Northern drapery, is shown in figure 11. At this date, the techniques required to represent figures so convincingly had been available only for a few decades, and artists took delight in matching gesture to details of the all-important devotional narratives within paintings. Whatever would this Jerome's grand opera gesture mean?

In this case, all roads seemed to lead to Rome, but not necessarily in the sixteenth century. The anatomical detail resembles that in Leonardo's *St Jerome* in the Vatican, and even more some of his drawings now in Windsor.[7] In the sixteenth century these would have been highly unlikely examples for an apparently provincial painter to have had access to, but by the end of the nineteenth they would have been available for a forger, in the Vatican collection and (just) as reproductions. There is a rare example in Rome too of a formalised pedestal of drapery, and around the knees of a not dissimilar Saint Jerome, from the early sixteenth century, in a painting attributed to Pinturicchio in the Borghese Gallery. Finally, it is in Rome too that one does find rather formalised drapery even in the mid-sixteenth century, in illuminated manuscripts. Appollonio de' Bonfratelli, papal miniaturist at the time, sometimes painted sinuous formalised scalloping of hemlines a bit reminiscent of St Jerome's. Nothing else about the static composition and austere colouring of this St Jerome resembles the rollicking compositions and electric hues of miniatures by this date, but could this suggest a pastiche or fake, and perhaps by someone deeply familiar with sixteenth-century painting as still to be found in nineteenth-century Rome?

There seemed every chance that scientific investigation would throw up anomalies, but timber and pigment analysis proved inconclusive. The timber analysis was an old one, from the painting's record, but it did confirm just what

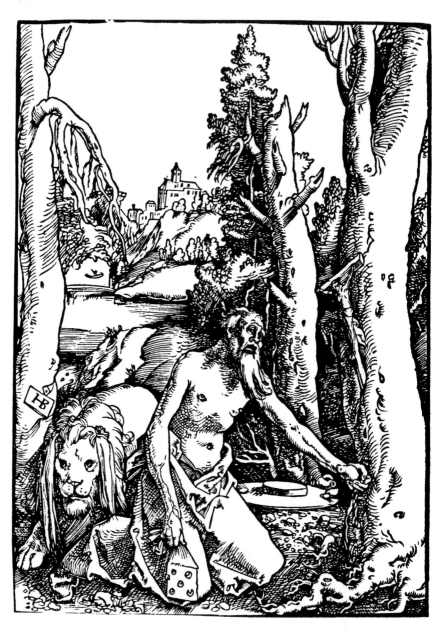

11 *St Jerome in penitence*, woodcut by Hans Baldung

an odd object it is. The wood of the panel had been analysed in 1970 by the Timber Research Association in High Wycombe, and found to be cedarwood. Cedar has occasionally been identified in seventeenth-century paintings, and is known for encaustic portraits in Egypt in the late Roman period and for icons, but for earlier Western pictures has not commonly been found at all. Jacqueline Marette, in a study of 1,800 panels from all over Western Europe from the twelfth to the late sixteenth century, identifies some fourteen woods, but never cedar. Furthermore, artists in the major centres of production, in Italy, Germany and the Low Countries, tended to stick to an even narrower range. For Italy, Marette found 310 out of 345 panels to be poplar. In Germany, a variety of firs and oak account for 210 out of 219 panels examined.[8] Cedar suggests a source in the eastern or southern Mediterranean, but nothing seems known of painters in any small trading or religious communities of the Western church in the Islamic South or Orthodox Christian East. Using an inappropriate panel, however, would not have worried a turn-of-the-century forger. Timber analysis is quite a recent addition to the art historian's preoccupations. However, nothing indicative of forgery emerged from recent pigment analysis. The pigments available, red, green and earth colours, happen not to include the ones most easy for forgers to trip up with – strong blues and yellows – but analysis of what there was, kindly done by Anne Bacon and colleagues on the MA Conservation of Fine Art Programme in the University of Northumbria, turned up nothing anomalous. The red in the drapery, for example, is vermilion, the green of the landscape a copper resinate, all as it should be for the sixteenth century.

Still, none of that ruled out a forgery, and on the contrary, conclusive evidence for a fake did seem finally to hand in the X-ray of the painting in figure 12, taken about the time the timber sample was analysed, in 1970. X-rays of paintings can look deceptively like pictures. Highlights in paintings present white, metal-containing pigments in thick paint, so that they often show up as highlights in an X-ray too, as in this case, in which the features of the saint's upper body do faintly appear. It can be easy to read features into what turn out to be mere variations in thickness of underpaint. The X-ray needs to be read in terms of what happens in the encounter between the radiation and the materials of the panel. In this case, of most interest are the escape-holes through which beetles have exited, which have clearly come to the surface of the panel on the painted side. They appear white, with dark spots in some cases, and it is only in the dark spots that the X-rays have been able to pass through empty holes, to darken the photographic plate. Most of the holes have been filled with an X-ray opaque filler, so that they appear white in the X-ray. The suspicious point is that they lie underneath the old painted surface, even in places that seem not to have been damaged. The panel must have been wormeaten, in other words, before the painting was done, but artists of the period just did not paint on panels like that. Their panels are of very high quality, carefully

12 *St Jerome in penitence*, sixteenth century, X-ray made in about 1970

prepared. No less an authority than Stuart Fleming of the National Physical Laboratory has declared unequivocally that filled worm-holes under the paint are diagnostic of a forgery, dismissing a panel of the kind employed for another (undoubted) forgery as 'a badly mutilated piece that no Renaissance painter in his right mind would have looked at twice'.[9]

But this evidence of forgery weakened with comments on the X-ray from Caroline Villers in the Scientific Department of the Courtauld Institute. Fifteenth-century Netherlandish guilds, she points out, went to the trouble of outlawing the use of wormeaten panels, under pain of destruction of the resulting painting and a fine.[10] It must have been known, if they bothered to legislate. Examples from Italy have survived. A Botticelli School *Annunciation* in Glasgow is on such a panel, and Anne Rinuy and Francois Schweizer of the conservation laboratory of the Museum of Art and History in Geneva describe another, a fourteenth-century Florentine *Madonna and Child*, in a paper specifically challenging the assumed association of such worm-holes and forgery.[11] *St Jerome* is

certainly an odd painting. Caroline Villers also points out that the strong contrast of the wood-grain pattern in the X-ray appears where the ground, coating the panel surface as a preparation for painting, has gathered in the irregularities in its surface, indicating only rough preparation of a surface, unlike the carefully smoothed panels normally used. But that does not necessarily make it a forgery.

Images made in ultra-violet and infra-red illumination by Anne Bacon and her colleagues suggest that, on the contrary, this is a very old object. The one in ultra-violet (figure 13) shows the painting to be exceptionally damaged. Ultra-violet inspection is in some ways like spectroscopy. The lamp does emit visible bluish light, but also an invisible ultra-violet component, which is absorbed to a greater or lesser extent by the paint film, but then re-emitted as fluorescent visible light by some components. Generally, it interacts just with the surface paint. Recent paint absorbs and retains the illumination, so that it appears very dark in the image, whereas older paint reflects the visible component in the illumination or fluoresces, appearing lighter. Varnish, however, masks the effect, and the results of ultra-violet inspection can be bafflingly hard to interpret. In this case the results are clear. One expects a good fake to be a bit damaged and repaired, but if this is one, someone has wreaked something like vengeance on it. The band of repair horizontally across the middle of the painting is a known recent repaint, where most of the old paint has been lost because of movement along the horizontal join of the two pieces of wood comprising the panel. Dark touches of repainting to enhance the contrast around the saint's shoulder and arm are very usual, too. But the extent of damage in sky and landscape is extraordinary.

Just to make it worse, Anne Bacon pointed out that the infra-red image in figure 14 shows even more damage. The longer wavelength, infra-red illumination passes through the upper layers of paint to yield information about deeper layers, often being absorbed strongly only by the dark preparatory drawing on the preparation on which the picture is painted. In this case, the point it shows is subtle. The profile of the rocks to the right of Jerome's head shows up strongly, and where the rock curves outward just at the level of the halo there are signs of abrasion in the deep paint, but even underneath some areas which, in the ultra-violet image, seem to be intact old paint. That suggests damage and repair a long time ago, in addition to the massive disturbances of the visible surface. (It is possible that some of this deep damage might have occurred during more recent treatments, and more knowledgeable readers may note that the infra-red image is odd for a painting of this date in showing no under-drawing, and wonder too why we did no analysis of the ground. But that is a part of the history of this painting to reserve for later.) The painting remains all the more intriguing because it is so tricky to place, but in the process it also indicates how open even quite extensive scientific evidence can remain to interpretation.

The evidence of history

Historical evidence, like scientific evidence, is often suggestive, but again only rarely conclusive. With *St Jerome*, once again, the known history of the painting also seemed at first consistent with a forgery, but then rather less so. It

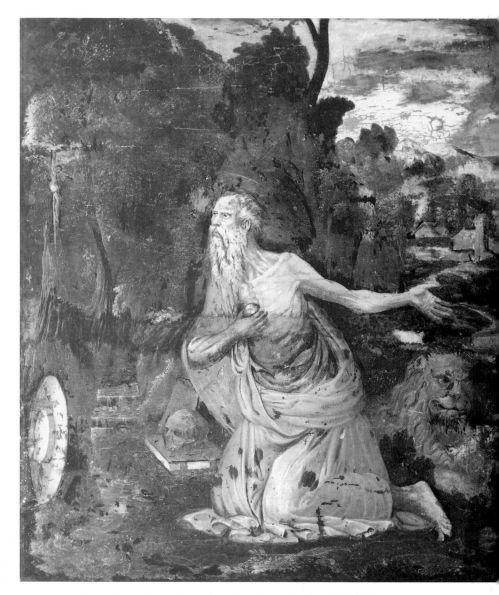

13 *St Jerome in penitence*, sixteenth century; image in ultra-violet light

entered the collection of Nottingham Castle Museum in 1909, and if bought by
the donor shortly before would have emerged from a market becoming richly
supplied with forgeries of early paintings of this kind. But Oliver Garnet,
researching the collection from which the painting came to the museum,
kindly pointed out an overlooked record, locating the painting on loan in the

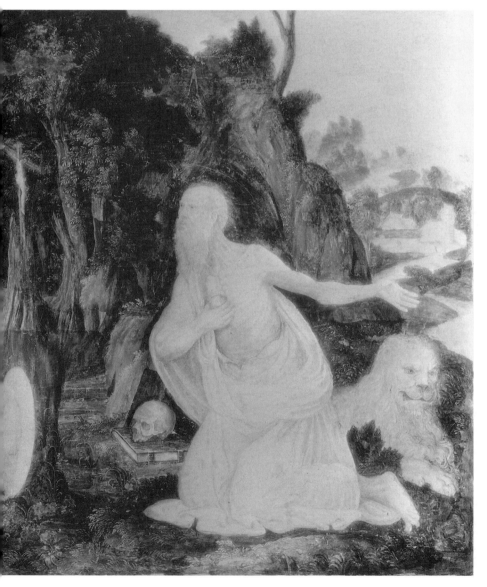

14 *St Jerome in penitence*, sixteenth century; image in infra-red

museum by 1878, a rather less plausible date for a forgery of the kind.[12] In this case only a brief description in a catalogue served to locate the object in the historical record, but often there is much evidence on the object itself as well. Inscriptions, labels and marks, can often indicate independent evidence of provenance, or information about the history of an object, ideally since it left the artist's studio. What matters in this kind of research is not so much any individual inscription – these by themselves can be misleading – but a pattern of correlation between such clues and the independent record, adding up to a history consistent, or inconsistent, with the supposed nature of the object.

Figures 15–18 show examples of the difficulties and possibilities, from the backs of paintings. Figures 15 and 16, showing the back of a panel now attributed to the fourteenth-century Master of the Strauss Madonna, reveal a bold label, in an apparently seventeenth-century hand, mistakenly, or deceptively, identifying the painting as a Giotto. One should not believe everything one reads on the back of a painting! Higher up is a potentially useful mark, in which we can make out 'Dogana di Milano', a stamp from the Milanese customs. The typography of this seal suggests export from Italy during the nineteenth century, but nobody has yet undertaken the painful task of assembling a reference collection of the customs seals of Europe. With no independent record for comparison, it would be trivially easy for a forger to make such a seal, though in this case there is no reason to doubt that it is what it is supposed to be.

Such marks come to life, however, when they can be related to the independent record. Figures 17 and 18 are from a small landscape by the nineteenth-century British painter John Linnell, in the Cooper Art Gallery in Barnsley. They suggest that the painting was at one time in the collection of one John Pye ('No. 27 of my pictures . . . Pye', lower label), confirmed in another hand in the top label ('. . . originally bt at John Pye sale cost 77.14'). The writer of this top label then tells us that he briefly sold the painting to J. C. Hooke, RA for £84 pounds, but bought it back before selling it again to one Roberts for £100. None of this suggests how the painting got from Linnell to Pye, nor from Roberts to Cooper, but if we can confirm that these labels seem not to have been fabricated, they may still offer confidence in the attribution of the painting.

Confidence is needed, because Linnell was sufficiently well known to be extensively faked by copyists by the mid-century. On one occasion he personally intervened decisively to alert an Old Bailey Court that an alleged and subsequently convicted forger of his work had turned up for his trial, but was still across the road, too scared to come in, until hauled into court by a sergeant.[13] Linnell himself however, seems on other occasions to have been prepared, for a consideration, partially to repaint the work of others so that their paintings could be sold as his own, for example in 1873 painting some sheep into a contested painting attributed to Constable, in order to save its owners from unpleasantness. 'It is not easy to understand why Linnell consented to paint on

other artists' work', David Linnell loyally remarks.[14] Observers with no connection to the artist are bound to wonder whether the fee of £100 – an annual wage for many at the time – might have nudged things along.

However, as it happens, in our case just disturbing the topsoil of the historical record proves reassuring. John Pye was a leading engraver of the first half of the nineteenth century, whose passion for the study of effects of light and shade in nature and of gradation in representing them in printmaking enabled him, unusually, to endure for many years when others fell, or were pushed, by the wayside, as a platemaker for J. M. W. Turner. Such a figure would be unlikely to own a spurious Linnell, especially since Linnell worked for Pye in the 1820s. A standard work of reference for the Victorian auction world, *Redgrave's Art Sales*, does record other paintings by Linnell in a sale from Pye's collection at Christie's, on 20 May 1874. No. 27 in the catalogue of the sale is indeed 'Trees, buildings, cattle etc. under a rare effect of low-toned sunlight.' We would therefore expect to see, as on the back of any painting sold at Christie's, a stencilled reference number and a white chalk note of the sale date (yellow chalk indicates Sotheby's), but their absence is not too worrying, since they may be under the labels, or on a frame subsequently changed. Christies's archives certainly confirm the details.[15] The first price given on the label, £77 14s., might seem an odd sum to bid at a sale, but it works out as just 74 old guineas, and at Christie's until quite recently bidding was in guineas. The buyer was one White, a common name but a suggestive one, since this buyer, as we see from the labels, was clearly dealing, and Linnell's principal dealer in the 1870s, and the purchaser of all his new paintings from 1871 to 1874, was Edward Fox White.[16]

Of course, a forger could set all that up from the record, but the record was not available before the painting came to Barnsley, and the effort, for so modest a picture, is implausible. Pye's handwriting survives in extensive manuscript archives in the Victoria and Albert and British Museums. The former even include a possible route for the painting from Linnell to Pye. In the 1820s Linnell had still to depend on such hackwork as making copy drawings from National Gallery pictures, to be given to platemakers for engraving in an ill-fated reproduction project that Pye was managing. Whether out of admiration or to ingratiate himself with Pye, Linnell offered to Pye in February 1831 the gift of 'a small landscape' that Pye had been reported to admire. 'Mr. Linnell's note in which he proposes I shoul[d] accept from him a picture. JP', Pye has scribbled, a bit equivocally, on the outside of the letter.[17] A good deal more research will be required to try to establish whether this is indeed, by chance, Barnsley's picture (remember Pye had others by Linnell), but just from the point of view of attribution to Linnell the evidence is reassuring.

There are no reference books in which the background for this kind of modest sleuthing can be learned, and vast amounts of it are required, since just

15 Detail of the reverse of The Master of the Strauss Madonna, *Madonna and Child with saints*

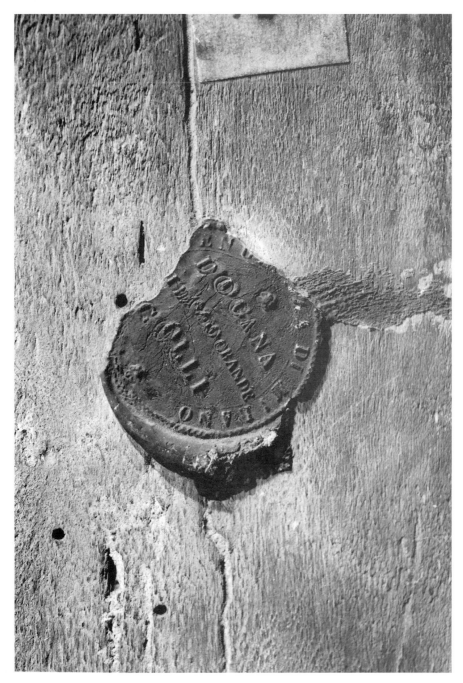

16 Detail of the Milan customs' seal on the reverse of The Master of the Strauss Madonna, *Madonna and Child with saints*

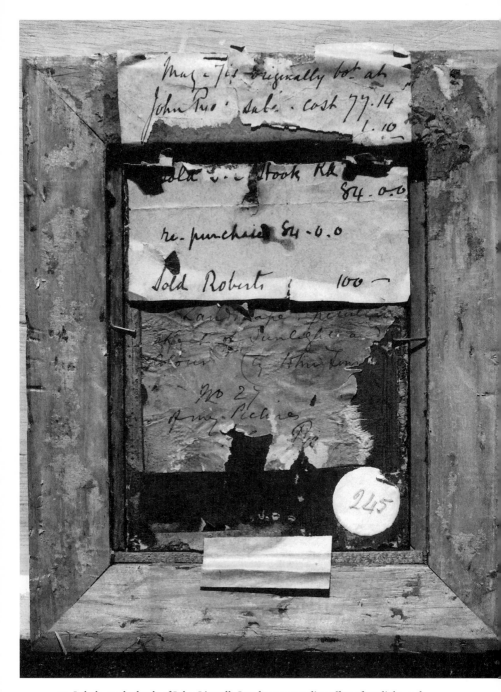

17 Labels on the back of John Linnell, *Landscape, peculiar effect of sunlight and colour*

for British paintings of this period there are a host of clues apart from the kinds of label illustrated in this example, for example canvas stamps, coats of arms, or watermarks, each a field in itself. For paintings and markets of other nations and periods the data and sources are different again. The important point is that the question to be asked is always how the indications on the object can be tied up with an independent record. In two instances, for example, workshop archives now identify metalwork and jewellery fabrications, supposedly of the fourteenth to sixteenth centuries, but in practice produced in the late nineteenth century and put on the antiquities market in Paris. In the mid-1970s C. Truman discovered in the Victoria and Albert Museum 1,079 working drawings of Reinhold Vasters, working for such notorious dealers as Frederick Spitzer.[18] More recently Dr Rudolph Distelberger of the Vienna Kunsthistorisches Museum has discovered, in the still operating workshops of the Paris restoration house of André, hundreds of plaster and wax models of late-mediaeval and

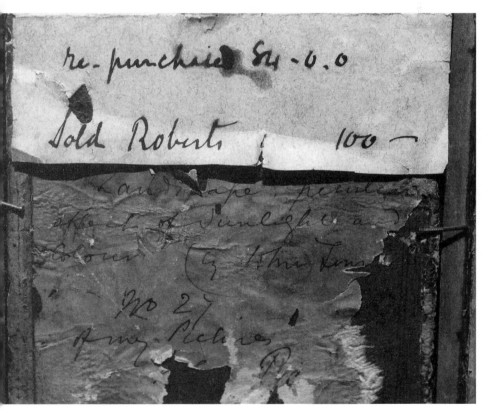

18 Detail of a label from the back of John Linnell, *Landscape, peculiar effect of sunlight and colour*

Renaissance-style jewellery from the time of Alfred André, working in the last decade of the nineteenth and the first decade of the twentieth century.[19]

The independent historical record can take many forms, and one of the most illuminating is dendrochronological research, the dating of objects with reference to tree-ring patterns. Climatic variation causes variations in the rings of material incorporated season by season into tree trunks which are remarkably consistent for some species within a geographical area. Tree-ring patterns can therefore indicate not only geographical source but date of wood, since from a few objects of known date the patterns can be mapped on to the historical record. The last ring visible on a panel shows only when a tree was cut down, but that fixes the earliest possible date for an object, and cut wood was usually used after just a few years of seasoning. A number of sustained tree-ring reference records have been established for wood of different types and from different sources. However, in panels from some Netherlandish paintings of the fourteenth to mid-seventeenth centuries, researchers had noticed before 1987 a consistent patterning, but one which could not be correlated with that on any of these dated sequences for oak. The anomalous samples offered a 530-year sequence, which was only fixed historically when the pattern was unexpectedly traced to Polish and Lithuanian sources. The export of this Baltic timber ended with the war between Sweden and Poland in 1665–60. A number of these now datable panels were used by Rembrandt, including three from the same tree trunk, for paintings now in Washington, Rotterdam and Kassel.[20]

The historical record can still be suggestive even when less precise in its indications. On occasion, it can even be suspicious absence of historical record that holds the key. A good example is offered by a case of positive identification of forgeries. Between 1983 to 1990 somebody fed into the market a steady stream of Staffordshire earthenware fakes.[21] They were of an unusually high technical standard, and before they were spotted more than a dozen ended up in one of the most distinguished of American private collections, formed by Henry Weldon. They appear, in full colour, in the lavish catalogue of his collection published by Sotheby's in 1990.[22] Had the forgers not taken to faking pieces so spectacular that they sold for several tens of thousands of pounds each, they might not have been noticed. All the pieces showed anomalies either in the characteristics of materials or of technique, but not ones which, in the occasional piece, would have been so unusual. It was the slow realisation that there were newly in circulation some tens of important pieces, not one of them illustrated in older literature, but sharing unusual features, which began to ring alarm bells. Many of the pieces, for example, showed the same colour scheme, with similar splodges of colour. That was apparent, though not the reason for it, by the time the catalogue was written. 'One bear jug, in Figure 229,' the text for no. 237 notes, 'is in a similar colour range, brown with traces of blue, but was created in the more typical technique used for agateware press moulding.'

More similarities began to emerge. Chance marks from the process of manufacture showed similarities in pieces supposedly decades apart. The pieces tended to be somewhat low-fired, soft-bodied, and in some cases showed iridescence on one side, where the glaze had been laminated by heating intended to induce a rather unusual crazing. Handles and spouts on different pieces were from the same mould. Once the characteristics of the forgeries were identified, they proved easy to spot, though not before hundreds of thousands of pounds had changed hands. (The only prosecution brought to date ended in acquittal.)[23]

When looking at the historical record left on the object by the hand of time in the form of wear, damage and repair there is usually no documentary record to refer to, but it is at least possible to assess whether the transformations seen are consistent with known history. An object which shows no signs of age is bound to be suspect unless it is known to have remained undisturbed and in good condition in some special circumstances. Oil-paintings almost always show cracking of the kind seen in figures 19–22. The patterns of craquelure present are in effect a diagram of the stresses to which the surface has been subject. Figure 19 shows, larger than life-size, typical cracks in thin paint on a fourteenth-century panel, long ones along the grain, fine ones at right angles to it. Figure 20 shows, also enlarged, the much more regular, crazy-paving patterns from heavier paint in a flame in an early eighteenth-century painting on canvas. Figure 21, at the same scale, shows a later eighteenth-century painting with what is called a sigmoid crack, again in quite heavy paint, where a knot in the back of the canvas, or a blow, has induced a spiral pattern of stress. Figure 22 shows cracking from a quite different process, which happens as the paint film slowly hardens in the early months of the life of some pictures, mostly of recent date. It occurs when a layer of paint containing little oil medium overlays a fat, oily layer, so that the top layer hardens first, only to be torn apart as the lower layer continues to move a little. The tearing can be seen in the way that the cracks are sharp at their points, thicker where they connect. These patterns and numerous others are highly diagnostic of paint of different styles and dates.

In the decorative arts, even seventeenth-century British glass, for example, may show the drops or 'weeping' more characteristic of ancient glass. Ceramic is much more stable than glass, but the glaze can craze, and an experienced eye may detect an inappropriate broadness in a forged pattern, sometimes with dirt or colouring rubbed into it. The oxidation of metalwork should be worst where damp accumulates. As with other signs of history, reading the signals is a battle of wits between specialist and forger. Forgers of pewter sometimes stain it with acid, or bury it in grass cuttings, adding drilled or acid-bitten holes to imitate characteristic eruptions due to oxidation from bubbles in the metal. Battle is joined particularly in signs of abrasive wear. All small decorative arts objects

which have been used at all generally show signs of it. Mostly this will be under the foot, and an easy point to check is whether, if the piece wobbles at all, the abrasion is where it should be, at the points of maximum contact with the surface. Any regularity, especially in direction, in the striations of the wear, and any wear at all in pieces made mostly for display, must be suspect. Metalwork is exceptionally subject to wear and to denting, for example where the front of the foot of a vessel in soft metal has taken the stress of a lifetime of impacts with table-tops. The wear is characteristic for different metals. Old silver plate, on the other hand, is very tough, and dents suggest later pieces, but its silvering should have worn if not renewed, to show the copper.[24] It takes very little time to learn the major indicators of this kind within any speciality, but decades to get any good at interpreting them.

In general, a whole pattern of correlation with the historical record is what the researcher hopes to see. Conversely, isolated scraps of uncorrelated inscription may be suggestive, but evidence they are not. The point is not well understood, and odd labels and certificates get accepted as evidence, particularly in corners of the art market a bit off the beaten track. Some spurious provenances attached to the forgeries of the American realist painter Thomas Hart Benson which came on the market around 1980 are typical. *Missouri flood* came with a

19 Craquelure in paint on a fourteenth-century panel painting, slightly magnified

20 Craquelure in paint on a seventeenth-century oil-painting on canvas, slightly
magnified

21 A sigmoid crack on an eighteenth-century oil-painting on canvas, slightly magnified

photograph of an authenticating certificate, apparently in Benson's hand, and for good measure a letter apparently from his son, T. P. Benson. *Georgia cotton pickers* was sold to a Kansas gallery with a letter from A. L. Davis of Missouri, who then conveniently disappeared, stating that the picture had been given by the artist to his father. *Plowing the field* had a fake label on its reverse from the genuine Kraushaar Gallery, complete with stock number, artist's name and title, but the label did not even resemble one of the gallery's.[25] In the same way, David Sylvester, researching a Magritte show for London's Hayward Gallery in 1985, became aware of forged statements, almost perfectly imitating his handwriting, providing a spurious credibility for fake paintings through the suggestion that they were to be included in his catalogue.[26]

One kind of historical evidence which rarely wins consensus is often advanced. The more dramatic an accusation of forgery, or of misattribution, the more likely that it will include the insistence that this or that detail in a work is historically inappropriate for its supposed age. For example, Alan Tarica criticises the canopy of the bed in the Virgin's room, amongst a battery of points in support of his claim that an *Annunciation* aquired by the J. Paul Getty Museum and accepted by most as by Dirk Bouts, is a forgery. Because the canopy is trapezoid, he insists, not rectangular, it resembles a harem tent, and the fact that one side of it, abutting the wall of the room, lacks curtains, is inappropriate for the period. And then, he goes on, the book the Virgin is

22 Drying craquelure, slightly magnified

reading is not lying down on a prie-dieu as it should be, but is leaning against the wall, 'in equilibrium, which arises from a modern conception inconceivable for the period'.[27] But we have surely no idea what might look acceptable where canopies are concerned to the most house-proud fifteenth century virgin, let alone to an imaginative artist, and even in the fifteenth-century they must have seen things leaning against walls. Such judgements, where they can be made at all, admit too many uncertainties for any correlation with independent record to be exclusive. Evidence of this kind can never be more than very loosely suggestive, any more than the observation of a St Jerome with the stone in his wrong hand.

Attribution can never be absolutely certain. Even for a work whose every moment seems accounted for, there is always the faintest possibility of the substitution of a replica at some unknown time. Brother Benedikt Weingartner's discovery in 1995 that some of the Dürer woodcuts in his care in the monastery at Lambach on the Traun were not all they should be, but, on the contrary, crudely forged substitutes, is only the latest example of a venerable scam.[28] All the same, in more cases than not, the attributions of works of art in museums that are considered certain on the basis of a stylistic match widely agreed as decisive, or a compellingly comprehensive correlation of inscriptions with the historical record, probably are on the whole reliable. That, though, still leaves a substantial minority of objects whose attribution is by no means so certain. In these cases attribution remains obviously a matter of probabilities, and the key issue becomes not just the evidence, but the weight that should be attached to it. However, the way that probabilities are handled in the art world proves suggestive about the whole business, as we will see in the next chapter.

Notes

1 A. P. Laurie, *Pictures and politics* (London, International Publishing Company, 1935), pp. 104, 105.

2 R. Newton and S. Davison, *Conservation of glass* (London, Butterworth, 1989), p. 193.

3 W. Voelkle, *The Spanish forger* (New York, Pierpont Morgan Library, 1978), pp. 76, 77.

4 P. Watson, 'Museum treasures found to be fakes', *Observer* (13 July 1986), 3.

5 *The fine art of faking it*, a documentary for Nova (Philadelphia, Films for the Humanities and Sciences, 1991).

6 J. V. Noble, 'The forgery of our bronze horse', *Bulletin of the Metropolitan Museum of Art*, 26:6 (1968), 253–6; K. C. Lefferts, L. J. Majewski, E. V. Sayre and P. Meyers, 'Technical examination of the classical bronze horse from the Metropolitan Museum of Art', *Journal of the American Institute of Conservators*, 21 (1981), 1–42; and Thomas Hoving, *Making the mummies dance* (New York, Simon and Schuster, 1993), pp. 134, 135, 139, 140

7 Compare for example K. Clark, *The drawings of Leonardo da Vinci in the collection of Her Majesty the Queen at Windsor Castle* (London, Phaidon Press, 1969), 19003, recto.

8 J. Marette, *Connaissance des primitifs par l'étude du bois* (Paris, Editions Picard, 1961), pp. 48, 52, 53.

9 S. J. Fleming, *Authenticity in art: the scientific detection of forgery* (London, Institute of

Physics, 1975), p. 50 cited in A. Rinuy and F. Schweizer, 'A propos d'une peinture florentine du Trecento, une contribution à la définition de critères d'authenticité', *Genava*, n.s. 34 (1986), 95–112, 111, note 53.

10 Caroline Villers, personal communication, 4 March 1996.

11 Rinuy and Schweizer, 'A propos d'une peinture florentine du Trecento.

12 Personal communication, 27 February 1996. (The painting was in the collections of Alexander Graham and his son-in-law Kenneth Muir Mackenzie.)

13 D. Linnell, *Blake, Palmer, Linnell and Co.: the life of John Linnell* (Sussex, The Book Guild, 1994), p. 269.

14 *Ibid.*, pp. 328, 329.

15 Personal communiction from Christie's archivist Jeremy Rex-Parkes, 19 August 1996.

16 Linnell, *Blake, Palmer, Linnell and Co*, p. 330.

17 John Pye, 'A selection of his correspondence and papers relating to Turner and other artists . . . 1813–1834', manuscript collection, Victoria and Albert Museum Library (86.FF.73), f20.

18 H. Tait, 'Reinhold Vasters, goldsmith, restorer and prolific faker', in M. Jones (ed.), *Why fakes matter* (London, British Museum Press, 1994), pp. 116–33.

19 R. Distelberger, A. Luchs, P. Verdier and T. H. Wilson, *Western decorative arts*, Part I (Washington, National Gallery of Art and Cambridge, Cambridge University Press, 1994), cited in 'Master faker's cache of evidence revealed', *The Art Newspaper*, 5:36 (March 1994), 1.

20 P. Klein, D. Eckstein, T. Waznt and J. Bauch, 'New findings for the dendrochronological dating of panel paintings of the fifteenth to seventeenth centuries', *Preprints of the ICOM Committee for Conservation, 8th Triennial Meeting, Sydney, 6–11 September 1987* (Los Angeles, 1987), pp. 51–4. cited in J. Bruyn, B. Haak, S. H. Levie, P. J. J. van Thiel, and E. van de Watering, *'A corpus of Rembrandt paintings* (Amsterdam, Martinus Nijhoff, 1989), vol. II, p. 783.

21 I am grateful to Pat Halfpenny, who played a role in the revelation of the forgeries and then as a witness in the trial which followed, for the information which follows.

22 L. B. Grigsby, *English pottery, 1650–1800 the Henry H. Weldon collection* (London, Sotheby's Publications, 1990).

23 S. J. Checkland, 'Court case casts doubts on thermoluminescence testing', *The Art Newspaper*, 5:38 (May 1994), 2, 3.

24 Based on notes made from interviews with Charles Hajdamach (glass), Pat Halfpenny (ceramics) and Gerry North (metalwork), for 'Forgeries!', a day seminar organised by the course in Art Gallery and Museum Studies, History of Art Department, University of Manchester, 18 June 1992.

25 *Art Research News*, 2:2–3 (1983), 11–13.

26 *International Foundation for Art Research Reports*, 6, 8, 9 (October and November 1985), 10.

27 F. Duret-Robert, 'Le Faux du siècle?', *Connaissance des arts* (June 1986), 86–91, 89.

28 A. Cowell, 'Brother Benedikt and the monastic forger mystery', *Guardian* (23 September 1995), 14.

4

VERDICTS

Weighing the evidence

WEIGHING EVIDENCE is such a chancy business because decision-making, whether by individuals or groups, is every bit as tricky as perception. Indeed, recognition is a special kind of decision-making, and many of the problems of perception, to do with the role of prior expectation and selectivity in the evidence taken into account, recur in decision-making more generally. In making any decision an instinct to go for speed and economy drives us to bet too much on experience, rather than probabilities which take account of all possibilities. Capture or escape in nature must depend upon such decisions, and an unfavourable outcome for a proportion of individuals is acceptable if it permits the survival of a species. Life in the state of nature is a mercilessly averaging business, and a cognitive system which hung around to ponder long enough to avoid error for more than a statistically adequate portion of the time available would play only a brief role on the stage of evolution, as someone else's lunch.

The same system is less well suited for modern social life, and the problems of art historians are the least of it. Decision-making under uncertainty has therefore attracted a good deal of recent attention from psychologists, notably in a substantial collection of papers assembled by Daniel Kahneman, Paul Strovic and Amos Tversky in 1982.[1] If our passion for lotteries was not evidence enough, these studies demonstrate that we are constitutionally unaware of degrees of probability. In assessing likelihood, we accept uncritically the slant put on issues by the way they are framed. That is surely reflected in the conventions of English law, that the accused is innocent till proved guilty, as opposed to those of Roman-derived practice, in which it is the other way around, and also in the spirit in which specialists approach questions of art attribution. For a fair judgement, the likelihood of each piece of evidence showing up needs to be assessed separately under each hypothesis, guilty or innocent, fake or original, autograph or imitation. Instead, as Anthony Grafton notes in his study of

criticism and forgery of the written word, the way in which literary forgers focus the attention of critics is like the illusion created in a flight simulator. The reader is mesmerised by the detail on which attention is focused, to the exclusion of peripheral data – especially evidence for an unfavoured hypothesis. Once admitted, the evidence can instantly break the spell.[2] Often, though, there is no other evidence; here too we are uncharacteristically tolerant when it comes to decisions. There is so much in most cases that we just do not know; yet the less the evidence, it often seems, the greater the passion with which hypotheses are defended.

Attributions are particularly prone to a galaxy of other errors described in the 1982 study. In assigning any objects to categories we overweigh the significance of features our experience suggests are stereotypical, to the point that we will think it more probable that our specimen belongs to a category that accommodates a combination of the stereotypical features that we detect in it, than to a broader category that matches only one of them. That has to be a logical error when membership of a broader category does not rule out membership of a smaller category contained within the larger, and membership of the broader category must be more probable. Tests in which our answers to questions that are demonstrably either right or wrong are compared with our assessment of the probability that we got it right reveal that we also consistently overrate our own likelihood of being right. Worse still for the art expert, the more expert we are on the issue, the more we overestimate our abilities. Massimo Piattelli-Palmerini, in a popular treatment that incorporates developments since the rather technical 1982 study, suggests that these decision-making strategies are so embedded in our experience of the world that they comprise a structured unconscious as inescapable as the unconscious basis of emotional life proposed by Freud, unless we adopt systematic procedures to outwit it.[3]

To add to these psychological problems, it is in practice often impractical to bring in all the evidence available in every case, or to give full weight to what we just do not know, yet the problems of selective evidence when all is not revealed have caused the issue to be one of passionate legal debate in the UK in 1995. This is just as much a part of the problem for art historians, and the legal debates are as worth the attention of art historians as those of the psychologists. International practice was surveyed in the official reports prompted by such miscarriages of justice as the Birmingham Six and the convictions following the Guildford and Woolwich bombings of 1974. In non-adversarial systems, like that of Germany, all the evidence gathered by the prosecution, incriminating or otherwise, is at least in theory available to both defence and prosecution. In adversarial systems practices vary widely, from Spain, where the defence have no right of access to any evidence which the prosecution do not wish to use, to Denmark, where there is disclosure of all the evidence

gathered in the investigation. In Britain, following Lord Justice Nolan's judgment in the case of Judith Ward, found guilty in 1976 of a bombing in spite of evidence, concealed by the prosecution, which established her innocence, disclosure of all evidence has been the rule. But 'more *ad hoc* arrangements were observed in the course of our research', as the writers of a recent report noted. 'There are times', remarked defence solicitor E, 'when you want to say, "Well, that's very interesting, but keep it quiet."'[4]

In Britain, the recent aspiration that all evidence collected during an investigation should be available to all parties has broken down, partly because the volume of paperwork has proved unmanageable, partly because the defence in a number of cases have proved no more scrupulous than, on occasions, prosecution lawyers have in the past.[5] The volumes of evidence offer endless opportunity for obfuscation in wild-goose chases after trivial points of circumstantial or even irrelevant evidence, or for pressure on the police to reveal informants. Major art institutions, rather similarly, have sometimes allowed themselves to be in a position where revealing the true source of an acquisition would be an embarrassment, and where revealing full scientific data would add fuel to polemics they consider tedious, damaging and ill founded. The question at issue need not be of attribution. Martin Wyld in London's National Gallery in April 1996 justified his refusal to show the dossier on the cleaning of Holbein's *Ambassadors* to the persistently polemical foe of the gallery's cleaning policies, Michael Daley, thus: 'We've shown him a great many restorers' dossiers in the past. We tend to restrict access to these working notes to experts in the field.'[6]

The trouble is that when we do attend to evidence, our resistance to probability means that we are bad at assessing the weight that should be given to it. That emerges most clearly in relation to scientific evidence, which has traditionally been accorded an almost oracular status. In many forgery scandals – that of Keating's Palmers, for example – there was heated public debate before the people in white coats, in that case the impressively venerable paper expert Dr Julius Grant, pronounced. Consensus and then confession followed, which is often the pattern, and fortunately so, since most of those involved were quite unqualified to assess the weighting, let alone the integrity, of the scientific evidence on its own. In law as in art there has been a tradition that scientists seem to stand apart, more objective in their proceedings, more authoritative in their findings, than witnesses presenting other evidence. Of course, as in art, the verdict of science is often, as we have seen, not as clear-cut as authoritative conclusions make it appear.[7] 'I would expect my boys to be trying to get an angle,' one lawyer explained of his forensic consultants, 'we are not Snow White and the Seven Dwarfs.'[8]

The status accorded to scientific evidence is, however, changing, in art history as in law. There are grave doubts about a kouros acquired by the Getty

Museum, an object now without any history at all, since its provenance when acquired has been shown to be spurious. The Getty scientists remain convinced that a calcite encrustation on its surface has been caused by ageing, not through forgery. They have tried to synthesise it without success; it does not resemble known spurious deposits, and they are sure the piece is ancient. Yet Marion True, the museum's Keeper of Antiquities, was prepared to go on record in Nova's documentary *The fine art of faking it* in 1992 as disinclined to accept this evidence as conclusive. The fact that they had not been able to synthesise the deposit did not mean it could not be done.[9]

For all the lessons of such cases, art historians with an interest in attribution have not been much interested in the technicalities of decision-making and the weighing of evidence. In comparison with the shelves of legal literature on rules of evidence, the debates of art history are unsystematic. There is often no decisive evidence at all. In other cases there are armies of evidence, but none decisive, and little consensus on how it should be marshalled. But although art historians get by without formal rules of evidence, their verdicts do share one characteristic with those of the courts. The issues in question often come down to probabilities, but the verdict is generally delivered in much more decisive terms.

However, it is precisely when art comes to court that the deficiencies of the weighing of evidence in art-historical attribution are paraded for all to see, because even those alive to the dubious record of the courts in assessing evidence tremble at the contrast between the waywardness of the debates of art experts and the firmness of the verdict that must finally be delivered. A tale of two court cases makes the point that this is a long-running issue. In about January 1796 a Mr Jendwine – or maybe Jewdwine, or Judwine, reports vary – purchased from a dealer called Slade for £621 twelve old masters for his house near Epsom in London, but then learned from a knowledgeable visiting relative that all were doubtful attributions. The visitor brought along a respected young painter, Thomas Stothard, who agreed, and Jendwine decided to sue Slade. The case was heard on 12 July 1797, with a phalanx of art-establishment artists, dealers and collectors on each side. From the newspaper reports and the diaries of the painter Joseph Farington, a witness against the dealer, we know that the supposed attributions included a seaport by Claude, a Teniers fairground scene, a Cuyp, a Ruisdael, more than one Brueghel, a Berghem, a Rosa and a Bassano. Jendwine, perhaps, had the stronger team, including Farington, two very established portraitists, Hoppner and Abbot, and younger painters of Romantic scenes, Stothard, Westall and Smirke. Slade, however, had Sir Francis Bourgeois, then building up what remains one of London's finest collections, in Dulwich, and fielded another establishment portraitist, Richard Cosway, as well as the knowledgeable dealer Tassaert, along with others.[10]

The evidence, however, seems to have consisted of nothing but connoisseurial assertions by the experts. There was agreement that the Claude was a copy, good enough to justify the price, according to Slade's team, just a copy for Jendwine's. There was little other consensus on anything. The witnesses for Jendwine thought almost all the paintings copies, except that Farington thought the Rosa and the Bassano probably original, and the Brueghel original, but by some other artist than Brueghel and damaged. Bourgeois thought the pictures by Cuyp, Ruisdael and especially Berghem 'gems', whilst even Cosway, also appearing for Slade's defence, thought the last doubtful. The Teniers looked to Bourgeois like a damaged Teniers the Elder, to Tassaert, also for Slade's defence, like Teniers the Younger, to Farington not like an original picture of any master. All of this seems to have left the judge, Lord Kenyon, unimpressed. It also undermined the reference by Erskine, counsel for Jendwine, to another recent case (unfortunately not specified), in which the purchaser of what was supposed to be a Kirkman harpsichord did successfully sue for reimbursment, having found 'when he came to play on it, instead of discoursing most sweetly and melodiously . . . it turned out to be a hurdy-gurdy of the worst description'. But sound quality is more obviously a property of objects, open to evaluation by sensory judgement, than is effect in painting. Satisfied that there had been no explicit undertaking by Slade that the attributions were sound, and that there had been no deliberate intent to deceive, Lord Kenyon persuaded the parties to refer the matter to an arbitrator, for a decision in respect of the fairness, or otherwise, just of the prices paid in relation to market convention. 'His Lordship said', *The Times* report notes, of what became a landmark decision, 'it seemed to him impossible that there should be an absolute warranty in pictures.'[11]

Even given the shift in art-historical attributive debate away from mere connoisseurial assertion, the difference between modes of treating evidence in academic debate and in court remains. The second case is the *cause célèbre* of *Huntington v. Lewis and Simmons* in London in 1917.[12] The legal issue was slightly different, in that the defendants, once again London dealers, did not deny that there was an implied assurance as to the soundness of their attribution, so that the question came down just to attribution. At issue was a portrait, which they had believed to be by the then hugely coveted eighteenth-century portraitist Romney, and then had the temerity to sell to Henry Huntington, an American millionaire. Temerity, because Huntington was already the client of the scheming, bullying dealer, Duveen, and because Lewis and Simmons had made a bad mistake. The painting was not by Romney, but by a figure of lesser reputation, Ozias Humphrey, and it was not, as they suggested, of the famous actresses Fanny Kemble and Mrs Siddons, but of two society belles, the sisters Waldegrave. All that might never have emerged had the issue been left to the teams of connoisseurs wheeled out, making dramat-

ically various assertions. The ancient painter Sir William Richmond declared that even if the picture was pronounced by the Almighty as not by Romney, he would not change his opinion that it was.[13] It has to be noted in passing too that the museum profession distinguished itself by presenting, on connoisseurship grounds, an almost solid phalanx of support for the wrong attribution, notably from the director of the Walker Art Gallery in Liverpool and from our old friend, Alfred Temple from the Guildhall Art Gallery, batting for the artistic losers, as ever.[14]

However, Duveen, though not overtly a party to the case, was determined to annihilate the rival dealers who had trespassed upon his patch, and saw to it that more compelling evidence was brought to bear.[15] Arthur Laurie, for example, was commissioned to introduce objective stylistic evidence into the case, with some of his photographic details of brushwork, and with other photographs of drapery models to demonstrate incompetent draughtsmanship. If the shadow of the nose in the disputed picture was taken to indicate the source of the lighting, Laurie proudly explains in his memoirs, then the lighting on the face and drapery was inconsistent, unusually for Romney.[16] What he missed out is that all this seems to have bored the judge, Lord Darling, for whom the whole affair was something of a spring circus, an occasion for constant witticisms which everyone agreed were fearfully funny. Laurie was interrupted with a put-down: 'It's bad enough to have to judge whether it's a Romney, but to have to judge it with the knowledge of a haberdasher is quite a different thing.'[17] In the event, the decisive evidence came from the historic record. First it emerged that Fanny Kemble, Romney's supposed sitter, was performing in Manchester when the defence tried to establish that she was referred to in his appointment-book as sitting for him in London. Then, as researchers for both sides continued to scour the archives even as the case proceeded, a sketch clearly for the painting in question was found in the Royal Academy, manifestly by Humphrey, and rapidly associated with the Waldegraves. It was produced by the defence in a dramatic *mea culpa,* but with Duveen's team closing rapidly on it from a different direction. Such a sketch might just have been a study by Humphrey of a Romney, but suggestively the sketch does show differences in composition. More decisively, once identified, the portrait was recognised as a famous one, scandalous in its own right. Humphrey never got paid for it, because the young women's mother thought it improperly revealing.[18]

Darling was lucky that such decisive evidence turned up. He would otherwise have found himself having to deliver a decisive legal verdict, but on the basis of a debate that had not been framed with due legal caution. The law seeks above all to avoid false positives, false convictions, whilst art history is notoriously relaxed in accommodating the equivalent, false identifications. Yet in this case Lord Darling allowed the conventions of art history precedence over the

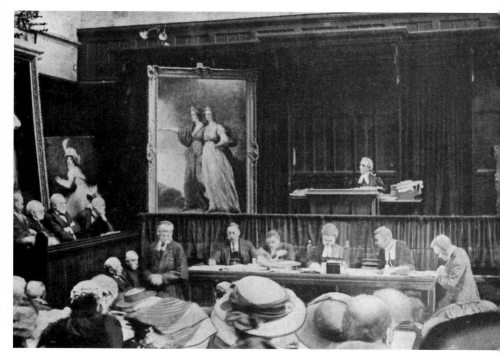

23 The Romney case in court

usual rules of legal evidence. First, the traditional reliance upon the connois-
seurs as expert witnesses meant that in effect they were commenting not just
on technical points of evidence, but on the whole substance of the case, the
issue of attribution. As a rule in court, the testimony of the expert witness is
limited to opinion on the status of evidence that lay people cannot be expected
to assess. Second, every kind of evidence was admitted. At one point, in
response to a chance remark by Darling, a whole collection of accepted
Romneys appeared over lunch and were allowed just to hang on the walls of
the courtroom, mutely reproaching the disputed picture, as we see some of
them doing in figure 23.[19] At the end of the case counsel for the prosecution
even thanked the court for allowing evidence which was 'strictly not evidence,
according to the rules of law'. Darling, summing up, noted that the case 'had
been fought not on the somewhat narrow lines of evidence laid down in
English jurisprudence. It had been fought in the full light of day. Everything
that anybody knew had been laid before the court.'

A much livelier sensitivity to these points, however, about procedures in
considering evidence and degrees of probability in final judgements in art
history, have begun to emerge as a positive outcome from the discomforts of
the Rembrandt Research Project, funded by the Netherlands Organisation for

the Advancement of Science (NWO). It got under way after the 1969 trecen-tennial of Rembrandt's death, because of the exceptionally contentious state of Rembrandt attributions. In nearly a century of successive *catalogues raisonnés*, the paintings attributed to him had risen from 595 to 711, then declined again to 430.[20] The words of the preface to the first volume to be published, in 1982, have proved singularly prophetic: 'The way decisions on a final opinion have been taken, and the unperceivable forces that have played their part . . . would be an interesting subject for socio–psychological study.'[21] The ongoing project is proving as searching a study of attribution as it is of Rembrandt.

Those involved in the project were innovative in attempting from the start to formalise, to some extent, a process leading to authoritative judgements through the consensus view of a committee of five. Their first volume took fourteen years to prepare, their third, appearing in 1989, taking Rembrandt's career up to 1642. Every painting was inspected by at least two of the team, and the pairings constantly changed. The consensus views were developed around a table in Amsterdam. As far as possible, technical means of inspection were brought to bear, such as the dendrochronological evidence mentioned in the previous chapter, but the extent of what could be done varied from painting to painting, and at the outset the role of science was played down. A role for tech-nical evidence was anticipated in what was expected to be the easy part of the job, weeding out the eighteenth-century and later imitations, but not in the tricky bit, distinguishing Rembrandt's own work from that of his studio or of other close imitators. The team therefore called upon the expertise of scientists, but did not include one, since 'homogeneity of method and results would be best served by forming a team of art historians only'.[22] In the best traditions of even cautious art-historical practice of the time, paintings were assigned to only three categories, firmly attributed, problematic and rejected as works of Rembrandt.

Inevitably such a high-profile project, involving such high stakes, has attracted a great deal of criticism. A number of the attributions have been dis-puted, and several remain so. It took some time for the National Gallery to concede publicly that its *Man reading in a lofty room* is an imitation, and a number of the group's other decisions have been challenged. Hubert von Sonnenburg, then director of the Doerner Institute in Munich, a leading centre of scientific research in attribution, firmly rejected one of the committee's cat-egory B paintings, a portrait of Rembrandt's son Titus in the Norton Simon Museum, but was confident about the *Polish rider* in the Frick Collection in New York, one of the hitherto most accepted pictures about which the com-mittee came to have doubts.[23] Overall, this huge research effort has generated reliable conclusions, according to one independent estimate, in perhaps 80 to 90 per cent of cases,[24] but there has still been extensive criticism of the methods as well as the verdicts of the project. Amongst the reservations of Mansfield

Kirby Talley, for example, in an extended critique, is concern that the committee system left no room for intuition, but on the other hand encouraged the nurturing of doubts.[25] He rejects some of the committee's convictions about Rembrandt's working methods, and reports anxieties that the team had at times rejected study of treatment of details of a rather Morellian or van Dantzig-like kind, then come to depend upon them.

These anxieties seem to have been reflected in developing unease within the group, too. The main casualty has been the early confidence in connoisseurship. The early expectation that many of the traditional mistaken attributions were much later imitations of Rembrandt, which technical evidence would readily reveal, proved wrong. The technical evidence, to the contrary, revealed that far more than expected of the puzzle pictures were demonstrably from Rembrandt's circle or studio, so that scientific distinctions in material seemed to the project members at first to offer little help, leaving traditional connoisseurial judgement apparently with the leading role. But all the careful procedures of the group have made little headway against the inherent limitations of connoisseurship as a methodology leading to consensus. The *Polish rider* is an example. 'Every time we are in New York we go look', project director Ernst van de Wetering remarked of it, 'and we say "Yes", "No", "Yes", "No." '[26] After the production of volume III, four of the remaining members of the group decided that the project had taken up more of their time than they could afford to continue to give, whilst also owning to reservations about new working procedures proposed, and now adopted.[27] The manifest fallibility of connoisseurship on the one hand, and growing confidence in technical innovations on the other, have meant that by 1996 'The means of connoisseurship will be deployed with the greatest possible reserve and only when all other arguments have been exhausted and have not led to a defensible hypothesis or (as occurs rarely) actual proof.'[28] For the remaining volumes there will only be a project director and assistants, but they will call upon a wider range of regular specialists, including more technical specialists than before, besides others consulted in connection with individual attributions.[29]

This trend only reinforces the lessons of the connoisseurs' paradox set out in chapters 2 and 3, but the project has also led to a much greater acceptance of variation in probability. 'The further the project developed,' current director van de Wetering noted in a letter to the *Burlington Magazine* in 1993, 'the more evident it became that in the attribution of paintings the degree of certainty varies from one instance to the next.'[30] The three-category convention does not seem to have accommodated debate within the team much better than debate with outsiders. Differences of opinion within the group in the first three volumes were discussed openly in the entries for one category A, one category B and four category C pictures, but others remained implicit. Van de Wetering added in his 1993 letter that within the group constructive differences of

opinion were 'unfortunately obscured' by the decision to put the paintings into rigid categories. The fixed A, B, C classification scheme has therefore now also been abandoned. Even the language in which the change is explained suggests probability: by 1996 'a condition of our present working method is that the kinds of arguments we use be as diverse as possible, generally based on . . . statistically significant data. From our reasoning, it should be clear that individual arguments on their own are virtually never decisive when attributing or rejecting a work, but that when taken together they may converge towards a clear conclusion.' A substantial number of paintings have now been X-rayed, yielding data on types of canvas and methods of stretching as well as on the paint layers themselves, and technical information on Rembrandt's grounds, signatures and the timber of the panels is beginning to accumulate to levels that would allow much more systematic approaches.[31]

Rembrandt studies have no monopoly on confusion in regard to the attributional record, but few projects so resolutely raise the problems. It will be interesting to see how they will be addressed in the forthcoming van Gogh research project, a bit less formal in organisation, but calling on team research based in the Van Gogh Museum, and now under way because of very widespread reservations about the existing corpus of works accepted, and wide divergence between the opinions of more recent specialists, even when well respected.[32]

It is still not easy in most situations to systematise the weighting of evidence in art-historical attribution better, because of the lack of quantitative data. The problems appear vividly if we attempt to apply to attribution a methodology recently proposed as a remedy for problems in decision-making in law, the elementary application of so-called Bayesian statistics.[33] There would be a certain poetic vindication if we could apply them in art-historical judgements, since probability was on the agenda of mathematicians in the early eighteenth century, as of the Rev. Thomas Bayes after whom the approach is named, because of the philosophical problem that, however preferable the evidence of the senses to received authority, it could only offer probability, not certainty of the truth. The idea of applying the methods of probability in court is an old one, proposed in their day in France by both the leading French mathematician of the nineteenth century, Siméon Poisson, and the early twentieth-century physicist Henri Poincaré.[34] For most of this century, however, the Bayesian approach has been marginalised even amongst statisticians, displaced in the courts by the methods of classical statisticians. Scope for Bayesians to fight their way back into court has arisen because of the monotonous regularity with which the courts in Britain have made manifest logical errors in interpreting evidence from classical statistics, even when (as has not invariably been the case) the data has been sound. Classical statisticians still accuse the Bayesians of hopeless subjectivity (the battles of Bayesian and classical statisticians have

the flavour of religious wars), but this explains the attraction of Bayesian approaches for application in matters of art attribution, whether or not they are appropriate in court.

The problems confronting the art historian in attributions can be illustrated if the method is applied to the mysterious *St Jerome* discussed in the previous chapter. First we need to note that the difficulties in this case are not quite the same as they might be in the case of a doubtful Rembrandt. The great majority of the paintings addressed by the Rembrandt Project start off attributed, for better or worse, to the classification 'Rembrandt', so that the question is whether they are properly attributed to that class, or whether they fall short of it as copies or imitations, or because of their condition. Essentially the problem is to compare each problem painting with ones confidently attributed to Rembrandt, to assess similarity and difference in as many ways as possible. Only when they have been dismissed as members of the class 'Rembrandt', even as copies, need the matching extend to comparative examples by other artists, in search of an alternative hypothesis. With *St Jerome* the problem is not so much whether the picture is a copy, imitation or transformed travesty, but with what school of painting it should be associated at all, so that the problem becomes that of trying to find a match for it within a hugely wider variety of paintings. However, in trying to bring a statistical argument to bear on either kind of matching, the art historian confronts a similar difficulty, an absence of quantitative data.

The first step of the Bayesian approach allows for that. Room for intuition is specifically built into the method, to the dismay of classical statisticians. The procedure begins with the researcher's best guess, before looking at new evidence, about the probabilities of each hypothesis involved, known as the prior probabilities. In the case of *St Jerome,* three hypotheses might be considered, the first that it is a late nineteenth-century forgery, the second that it is, though unusual, a sixteenth-century painting from Germany or Italy, and the third that it is old, but from some other place or later period – perhaps some pastiche done in the seventeenth or eighteenth century for reasons that will never now be discovered. Now in any museum collection of twenty or so paintings attributed to Italy or Germany from the sixteenth century it would be unremarkable to find one or two that are much later forgeries, and two or three that are from some other unusual source or later date, but the majority might indeed be Italian or German. (In the latter case, a number of the paintings would usually turn out to be later copies made in good faith, but since the first problem with *St Jerome* is to establish with what category it should be associated at all, we can simplify the problem by ignoring that distinction at this stage.) That makes it possible, without even looking at the picture, to allocate reasonable prior probabilities to each hypothesis, say, one chance in twenty to A, seventeen in twenty to B and two in twenty to C. Many Bayesians would,

however, be quite happy for even these imprecise estimates to be adjusted at this prior stage to allow for any hunch of the researcher.

It is as we turn to the evidence that the problems faced by art historians become obtrusive. At first sight the evidence seems very specific, about the type of timber, the analysis of pigment, the worm-holes, the stylistic oddities and so forth. But what is missing is any quantitative measure of the extent to which each of these characteristics is decisive, or just suggestive of each hypothesis. This is the heart of the problem, because a judicious verdict must include not just the evidence, but assessment of the different weight it should be given under each hypothesis. That can seem a puzzling idea, but consider the timber of the panel, for example. Thanks to Marrette's study, mentioned in the previous chapter, we know that under the hypothesis that the painting is an early sixteenth-century German or Italian one, we do, exceptionally, have some figures. Marette found only 44 paintings on timber other than oak, poplar or fir out of 564 from these countries. Her figure was for paintings from four centuries ending in the sixteenth, not just for the latter, as it should strictly be to match it with our hypothesis B, but if we still allow ourselves to use the data to give us a likelihood of only 44/564 of finding such a panel under hypothesis B, we are being far more precise than we can be for any of the other hypotheses or data. For the use of cedar specifically, or for timber other than oak, poplar or fir under the other two hypotheses, we can only fall back on intuition, based on experience, but not on counting. Under hypothesis A (forgery), it would not be at all unusual to find a painting on a less common type of panel, since only recently did forgers have to anticipate timber analysis. One might guess, therefore, that it would not be unusual at all to find three out of five late nineteenth-century forgeries of main school sixteenth-century paintings on something other than oak or poplar, but a guess is all it would be. If hypothesis C is true, and the painting comes from some other place or period, then again there is no data, since Marette's study stops at 1600. Oak, poplar or fir remain favourites, but one painting in three on some other timber would surely not be surprising. Intuitive guesses of that kind are all we will be able to call on about the all the other pieces of evidence, since in a case as open-ended as the attribution of St Jerome, there would be no chance of building up figures for their incidence in such wide potentially matching categories. In the case of Rembrandt attributions, where the sample of paintings against which a new candidate must be matched is only a few hundreds or so, and where thanks to the Rembrandt Research Project impressive bodies of evidence are accumulating, it may be possible to quantify the incidence of each piece of evidence. Art history offers nothing else comparable.

The judgements of art historians, therefore, except where evidence widely accepted as conclusive turns up, are very much matters of probability, but based only on intuition drawn from experience. Casting the argument in elementary Bayesian terms might in some cases still be useful, though, since it obliges us to

Table 1 *Saint Jerome*

Under this hypothesis the evidence	would be unremarkable in	out of this no. of paintings called '16th-cent. German' or 'Italian'		Likelihood
Prior P(A)	1	20	=	0.05000000
Pe(1) if A is true	1	5	=	0.20000000
Pe(2) if A is true	1	100	=	0.01000000
Pe(3) if A is true	1	5	=	0.20000000
Pe(4) if A is true	1	10	=	0.10000000
Pe(5) if A is true	1	50	=	0.02000000
Pe(6) if A is true	3	5	=	0.60000000
Probability of all the evidence if A is true, multiplied together			=	0.00000002
Prior P(B)	17	20	=	0.85000000
Pe(1) if B is true	1	500	=	0.00200000
Pe(2) if B is true	1	20	=	0.05000000
Pe(3) if B is true	99	100	=	0.99000000
Pe(4) if B is true	1	500	=	0.00200000
Pe(5) if B is true	1	2	=	0.50000000
Pe(6) if B is true	44	564	=	0.07801418
Probability of all the evidence if B is true, multiplied together			=	0.00000001
Prior P(C)	2	20	=	0.10000000
Pe(1) if C is true	1	100	=	0.01000000
Pe(2) if C is true	1	10	=	0.10000000
Pe(3) if C is true	1	2	=	0.50000000
Pe(4) if C is true	1	100	=	0.01000000
Pe(5) if C is true	1	2	=	0.50000000
Pe(6) if C is true	1	3	=	0.33333333
Probability of all the evidence if C is true, multiplied together			=	0.00000008

POSTERIOR PROBABILITIES

Pe (all multiplied together) if A is true **divided by**	0.00000002
Pe (all) if A is true *plus* Pe (all) if B is true *plus* Pe(all) if C is true	0.00000011
gives the posterior probability of hypothesis A given the evidence	**0.21071443**
Pe (all multiplied together) if B is true **divided by**	0.00000001
Pe (all) if A is true *plus* Pe (all) if B is true *plus* Pe(all) if C is true	0.00000011
gives the posterior probability of hypothesis B given the evidence	**0.05763824**
Pe (all multiplied together) if C is true **divided by**	0.00000008
Pe (all) if A is true *plus* Pe (all) if B is true *plus* Pe(all) if C is true	0.00000011
gives the posterior probability of hypothesis C given the evidence	**0.73164733**

lay out an argument like the one about the painting presented in the previous chapter in a more transparent and systematic way. Table 1, therefore, shows guesses of the likelihoods that our six pieces of evidence might have shown up, under each hypothesis in turn (A, late forgery; B, sixteenth-century German or Italian; and C, some other source). The pieces of evidence are:

e(1) the painting was done on an already wormeaten panel;
e(2) there are many layers of damage and repair;
e(3) the red pigment is vermilion and the green copper resinate;
e(4) formalised drapery combined with inaccurate anatomical detail;
e(5) the painting has a known history going back to 1879;
e(6) the panel is not oak, poplar or fir

The method named after Thomas Bayes, in its simplest form, stipulates how these estimates of the likelihood of the evidence weighted under the competing hypotheses are to be combined to give an estimate of a likelihood ratio of each.[35] The process is simple to do, but slow to explain, and readers for whom maths is torture could take it on trust and skip a paragraph. First the prior probability of each hypothesis is multiplied by the weighting given to the first piece of evidence under that hypothesis, the result multiplied again by the weighting given to the second piece of evidence under that hypothesis, and so forth through all the hypotheses and all the evidence. Then the total for each of the three hypotheses is added to give an overall probability of the evidence under all the hypotheses. That total is then divided into the smaller total for each hypothesis separately, to give in each case what is called the posterior probability of the hypothesis, given the evidence. In equation form, if $P(A)$ is the prior hypothesis, Pe_1/A the probability of evidence 1 showing up if hypothesis A is true, Pe_2/A the probability of evidence 2 showing up under that hypothesis, and $P(A)/e$ the posterior probability of the hypothesis, given the evidence, then:

$$P(A)/e = \frac{P(A) \times Pe_1/A \times Pe_2/A \dots \text{etc.}}{(P(A) \times Pe_1/A \times Pe_2/A \dots \text{etc.}) + (P(B) \times Pe_1/B \times Pe_2/B \dots \text{etc.}) + (P(C) \times Pe_1/C \times Pe_2/C \dots \text{etc.})}$$

This is a very simplified treatment, and even given sound data it would be easy to trip up, for example over technicalities to do with the number of hypotheses, and whether they are exclusive and cover all possibilities without overlapping. It would also be vital not to link evidence that is in fact related, not independent, so that one piece depends on another. For example, in this case we would quickly get into trouble if we tried to assess likelihoods of finding cedar specifically, at the same time as not finding oak, poplar or fir. But of course the data are far from sound. No classical statistician would entertain such estimates, and though some convinced Bayesians seem prepared to stretch a point as far as intuitive judgement goes not only in relation to the prior hypothesis, but even in relation to estimating likelihoods,[36] none would surely feel confidence in results dependent on likelihood ratios based on no hard quantitative data at all.

For all that, it does seem that in some cases the method might be helpful, so long as it is well understood that the estimate is not of intuition adjusted in the

light of objective evidence, but merely a tabulation of intuition. It is often all art historians have to go on, and if the argument is set up as a simple spreadsheet, as in table 1, it is at least easy to change any weighting to try out the effect of disagreement. For example, I have rated it very rare that this combination of stylistic features is to be found in any Italian or German painting of the sixteenth century. Some art historians I have been in touch with agree, others do not feel the combination is quite so anomalous. The effect of any more liberal rating of that evidence on the overall probabilities could immediately be demonstrated. Similarly, estimates could be corrected if data does become available, and it would be simple too to add any completely new evidence, weighting it as before against each hypothesis in turn. Most valuably, it requires that built into the argument is the possibility, however remote, that each piece of the evidence on which we are relying might have shown up under a hypothesis contrary to the one we are inclined to sustain. That is just the issue which has become central in the case of the scientific evidence about the Getty kouros, and which Joseph Noble in condemning the Metropolitan Museum's bronze horse, and I in too readily dismissing Jerome as an imposter, underrated. This is our escape route from Piattelli-Palmarini's labyrinth of mental tunnels.

A more successful attribution in this case will almost certainly depend upon some painting turning up which matches not just the unusual combination of features found in *St Jerome,* but presents close similarities of form in them. These, as we have seen, are extraordinarily hard to characterise in any way that gains consensus, but here too the method helps to clarify why it is quite so hard to assess the probabilities. Art history is dogged by cases in which, in the opinion of some specialists but not others, a stylistic match is so close as to offer conclusive evidence for attribution, and where other evidence is inconclusive. That kind of matching resembles assertions that often form a part of evidence in criminal cases. The matching most common in the courts takes the form of witness identifications, notoriously problematic, but there are also difficulties in the much more reliable matching of bullets with the weapons from which they have been fired, or fingerprints with those detected at a scene of crime. For these matching tasks very specific procedures are laid down to stipulate what constitutes a match, but Bernard Robertson and G. A. Vignaux, in their study of the application of Bayesian methods in court, argue that it would be better to build into the evidence an allowance not for the closeness of the match, but for the measured performance of each expert. Performance would need to be measured with tests like the ones described at the beginning of this chapter to assess our intuitive confidence in our judgements, based on choices that can subsequently be compared with answers known to be correct. The idea is resisted by both fingerprint and ballistic experts, because in controlled tests using their procedures, the specialists have been shown to produce no cases of false matches, and only a very low level of false negatives, matches that are

missed.[37] All the same, during 1996 in the UK there has been pressure from the police for the procedures to be relaxed, on the grounds that concern to avoid false positives has been carried too far, and that as a result prosecutions that should be brought are not being brought.[38] Whether the fingerprint community can resist the current pressures remains to be seen.

Art historians cannot claim any such privileged record. They can offer no procedures at all for assessing just how close a stylistic match is, and in making matching judgements they are perhaps no more wayward than witnesses identifying suspects, but they cannot claim anything like the record of fingerprint or ballistic experts. Nor are their assertions constrained by the obligation on the courts to avoid false positives at all costs. Old-style connoisseurs, therefore, tend to be as confident in their judgements as fingerprint specialists. Sir William Richmond's confidence in the *Huntington* v. *Lewis and Simmons* case is one example, and Michael Jaffé, commenting in 1979 on tapestry cartoons attributed problematically, according to some, to Rubens, is reported as declaring that 'They are their own documents . . . nothing can be seen in them which is not by Rubens's own hand.' Julius Held, citing Jaffé's remark in a paper presenting the opposing view, could find nothing in them that was by Rubens's own hand.[39] It is not easy to imagine such specialists welcoming a convention in which their opinions were weighted by some estimate of their reliability. There is no realistic chance, however, that we can put them on the Bayesian spot. Whereas it is readily possible to set up controlled tests of the matching ability of fingerprint or weapons experts, using material unfamiliar to the examinee, but for which the correct answer is known to the organiser of the test, it is not easy to see how anything of the kind can be contrived for art experts. But putting the issue in statistical terms does emphasise how much a matter of probabilities uncertain art-historical attributions are.

What we now need to consider is why that lesson is so little reflected in the conventions of attribution in art-historical literature and museum practice.

Probability and conventions of attribution

If a more satisfactory methodology for weighing evidence in attribution were to be found, one undoubted consequence would be that attributions would be distributed along a spectrum of probability, from very reliable to very doubtful. This is rarely explicitly apparent in museums or in the market. The terminology of each might seem to accommodate the uncertainty, but in practice the paintings that are presented to us in art museums and on the market with a firm attribution are by no means only those for which the evidence is truly compelling. There is a crude ranking of probabilities. In the celebrated codes of the major auctioneers, an artist's names given in full used to suggest confident attribution, initials indicated more probably a follower of the period,

name alone a later imitator. Museums prefer the qualifiers 'studio of', or 'school of', or 'follower of' or 'imitator of'. Just what these mean varies, and the categories they cover overlap, so these conventions only hint at the true variety of confidence in attribution. Overall, practices in attribution reflect market conventions rather than the uncertainties of scholarship, and in practice overall consensus seems more than anything else a matter of what confidence in the market will bear. Unsupported assertion has been tolerable because, as we have seen, since *Jendwine* v. *Slade* in England, the courts have generally attributed little contractual importance to attribution in art transactions, in the absence of any specific guarantee.[40] Norman Palmer explains that the principle until recently (1991) remained the norm, but that the Trades Descriptions Act has been used in a judgment which did attribute liability to an auctioneer in a comparable case, *May* v. *Vincent*, 1990.[41] That left it very unclear what level of tolerance of error in attribution in the practices of the market the courts in the UK now feel it reasonable to protect. In *De Balkany* v. *Christie, Manson and Woods Ltd* in 1995, the complainant against the auctioneers won damages only because a painting bought as an Egon Schiele was held to have been repainted to the point of forgery. Had it not, thereby, have been judged to 'have fallen within the scope of specific undertakings relating to forgery,' the auctioneers' disclaimers would, in the opinion of the judge, have protected them.[42]

The case in law may not even be based upon attributional evidence at all. The pragmatism that is forced on the market is illustrated by the way French law deals with the work of recently dead artists. The artists' *droit moral* in life to assert authorship of their works and denounce imitations and misattributions can be bequeathed, and the heirs can assert the rights, or assign them to a recognised authority. However, who this is can vary widely. Often it is someone of considerable authority. For Signac, for example, the holder is Françoise Cochin, granddaughter of the artist, author of a *catalogue raisonné*, and director of the Musée D'Orsay. For Léger it is Maurice Jardot of the gallery Louis Leiris, for Mirò Jacques Dupin, designated by the Mirò family. However, since such *droit moral* begins with inheritance, the system is open to characters of less integrity, and there is no shortage of them. The power of the holder of *droit moral*, dishonest or honest, lies not in expertise at all, but in the right to instruct the police to confiscate, and after due process to destroy, a work considered a forgery, as the British owners of a supposed Mirò, who innocently travelled with it to Paris to show it to Jacques Dupin, discovered to their amazement and cost.[43] It is open to the disappointed party to challenge the confiscation, but the vital point is that once the holder of the *droit moral* has issued a certificate, the market knows that there will be no confiscation.[44] On the one hand, therefore, the certificate is in no way a legal guarantee of authenticity, but on the other, for the purposes of the French market, it makes

successful legal challenge to attribution unlikely.[45] It is thus an institutional version of the principle which holds on the market more generally.

Droit moral is a special case, however, and in other cases just whose attack carries weight varies dramatically in different countries and market specialities. British precious metalwork provides an instance of a formal and effective system. The assay-master at Goldsmith's Hall presides over the Antique Plate Committee, to which hallmarked pieces can be submitted for verification. They are likely to spot misidentifications, or anything like simple 'letting in' of hallmarks, cut out of small, authentic early pieces and annealed into larger spurious ones, or composite pieces in which the bowls of early spoons are turned into larger salts. Numerous artists' estates offer something similar, based on authoritative archive material, for example the Henry Moore Foundation in the UK and the Paul Klee Stiftung in Berne. But nothing so formal exists for British ceramics. Although the archive and expertise of the Art Gallery and Museum in Hanley played a major role in exposing the Staffordshire fake racket described in the previous chapter, such expertise cannot be comprehensive, and ceramics forgers were particularly busy in Britain in the 1980s and 1990s, achieving farcical heights in the celebrated forgery in ceramics lessons in Wolverhampton prison of pots attributed to Bernard Leach.[46] In such a market, even in respected dealing in old items, attribution of old but unmarked pieces is also likely to be a relaxed affair.

The decisive issue for the market is not in the niceties of debate, just in the authority attributed, as a last resort, by the courts to any recognised opinion, but this too is uncertain. In the USA the courts have been struggling with the weight to be accorded to experts in connection with twentieth-century art. Two cases in early 1995 resulted in opposed judgments typical of the problems to which art attribution gives rise, on the status of acknowledged experts. A New York district court accepted the opinion of Quentin Laurens, a respected director of the Louis Leiris Gallery in Paris, in the case of a drawing attributed to Braque. But in the case of a contested attribution to Alexander Calder, a District of Columbia court has rejected the opinion of Klaus Perls, Calder's dealer.[47] On the other hand, where widely respected academic work has been done, an academic can aquire a sort of unspoken *droit moral* to pronounce, and often in the market the opinions of one or more academics considered to have made authoritative studies are canvassed and published. Of course, such specialists are not always the best of friends, and all the less so when in disagreement. Where no recent respected work has been done, things are even less clear. At times, anything goes, sometimes because of passionately held, but doubtful, confidence in an attribution, at others for more cynical reasons.

Even within art museums, the attribution the public sees can be a matter of local politics or of legal prudence. It may be a question of placating a supporter, or just reluctance to demote a prestige aquisition. There is also the danger of a

possible action for disparagement, especially if an opinion is published or is delivered as a firm expert opinion, intended for third parties as well as the owner of the object. US plaintiffs have to demonstrate that a legally protected interest has been affected by the injurious comment, that it is false, published in circumstances which give it credibility with a third party, taken by them injuriously as applied to the interests and subsequent pecuniary loss of the plaintiff. They also have to show that the defendant either knew the comment to be false, or was reckless with the truth.[48] These might sound a hard set of requirements to meet, but in practice any curatorial expression of opinion published poses a hazard, because of the extreme difficulty in matters of attribution in deciding what is the truth, and what expression of opinion might qualify as reckless. Though to date museum curators have not been targeted, other specialists have.[49]

This leads to a notable conclusion. Matters of attribution involve probability, but the tolerance for error, even in attributions in the academic and museum sphere, is not at all just a matter of debate within the discipline. It is very much a matter of uneasy consensus involving all the members of the opinion-forming cycle within which more generally, as emerged in chapter 1, artists are accorded canonical status. When it comes down to attribution of individual objects, however, not just the markets but the courts, too, enter the cycle. With this in mind, there is one way in which probability in attribution is registered, and at times with remarkable subtlety, though in a way that only initiates recognise, and that is in price. This chapter can end with a return to *Jendwine v. Slade,* back in 1797, but now with the experts reconvened ten days after the first hearing, this time with an arbitrator, and for another thirteen hours of discussion with only biscuits to keep them going, focused just on the issue of the fair market value of the pictures.[50] Jendwine, for example, had not paid anything approaching the going rate for a serious attribution to Claude. The attributions, however, will doubtless not have changed. If matters of attribution are quite so tied to matters of valuation, no wonder that in recent years there have been shouts from the public gallery that the whole business is suspect. The accusations must now be heard.

Notes

1 D. Kahneman, P. Strovic and A. Tversky (eds), *Judgment under uncertainty: heuristics and biases* (Cambridge, Cambridge University Press, 1982).

2 A. Grafton, *Forgers and critics: creativity and duplicity in Western scholarship* (London, Collis and Brown, 1990), p. 68.

3 M. Piattelli-Palmarini, *Inevitable illusions: how mistakes of reason rule our minds* (New York, John Wiley and Sons), 1994.

4 P. Roberts and C. Willmore, *The role of forensic evidence in criminal proceedings* (London, HMSO, 1993), pp. 108, 109.

5 D. Rose, 'On the dangerous road to a police state', *Observer* (21 May 1995), 23; Anon., 'Prosecution "should give evidence to defence"', *Independent* (7 Aug 1995), 3

6 Q. Letts, 'National Gallery accused of ruining paintings', *The Times* (Thursday, 18 April 1996), 1–2, 2.

7 Roberts and Willmore, *The role of forensic evidence*, pp. 37–9.

8 *Ibid.*, p. 98.

9 *The fine art of faking it*, a documentary for Nova (Philadelphia, Films for the Humanities and Sciences, 1992).

10 K. Garlick and A. MacIntyre (eds), The *diary of Joseph Farington* (New Haven, Yale University Press, 1979), vol. 3, pp. 866–71 and 875–7.

11 *The Times* (13 July 1797), 3.

12 E. Graham, *Lord Darling and his famous trials* (London, Hutchinson, 1929), p. 191.

13 A. P. Laurie, *Pictures and politics: a book of reminiscence* (London, International Publishing Co., 1934), p. 114.

14 *The Times* (22 May 1917), 4.

15 S. N. Berman, *Duveen* (London, Hamish Hamilton, 1952), pp. 148–52.

16 Laurie, *Pictures and politics*, p. 108.

17 D. Walker-Smith, *The life of Lord Darling* (London, Cassell, 1938), p. 191.

18 Sotheby, *Important English pictures* (London, Sotheby's sale catalogue, 18 November 1987), lot 50.

19 Laurie, *Pictures and politics*, p. 109.

20 S. Hochfield, 'Rembrandt, the unvarnished truth', *Art News*, 10 (1987), 103–11.

21 J. Bruyn, B. Haak, S. H. Levie, P. J. J. van Thiel and E. van de Wetering, *A corpus of Rembrandt paintings* (Amsterdam, Martinus Nijhoff, 1982), vol. 1, p xvii.

22 *Ibid.*, p. x.

23 H. Koning, 'The real Rembrandt', *The Connoisseur* (April 1986), 106–13, 112.

24 S. Hochfield, 'Rembrandt, the unvarnished truth', *Art News*, 10 (1987), 111.

25 M. Kirby Talley, jun, 'Connoisseurship and the methodology of the Rembrandt research project', *International Journal of Museum Management and Curatorship*, 8 (1989), 175–214.

26 Koning, 'The real Rembrandt', 112.

27 J. Bruyn, B. Haak, S. H. Levie, P. J. J. van Thiel, 'The Rembrandt research project' (letter), *Burlington Magazine*, 135:1081 (April 1993), 279.

28 E. van de Wetering and P. Broekhoff, 'New directions in the Rembrandt research project, Part I: The 1642 portrait in the Royal Collection', *Burlington Magazine*, 138 (March 1996), 174–180.

29 E. van de Wetering, 'The Rembrandt research project' (letter), *Burlington Magazine*, 135:1088 (November 1993), 764, 765.

30 *Ibid.*

31 E. van de Wetering and P. Broekhoff, 'New directions in the Rembrandt research project', 175.

32 S. Koldehoff, 'Der brockelnde Mythos, auf den Spuren falscher van Gogh's', *Frankfurter Allgemeine Zeitung Magazin*, 847 (24 May 1996), 14–21.

33 B. Robertson and G. A. Vignaux, *Interpreting evidence: evaluating forensic science in the courtroom* (Chichester, John Wiley and Sons, 1995).

34 R. Matthews, 'Improving the odds on justice?', *New Scientist* (16 April 1994), 12, 13.

35 P. Urbach, 'Clinical trial and random error', *New Scientist* (22 October 1987), 52–5.

36 Robertson and Vignaux, *Interpreting evidence*, p. 27.

37 *Ibid.*, p. 99.

38 J. Bennetto, 'Fears for justice as fingerprint rules eased', *Independent* (28 November 1996), 5.

39 J. Held, 'The case against the Cardiff "Rubens" cartoons', *Burlington Magazine*, 125:960 (March 1983), 132–6, 132.

40 S. Weil, *Beauty and the beasts* (Washington, DC, Smithsonian Institution Press, 1983), p. 193.

41 N. Palmer, 'My toaster won't toast; my Turner isn't a Turner, I want my money back', *The Art Newspaper*, 6 (March 1991), 13.

42 *De Balkany* v. *Christie*, Manson and Woods Ltd. LEXIS transcript, 11 January 1995.

43 P. Johnson, 'Bargain work of art gets "guillotined"', *Sunday Times* (16 October 1994), section 1, 4.

44 A. Israel, *Guide international des experts et specialistes* (Paris, Editions des Catalogues Raisonnés, 1991), pp. 43, 44.

45 See, however, J.-M. Schmidt, 'Fake Fautrier, can you trust an artist's heir?', *The Art Newspaper*, 63 (October 1996), 27. A challenge is not impossible.

46 M. Jones (ed.), *Fake! The art of deception* (London, British Museum Publications, 1990), p. 243, cat. no. 264.

47 L. Rosenbaum, 'Art and experts on trial in authenticity disputes', *Wall Street Journal* (11 April 1995), A18.

48 International Foundation for Art Research, *Report*, 8:7 (October 1987), 5; R. C. Lind and L. H. Wise, 'Critical opinions: you have the right to remain silent', *Museum News* (January/February 1992), 86, 87.

49 International Foundation for Art Research, *Report*, 8:7 (October 1987), 5.

50 Garlick and MacIntyre (eds), *The diary of Joseph Farington*, p. 877.

5

THE JUDGES IN THE DOCK

THE MOMENT has come when the tables must be turned, and the whole process of judgement of artworks be put in the dock. All the hard work of attribution and identification is done ostensibly to help us to understand the production of objects endowed with transcendental properties. However, from a detailed look at what is involved in the work, the values that emerge unequivocally and consistently associated with the business of attribution, right through to the courts, are not transcendental but financial. The case now to be heard is that when it comes to the identification of individual objects, with the law courts very much members of the value-adding cycle, the traditions of attribution load objects with unspoken financial and social value, whilst masking much of what the objects mean behind fantasy explanations emphasising creative genius.

Creativity and credit

Metalwork is a good field in which to start, because the connection with cash value is so transparent. A Florentine writer of the late fifteenth century describes in his memoirs how a fellow-citizen, Antonio dei Pazzi, had found himself earlier in the century at a banquet given by one of the most powerful men in England, Cardinal Beaufort. As a member of a major banking family, Antonio was someone with whom it could have been useful for the cardinal to establish credit. Amongst other delights for the guests, 'two rooms were prepared, hung with the richest cloth and arranged all round to hold silver ornaments, one of them being full of silver cups and the other with cups gilded or golden. Afterwards, Antonio was taken into a very sumptuous chamber, and seven strong boxes full of English articles of price were exhibited to him.'[1] This kind of blatantly social ostentation is an enduring convention. Here is Samuel Pepys, just establishing his position, confiding to his diary his gratification after a dinner party a couple of centuries later, on 8 April 1667: 'but Lord, to see with

what envy they looked upon all my fine plate was pleasant, for I made the best show I could, to let them understand me and my condition'[2]

It is an enduring tradition, and one much older than these examples, but it is striking how indifferent the early commentators were to who the objects were made by. Value was essentially in the metal, not the making. It is very different now. Consider the *Sunday Telegraph* on the collection of Arthur Gilbert, a British-born, California-based property dealer, which he is generously to give to Britain, and which is currently (1997) scheduled for display in Somerset House in London.

> The dining-room is a blaze of gold. Among the place settings are some of the finest examples of eighteenth-century craftsmanship – a magnificent candelabrum by Paul Storr and a pair of wine coolers by Benjamin and James Smith. In the drawing-room are Sèvres vases similar to a pair that resides at Buckingham Palace. A table in the hallway, made of malachite and gilt-bronze, bears the monogram of the Duc d'Orléans. This scene of pomp and splendour is found not at Chatsworth or Blenheim, but Beverly Hills . . .[3]

No question, the collection was put together with a love of the stuff, and the pictures accompanying the report suggest the festival of ornament in precious stuff to which we can look forward when the collection is displayed. The newspaper report, though, sounds more like Pepys, except that what is being emphasised for *Sunday Telegraph* readers is not just the stuff, but ingredient X too, attribution to named makers, sign of a social world so rarefied that here even vases are not just *in* Buckingham Palace, but 'reside' there.

Amongst the shouts from the dissenting voices in the public gallery of art history's courtroom is the accusation that the close association of creativity and attribution on the one hand with the methods and conventions of the law and the markets on the other is no accident. The key lies in the way in which an exalted notion of creativity, attributing 'genius' to people, or even whole peoples or ages, has become a kind of currency. Perhaps it is no accident that what was most valued in art came to depend less on the value attributed to the materials used and more on the creative gifts attributed to the artist, just in the period after 1450 when credit within the banking system, rather than possession of heaps of stuff, was becoming the key to wealth, and nowhere more than in the towns where the creative status of the artist was highest, Florence, Nuremberg and Antwerp. Commerce and social life had developed to a point where more flexible tokens of exchange were required. Paper instruments of credit were tokens of one kind, artworks endowed with what can seem a kind of magical creativity another. Art consumption is associated with social credit in some way in most societies, notably in ancient China,[4] but the complexities of the link to financial capital seem unique to the West. Curators, in this view, are just bankers in disguise, complete with specialist assaying

departments at their disposal, links in an ill-concealed chain associating credit with creativity.

However, as we have seen, the authenticity conferred or denied by the assayers in the narrow sense of correct identification has turned out in a substantial proportion of cases to be a matter of market convention as much as of objective assessment. But, of course, an object assessed as authentic gains much more than just an identification label. It is validated as a expression of the creativity that masks the cash. We now need to look a little more critically at the idea of authenticity in this larger sense.

Creativity and authenticity

Creativity as social credit in the liberal democracies hides behind two rather different models of the way in which it endows objects with transcendental properties. The first might be called the Romantic model of creativity, associated with the focus on the artist as a prodigiously gifted individual, often standing apart from society, like Gauguin in Tahiti. The other finds creativity more in the collective productions of a society or ethnic group in a particular era. Carol Gibson-Wood, in her study of connoisseurship, points to Herder's theories of racial evolution as one of the mature manifestations of the source of this latter idea, and to its role in the long-term goal of Morelli. His preoccupation with attribution, she explains, was less in pursuit of individual personalities than of the evolution of whole schools expressive of local character, and she points for example to the characteristics he identifies as typical of artists local to his native Bergamo, who remained true to the spirit of the place, with heavy and dark colouring.[5] What both models share is that the transcendent qualities that the objects aquire are understood to arise independently of the small change of social and political life, coming instead from the psyche and skill of the gifted individual, or from racially evolved, ethnic character. But why should remaining true to self or roots in that way seem to have such virtue?

The answer is that keeping the faith in that sense has come to be associated with authenticity in the sense of personal integrity, rather than of the originality of artefacts. To make the link between these manifestations of authenticity more apparent, we need to pursue its less artistic connotations a little further. We should observe ourselves as tourists, leaving the tourist trail at some safe point, to discover the 'real scene', of rural traditions, or food or craft.[6] On the face of it, the attraction of such detours lies not in the virtues of whatever we discover at all, but in our own experience of them as culturally different. Brian Spooner suggests how this makes sense of the history of Western fascination with a very Westernised notion of oriental carpets,[7] because social distinction accrues to the Western collector or traveller who identifies with cultural otherness. Distinction through association with otherness, though, does not seem

applicable to all the contexts that exert an attraction in the name of this sense of authenticity. We might extend it to objects from our own culture, if they are old, by citing temporal distance, but what about real ale? Otherness can be part of the lure of authenticity, but it is not the whole story.

Most of us as tourists would be pretty disconcerted if, straying from the tourist route, we stumbled, not upon elderly Frenchmen playing boules, but on a very different fantasy, the row of rotting heads on spikes in Conrad's *Heart of darkness*, outside the hut of Kurz, who has discovered the darkness within himself in the abandonment of his European background. However, this escape from the moulding of home culture, rather than whatever is discovered in the unknown, gets a lot nearer to the heart of current notions of authenticity. The ancient Greek roots of the word, as Lionel Trilling points out, suggest an unsociably complete power over others, even murder, and he goes on to explore the meanings it has acquired since the sixteenth century, as notions of personal sincerity emerged, only to be replaced by ideas of authenticity.[8] In response to the question of the eighteenth-century author Edward Young, 'Born originals, how comes it to pass that we die copies?', he explains that at that time the compromises of social life came to be understood to suppress individual authenticity. Marshall Berman has developed a similar theme, tracing authenticity in the sense of individuality and of truth to oneself, arising out of the way in which the rise of city life from the eighteenth century onwards has isolated us socially and thrown us on to ourselves. In writing from the Enlightenment to the existentialists of the 1940s and 1950s, especially Heidigger and Sartre, authenticity in this sense is associated with the rejection of the insincerities of social life.[9] Trilling follows that trail one step further still, to the whim of the 1960s associated with Foucault and R. D. Laing, that we find ourselves authentically only in madness.[10]

Even in an age when tourists put to sea to watch attempts to raise the *Titanic*, descent into madness and the heart of darkness would make a novel travel package tour, to say the least, but it does illuminate what makes artefacts fit, or unfit, in the sense of authenticity. What historic works of art, culturally distant ways of life, the spectacle of untouched nature and even, in a rather bizarre extension, traditional values associated with hand-made and designer-label consumer goods, do seem to share is resistance to the instability and constant reinterpretation that characterise our own culture. Figure 24, showing a magnetic fridge-door ornament, is everything that authenticity is not, and (magnet apart) in the defining material of our own culture, plastic. It is fun, but it is also just what we seek to distance ourselves from in identifying ourselves with things which seem less transient, whether the 'original' David, the great outdoors, freshly-made spaghetti in Italy or real ale in England. The last hints at a sinister dimension to authenticity. Nationalist sentiment as a spur to collecting 'cottage' furniture in the UK and its equivalent in the USA was mentioned in

chapter 1, and it was noted above that there are notions of racial purity in the background of Morelli's formalist analysis of style. Joseph Grigely goes so far as to see an analogy between the rise of modern textual editing in the spirit of authenticity and eugenics.[11] The perceived threat to identity from what we would now call multiculturalism is one of the strands from which the fabric of authenticity is woven. It is a lurid strand, however, and perhaps it is easy to attach too much weight to it. Authenticity seems to offer shelter from the bewildering onrush of change that has now to be accommodated within social life.

Truth to self and cultural identity, on the other hand, is just what art history celebrates, complete with madness and alcoholism, in the life of van Gogh or Jackson Pollock. It is in the works of these figures, along with others unwilling to compromise, such as Michelangelo or Blake, that an association is made between authenticity of self and authenticity of attribution and condition of the objects all artists make. It will surely not do, however, as a rationale for what we do as art historians. Part of what artefacts seem to resist, if authentic in these terms, is any social or commercial compromise at the point of origination. However, such compromises are inevitable in the lives of artists, even those mythically resistant to them, let alone the vast majority, who are as willing as most to meet the market. The paradox has reached a high point in contemporary art. It is often imaginative, but is the invention and wit involved so

24
'Dress me up!' *David* fridge magnet

different from what is to be found in contemporary advertising? The stylishness of Mapplethorpe may seem associated with a reassuringly authentic rejection of convention, but is it really so different from the stylishness of equally challenging Bennetton advertisements? Authenticity is not just rather a recent member of the club of supposedly transcendent terms like 'true' and 'real', as noted at the beginning of chapter 1. In making its appeal for membership it conceals a decidedly paradoxical, and to an extent even sinister, set of associations. Yet it remains the rationale for a great deal of art-historical and museum practice. How has it got away with it?

Creativity and classification

It is done through the apparently down-to-earth business of identification and classification, which must always impose theoretical assumptions on whatever is classified, but without the assumptions necessarily being obvious. As natural historians found out before art historians, any identification system more ambitious than just numbering items as they turn up involves putting things into categories of some kind, and it is impossible to devise an extended system of categorisation without some theory about the subject under investigation. So early taxonomic schemes in natural history assumed that species were stable entities and could be described in terms of constant characteristics, but the constancy has turned out to be an untenable theoretical assumption. Variation proceeds not only within species of animals as well as plants from generation to generation, but even, it seems, in hostile environments sometimes by hybridisation, with swapping of features between species by interbreeding.[12] So much for constant features. It can be hard to tell where one species ends and another begins. For practical purposes the scientists impose order with an extremely systematic terminology, from subspecies to species and up through varieties of genus, tribe, family and so forth. The system is grounded by reference to individual type specimens, just a handful at most for each species, in aspiration representing the constant features, the essential morphological type of a specimen, in practice providing mere bench-marks in the continuum of variation. Bitter debates divide advocates of new systems of taxonomy, the numerical taxonomists, for example, urging van Dantzig-like anatomical feature counting, the enthusiasts for cladistics seeking categories reflecting varieties of hierarchical relationship. The association of the problem with museums is summed up in a German headline over a story about the problems posed for palaeontologists by new finds of extinct feathered creatures which elude neat classification, 'Ausbruch aus der Vitrine' ('break out from the showcase.')[13]

Figures 25 and 26 suggest how the museum classification of artworks mirrors that of the natural sciences. As systematic classification of artists and

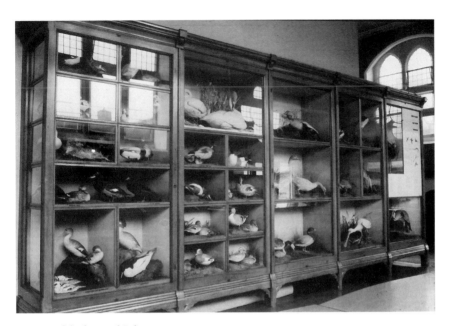

25 A caseful of water-birds

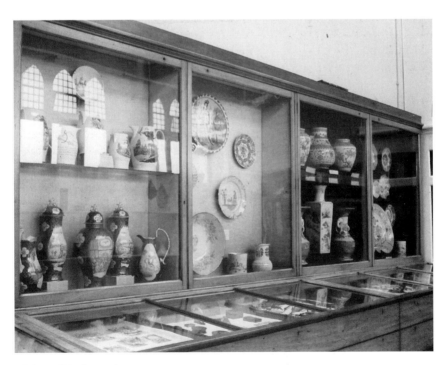

26 A caseful of ceramics

schools became the established approach to the study of art history in the later eighteenth century, it incorporated the techniques of earlier connoisseurship, and could draw too on the much older example of textual criticism, but classification in the sciences probably offered the most influential model. In the seventeenth century the early writer on art, Giulio Mancini, was scientifically trained as a doctor and was medical officer for Siena, whilst in the eighteenth century A. J. Dezallier d'Argenville was not only a noted student of individual character in art, but also the author of a systematically classifying text on shellfish.[14] By 1793 the prominent French dealer Jean-Baptiste Pierre Lebrun noted that any art display not arrayed by artist and school was 'as ridiculous as a natural history cabinet arranged without regard to genus, class or family'.[15] No specimens lend themselves more to arrangement in arrays of comparative examples than coins, and it was via this discipline that art history came to approach not just the expertise of the textual purifiers, but also the categorising discipline of the scientist.[16] Thus Charles Newton, a mid-nineteenth-century keeper of sculpture in the British Museum, served his apprenticeship as a curator, as did a number of British Museum keepers, in several years of cataloguing in the department of coins. He emerged with the conviction that the study of art more generally could be put on the kind of systematic, scientific footing possible in numismatics: 'Class your specimens as a naturalist classes types: then you will be in a condition to state the characteristics of successive styles in clear concise formularies, and to recognise them everywhere in collections of sculpture, in spite of unscientific arrangement.'[17] And what was thus to be discovered in artefacts, for Newton, was the level of civilisation revealed in formal developments that could be seen in systematic arrays. This is the implication of the division of collections still overwhelmingly observed in art museums today, preserved as if in amber.

The nomenclature of art-historical taxonomy lacks the consistency of natural history classifications, and, as we saw, masks the extent of uncertainty in attribution, but still rather systematically sustains the distinction between the two models of creativity, romantic and generic. Not only that; another layer of meaning has become associated with the classification scheme, because of the way in which whilst associating value with both models, it privileges the authorial over the generic one. The authors – of paintings or sculpture as a rule – are distinguished by name where possible, qualified with 'school of', 'studio of', 'manner of', 'follower of', 'circle of', or, if all else fails, just 'school', as in 'French School'. Even multiples of works in this authorial category, 'variant', 'replica' or 'copy', are distinguished from true multiples, 'reproduction', 'print', 'photograph'. On the other hand a French work in the second category – usually decorative or non-Western art – will generally just be called 'French', unless a factory or firm can be specified. The identifications applied to artefacts in this category may, therefore, be geographical or specify a social or ethnic group, or

alternatively may specify period, but in either case the label usually implies a period and an ethnic group. Thus a raffia cloth described as 'Kuba', from a group in what is now Zaïre, will not date from earlier than 1800 or so (very rarely from before 1890), whereas 'Shang' characterises a bronze as Chinese, from the region of Anyang and of a dynasty some 3,000 years ago. All these labels, therefore, suggest both peoples and periods in whom creative genius reached a local peak, though of a secondary, pattern-following order, if not associated with named authors like those of the major Far-Eastern and Western fine arts.

The distinction of terms between the individually authorial and generic categories is not rigorous, any more than is the terminology within categories. Authorial attribution is not unknown in the decorative arts, and the term 'copy' can apply between categories too. A 'Victorian' object could equally be 'British, nineteenth-century', and the label might be applied to a low-grade decorative or fine art object. As to multiples, we speak of 'prints' and 'reproductions', but on the one hand whilst a print may be a reproduction, it may also be as unique as a monotype, and on the other a reproduction will usually be a print but could be a piece of furniture. However, although such terminology is a far cry from the disciplined species, families, orders and many other divisions of natural history, it tends to distinguish the categories that are distinctive because laden with assumptions, since most of the overlap between terms comes within categories. Thus, as we saw, a painting from the 'studio of' an artist might also be called 'circle of' or 'manner of', but one by a much later imitator might be called 'manner of' or 'follower of'. 'School of' could apply to any of them.[18] None of these would be applied to decorative art or non-Western artefacts. Hence the hierarchy of creativity established by the system, which it is hard to escape remarking closely reflects the political status of the originating societies and the social status of makers within them. The classifications to which works of art are attributed, therefore, may seem objective categories based on the essential nature of the objects, but in practice they are laden with assumptions.

Classification and the suppression of meaning

The critical tradition in which these conventions had become established by the end of the nineteenth century was formalist. In this tradition, the social connotations of the terminology of classification vanish in the implication that artistic development follows an inner logic, with the evolution of style as a kind of formal conversation between artists speaking across barriers of time and culture. Figure 27, a photograph of a cast gallery in Manchester's Whitworth Art Gallery early in the twentieth century, with the head of Michelangelo's *David* communing with his classical ancestors, all in ghostly white as if in some

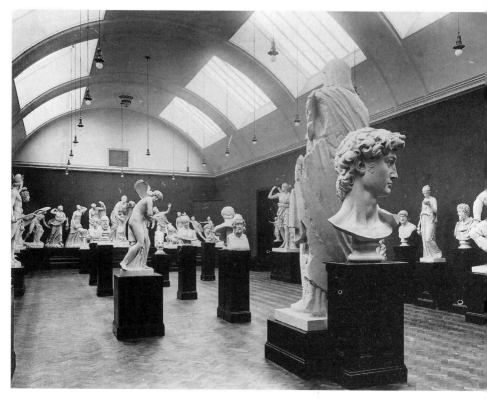

27 A gallery of casts in the Whitworth Institute in Manchester, early in the twentieth century

sculpture heaven, or perhaps limbo, makes the point. In an architectural history study of only a little earlier, Banister Fletcher's *History of architecture on the comparative method*, the diagrams, for example of the development of vaulting patterns in English Gothic in the fourteenth and fifteenth centuries as shown in figure 28, imply the same kind of point. Of this kind of evolution, the French art historian Henri Focillon wrote of 'a logical process . . . within the styles themselves.'[19]

In the way emphasised by those ghostly white casts, under that approach to art history all the complexity and variety of artefact production and meaning disappears within such a narrow set of assumptions. To see how narrow they are, let us start with the complexities of the production of artefacts, and contrast Focillon's view of geometric decoration with a more empirical one, a study of production by the Shipibo-Conibo, who live along the river Ucayali in eastern Peru. Their houses and textiles as well as pottery were, until a couple of generations ago, also often decorated with similar motifs, relating to sounds

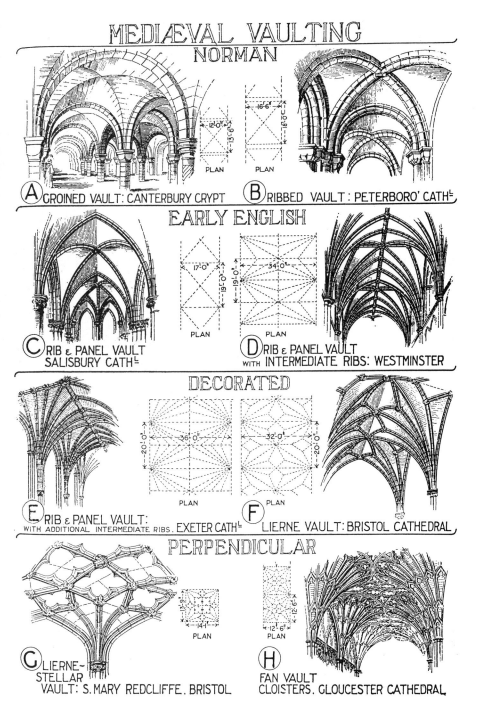

MEDIÆVAL VAULTING
NORMAN

A GROINED VAULT: CANTERBURY CRYPT

B RIBBED VAULT: PETERBORO' CATH^L

EARLY ENGLISH

C RIB & PANEL VAULT SALISBURY CATH^L

D RIB & PANEL VAULT WITH INTERMEDIATE RIBS: WESTMINSTER

DECORATED

E RIB & PANEL VAULT: WITH ADDITIONAL INTERMEDIATE RIBS. EXETER CATH^L

F LIERNE VAULT: BRISTOL CATHEDRAL

PERPENDICULAR

G LIERNE-STELLAR VAULT: S. MARY REDCLIFFE, BRISTOL

H FAN VAULT CLOISTERS, GLOUCESTER CATHEDRAL

28 A diagram of the development of mediaeval vaulting

and patterns experienced in hallucinatory states, and understood to express cosmological significance. The patterns also indicated the superiority of Shipibo-Conibo culture to that of dominated neighbouring groups, whom they forced to live further from the river, in the forests reaching to the foothills of the Andes. Now the pots are a focus of adjustment of the earlier patterns of life to a Western-style, commodity-based economy.

They are produced and decorated as they traditionally have been, by women, and production in one area was studied by Donald Lathrap in the 1960s. Diagrams of the patterns as pottery decoration can only hint both at the visual and social effect they must have had, and at the sensitivity to their nuances within the community, when they were applied to much of the visible surface in Shipibo-Conibo living space, in a way now visible only in older photographs. Lathrap found that the stylistic tone of each group of producers was typically set by a dominant matriarch, overseeing a family of junior producers. One of the most admired makers, however, Wasemea, moved from group to group, recruiting followers for her curvilinear innovations, including her sister Valentina (figure 29a). More typical were a family in the settlement

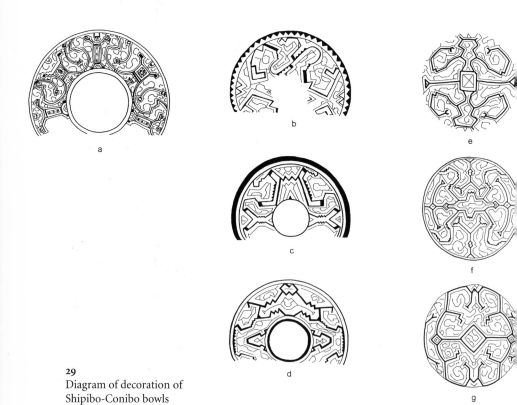

29
Diagram of decoration of
Shipibo-Conibo bowls

of Nuevo Destino, the elderly Antonita (figure 29b) presiding over the styles of her two adoptive daughters, Rosa (figure 29c) and the younger Ilsa (figure 29d). An even more dominant and coherent group, imitated by less specialised families, were presided over by Asunciana (figure 29e), her eldest daughter Ana (figure 29f) and younger daughter Jesusa (figure 29g), each developing a decidedly personal idiom. Somewhat out on a limb, though equally coherent as a family group, were the tightly knit Cruz family, Clara, Maria, Teolinda and Celia, perhaps because they had set themselves apart by a notably ostentatious adoption of Christianity.[20] Angelika Gebhart-Sayer, in a more recent study, notes how in older times two women might collaborate on one pot: 'They sat opposite each other, with the vessel between them, unable to see the other woman's half. By singing, they managed to tune into each other's mood to such an extent that they could paint two harmonizing and inter-relating design halves.'[21] The practice was known as the meeting of the souls. The conventional label 'Shipibo-Conibo' beside one of these pots in any museum display therefore masks a range of personal ability and invention quite as rich as that involved in the production of many 'higher-status' paintings of West or East, but also the way in which both personal and social identity are involved in the making and use of the pots.

On the other hand, production of authorial works in the West can be a much less individually creative business than is sometimes assumed. In the case of Rembrandt, for example, some scholars complain that production practices at the time make the effort to attribute individual authorship redundant. The question had become inescapable for the Rembrandt Research Project members by the time their second volume was going to press, given that, as the preface to that volume admits, at that period in Holland even the artists involved 'did not have over-strict ideas about whether products sold under their names were autograph or not'.[22] No one who has spent a few hours searching one of the major photo-archives of Western art, The Witt Library or the Marburg photo-archive, can fail to have been struck by the power of established pattern and convention underlying much of the apparent variety and invention of Western painting. Sometimes the evidence is explicit in the historical record. The day before pronouncing on attribution in the case of *Jendwine* v. *Slade* in July 1797, discussed in the last chapter, Joseph Farington noted in his diary, after a dinner at the home of the established portraitist Hoppner, that his host had 'a full tide of success. Has many copies to make – money witht. trouble – G assists him – very bad – Owen also assists him.'[23] Note that it seems to be G's incompetence that is bad, not the fact that Hoppner is using assistants to produce replicas.

Or consider the agonies of the printmaking and publishing communities of the early 1990s, as they wrestled with the status of the original in printmaking, under assault from the epidemic of publishing scandals associated with

Salvador Dali, on top of the challenges to traditional ideas of originality posed by such innovations as the role of photography in creative practice and postmodern notions generally. For most of 1992, readers of the spring edition of *Printmaking today* were assured, a British Standards Institute Fine Art Prints Committee was deliberating standardisation of terminology, taking into consideration the recommendations of the International Fine Print Dealers Association, so that 'we expect to publish the BSI document in our next issue'.[24] But it was not to be. The publishers and artists could not agree.[25] 'The issues seem more appropriate to a club of stamp-collectors than to the makers and consumers of a living visual culture', comments the author of an article in a later issue, deriding, amongst other things, lingering notions that 'the artist's personality (or soul or essence) is of interest to anyone (apart from those traders canny enough to commodify it)'.[26] The draft standards which emerged by mid-1995, some changes of committee membership later, wisely avoid any reference to originality, and just classify varieties of involvement of the artist in originating the printing matrix, the plate or block.[27] They do so in a sequence that implies ranking in the market, the greater the involvement of the artist the better, but they wisely side-step the issue of why this matters. The cult of the named maker has of course been the core of twentieth-century art history and art production too, but it does not in practice match very well the great variety of contributions that can be made by artists, assistants, friends, clients and agents in the production of art.

So much for the way that traditional classification masks the production of artefacts. What they mean for those who pay for or use them vanishes in studies focused on attribution too. Here is Josiah Wedgwood in the 1770s, writing to his business partner about a gratifying craze amongst buyers of his new line in vases in the antique style:

> there seemed to be a violent vase madness breaking out amongst them . . . This dis-
> order sh'd be cherish'd . . . We are looking over the English Peerage to find out lines
> channels and connections – will you look over the Irish Peerage with the same view
> – I need not tell you how much will depend on a proper and noble introduction . . .
> Lady Bingham fell violently in love with one of the new Tripods, a waster . . . said
> she sh'd die if she had not one of them . . . and as she had promised to be a good
> friend to us in Dublin I indulged her . . .[28]

Wedgwood was a pioneer in every aspect of the manufacture-based consumer market, an innovator in production and distribution, but an inspired manipulator of markets too. The classical styles he helped to introduce made the previous ornamentation of Rococo seem frivolous and old-fashioned. They were associated with enlightened democratic principles too, with reference to the imagined principles of republican antiquity, whereas Rococo was associated with the old aristocracy. This was just at the period when current notions of

authenticity were beginning to emerge, as a shield against the world that Wedgwood played no small role in ushering in. There is no hint of that in the twentieth-century collectors' literature on the minutiae of the stamps used by the firm, the roles of this or that designer in the applied-white figure work, and the extent of undercutting of its fine details, as the signs of authenticity to look for in Wedgwood blue and white jasper ware.

Meaning and the suppression of the author

On the other hand, some art historians who focus upon the meaning of artworks are no less adept as conjurors, except that with them it is the creative artist as author who disappears. For some critical theorists, even the kind of social contextualisation suggested by the example of Wedgwood as an explanation of artworks imposes limitations on the nature of the object, by locating it in a settled context and set of meanings through an ostensibly objective narrative, instead of opening up the artefact to a dialogue revealing of both object and commentator.[29] This is best seen if the visual elements of pictures are understood as comprising something like a language. Faces are quintessentially sites of visual meaning, and a very early hint of analogies between visual and verbal components of meaning in faces was offered in 1768 in an unusual study of physiognomy by a passionate lover of systems, Alexander Cozens. His idea is suggested in figures 30–32. For every facial feature Cozens illustrates comprehensive tables of numbered variations, from which combinations can then be selected to compose faces expressive of different characters, if Cozens is to be believed. So the 'majestic' profile in figure 31 is composed of forehead variation no. 1, nose no. 5, chin no. 2, mouth number 4, and so forth.

Cozens himself certainly saw this scheme as a revelation of settled meanings. He first establishes the combination of features he considers characteristic of simple beauty, the ideal profile. Combinations that deviate just a little then characterise a set of still noble 'characters or impressions of the mind,' like variations on a musical theme.[30] If, however, Cozens's confidence in the absolute character of his basic set of features is abandoned, the way in which the meaning of the profiles varies may be better understood with reference to language. The profile is then like a sentence, with the features as words. There are rules for what kind of word – what feature in this case – can go where, and the meanings Cozens attributes to combinations arise not so much from properties inherent in each feature, but instead first from differences between the features within one class of features, eyebrows for example. Thus serpentine eyebrows seem to characterise the more emotional characters, whereas regular curvature appears more the ticket, if steadiness is what you are after. However, in each case, as with words, the larger meanings, such as 'Majesty' (figure 31), or 'Melancholy' (figure 32) in Cozens's study, only emerge from combinations

30 Composite plate of noses and mouths, from Alexander Cozens, *Principles of beauty relative to the human head*

of features in whole profiles. Note the baldness of these figures too. To add even more varieties of combination, Cozens provided a small number of hairpieces, printed on tissue-paper and only loosely interleaved when the books were first issued, so that readers could try for themselves their transforming effect on the characters.

Cozens did not, perhaps mercifully, try to systematise just what the various hairstyles add, but he was, of course, quite right that hairstyles, clothes, furnishings, gestures, the elements of landscapes or other features in pictures and, in due course, the objects we choose to assemble in a museum display, indeed any set of cultural images or objects, aquire much of their meaning in relation to one another in a systematic way. When we choose what clothes to wear, or what objects to include in a room, not just on practical grounds, but also with an eye to what is appropriate or effective for a social context, we are composing signals. How the elements we choose combine into messages has been at the heart of postmodernist study in humanities criticism and anthropology, but requires an understanding of verbal language in much greater depth than was available in Cozens's day.

A striking feature of twentieth-century studies of language is one shared with many other aspects of twentieth-century thought, a distinction between

31, 32 'Majesty' and 'Melancholy', plates from Alexander Cozens, *Principles of beauty relative to the human head*

what is apparent in everyday exchanges, and invisible deeper levels of rules and meanings. In a number of cases, this distinction has been enshrined in key terminology. In linguistics it was expressed at the turn of the century in the difference established by the Swiss Ferdinand de Saussure between the hidden grammatical and semantic rules of *langue,* roughly 'language', and *parole,* roughly 'speech'. An analogous, though not identical difference is sustained in the more recent distinction of Noam Chomsky between the *competence* of speakers in the essential structures of language, and their *performance* in actually uttering it. Even in the nineteenth century, however, Karl Marx understood everyday transactions much more generally as comprising a social *superstructure,* formed by an invisible *substructure* of social and economic relations. Sigmund Freud, of course, contributed a clear statement of the distinction emerging at the same time between the *unconscious* and *conscious* minds. From the 1940s the structuralist anthropologist Claude Lévi-Strauss, though for once without a helpful pair of key terms, analysed social life in terms of deep structure inherent in kin relationships, and its superficial expression in the narratives of myths, the forms of artefacts, the layout of villages and behaviour.

In each of these schemes, whatever we make, do or say in everyday life, for example in announcing the type of jacket we plan to wear for some special occasion, may seem to be determined by practical considerations, but in practice is a clue to deep structures, psychic, social or linguistic. The choice of jacket on its own, however, will not reveal much, any more than one of the numbered eyebrows in Cozens's scheme taken in isolation. It is only when the choice of jacket as a commodity, as an item in an outfit as a whole, or just as a word in a sentence, is analysed that the deep structures may be understood, whether of psyche, social role or language.

When cultures and their artefacts are understood from the viewpoint of one of these schemes, the first casualty (except under the Freudian scheme) is any exalted role for the individual as creator. The point is that the individual can exercise choice only at the superficial, everyday level of meaning, not where it matters, at deeper levels. Roland Barthes, for example, suggests an analogy between, on the one hand, the deep structures of language and the limited repertoire of basic plots and conventions that seem to underlie the apparent variety of literary narratives, and, on the other, Chomsky's idea of *performance* and the particular narratives that authors contrive. A crude example of what Barthes had in mind is offered by the computer programmes now available, which provide for aspiring authors menus of possible developments out of which to construct an overall plot. The idea is only possible because of an understanding that all the twists and turns of adventure and plot that we are accustomed to in stories are only variations on quite a small repertoire of basic situations. Plot was only one of the aspects of narrative that

Barthes suggested offered deep structure of this kind, but it serves to make the point.[31] Performance of music rather than language offers a rough analogy. The author, artist or composer, as much as the player, is only like a performer within a musical tradition, not perhaps one as restricted in choice as the performer of Western classical music, and so one free to improvise as in jazz or Indian music, but by no means a creative genius. Nor can this point of view accommodate attribution to a national or ethnic group, even less attribution to individuals, as an explanation of artefacts, as long as it implies that cultural forms evolve in a formalist way, independently of the deep structures of social life.

Traditional explanations of artefacts in terms of authorial or ethnic attribution are also incompatible with more recent, poststructuralist trends in criticism. In a number of these trends there is still awareness that there are levels to meaning, but the fixed deep structures of Marxism, or of Lévi-Straussian structuralism, have been abandoned. Those approaches aspired to reveal the 'true' deep meanings, only hinted at in the clues of everyday transactions. No fixed meanings at all are sought in poststructuralist criticism. What is emphasised instead is how the play of meaning is produced by a constant feedback between the meaning that objects, words or actions carry in different layers, which are not constant at all. This process, and in particular the way in which the conventions of museums contribute to it, has been lucidly explored in detail by Sue Pearce for museum objects in general, including works of art.[32] My account is an attempt at an extremely compressed hint at it, and is best illustrated by an example. A palpable one is at hand, in the cultural production perhaps more directly than any other associated with visual creativity, heavy expressive impasto in oil paint.

Hieronymus Bosch, at the start of the sixteenth century, was one of the first in the North to abandon the smooth painting style of his predecessors, in which the marks of every brushstroke are effaced. The immediate meaning of these textures in his pictures, their role in the painterly *parole* of their day, lies in their contribution to the vividly illusionistic representation of things. But that is not, of course, all they mean. As Helmut Ruhemann, the National Gallery's Chief Conservator for many years, noted, this impasto also asserts Bosch's 'vigorous personality, and deliberately leaves the traces of most expressive "handwriting" crisp and unblurred'.[33] Within a generation this kind of thick paintwork, adopted, of course, by a number of artists besides Bosch because of its immediate visual effectiveness, became a sign of individual creativity, a feature of those flourishes, it will be recalled, in which connoisseurs from the seventeenth century to Laurie discovered signs of genius. The individual, handwriting-like impasto that appears in Laurie's photographs in figures 6–8 is no longer just an effective gesture in painterly *parole*, but has become part of the artistic *langue* of the seventeenth century. But at this point

something remarkable has happened. It was no longer understood, even in the seventeenth century, just as representation, but, as we saw, had become explicitly recognised as a sign of individuality. In other words, a meaning at first established only in the deeper level, of connotation, has been brought up into everyday painterly usage.

This kind of exchange, whereby what is at first only implied becomes immediate meaning, is understood by semioticians (students of signs) as a continuous process. In the case of impasto, the mere individuality that impasto was understood to stand for by the seventeenth century aquired connotations of emotional range and of personal authenticity, which in turn surfaced in the everyday language of paint as the 'expressive paintwork' of subsequent centuries, with the ever-more exaggerated impasto of a van Gogh, a Vlaminck, a Schnabel. Meanwhile the implications of 'inexpressive' linework, such as that chosen by Cozens for the documentary prints in figures 30–32, also change, thanks to the contrast it offers with expressive paintwork. In this way whole systems of significance build up, in a constant feedback between layers of meaning. In the process, the role of the individual creative personality supposedly revealed in the paintwork can come to seem only a play upon convention. The creative author is banished from the process of production, but that is not all. In the play of signs, any original meaning intended by the author, or understood by others at the time of production, also rapidly transforms for later interpreters. At least in the face of this onslaught the artist as author was allowed to expire quietly, in Barthes's famous notion of the death of the author. At the hands of Rosalind Krauss, introducing a collection of seminar papers on the status of copies, the poor artist actually explodes, in 'the atomization of the author into a social or religious practice, in which neither authorship, nor originality, have any function'.[34]

The death of the author is, in fact, by no means as recent an event as is sometimes supposed, being no less a feature of the extreme school of formalism that developed in Russia in the 1920s, and that proved suggestive for later structuralists. As early as 1923 the Russian critic Osip Brik declared that had Pushkin never lived, *Eugene Onegin* would still have been written.[35] Such an extravagant claim needs to be understood as a reaction against a tradition that explained the work solely in terms of an obsessive attention to the details of the author's biography, and the same is surely true of the later postmodern suppression of authors. In the tradition of art history that art museums reflect, as Mieke Bal and Norman Bryson put it, in a helpful survey of semiotic approaches, the 'whole purpose of art historical narration is to merge the authorised corpus and its producer into a single entity . . . in which the rhetorical figure of author = corpus governs the narration down to its finest details'.[36] That again sounds a bit abstract, but when Morelli describes the early sixteenth-century painter Cosimo Tura as 'rugged, knarled and angular, but

rather grand', it comes to life. Whatever is Morelli talking about? A particular painting? Tura himself? The description is of an odd mental composite of the man and the work. Berenson hits the same note in a more concrete way with the suggestion in his book on Lorenzo Lotto that for any Italian master, the art historian can often find, somewhere in his work, a particular face that is not a self-portrait, but which perfectly expresses the artistic personality of the painter.[37]

Are clues evidence or signs of authenticity?

Earlier art history was not in practice always quite so limited. The way in which artefacts are unquestionably illuminated when seen as part of systems of signs and meanings is indeed a recent revelation, but earlier art history, for all its emphasis on attribution, still often offers detailed discussions of the variability of patterns of production, of the role of patrons and audiences, of the social dimension of artworks, of the way that the whole business of art history is interpretative. It is more that the conventions of traditional art history suggest an authority and objectivity that many practitioners, at least, knew to be a fiction, and that the awareness of the complexity of art as a social phenomenon is not systematically theorised in earlier studies. However, there has been an undeniable tendency for these aspects of art history to be pushed into the background, leaving in the foreground of discussion an emphasis on technical and stylistic clues to attribution, like those discussed in the previous three chapters. Hence the current tendency for polarisation in art history. To some art historians all the technical evidence makes for an objective account of the production of art in the past. For others, all these clues are themselves merely signs of ideology-laden notions of authenticity.

It was first pointed out in an essay by Carlo Ginzburg that focusing upon clues of this kind reveals more than just data about attribution. He noted that Arthur Conan-Doyle, who as the inventor of Sherlock Holmes is Mr Clue himself if anyone is, was trained as a doctor. So too, he goes on, were both Freud and Morelli. All three, therefore, were trained in the inference of pathology from symptoms. In transferring that kind of expertise to art history, psychotherapy and criminal detection, what all three were doing, Ginzburg proposed, was to systematise in prestige fields of knowledge the kind of inference from clues that from time immemorial has characterised popular knowledge, for example in the conjectural interpretation of clues by hunters. That kind of popular, intuitive process stands in contrast to earlier higher-status philosophical and scientific models of inference, which worked not from observation but from accepted principle. Ginzburg's thesis was that the appropriation, into the prestige disciplines of the dominant class, of popular modes of conjecture has to be understood politically, eventually culminating in the use of clues to

individual identity, for example in handwriting and fingerprints, as tools of social control.

If we wanted to extend this, we might note how the application of the appropriated knowledge in authenticating the artistic canon has indeed contributed to social control, as we saw in comparing the roles of museum and Church authorities in chapter 1. Nor could it pass un-noticed by anyone emphasising this aspect of museums that the Grande Galerie of the Louvre, the most influential of all the pioneering sites for display of the artistic canon at the end of the eighteenth century, had earlier housed a military archive of giant strategic models of the 127 key fortified towns and harbours of France, closed to general access in the more naked power conventions of the *ancien régime.* Creativity, on this account, becomes not only an alternative kind of credit, as suggested earlier in this chapter, but a substitute for gunpowder too, in cannons of the latest kind.[38]

Ginzburg's account of clues, in terms of class conflict, does not exhaust what clues have come to mean. We noted earlier how the meaning of impasto evolved over time, and impasto is just one of the clues that we are now considering more generally. The clues that were at first effective in some local context, as evidence of an individual, or of an aspect of the history of an object, can also be understood as having entered the *langue* of art history. What has happened within art history is that the clues that were at first indications of authorship came later to stand for outstanding creativity, and finally for the prevailing notion of authenticity itself.

If that sounds like mere wordplay, consider how feedback from the process of study generates authenticity signalled by clues in the development of the set of collecting practices which saw the Olde Curiosity Shoppe of the age of Dickens become the modern antique shop. All the roles in the cycle of exchange in which value becomes attributed to objects, described in chapter 1, are in evidence, including museums. The process has been chronicled by Stefan Muthesias.[39] First the critics – Ruskin and Morris most famously, but many others too – called for alternatives to the elaborate and mechanised ornament of manufactured furnishings of the mid-nineteenth century. Buyers then expressed their preference, from the 1870s, first for English farmhouse furniture, then for the more elegant productions of eighteenth-century English cabinet-makers, then for old English earthenware rather than porcelain, and so forth. Finally the dealers caught up with the trend, lagging, surprisingly, after the amateur collectors. The first 'Antique furniture dealer' appears in London directories in 1826, and they only replace 'curiosity shops' by the 1870s; by the end of the century there were some 200 'antique dealers'. Historians and museums play their part too, with more domestic material on display, and with the publication of Hungerford Pollen's *Antique and modern furniture and woodwork in the South Kensington Museum* in 1874.[40]

Of course, as a part of the process, as Muthesias explains, notions of just what about old artefacts was authentic changed. The emphasis at first was on imitation. Up to 1870 or so, faithful reflection of designs recorded in reference books was the important thing, the sign to look for. There was a great deal of reproduction in this spirit across Europe by the mid-nineteenth century, and it continues to this day. Thus, thanks to the involvement of Hoechst in porcelain manufacture, we read in a recent advertisement, 'in the Hoechst Porcelain factory today once again artists are at work, making and painting by hand figures, bowls and vases, true to the patterns of the eighteenth century'.[41]

However, by the 1870s, Muthesius suggests, this importance of faithfulness to a pattern was being supplanted, as the key indicator of authenticity, by concern that the actual fabric of the piece should present clues that reflect its age. This, therefore, set the agenda for producers of more expensive authentic imitations, their craft happily signalled by the appearance in the London directories in the 1880s of a category of 'Antique Furniture Makers'.[42] By 1906 the author of one of the many books for collectors beginning to appear warns of signs of spurious authenticity so institutionalised that a woman appearing in court could give her husband's occupation as 'worm-eater'.[43] Little did Sherlock Holmes and Dr Watson suspect, if we are to believe another writer for collectors, that even as they followed clues to crime through the swirling fogs of London's docklands, within the damp, looming warehouses, other clues were maturing, to authenticity this time, and in the form of spurious patina on imitation eighteenth-century furniture.[44]

Miles Orvell describes a very similar process in America, where a reaction against imitation generated an emphasis on authenticity and the 'real thing', first in a revival of interest in vernacular artefacts, like that described for the UK by Muthesius, later extending into the culture of commodities very generally.[45] Clues can get equal billing with content in reproductions made in perfect good faith. If that sounds like an exaggeration, an example immediately to hand illustrates how what museums do trickles down into the market-place, to the extent that the validation of canonical texts, themselves the guarantors of social values, has become removed from the actual content, and appears instead even in reproduced signs of authenticity. Through my letter-box comes a circular for the Millennium Edition of the Harvard Classics. The contents 'represent timeless tradition. They consist of more than 2,000 years of the greatest works, by the finest, most imaginative and most inspired writers who ever lived. Homer. Dante. Shakespeare . . .'. This new edition is, of course, only the latest in a long sequence from an imaginative and generous-spirited nineteenth-century project. But now the interesting thing is the emphasis on the need for the edition 'during a time when formal education has tended to become specialised and narrow . . . losing touch with traditions and values'. At

such a time, what is needed, it seems, is not only the content (no doubt readily available now in paperback). What is needed is '*An authentic re-creation of the original leather edition!*' (emphasis in original). It will be available in 'the original leather binding design, the original size, the original illustrations . . .'. There is even a bit of reassuring technical data: 'The spine of each volume is graced with raised rings – called "hubs" – and accented with precious 22 kt gold.' This is what the practices of art history come to mean, whether art historians intend it or not.

In a culture in which technical details have aquired these connotations, they can never retrieve, if they ever enjoyed it, an age of innocence as mere indicators of correct attribution. The war of clues between art historian and forger is not just a question of art-historical G-men battling the bad guys, but a team effort, in which the forger is just as much a contributor as the art historian to the notion of authenticity and its complex of associations. In the process the museum plays a role not as the site of scientific truth, but as a hall of mirrors. For the makers of the 1992 Nova television documentary *The fine art of faking it* Christian Goler, the Bavarian maker of a painting of *St Catherine* in the manner of the sixteenth-century German painter Grünewald, which the Cleveland Museum of Art in Ohio bought as an original for a million dollars in 1974, made a replica of his replica, showing just how the all-important age craquelure was achieved.[46] It is hard to get right on panel, and so the painting is first done on canvas, then, with the canvas loose off its stretcher, strained over the edge of a table to get the cracks along the grain. A pencil pushed into the back of the canvas, finally, induces shorter, transverse cracks. Next comes the clever bit, as the painting is transferred from canvas to a more convincing panel. Goler takes a leaf out of the restorer's book in the form of a two-and-a-half-century-old technique in which, with the painting face-down, an old panel can be ground away, to leave just the paint film and ground, on to which, once prepared with adhesive, a new support (panel or canvas) is lowered. However, in Goler's demonstration the usual process is reversed, with the conveniently stressable canvas now removed, and in its place an old panel is secured to the paint film. Many traditional methods of generating craquelure clues are less elaborate. Robert Moore, reported as the source of numerous nineteenth-century ship paintings making their way through the UK market in the 1980s, explained to the art journalist Geraldine Norman how he obtained a convincing craquelure, and also anticipated tests with simple solvents with a thin layer of water glue size, cracked by treatment after drying with a hair-drier. 'That's the normal way of doing it, I think.'[47]

The most obvious signs are signatures and stamps. Those used to mark works in the estates of some nineteenth-century French painters are a notable minefield. The confusion surrounding the Delacroix estate, described by Susan Strauber, is so exemplary that it is worth quoting:

The confusion begins with Lugt's widely consulted original volume of 1921, which reproduces as the illustration of the authentic estate stamp . . . the diagram Lugt subsequently identified as the false 'Andrieu' stamp. . . . The second complication derives from Lugt's inclusion of a diagram of a second false mark. . . . However, the precise morphology of the two stamps remains subject to . . . clarification . . . indeterminacy . . . is exacerbated by the fact that false stamp impressions do not always correspond precisely to Lugt's two diagrams of imitation stamps . . .[48]

Since, as Strauber points out, the Andrieu mentioned is known to have stamped at least some of his own drawings as Delacroix's, and later forgeries were also stamped, the Delacroix estate stamp becomes more a sign of the problems of the process of identification than of authenticity.

Even the clues in the supposedly independent historical record become a covert battleground. Charles Stuckey has recounted the mysterious history of a collection of photographs made for the record of paintings remaining in Manet's studio some months after the painter's death in 1883. Manet himself very frequently made changes to paintings he had not sold, and some of his heirs and their dealers, it seems, kept the tradition alive, to ginger up for the market paintings left unfinished on his death. One of his widow Suzanne's brothers, and her nephew, were accomplished pasticheurs of his style. The chances of sorting out all the changes, whether Manet's or posthumous, are reduced by doubts about the status of the photo-archive. It was apparently put in order for the artist's widow Suzanne by 1899, by the dealers Bernheim Jeune et Fils. The photo-archive that now survives is not numbered as the original photographs were supposed to be, omits paintings inventoried as in the estate, and includes others known not to have been in the estate. Stuckey chronicles an instance of the repainting of a picture which Suzanne had, before the repaint, been persuaded to sign on the back as her late husband's work, with a substitution in the photographic record for good measure, to leave an image of the finished painting for the independent record. As it happens, the conspirators in this case could not eliminate enough independent record to elude Stuckey's virtuoso sleuthing. A negative remains, of the painting as unfinished at the artist's death, and his 19-year-old niece Julie, the daughter of Berthe Morisot, left an outraged account of what she knew of the business. Her aunt, the teenage Julie confided to the diary, was unmoved: 'she is very calm and says that it is always like this with the sketches; it's true that her own brother repainted several of my uncle's pictures . . .'[49]

Successful artists are geese that lay golden eggs for their heirs, and polishing up leftovers with a perfect provenance, like the ones left in the Manet nest, has helped dry the tears of the heirs in plenty of other artistic families. The right family connections offer the ideal route to faking convincing provenance, but all is not lost if they are not available. When Anthony Conduct took to faking the works of Peploe and other Scottish colourists in 1981, he

took the precaution of borrowing 3,000 labels and 5 record books from the Scottish Gallery in Edinburgh, dealers who had acted for such artists for decades, so that his pastiches could carry labels and stock numbers to correspond with their subjects.[50] In the early summer of 1996 the story broke of the way in which someone, taking advantage of lightly supervised access to archive sources in the libraries of the Tate Gallery and the Victoria & Albert Museum, had allegedly tampered with records to ease the market acceptance of spurious works attributed to Ben Nicholson, Giacometti and others.[51]

The way that the obsessive concern with clues turns in upon itself mirrors a more general sense in which over the course of history forgery has been not so much policed and exposed by growing expertise in authenticity, but generated. The scholarship of authenticity finally swallows its own tail in the generation of fake scholarship. At this point museum work joins a venerable tradition. Anthony Grafton has shown how this kind of self-reference was an integral part of the ancient tradition of textual criticism, but it comes into its own with the textual recovery of authorial authenticity from the sixteenth century. The great Renaissance scholar Erasmus, for example, whose life's work was the recovery of the authenticity and authority of ancient texts, seems to have gone a touch further, adding an invention of his own to the fourth of his editions of the works of St Cyprian; a *Treatise on the two forms of martyrdom.* The text expounded a cause in which Erasmus passionately believed, that everyday virtue counts for as much as spectacular martyrdom.[52] In the end, fashions in forgery are not only the best indicator of the ideologies which may be hidden in the supposedly objective methods of criticism, but forgers as much as the authors they forge come to set the agenda for critical debate. As soon as museums become recognised sites of authorial authenticity, they become sites of forgery in scholarship too. Malice, it seems, may have been behind the allegation of forgery of a definitive nineteenth-century Shakespeare text by John Payne Collier, if we accept that he was framed by his enemy, Sir Frederick Madden of the British Museum.[53] In our own century the Bodleian Library seems to have received many spurious as well as many authentic manuscripts from the Chinese scholar and adventurer Sir Edmund Backhouse.[54] London's Natural History Museum has been particularly unlucky. The famous Piltdown forgery now seems to have arisen out of mere resentment over a refused pay enhancement in the museum. Rather more glamorously and insidiously, an initially wise decision to keep the specimens of the ornithologist and alarmingly violent secret agent Richard Meinerzhagen separately from the museum's authoritative collections was unfortunately forgotten over the years. Now painstaking researchers are sorting out the confusions introduced into avian taxonomy by his mislabelling of his own specimens, and, it seems, others which he stole from the many museum collections to which he was given access.[55]

In the world of fine and decorative art, the amounts of money at stake have

fostered an impressive tradition for art historians and knowledgeable dealers, with reputations as gamekeepers in the market, to turn poachers. They mingle outright fakes, and pieces over-restored and made up from fragments, with the more authentic examples which they handle. The eighteenth-century trade in classical sculpture was notorious, but there are many less well-known examples, like Leopoldo Franciolini, the turn-of-the-century Florentine musical instrument dealer.[56] The best-known partnership in this tradition was that between the dealer Joseph Duveen and the scholar Berenson. Berenson unquestionably set new standards for connoisseurship in art history, but his insistence on a hidden financial interest in any painting on the market on which he gave an opinion was notorious in the trade. It seems to have resulted, at the very least, in support for over-restored paintings, and may have extended to forgery and smuggling. The case for the latter has been advanced by the ex-*Sunday Times Insight* journalist Colin Simpson, but is vulnerable because the evidence on which his claims are based has not been cited, according to him because of disputes with the controllers of the Berenson archives. As a result his allegations were roundly dismissed in a review by Sir John Pope-Hennessy, who had known many of those involved for decades, but at the very least it seems clear that Berenson's opinions became distorted into misrepresentation by the time they got to market.[57] There are doubts too about the extent to which the suspiciously vacillating van Gogh attributions of Bart de la Faille were independent of the powerful collectors whom he allowed to finance his lavish catalogues.[58]

It would all have been old hat 500 years earlier, in the art market of Ming dynasty China. There was little shame on the scholar who cheated, even less pity for the buyer who was duped. The distinction was not so much between authentic, restored and forged works, as between true scholars, amateurs and downright dupes. The colophons, or certificates of scholarly opinion of authenticity customarily attached to works were often removed and attached to lesser works. The noted connoisseur and market operator Zhang Jingfang reckoned that only one in ten of the later sixteenth-century paintings sold were genuine. Shen Defu mentions that scholars could not have survived without forgery.[59]

The most vivid picture of an art market of this kind, and of the role in it of the expert and the museum, is offered by the saga of the anarchist and frontman for forgers, Luigi Parmiggiani, alias Louis Marcy, alias Luigi Parmeggiani, now the subject of sustained study by Marion Campbell and Claude Blair.[60] Marcy started out taking rough jobs, including circus work, but seems to have made connections with both anarchist and forgery circles by 1890. Before the end of the nineteenth century he had made a number of spectacular sales of forged mediaeval works of art, amongst others the sales to the Victoria & Albert Museum which helped precipitate the 1897 select committee

inquiry, as well as to the British Museum. He rapidly became notorious in the museum world, yet still operated as a knowledgeable dealer. The view he gives us, looking at the market from the underside up, as it were, is contained in a journal which he produced in Paris between 1907 and 1914, *Le Connaisseur*. Marcy's Paris is hardly typical. It was a high spot of so much forgery that just taking the wrong accommodation could mean joining a gang, as the play-wright Strindberg found he had inadvertently done, when he sociably joined in a bit of painting with his fellow-lodgers in Versailles, before noticing that they were a rather alarming bunch of forgers.[61] Marcy was born for it.

'We are asked why we, who are art dealers, have declared war to the death against certain of our colleagues,' we read, 'perhaps because of concurrence?' No, the editor explains, the House of Marcy has no tolerance for this 'metier of pirates'.[62] The House of Marcy, he insists, 'possesses and displays only pieces of which it is absolutely sure'. No doubt true, since he does not specify whether his certainty was of the authenticity or spuriousness of his pieces. He repeat-edly vows war on both experts and museums, since 'an erroneous attribution is terribly dangerous in a museum . . . in the sense that it falsifies the very prin-ciple of instruction which whoever studies expects of it'.[63] A bit rich, consider-ing that Marcy had notoriously sold forgeries to both the British and South Kensington Museums, but his contempt for his fellow-dealers, experts and museum curators was no doubt the one genuine thing about him. He offers to give 10,000 francs to the poor if there is one expert in Paris capable of correctly identifying a dozen objects to be selected from the collections of the Louvre and Cluny. He repeatedly comes up with anecdotes to demonstrate that the major museum officials are mere ciphers in the hands of his arch-enemies, the dealers Jacob Seligman, Joseph Duveen and Hans Sedelmayer. There are numerous colourful tales, some true, some probably not. The tarnish upon the names of Seligman, Duveen and Sedelmayer is by no means only down to Marcy. A report of a row over the credit due to the miniaturist van Driesten for an exhibition about the Order of the Golden Fleece in Bruges in 1907[64] seems quite accurate. So too is a report of the case of *Donaldson* v. *Temple*, mentioned above.[65]

Truth, however, seems thinly scattered in fantasy, as the journal mirrors the confusion of fake and genuine in the market. Perhaps the point was to sow confusion. Amongst supposed forgeries in the Louvre, to which Marcy returns more than once, are a hand reliquary from the collection of Spitzer, and a thir-teenth-century reliquary of St Francis. These are readily identifiable, according to Elisabeth Taburet-Delahaye, currently head of the department of objets d'art at the Louvre,[66] and are outstanding, authentic pieces, the arm reliquary of St Louis of Toulouse described in a recent account as amongst the most impor-tant pieces of mediaeval art in the Louvre.[67] Marcy insists they are bogus, cun-ningly adding that only a sun and moon engraved on the St Francis reliquary

distinguish it from the original, in the cathedral of Majorca.[68] In fact this seems to be just where the Louvre piece came from.[69] Also, although the Louvre reliquary is apparently in its original condition, another quite similar reliquary in the Musée de Cluny has indeed had additions made, and did indeed come from the collection of Spitzer.[70] We now know Spitzer was a crook, as well as a major collector, associated with forgery workshops in Aachen. No wonder Mme Taburet-Delahaye warns, in the foreword of a catalogue to the Musée de Cluny collections, that 'Like all collections formed principally in the nineteenth century, those of the Musée de Cluny include items whose authenticity must be in doubt', and that these include transformed pieces, as well as imitations made in good faith, besides outright forgeries.[71]

The Connaisseur eventually tails off into near madness, with a final edition in Italian instead of French, edited by Marcy, now using a newly spelled version of his original Italian name. We read in it of attempted assassinations in London, of the death of an enemy choking on his throat cancer. Perhaps Marcy was not a very nice man. He continued to deal and collect in Italy, however, and crowned his career by selling his collection to the municipality of Reggio Emilia as a museum, with himself installed as curator. The Galleria Parmeggiani still exists, and labels have only been added to identify some mis-attributions in recent years. Of course, all of this is not typical of the art market as a whole, but represents an enduring component of it. Even Marcy's achievement in crowning a career in the market with the establishment of a museum displaying mis-attributions and authentic works together has, it is said, been repeated in recent years, with the opening to the public in Zagreb of the collections of the dealer Ante Topic Mimara.[72]

Mapping as a metaphor for attribution

In spite of all this, it would be eccentric not to recognise any value in the large volume of painstaking work that has been going on over the last century, in successfully tracing the origins of objects. Projects like the one devoted to Rembrandt, for all the mythology involved, are part of a much longer process which has established a host of points of reference for the study of art history. As James Fenton reminds us in a recent review of a definitive Pisanello show, Leonardo was until recently credited with work now understood to date from the early fifteenth to the late seventeenth century, amongst it much of the work of Pisanello, now itself more reliably sourced.[73] Is all this a waste of time?

An example which might stand for hosts of others is an image of an ancient astronomer reaching the edge of the world and peering into the heavens beyond, reproduced in figure 33. During the 1970s and 1980s it was repeatedly chosen by picture-editors and authors, often as little more than a signifying ornament, for popular articles and books about the new cosmology emerging

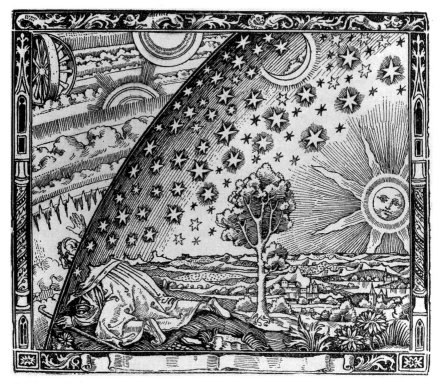

33 'The explorer at the world's edge'

from the conjunction of astronomy, mathematics and particle physics at the time, such as Fred Hoyle's book on *Astronomy and cosmology* in 1977.[74] It turned up in a number of *New scientist* news reports on such topics and on the covers of popular mathematics books. Why such an image has such a compelling role in these contexts – and why it has vanished from them in the mid-1990s – is a fascinating issue. But this is only the latest episode in the social life of an astonishing picture. In all it has been reproduced hundreds of times, until the 1960s usually identified as a German print of the sixteenth century. It is easy to see why, if the trees in figure 33 are compared with the one in figure 11. Joseph Needham cites it, so identified, as evidence of European ideas of sixteenth-century cosmology for comparison with Chinese notions of the period, in his huge study of science and civilisation in China.[75] But then Bruno Weber established that the source of the image seems to be a nineteenth-century work of popular science[76] by the astronomer Camille Flammarion.[77] Flammarion's pioneering books, published in editions of hundreds of thousands, included innovative use of illustration, but in a convention which did not discriminate between period and reconstructed imagery.

The drawing is quite possibly Flammarion's own. In his version, it has a border, which is also less convincingly reminiscent of the sixteenth century, though of Venetian or Florentine book-illustration, rather than German, but the border has usually been left out in reproduction. The ensemble is instantly anomalous, and parts of the linework (notably the dotted hatching in the extreme lower left) would have been impossible in the technique of sixteenth-century woodcut. But once the image was identified thanks to clues of this kind, it was not just Flammarion as its author that was established. If this object is to be understood not just as evidence of Flammarion's creativity, but as one that buts compulsively into visual conversation decade after decade, its status as a re-presentation of sixteenth-century conventions, as an example of attitudes to authenticity in the nineteenth century, thanks to its inauthentically authentic border, and as an image that in some way has become quintessentially a sign of cosmology (but preferably shorn of its border) then Bruno Weber's researches were indispensable.

An initial reading of postmodern criticism, especially in its extreme form, of Derrida or of strictly semiotic art history, can give the impression that the retreat from the aspiration to objectivity in interpretation implies that there is no such thing as accuracy in reference to record, indeed no historical record at all. So a hasty reader might interpret a sentence from Keith Moxey, especially one lifted from context: 'In the light of Derrida, it becomes impossible to subscribe to the view that any historical interpretations are endowed with truth value . . .'.[78] But the emphasis here is on interpretations. Later in the same book Moxey frequently refers to the archive record, to Hieronymus Bosch's tax records,[79] for example. He even remarks that 'The alleged madness of Van Gogh . . . flies in the face of the historical evidence.' The point which Moxey stresses is that correspondence with the record of the kind he cites in relation to van Gogh does not make his account true, a transparent representation of what happened in the past. So far, any thoughtful historian, even of the most positivist persuasion, would agree. Moxey goes much further, rejecting truth-value in historical texts at all, and insisting on reflexive reference to the commentator's own culture, but the historical record remains a key to the changing contexts in which the play of the signs produces meaning. Semioticians, like any student, of history, do depend on the keepers of the archive keeping as well the record of identification of what they have.

On the other hand, scholars of art, as much as natural historians, are missing a point if they do not understand that their identifications do imply theoretical positions, that identifications just don't come unpackaged. What curators are doing is somewhat analogous to making a political map. On the one hand, the map may be based on painstaking technical work, so that it corresponds to the landforms represented, and in this sense is either right or wrong. On the other hand, even the most reliable map is by no means a transparent representation

of the landscape. It is selective, in the level of resolution chosen and in just what it is about the landscape that is recorded on the map, and it is conventional in the graphic forms it uses. Michael Baxandall suggests, in a discussion of explanatory strategies available in approaching a painting by Piero della Francesca, that any explanatory scheme for a work of art of a remote culture is map-like in this sense, of correspondence with the object and archive on the one hand, selectivity and representation in our own terms, inevitably, on the other.[80] The thing that can be hard to accept, for curators or art historians conscientiously working away, and happy enough to think of themselves as cartographers of the past, lone explorers, very often, navigating with a lifetime of expertise where others would founder in confusion, is that the maps they help to produce will inescapably aquire a political colouring, and from the very institutions for which they innocently toil away. Good practice in identification, therefore, properly remains a fundamental part of what art historians do, but authenticity is not a helpful way of explaining why it is useful. On the contrary, the particular notion of authenticity, the association of artefact and personal integrity that we have been discussing, is in practice the overall shape that gradually emerges from the map, as the positions of selected artefacts upon it are so expertly plotted.

Authenticity is just as often cited as the rationale for conservation too, and I want now to explore how helpful it proves as an explanatory term in that field. As in looking at attribution, I shall consider first the problems that turn up in the everyday work of conservation, and then see how these problems reflect theoretical difficulties that are readily overlooked in routine practice.

Notes

1 V. da Bisticci, *Renaissance princes, popes and prelates,* introduction by M. Gilmore, trans. W. George and E. Waters (New York, Harper Torchbooks, 1963), p. 352.

2 R. Latham and W. Matthews, *The diary of Samuel Pepys* (London, G. Bell and Sons, 1974), vol. VIII, p. 157.

3 J. Ducas, 'Golden Gilbert', *Sunday Telegraph Magazine* (14 July 1996), 30–2, 30

4 C. Clunas, 'Connoisseurs and aficionados, the real and the fake in Ming China (1368–1644)', in M. Jones (ed), *Why fakes matter* (London, British Museum Press, 1992), pp. 152–6.

5 C. Gibson-Wood, *Studies in the theory of connoisseurship from Vasari to Morelli* (New York, Garland Publishing, 1988), pp. 211–13.

6 J. Culler, *Framing the sign* (Oxford, Basil Blackwell, 1988), pp. 153–67, 159.

7 B. Spooner, 'Weavers and dealers: authenticity and oriental carpets', in Arjun Appadurai (ed.), *The social life of things* (Cambridge, Cambridge University Press, 1988), pp. 195–235, 222, 223.

8 L. Trilling, *Sincerity and authenticity* (Cambridge, Mass., Harvard University Press, 1971), p. 131.

9 M. Berman, *The politics of authenticity* (London, George Allen and Unwin, 1971), p. xiii.

10 Trilling, *Sincerity and authenticity,* pp. 167–72.

11 J. Grigely, *Textualterity* (Ann Arbor, University of Michigan Press, 1995), pp. 11–50.

12 J. Weiner, 'Fusion or fission', in *The beak of the finch: evolution in real time* (London, Vintage, 1995), pp. 190–202.

13 A. Sentker, 'Ausbruch aus der Vitrine', *Die Zeit* (19 January 1996), 41.

14 Gibson-Wood, *Studies in the theory of connoisseurship*, pp. 82–91.

15 J.-B. P. Lebrun, *Observations sur le muséum national* (Paris, Charon, 1793), p.15, cited in A. McClellan, *Inventing the Louvre* (Cambridge, Cambridge University Press, 1994), p. 4 and note 3.

16 A. Burnett, 'Coin faking in the Renaissance', in Jones *Why fakes matter* pp. 15–22.

17 I. Jenkins, *Archeologists and aesthetes* (London, British Museum Press, 1992), p. 70.

18 J. Bruyn, 'The concept of school', in H. L. C. Jaffé, J. Storm van Leeuwen, L. H. van der Tweel, *Authentication in the visual arts, a multidisciplinary symposium* (Amsterdam, B. M. Israel BV, 1977), pp.1–25 (papers from a symposium held in Amsterdam, 12 March 1977).

19 H. Focillon, *The life of forms in art* trans. C. Hogan and G. Kubler (New York, George Wittenborn, 1934), p. 8.

20 D. Lathrap, 'Recent Shipibo-Conibo ceramics and their implications for archaeological interpretation', in D. Washburn (ed.), *Structure and cognition in art* (Cambridge, Cambridge University Press, 1983), pp. 25–39.

21 A. Gebhart-Sayer, 'The geometric designs of the Shipibo-Conibo in ritual context', *Journal of Latin American Lore*, 11:2 (1985), 143–75, 170.

22 J. Bruyn, B. Haak, S. H. Levie, P. J. J. van Thiel and E. van de Wetering, *A corpus of Rembrandt paintings* (Amsterdam, Martinus Nijhoff, 1986), vol. 2, pp. 60, 61.

23 K. Garlick and A. MacIntyre (eds), *The diary of Joseph Farington* (New Haven, Yale University Press, 1979), p. 868.

24 'British standard for prints', *Printmaking Today*, 2:1 (spring 1993), 3.

25 'Recurring problems', *Printmaking Today*, 2:2 (summer 1993), 3.

26 S. Lewandowski, 'Printmaking printing printout', *Printmaking Today*, 2:4 (winter 1993), 13.

27 J. Winkleman, 'Towards a British standard for the print', *Print Quarterly*, 12:2, 179–81.

28 K. E. Farrer (ed.), *Letters of Josiah Wedgwood* (Manchester, E. J. Morton, 1973), vol. 1, pp. 256, 257.

29 K. Moxey, Introduction, in *The practice of theory: poststructuralism, cultural politics and art history* (Ithaca, NY. Cornell University Press, 1994), pp. 1–19.

30 A. Cozens, *Principles of beauty relative to the human head* (London, printed by James Dixwell 1778), p. 2.

31 R. Barthes, 'Introduction to the structural analysis of narratives', in S. Heath (ed. and trans.), *Image, music, text* (London, Fontana, 1977), pp. 79–124, 80.

32 S. M. Pearce, *Museums, objects and collections* (Leicester, Leicester University Press, 1992), pp. 24–30, 166–91.

33 H. Ruhemann, *The cleaning of paintings* (London, Faber and Faber, 1968), p. 352.

34 R. Krauss, 'Retaining the original, the state of the question', in *Studies in the History of Art* (Center for the Advanced Study of the Visual Arts, National Gallery of Art, Washington, DC), vol. 20 (1989), pp. 7–11, 10 (Proceedings of the symposium 'Retaining the original: multiple copies, originals and reproductions', Center for the Advanced Study of the History of Art and Johns Hopkins University, Baltimore, 8–9 March 1989).

35 V. Erlich, *Russian formalism* (New Haven, Yale University Press, 1981), p. 253.

36 M. Bal and N. Bryson, 'Semiotics and art history', *The Art Bulletin*, 73:2 (June 1991), 174–208, 181, 182.

37 Gibson-Wood, *Studies in the theory of connoisseurship*, pp. 216, 247.

38 A. McClellan, *Inventing the Louvre* (Cambridge, Cambridge University Press, 1994), p. 53.

39 S. Muthesias, 'Why do we buy old furniture? Aspects of the authentic antique in Britain, 1870–1910', *Art History*, 11:2 (June 1988), 231–54.

40 J. H. Pollen, *Antique and modern furniture and woodwork in the South Kensington Museum* (London, Chapman and Hall, 1874).

41 'Getreu den Vorbildern des 18 Jahrhunderts sind in der Höchster Porzellan-manufaktur auch heute wieder Künstler am Werk, die von Hand Figuren, Schalen und Vasen formen und bemalen', *Die Zeit* (*Magazin*), 16 (12 April 1996), 4.

42 Muthesias, 'Why do we buy old furniture?', 243.

43 F. Lichfield, *How to collect old furniture* (London, Bell and Sons, 1906), p. 127.

44 A. Hayden, *Chats on old furniture* (London, L. T. Fisher Unwin, 1912), p. 260.

45 M. Orvell, *The real thing: imitation and authenticity in American culture, 1889–1940* (Chapel Hill, University of North Carolina Press, 1989).

46 *The fine art of faking it*, a documentary for Nova (Philadelphia, Films for the Humanities and Sciences) 1992.

47 G. Norman, 'The cheerful picture faker with a taste for vodka', The Times (21 April 1986), 5.

48 S. Strauber, 'Delacroix drawings and the false estate stamp', *Journal for the History of Collections*, 3:1 (1991), 61–88, 79.

49 C. F. Stuckey, 'Manet revised, whodunit?', *Art in America* (November 1983), 158–77, 168.

50 G. Rosie and J. Bright, 'Conduct unbecoming an artist. . . .', *Sunday Times* (17 November 1985), 4.

51 M. Bailey, 'Archive scam is "mega-fraud"', *The Art Newspaper*, 61 (July-August 1996), 3.

52 A. Grafton, *Forgers and critics: creativity and duplicity in Western scholarship* (London, Collis and Brown, 1990), pp. 43–5.

53 I. Haywood, *Faking it* (Brighton, Harvester Press, 1987), pp. 73, 81.

54 H. Trevor-Roper, *The hermit of Peking* (Harmondsworth, Penguin Books, 1978).

55 A. G. Knox, 'Richard Meinerzhagen – a case of fraud examined', *Ibis*, 135 (1993), 320–5.

56 E. M. Ripin, 'The instrument catalogues of Leopoldo Franciolini', in *Music indexes and bibliographies*, edited by George R. Hill, no. 9 (Hackensack, NJ, Joseph Boonin, 1974).

57 S. J. Checkland, 'A picture of deceit', *London Daily News* (6 April 1987), 17; J. Pope-Hennessy, 'Berenson's certificate', *New York Review of Books* (12 March 1987), 19, 20.

58 S. Koldehoff, 'Der brockelnde Mythos, auf den Spuren falscher van Gogh's', *Frankfurter Allgemeine Magazin*, 847 (24 Mai 1996), 14–21.

59 C. Clunas, 'Connoisseurs and aficionados, the real and the fake in Ming dynasty China', in Mark Jones (ed.), *Why fakes matter* (London, British Museum Press, 1992) pp. 151–6, 151–2.

60 M. Campbell and C. Blair, ' "Vive le vol", Louis Marcy, anarchist and faker', in Jones *Why fakes matter*, pp. 134–47.

61 M. Robinson, *Strindberg's letters* (London, Athlone Press, 1992), vol. II, p. 557.

62 *Le Connaisseur: revue critique des arts et curiosités*, 30 (11 December 1909), 117, 118.

63 *Le Connaisseur: revue critique des arts et curiosités*, 5 (8 June 1907), 17.

64 *Le Connaisseur: revue critique des arts et curiosités*, 23 (30 June 1908), 90; L. Maillard, *J. van Driesten et la Toison d'Or: un point d'histoire artistique* (Paris, Groville Morant, 1907).

65 *Le Connaisseur: revue critique des arts et curiosités*, 43 (January 1914), 177; *The Times* (5, 6 and 7 November 1912), 3.

66 Personal communication, 15 May 1996; The reliquary of St Francis is OA 4038, and the arm reliquary of St Louis OA 3254.

67 D. Gaborit-Chopin, 'Le Bras reliquaire de Saint Luc au Musée du Louvre', *Antologia di*

Belle Arte, 27:28 (1985), 5–18, 5.

68 *Le Connaisseur: revue critique des arts et curiosités,* 18 (1 February 1908), 75.

69 E. Taburet-Delahaye, 'Reliquaire de Saint François d'Assise', in *Œuvre de Limoges* (Paris, Réunion des Musées Nationaux, 1995), exhibition catalogue (Metropolitan Museum, New York, 5 March to 16 June 1995; Louvre, Paris, 23 October 1995 to 22 January 1996), no. 102, pp. 306–9, 309.

70 E. Taburet-Delahaye, *L'orfévrerie gothique au Musée de Cluny* (Paris, Editions de la Réunion des Musées Nationaux, 1989), p. 49.

71 *Ibid.,* p 11; 'Comme toutes les collections formées principalement au XIXe siècle, celles du Musée de Cluny comportent des pièces dont l'authenticité doit être mises en doute . . .'.

72 Anon., 'Real and fake in the Zagreb Louvre', *Art News,* 86 (summer 1987), 151–8 cited in J. E. Conklin, *Art crime* (London, Praeger, 1994), p. 53.

73 J. Fenton, 'The best of both worlds', *New York review of books* (8 August 1996), 21–4.

74 F. Hoyle, *Astronomy and cosmology* (San Fransisco, W. H. Freeman, 1975).

75 J. Needham and W. Ling, *Science and civilisation in China* (Cambridge, Cambridge University Press), vol. IV, part II, section 27, figure CCLXV, p. 542.

76 B. Weber, 'Ubi caelum terrae se conuingit: ein altertümlicher Aufrisse des Weltgebaudes von Camille Flammarion', *Sonderdruck aus dem Gutenburg-Jahrbuch,* 1973.

77 C. Flammarion, *L'atmosphère: meteorologie populaire* (Paris, Flammarion, 1888) 2nd edn, p. 163.

78 Moxey, *The practice of theory,* p. 18.

79 *Ibid.,* p. 112.

80 M. Baxandall, *Patterns of intention* (New Haven, Yale University Press, 1989), pp. 117, 118.

6

CONSERVATION AND CONDITION

RECENTLY in the British Museum three major, previously fragmented but restored pieces have been taken apart again and reassembled: the Portland Vase, the Sophilos vase, and the helmet from the Sutton Hoo Viking burial. In these three quite unrelated cases, edges of fragments had apparently been filed down in the course of earlier treatments, to get them to fit during the extremely tricky process of reassembly.[1] In the case of the helmet, the earlier reassembly for whose benefit the filing was done is now considered quite fanciful. It comes, therefore, as no surprise, when we read of a more modest recent reassembly, of an Etruscan decorated *holmos* (a support for a bowl or vase) from the Wellcome collection, now in the Manchester Museum, to learn that earlier restoration 'caused damage . . . Sherds were misaligned and filed down to fit into (incorrect) places'.[2] The last example had very probably been done nefariously and for commercial purposes, but the earlier treatments of the British Museum objects were not. The conclusion must be that filing down was an accepted procedure in the extremely tricky final manoeuvring required in reassembling objects from fragments. Surprisingly, it was even considered acceptable when the assembly was conjectural.

There would, no doubt, now be agreement that past practices of that kind are to be deplored. Indeed, a good deal of the emphasis in recent discussion amongst conservators has been not on interventive treatments of individual objects at all, but rather on preventive strategies, to reduce the rate of decay of whole collections. In current interventive treatments, the contemporary conservator is guided by codes of practice which insist upon absolute respect for whatever is integral to the object, upon reversibility, whenever feasible, of any process applied. On a rare recent occasion when material was accidentally removed, in the form of a yellow surface-layer of paint mistakenly assumed on strong evidence to be overpaint on the sky of a Canaletto in the National Gallery of Canada, the whole affair was courageously published.[3] Yet still the business of making objects fit, in the sense of being fit to be seen, to be on show in a museum

34
Conserving Walter Crane
wallpaper, Wythenshawe
Hall, Manchester, mid-
1980s

display, can be little less problematic than fitting fragments into a reconstruction. It is much less amenable merely to fastidious technical good practice.

Artistic intention and the hand of time

Figure 34 illustrates a problem at the heart of all interventive conservation. It shows a conservation team from Manchester City Art Galleries in the early 1980s, carefully removing wallpaper by Walter Crane, of the 1890s, from a library in a wing added in the early nineteenth century to one of the city's seventeenth-century historic houses, Wythenshawe Hall. The paper was subsequently carefully treated to arrest decay, and its condition stabilised. But it was not returned to Wythenshawe Hall, in spite of the distinction of the designer. With the intention of re-creating an interior based on historic records which would make sense as an early nineteenth-century whole, it had been decided to remove from it some late decorative features, however much they were a part of the authentic later history of the house.

The decisions taken at Wythenshawe arise in every debate over condition. On the one hand is the aspiration to return the object to a condition in which it seems to have aesthetic integrity, ideally to its original condition. On the other hand, there is often concern too to respect and preserve the changes which time and reuse have brought through history. The idea is enshrined in a brave attempt at a definition of authenticity in the preservation of the cultural heritage, drafted for the International Centre for the Study and the Restoration of Cultural Property (ICCROM) by Dr Jukka Jokilehto and Professor Paul Philippot: 'a measure of the truthfulness of the internal unity of the creative process and the physical realization of the work, and the effects of its passage through historical time'.[4]

The trouble is that, as at Wythenshawe, these two notions, of respect for internal creative unity and the passage of time, very often prove simply irreconcilable. The problems are always prominent in historic interiors. First it must be said that the kind of policy so expertly applied at Wythenshawe was very standard practice in the 1980s, particularly for many much adapted properties so unfortunate as to fall, usually stripped of furnishings, into the care of British local authorities. It must be questionable whether, in retrospect, the policy can ever retrieve internal creative unity. Such reconstructions were justified with reference to authentic period detail, and in terms of the appropriateness of the period contents introduced as furnishings, but either an interior environment was constructed in the past by and for a particular household, and to a substantial extent preserved, or it was not. If it was not, is a reconstruction from bits and pieces any more authentic than an 'antique' cooked up by some Arthur Daley of the salerooms from odds and ends of furniture – which no knowledgeable curator would dream of putting into his or her expertly reconstructed interior? The intention may be simply to use the historic house as an appropriate display background to the objects placed in it, but when we visit we are likely to understand the whole interior as 'authentic'. When such interiors, as is often the case, are enlivened by costume events, in which case the whole frame is interactive theatre, they may have some integrity. Opened to the public as expressions of a period, they are forgeries. They are fun to do – I am not quite innocent in this respect – but then so, no doubt, is most forgery.

Historic houses, however, have sometimes been so little changed that a return to their original condition, or at least some well-documented earlier state, is possible. Later additions can be stripped out, original paint discovered with scrapes that lay bare, layer by layer in archaeological sequence, the historic changes of the decorative scheme. An example of the kind is the recent refurbishment of Apsley House, The Duke of Wellington's Hyde Park Corner mansion. The house, by Robert Adam, dates from the 1770s, but Wellington's scheme of the 1820s has been chosen as the magic moment. Later watercolours

of the interior provide some of the evidence for an interior distinguished by the spoils of the Peninsular War liberated from Louis Napoleon, which the duke gallantly offered to return to the Spanish royal family, from whom they had been taken, but which they equally gallantly insisted he should hang on to. A fragment of silk found behind a bell-pull was the pattern for hangings woven on looms of the 1820s, a fragment of carpet found in the attic of the duke's country house the model for the replica carpet.[5]

The point at which even this sort of thing becomes a kind of forgery is hard to define. It surely does in the case of substantial reconstruction after a major disaster. Where enough evidence survives, the illusion may be very convincing, as at Uppark, also opened in June 1995 after very extensive restoration and replication of plasterwork, wallpapers, hangings and carpets by the National Trust, following a fire in 1989. Here the intention was not to reconstruct the interior as new, but as it existed just before the fire. Fabrics were rewoven on eighteenth-century looms, hair mixed in with the plaster to match eighteenth-century recipes, but then nineteenth-century repairs to fabrics replicated, down the twenty stitches to the inch achieved in the past by Lady Fetherstonhaugh.[6] As M. Kirby Talley, Jun. says, with reference to the reconstruction of the Russian Imperial palaces of St Petersburg after their deliberate destruction by the Germans in the Second World War, one must respect the reasoning behind the decision to restore in such cases. But how many such projects avoid the revelation of the restorers' devices with time? 'You cannot help but admire', he goes on, 'the level of craftsmanship which produced such impressive counterfeits. But when you walk up the *scala nobile* in Peterhof the loss becomes all the greater when you pause to compare the few remnants of genuine rococo carving with the extremely competent but nonetheless rather lifeless, and by now clearly dated, copies.'[7] It is the relentless transience of things that makes the ones we do preserve so precious, but we can ultimately no more arrest the process than we can transcend our own deaths by having ourselves embalmed, or frozen.

Even without a fire, the attempt to respect the evidence of historical process within a historical interior is extremely difficult. It has most commonly been tried in the now treasured instances where interiors do survive, because the remnant members of once prosperous families have lingered on, in ever-more echoing houses, incapable of much disturbance to the interiors at all, let alone of arresting their quiet decay. These are the so-called time capsules. Brodsworth Hall in Yorkshire, the latest to be opened in the UK, was built and furnished in the 1860s, with professional advice in contriving a decor so fruity that it shrugs off the small adaptations made for the comfort of later generations, a bit of plumbing, electric light, a new carpet here or there.[8] An uncompromising attempt has been made to accept the house as it had become, and certainly there has been no attempt to strip out the modern cheap basins and

baths plumbed into guest-rooms as other parts of the house were simply closed down.

But English Heritage has never claimed that this is an unchanged interior, and it would be naive to imagine that a good deal of compromise is not involved in the re-presentation even of the integral furnishing and decor which remains in this case. A couple of years elapsed between the death of the last full-time occupant, Sylvia Grant-Dalton, and successful conclusion of negotiations between the heirs, the National Heritage Memorial Fund and English Heritage. During this time the house was turned upside down in the process of valuation of the contents. Some of them, considered not integral to the Victorian interior and beyond the budget English Heritage could spare, were removed for retention by the family or sale. Small pictures and photographs are known to have been redistributed about the house at this time. Even in the main rooms, it was not possible to distribute furniture just as it had been.

Now that the house is open, conservation and safety raise other issues. A Brussels carpet in the bedroom corridor was replicated by Arena of Halifax, whilst an Axminster carpet to the same design in the main entrance hallway was also too worn for safe preservation, and was replaced with a replica, by Hill and Company, hand-knotted in Hungary. The adjoining carpet, taking the design up the main staircase, however, is the original one. The colours for the replica were taken from the risers of this stair-carpet, where the original scheme was less faded and dirty because protected from treading feet and exposed to less light. Even here an edge which was crimson is now a greeny gold, so there was no hope of matching the original colours. But just which colours should be used? The replica manufacturers require a very specific example, yet the remaining colours can vary from fibre to fibre. A choice made, the current curator, Caroline Carr-Whitworth, recalls how alarming it was to visit the Halifax carpet factory and see the huge production process of the Brussels carpet irreversibly under way, though the effect does, in the event, seem impressively close in colour and texture. The original textiles which do remain pose even greater difficulties than these replicas. If the aspiration is to preserve the effect as found, further fading in the light is unacceptable, but, particularly for the silks, inevitable, if visitors are to see the house with daylight streaming in. Some of the old photographs suggest that at times in the past case-covers were used to protect these textiles, but where the covers survive, should they be used and faded too, or is it better to use replicas? To what extent are blinds acceptable, or extra layers of curtaining to reduce light levels? The many old framed photographs pose similar problems. They were printed in a variety of early techniques, and have transformed with age, so that replicas will not be faithful, yet the Victorian prints will rapidly fade if displayed.

Another dimension of difficulty is posed by the most celebrated image from Brodsworth, shown in figure 35, of bedroom eight, containing the *lit-en-*

bateau, or boat, masterfully photographed by Paul Highnam, the head of photography for English Heritage. It seems a quintessential image of atmospheric decay, but true decay is messier. For some time in the disturbances of the house before the photograph was taken the room was used as a kind of rubbish dump, at one stage with surplus old mattresses being hurled from its windows for burning by ground staff. The strewn fabrics that we now see in the room seem more probably a residue of the emptying of cupboards during inventory and valuation than a part of the earlier life of a house. Can we quite believe the artful drape of the curtains falling from the bed? The photographers and curators, however, are not so much to blame if these are the images that we, as the audience, insist on discovering. A vivid example of how we impose in this way was often remarked upon in the 1980s by costumed guides in the kitchen of the house near Styal Mill in Cheshire in which, in the early nineteenth century, sixty orphan apprentice children lived. Everything has been done by the presenters to stress the harshness of conditions in this kitchen, with one cold-water

35　The *Lit-en-bateau* room, Brodsworth Hall, near Doncaster

pump outside it for the whole household. They have an inkling how hard life must have been, from preparing food in the kitchen as part of living history presentations. Yet from conversations with visitors they know how resolutely we visitors refuse to see the grimness. Instead, we admire the old stonework and fittings and the herbs hanging from the ceiling and we fantasise about the good life and the bygone values of old rural Europe. The effect seems authentic not only in the technical sense of scrupulous preservation, but in the sense of preserving authentic values from the past eroded in the present. As Brodsworth's general manager Peter Gordon-Smith remarked about the work there, 'The whole exercise, involving the preservation of 17,000 objects, charts the decline of a way of life. . . '.[9] It is very apparent that the decisions taken involve social as well as technical issues.

A good example came up in an earlier time-capsule re-presentation, this time by the National Trust, of Calke Abbey in Derbyshire. It presents acres of aristocratic neglect of a most evocative kind, except in the dining-room. Here something much less picturesque happened. Charles Harpur Crewe, the family relict, had taken on the role of High Sheriff of the county in the early 1960s, as such folk are asked to do, and had felt he really must have one room a bit more presentable for entertaining. So as any of us would, he had someone pop out for a spot of emulsion paint. All this was, of course, perfectly authentic and just as much a part of the history of the house as the echoing corridors and falling plaster upstairs, but it also represented the one element that, as we saw in chapter 5, is anathema to authenticity: the intrusion of an adaptation manifestly of our own culture, not just a tolerable bit of plumbing or an electric fire, but a splurge of ocean-going DIY. Since it could hardly be disguised by premature ageing, the Trust gave that room its immaculate alternative authentic treatment, a restoration to original decor, complete with scrupulous paint scrapes.

Because of the problem of reconciling original condition with the marks of historical process, interventive conservation cannot be just a matter of technical good practice, but requires interpretative decisions. The decisions can reflect, and in turn aquire, all kinds of social implications. William Diebold has explained the politics underlying the history of conservation conventions endured by the Aegina pediment sculptures. These warrior figures from the temple of Aphaea on the island of Aegina, aquired by Ludwig of Bavaria after their discovery in 1813, were shortly thereafter restored very extensively by the Danish sculptor Bertel Thorwaldsen, for installation in the Glyptotek designed for Ludwig in Munich by Leo von Klenze. Thorwaldsen's restorations had to fit in with his assumptions about how the figures would have been posed as a group. In 1901 the pediment bases were discovered, revealing an arrangement of figures very different from that devised by Thorwaldsen. Some of his reconstructed positions for individual figures were quite fanciful. A warrior whom

Thorwaldsen had reconstructed as a fallen figure lying on his back was a standing figure in the original arrangement. Yet William Diebold explains that the decision, after the Second World War, to dismantle Thorvaldsen's figures, expressed as much a positive desire to suppress the reflection of history in the presentation of these artefacts as to retrieve aesthetic integrity. Klenze's complete architectural ensemble, of which Thorwaldsen's reconstructions were but one component, had been adopted as the spiritual centre of Nazism, a shrine to the continuity of Aryan tradition. No hint of that intrudes on visitors to the Glyptotek today, neither in the grass which has replaced much of the paving outside, nor in the sculptures, now fragmentary again and supported where necessary on smart chrome poles. They show no obvious trace even of Thorwaldsen's intervention, though in fact casts from some of his additions to the sculptures have been used, amongst later small restorations to the figures, to preserve local anatomical integrity. Restoration policy is still a hybrid, and certainly not a matter of technical considerations alone.[10]

Even in the absence of such extreme connotations, there is still a good deal of fashion in conservation. There is more scope for it in some objects than in others, since some materials, such as ceramics, do last remarkably well, and some categories of objects, such as glassware, have relatively rarely been transformed for re-presentation. The conservation of many objects, however, involves decisions as difficult as those demanded by houses and sculptures. That awareness sits uncomfortably with perceptions of modern conservation, which seems to stand outside the processes of history, either restoring objects to some earlier state of integrity, or freezing them as received. We will explore the issue with a more detailed look at the issues discussed so far as they affect oil-paintings. These make a good subject first because, for all their fragility and changeability, they have sometimes come down to us remarkably unchanged, whilst at other times they have been as dramatically transformed and adapted as any country house, which makes consistency in conservation policy hard to sustain. They are an appropriate study too because the conservation policy choices made have been the subject of more than two centuries of consistent, bitter debate, now livelier than ever. What we will find is that the public polemics have served to divert attention from more subtle debates within the profession. These centre as much on compromise between the demands of creative integrity and of historical change as does debate over the conservation of any works of art.

Transformations of time and treatment in easel paintings

We will first survey the changes which typically happen in oil-paintings, starting with ageing changes and working from the surface downwards, before turning to transformations in the course of conservation treatments, working

back up from support to surface. As we go we will note the immediate consequences of each change, but then we will consider how the overall effects of such paintings can be compromised.

Surface dirt accounts for the gloomy appearance of many older oil-paintings, but the varnish layers, usually resins or mastics rather than oils, contribute too. As guardians of the paint layers, they absorb oxygen and reactive pollutants in the air, as well as ultra-violet radiation from light sources, before they can penetrate to the paint layers, but at the cost of becoming darker themselves. The paint layers too, though, also transform and affect tone and colour in the process. Oil paint consists of coloured particles embedded in transparent layers of oil medium, and the oil can become more transparent with age, occasionally allowing underpaint to show through, so that previously invisible changes of mind, or *pentimenti*, become obvious. Sometimes the increasing transparency enhances the effect of the colour of the preparation on which the paint layers have been applied. The green grounds under flesh tones in gold-ground paintings may become locally apparent, whilst the reddish and brownish grounds of the seventeenth and eighteenth centuries can overwhelm all but the bright pigments.

The visual effect of the paint is also affected because the layers of oil in which the grains of pigment are suspended, usually at least a millimetre or so thick, can crack once they lose their elasticity with drying, into patterns like those seen in figures 19–22. Cracking of these kinds literally adds a layer of meanings on top of those encoded in whatever the painting represents, as sets of signs of authenticity for connoisseurs, complete with a specialised terminology. The grains of pigment embedded in the oil also sometimes transform with age, some much more than others. Blues are amongst the most changeable. Before the discovery of Prussian blue in the early eighteenth century and cobalt blue about a century later the only reliably stable blue was ultramarine, based on lapis lazuli and extremely expensive. Even ultramarine can be turned to a pale grey blue by acid in the medium in which it is suspended.[11] In the seventeenth century it was commonly used in a thin layer over a lower layer of smalt, a blue comprised of particles of blue glass, which itself tends to turn brown or grey with time. Smalt was also often used on its own, as in the now completely grey skies of Veronese's four *Allegories* in the National Gallery. Azurite, an alternative blue based on copper carbonate, is pale if the particles are ground small, but it needs a lot of medium if the particles are left large, and then the medium darkens in reaction with the azurite. Indigo, a plant extract, by contrast, fades to become pale.[12] But plenty of other colours besides the blues change too. The so-called lakes, prepared by precipitating a dye on to white particles, such as yellow lake on chalk and cochineal on lead white, can be notably fugitive.[13] Copper resinate, a green copper pigment dissolved in oil, varnish or both, and commonly used for landscapes in Italy in the sixteenth century, usually turns

brown with age, for instance extensively in Titian's *Bacchus and Ariadne* in London's National Gallery. The staining can also on occasion migrate sideways through the medium, to add a halo around foliage.[14] The synthetic pigments available to contemporary painters are often no less susceptible where there is no protective layer of varnish. The colours in the abstract paintings of the American colour field painters of the 1950s, especially those where paint was dripped onto raw canvas, are as vulnerable and fade as fast as those in domestic curtains.

Oil-paintings from before 1820 or so are very sensitive to transformations of this kind, because their paint surfaces were commonly built up in successive, quite thin layers, in which the overall effect depends on the behaviour of light within the partially transparent medium. The layers can readily be distinguished in numerous micrographs of sectioned paint samples in reports in the *Technical Bulletins* of the National Gallery. In common seventeenth-and eighteenth-century practice the tonal structure of the painting is first put in place, in a rough monochrome blocking-in, with local colour then built up gradually, sometimes painted wet into the first tonal painting, sometimes into later layers of further tonal adjustment. The final colour adjustments were made with glazes, wash-like layers of paint, generally of dark paint over light paint, but sometimes of paler paint on darker, for example yellow added on top of blue for some foliage greens.

There are advantages to painting in this way. It offers a vivid effect with thin layers of pigment, and as long as pigment was ground laboriously by hand, it tended to be applied sparingly – Rembrandt, who delighted in effects of heavy paint, sometimes had to mix in additives to give it the necessary body, and then to get it to dry. Layered painting also offers a way of controlling the tonal structure of the painting whilst adding colour (a tricky problem, of which more below). Most of all, the play of light within the layers offers a micro-arena for the imitation of the great range of ways in which light reacts with materials in nature. Helmut Ruhemann has described just how Rubens achieved 'mother-of-pearl' flesh effects. A layer of pale, translucent paint over brown underpaint imitates the kind of optically-caused blueing that we see in everyday life in distant views, when the thickness of air alone shrouds distant, dark features of the scene, so that a distant wood or shadowed hill appears blue.[15] Colour-effects like these are vulnerable to changes in medium transparency or colour, and through damage to the upper layers in insensitive cleaning. In techniques of painting more widely used after 1820 or so, colour-effects are more often achieved not so much by these effects of overlaid transparent layers of paint, as by effects between adjacent patches of often stronger colour, which could be thickly applied from commercially prepared, mechanically ground paint.

Beneath the layers of paint are those of preparation, applied to form a barrier between the paint medium and the wood or canvas fibres of the

support. If the age-cracking of the paint layers that is such tell-tale handwriting for the connoisseur allows damp and pollutants to penetrate to this level, the preparation can degenerate, particularly if of water- rather than oil-based materials. Adhesion between paint and support breaks down, encouraged by movements of the support of the kind which also produced the cracking in the first place. The paint rises from the surface in blisters or cups, and eventually falls off. Surprisingly substantial areas of original paint can be missing from an old picture.

Finally, the movement of the supports which leads to cracking can also rupture the supports themselves. Wood, paper and textile fibres strive, as in life, to absorb and release moisture in the atmosphere, so that their internal moisture content is in balance with that of the air around them, but the walls of their cellulose cells have lost elasticity. Unseen, deep in the heart of the object, the structure steadily breaks down. Damage may be enhanced by insect or bacterial attack. Canvas and other textiles and paper are weakened all the more as emissions from domestic fuel-burning and a host of industrial and transport processes combine with atmospheric moisture to form acids or reactive agents such as ozone. Most of the ills of supports are very familiar, since there is little difference as a rule between the paper, textile and wood used for the supports of paintings and those whose gentle decay pervades any old domestic scene that is a little neglected. As in doors or furniture, the planks comprising panels for large paintings on wood have generally warped and separated, and commonly split. Textiles exposed to a cocktail of light, dust, atmospheric pollutants and damp have faded, embrittled, unravelled and split, and canvases do the same.

These changes are drastic enough, but pale beside the transformations as we proceed from the support up to the surface again, this time considering changes brought about in the history of treatments intended to remedy the transformations of ageing. The most drastic of these involve interventions to remedy a decayed support. When a wooden support had become hopelessly weakened, it was not uncommon, using procedures pioneered in Naples in 1731 by Alessandro Majello, to remove the paint and ground layers from it and secure them to a new support.[16] This is the procedure which, in chapter 5, we noted Christian Goler using for his imitation of Grünewald's St Catherine (though in that case to transfer a painting to a panel from the canvas on which it was first painted, to allow for the inducement of imitative age craquelure). More commonly in conservation, paintings on panel were transferred to canvas, or more recently on to a lightweight, stable supporting panel. In either case, in applications of the process until recently a quite alien texture, either of canvas weave or of board-like flatness, was usually introduced into the surface relief and texture of the object.

It is time for St Jerome to make an entrance again, but this time X-rayed in

36 Recent X-ray of *St Jerome in penitence*, sixteenth century

his present state, in figure 36. Compare this with the X-ray in figure 12. I am afraid that in 1970, I as a curator allowed this painting to be subjected to a radical transfer. With the best technical advice, the old panel, with those worm-holes discussed in chapter 3, was ground away. It had indeed become very fragile, and the procedure of the day, described by Helmut Ruhemann in his authoritative book *The cleaning of pictures* (1968),[17] was to transfer such invalids to a new support, of two sheets of resin-bonded fibreboard called Sundeala, sandwiching a wax-paper honeycomb to give rigidity with lightness, in a support which responds very little to changes in relative humidity. The honeycomb can be seen clearly in the X-ray, which also gives a vivid impression of the

way in which the procedure has anatomised just the pigment from the object, omitting nineteenth-century filler replacing paint missing across the centre of the panel. Now the thin layers of pigment are embalmed irreversibly in a thick new waxy medium, literally flat as a board and with a strange, dull sheen. We seem to have taken no photographs of the process, and kept no samples of timber removed, nor of the ground with which the panel was thinly prepared. From the point of view of evidence the last might have been very useful in helping to establish the source of this strange object, since grounds were usually made of local materials which can quite often be identified in one way or another. In a sense, the painting is preserved, but it was not, in retrospect, a happy intervention, or one which anyone would now contemplate, but very much more distinguished paintings than poor *St Jerome* have suffered it.

Much more commonly, degenerated canvas has been reinforced with another layer of canvas, the two held together in pre-twentieth-century procedures with an adhesive, starch-based and animal glue, forced through from the back of the new canvas and on through the old one too, into the preparation under the paint. In typical nineteenth-century commercial practice, the painting to receive the benefit of this treatment was first cut from its stretcher, often with substantial losses of paint near the edges. No account was taken of earlier lining canvases, so that it is now by no means rare to find three, four or more stuck-together canvases comprising the support, and in that case great pressure and heat was generally necessary to force through the adhesive. Figure 37 shows about life-size a detail of the corner of a seventeenth-century landscape which has had this kind of treatment. Three canvases can be made out, the most recent lining canvas extending over the edge of the stretcher at the top, the edge of one earlier canvas visible below it, a third – probably the original – concealed under the edge of the paint, a little lower down still.

The paint near the edges often flaked off during these procedures, and much of what can be seen here is old filler painted over, but a little in from the edge the surface appearance suggests how the texture of the original paint surface has been flattened in the process. Usually relief patterns of brushmarks in impasto were crushed and rounded, sometimes forced back into the canvas, leaving moats in which varnish gathers to darken with time. Subtler properties of surface relief vanished in these repeated procedures too, and alien textures were added. It is extremely rare for a picture from before 1800 to have been spared this kind of treatment. Martin Wyld and David Thomas note that only 4 out of 700 paintings from before 1800 in the National Gallery have escaped the treatment. Their remark comes in the course of a discussion of Joseph Wright of Derby's *Mr and Mrs Coltman*, which has, exceptionally, never been lined.[18] Texture is hard to reproduce in photographs, but any reader who doubts the contribution it makes to appearance should make a point of examining this picture. Wright's play upon varieties of texture in the paint of feath-

ers, hair, or the bark of the tree clearly shows that an entire dimension of visual language has been literally crushed out of existence in the vast majority of older paintings. Canvas or wood texture and paint texture on a scale from that of swirls of impasto down to the microscopic variations which determine the quality of shininess of varnish all play their part, and are transformed in lining. The successive lining canvases can often be readily made out at the edge of a painting, sometimes even whilst it is in its frame. A variety of problems arise from the adhesives used too, older ones made from animal size glues tending to biological decay, the twentieth-century, much more stable wax-resin mixtures commonly darkening the tone of paintings a little. Transfer and lining are

37 Three canvases visible in the corner of a much-lined seventeenth-century painting, about actual size

now carried out less frequently, with techniques that protect texture much better, but they remain undesirable, transforming interventions.

The restorer is, then, confronted by a painting, perhaps somewhat darkened, usually with some paint losses too. To add to losses from flaking, the paint layer may have been thinned in the cleaning process. Surface dirt and varnish generally yield readily to appropriate solvents, which either do not affect the paint medium or can be used at a safe dilution, but care to select solvents and strengths takes time and expertise which has not always been available. Stronger solvents and abrasion have been used instead, particularly to remove early oil and resin varnishes, which can become extremely hard and resistant. The wash-like glazes typically used for dark tints over lighter underpaint in the final adjustment of the colouring of paintings done before about 1820 often suffered.

By this stage the object confronting the conservator was often not one which a client would wish to pay out too much for, and a good deal of restoration of damage was usual. Losses of paint were generally covered over with generously extensive repainting, since to infill damage laboriously took time. No reputable conservator would now add retouching to cover original paint, but retouchings remain a problem, since they are clearly an infringement if authenticity is assumed to reside in a painting's original condition. There are differences of policy. More often than might be thought, where old repainting is not conspicuous, it is quietly retained. This policy offends notions of originality, and currently the overpaint which forms the majority of what is left of Leonardo's *Last Supper* is being removed, but there is a case for a more conservative approach. Martin Kemp points out that where not very much is left, there is a risk of eliminating older repaintings which might preserve more of what had been there than can otherwise be reconstructed.[19]

But more often overpaint is an obvious intrusion. Figures 38 and 39 show the face of the Infant from a fourteenth-century Italian panel of the Virgin and Child with attendants, here reproduced enlarged, first in natural and then in ultra-violet illumination. The revelation of the overpaint hardly needs the darkened enhancement of the ultra-violet image. On the child's jaw to the right, crude hatching overlays the old craquelure, intruding upon texture and image alike. The touches of shading added to emphasise facial features around the mouth and nose are in an illusionistic convention, in which form is merely suggested where shadow implies prominence of lighter adjacent features, quite alien to the style of the period. The shading is also discoloured. This one example, therefore, offers all the principal signs of overpaint: darkening in ultra-violet illumination, obliteration of texture and craquelure, stylistic incompatibility, and discolouration, because with time the overpaint and original paint both continue to transform, but differentially, so that however good an initial match, differences develop.

Removing alien overpaint is likely to leave a gap, perhaps smaller than the area of overpaint, but still crying out to be filled again. At one extreme is complete cosmetic repainting, imitating or reconstructing the original as closely as possible. At the other extreme are more frankly archaeological approaches, favouring merely toning in areas of damage with no attempt to disguise them. Compromise techniques were evolved during the 1950s, in line with what has been called the 6-inch, 6-foot rule.[20] The infill is in long parallel strokes, deliberately obvious on close inspection, but blending into the surrounding paint from a distance, since they are painted in variegated colours chosen from those adjacent to the damage. Connoisseurs of such techniques distinguish *rigatino*, in which the strokes are vertical, to allow them more clearly to be distinguished from the original paint, and what has recently been called 'chromatic abstraction', in which the colours are always primaries to reconstitute chromatic richness, but in hatching following the dominant directional emphasis in the original paint texture. These techniques offer a reconstruction of colour effect that can often pass quite unnoticed from a normal viewing distance, and the density of the hatching is determined by whatever that distance is judged to be. However, once noticed, it becomes obtrusive and very hard to ignore.[21]

With overpaint we are back at the surface of the painting, with the varnish. Whatever of the three-dimensional relief of the paint that has survived lining or transfer is liable to compromise at this stage, in the betrayal of structure at the very finest visible scale in the surface, through inappropriate choice of varnish. An older fondness in commercial conservation for an excessively shiny varnish to be used on oil-paintings has now gone out of fashion, but surface finish remains a problem. In a well-intended effort to avoid the frequent interventions provoked by the darkening of all varnishes made to traditional recipes, much current museum practice favours synthetic varnishes such as the acrylic co-polymer paraloid B, MS2A and ketone varnishes. These are and remain exceptionally clear, but have an evenness and a faint lustrous tooth to them which can appear incongruously like a protective layer on a consumer product.[22]

Problems also arise with later nineteenth- and twentieth-century works which the artist may not have intended to be varnished. If nothing is added to the surface, the paint itself is bound to be vulnerable. A number of Impressionist and Post-Impressionist painters still resisted varnishes, and Vojtech Jirat-Wasiutynski and Travers Newton made a detailed study in this respect of Gauguin's procedures. They point out that his *Breton bathers* in the Hamburg Kunsthalle, as exhibited in the Gauguin show in Washington in 1987, had been varnished, quite inappropriately, with a thick, glossy varnish.[23] No less an authority than Picasso pointed out to William Rubin, curator at the Museum of Modern Art in New York, that it was quite wrong to varnish a

Cézanne, and even worse to do it to a Cubist painting. John Richardson, Picassso's friend and biographer, who relates the incident, points out that for Braque too texture was of the greatest importance. His family background was

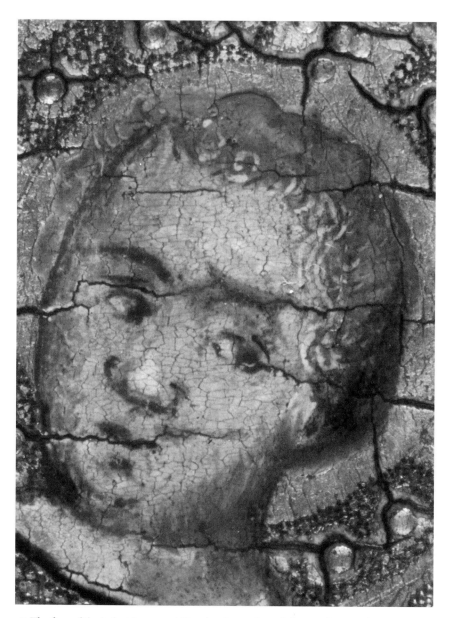

38 The face of the Infant in normal illumination, enlarged, from a fourteenth-century Italian school *Madonna and Child with saints*

in painting and decorating, and Braque took a delight in the usually despised skills of the trade, imitative marblings and wood-grains, textured paints and varnishes. In his earlier Cubist works, the correspondence between the texture

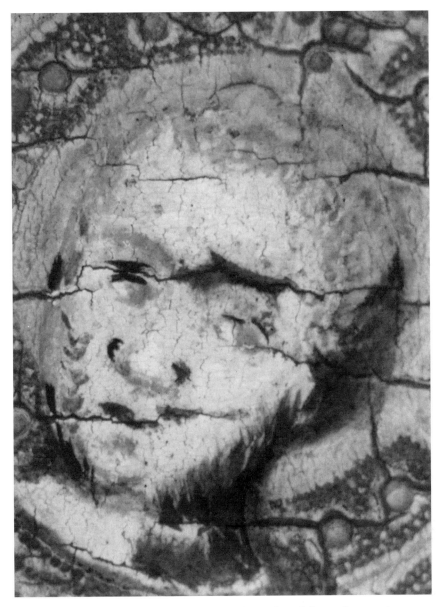

39 The face of the Infant in ultra-violet illumination, enlarged, from a fourteenth-century Italian school *Madonna and Child with saints*

of represented surfaces – glass or paper, wood or marble – and the real texture of his paintings was part and parcel of the Cubists' retreat from traditional illusionism. In his later works, a deliberate mismatch between real texture and represented surface contributed to the effect of *poésie* which he sought. It all vanishes under even the most discreet of varnishes.[24]

So far we have considered the local effects of ageing and treatment transformations, but now need to note that no change is merely local. Even a very local transformation affects the appearance of the whole.

The artist adjusting tone and colour locally in relation to the whole is engaged in a subtle business of balance. Pictures, even the most illusionistic ones, are, of course, very different from whatever they represent. They are odd objects, because they can be seen either just as objects, as more or less flat surfaces, or as representations. We seem to flip between the two perceptions, in a way summed up by the physicist Richard Feynman, coming across a painting in a Japanese museum: 'I saw a painting done on brown paper of bamboo, and what was beautiful about it to me was that it was perfectly poised between being just some brush strokes and being bamboo – I could make it go back and forth.'[25] However, the effect is not limited to representational pictures. Any colour arrangement is likely to offer a possible reading as an arrangement in space, so that here too the duality is set up. A few artists have sought to escape it, either in the most extreme illusionistic effects, as in the ceilings of some Baroque churches, where from one point of view the spectator may not be able to say where real architecture ends, and painting begins. A handful of others emphasise surface. So for the French painter Jean Dubuffet, in seeking to animate just the two-dimensional surface, 'the objects represented will be transformed into pancakes, as though flattened with a pressing iron . . .'.[26] For the great majority of painters, however, part of the effect of the picture lies in tension between surface and illusion. Often this is between patterning in freely applied paint and clever effects of illusionism, as most obviously, for example, in van Gogh's paintings.

Of course, the play between surface and representation is very readily disturbed by any change which alters the perception of tonal and colour distribution, and this was the point emphasised in a remark by Braque about the consequences of varnish on top of the lining of one of his paintings. John Richardson records how, on a visit to Braque's studio in about 1950, the artist pondered whether or not to sign a restored painting, whose original signature had vanished, with much else, in the process of the wax lining which had also tautened the surface of the canvas to a drum-like flatness. '"Look how the blacks jump out at you", he gasped. "Restorers are amazing. They have transformed my guitar into a tambourine", and he gave the taut oval a disconsolate tap with his paintbrush as he re-signed it.'[27]

Changes like these can be so unpredictable because, within this tug of war

between surface and depth, every touch in a picture has to play two roles at once, first as an element in the illusory spatial scheme, but then too in surprisingly distinct schemes of distribution of tone and of colour across the surface. In either of these roles, the local colour or tone which we perceive in any part of the picture does not depend only on light from that point, but also from the local stimulus weighted in relation to both neighbouring colours and tones, and, in a way poorly understood, to the sum of tonal and colour values within the whole visual field. Built into our perceptions are strategies for enhancing local contrasts of tone and colour, whilst standardising the great variations of colour and contrast across the field, and from moment to moment. These have made us exquisitely sensitive not just to local intensities of light and colour, but to the relationships between adjacent tones and colours at any point in what we see, and to the range of tone and colour across our whole visual field at any moment.[28]

Some famous episodes in the history of art hang on this sensitivity. No wonder every touch within a single painting could be such an agony for an eye so finely tuned as Cézanne's. When he was painting a portrait of the dealer Vollard, he emphasised that he could work on it only when the light was right, with a grey sky, not too overcast. Asked, after many hours of sittings, about two tiny patches of bare canvas in one hand, Cézanne remarked that he was hoping, if all went well, to discover just the tone for them in the course of his habitual afternoon of study in the Louvre. 'Be a little understanding, Monsieur Vollard; if I put there some casual touch, I would be obliged to start my whole painting all over again, beginning from that point.' [29] Tonal balance of that kind is readily thrown by colours in adjacent paintings in a display, and Turner famously used the few so-called 'varnishing days' before the opening of Royal Academy exhibitions, when exhibitors were allowed to add final adjustments to their works as framed and hung, sometimes in generous efforts to ensure that his powerful colours did not detract from the effects in neighbouring pictures, sometimes, on the contrary, to ensure that they did not lose their effects. So in 1826 he toned down a sky for the sake of adjacent portraits by Lawrence, whilst in 1827 he intensified his reds to compete with a portrait by Shee. In 1833 he engaged in a good-natured competition with George Jones, first enhancing the blue sky of his own painting to put down a very blue adjacent sky by Jones, then amiably conceding defeat when Jones made Turner's sky seem far too blue, by adding a great deal of white to his own.[30]

In order to understand better just how an effect can be compromised by transformations in tone and colour values, we will consider the tonal scheme first, then colour schemes, before seeing how both can be related to the illusory effects of the oil-painting tradition. The distribution of light and dark across a painting was most explicitly a concern for artists of the eighteenth century. Here is James Barry, for example, lecturing at the end of the eighteenth

century: 'it does greatly depend upon the happy or unskilful distribution of the lights and darks whether objects present themselves with that disgusting confusion and embarrassment which distract our sight, or with that unity and harmony which we can never behold without pleasure'.[31] Sir Joshua Reynolds, a little earlier, had even evolved a technique for studying such distributions:

> When I observed an extraordinary effect of light and shade in any picture, I took a leaf of my pocket book and darkened every part of it in the same gradation of light and shade as the picture, leaving the white paper untouched to represent the light, and this without any attention to the subject . . . such a blotted paper held at a distance from the eye, will strike the spectator as something excellent for the disposition of light and shadow, though he does not distinguish whether it is a history . . . or anything else.[32]

Probably the best account we have of just what kinds of effect of this kind an artist might seek emerges more specifically from the extensive correspondence between Turner and a number of the engravers of plates after his work: 'I want the work quieter and not broken into forms', he writes, for example, to the engraver Rawlinson, 'I take away forms but you follow me not . . . you get no tone or separation of one mass from the other.'[33]

Frustratingly, there are few other explicit accounts of what makes tonal distribution seem satisfying. It may in future be possible to be more specific. Image-processing has revealed, rather surprisingly, that visual tonal distribution can be analysed with exactly the same mathematics as tone in sound. To get an idea of what is involved, imagine a fluted column, lit from the side. It offers shading on three different scales. On one scale the shading emphasises the overall roundness of the column. On a finer scale, it picks out the shallower curves of the flutes, and on the finest scale of all shows up their sharp edges. Gradations from light to dark at different scales in images can readily be enhanced or eliminated by computer processing, so that the flutes disappear, leaving only the effect of overall roundness, or on the contrary so as to suppress the latter in order to emphasise the flutes. The analogy with sound comes in because showing all the edges, but no overall shading, is equivalent to eliminating all but the treble in a sound system. On the other hand, blurring the column so that the edges and flutes disappear and only the broad gradation of shading indicates the overall curvature of the column, is equivalent to eliminating all but the bass contribution to a sound. This kind of processing seems, remarkably, to reflect the exploration by artists of two quite different tonal conventions, that of the line drawing on the one hand, and concern like that of Reynolds for broad massing, on the other.[34]

Does this suggest that there might be analogies between tonal harmony in music and image? Not in any simple way, if only because of the differences between the physiology of sight and of hearing. All the same, the example given

is not the only suggestion of a sensitivity to tonal distribution that we do not yet fully understand. Consider the convention of the representation of drapery in Western oil-painting. Why have artists been so preoccupied with the vast clouds of often rather formalised drapery which fill so many scenes from the fifteenth to the eighteenth centuries? Surely because this convention offered a way of covering large areas of surface with a separation of tonal frequencies like those in fluted columns. It is not only, in these cases, the frequencies – the scale of the gradations from light to dark – which are controlled, but the very specific tonal intensities of those changes. It is just such balances as these, with which Turner demonstrated such concern, which can be disrupted by ageing and conservation.

In later paintings on dark grounds the problem was acute. Figures 40 and 41 show two versions from a substantial clone of replica portraits of Nelson from the 1790s, which must have been a nice little earner for the portraitist of the day, Lemuel Francis Abbott, or possibly for a hack copyist working for him. They help to show how time and treatment shift tonal scale. These two versions, apparently on identical tabby weave canvas, seem to be the two most closely similar in the larger series. They are hack efforts, in which the three-dimensional shape of costume details, for example of the ribbon round Nelson's neck, is quite undefined, if compared to versions in the National Portrait Gallery in London and the National Maritime Museum. It is hard in their current condition and without seeing them side-by-side to be sure just how similar these two paintings must have been when new. The one in figure 40 has been truly perfunctorily painted, in rather thinner paint than its companion. However, much of the substantial difference in effect they offer is certainly down to tonal and textural changes with age. The painting in figure 40 has never been lined, unusually, as we have seen, and (except for one large patched hole in the lower left, quite invisible here), shows remarkably little sign of retouching. Its surface presents an even network of cracks in the thin paint. Nor has it been cleaned recently, so it is currently more darkened by varnish than these photographs suggest. The darkening is particularly apparent in the recesses of the canvas, where older varnish has probably resisted earlier cleaning, enhancing the canvas weave and darkening the overall tone even more. In comparison, the lighter parts stand out starkly, and modelling in the face seems harsh. The painting in figure 41, by contrast, has been heavily lined, and the light parts of the face appear to have been refreshed with a pale glaze of overpaint, in places almost obliterating the craquelure. The details in figures 42 and 43 show these physical features more clearly, though the overall effects to which the differences contribute emerge more clearly in the images of the whole pictures.

The ultra-violet and infra-red images of the *St Jerome* in figures 13 and 14, finally, demonstrate a very common but transforming strategy adopted in the face of changes such as these. In place of the vanished subtlety of original tonal

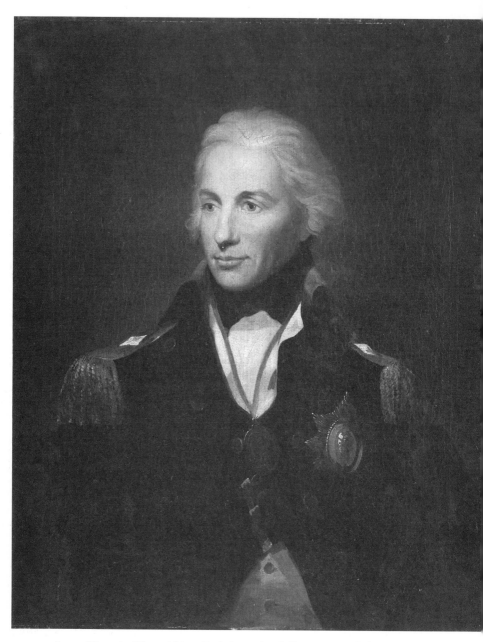

40 Lemuel Francis Abbott, *Nelson* (Lady Lever Art Gallery, Port Sunlight)

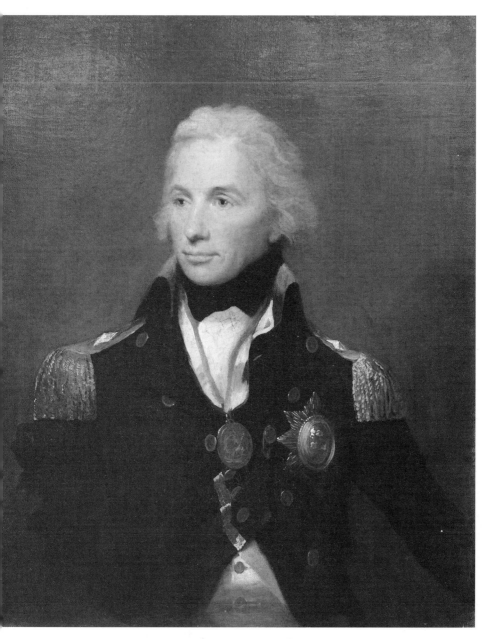

41 Lemuel Francis Abbott, *Nelson* (The Scottish National Portrait Gallery)

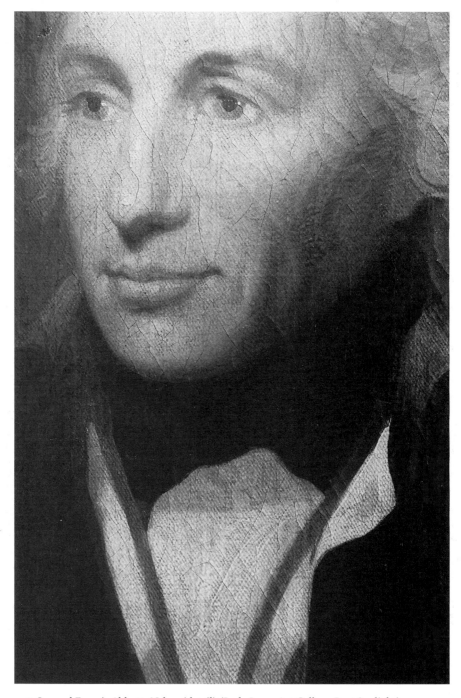

42 Lemuel Francis Abbott, *Nelson* (detail) (Lady Lever Art Gallery, Port Sunlight)

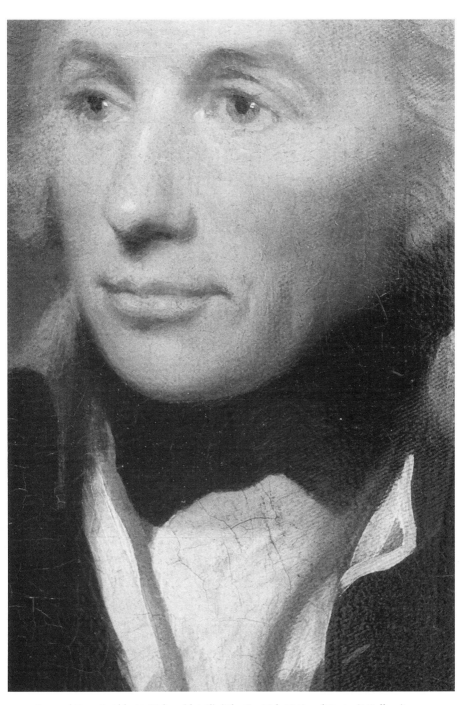

43 Lemuel Francis Abbott, *Nelson* (detail) (The Scottish National Portrait Gallery)

schemes, highlights were selectively cleaned, in this case in the profoundly damaged sky, and then contrasts between light and dark in the most significant parts of the image were enhanced with added shadow near the edges. This is very apparent in the ultra-violet image around Jerome's outflung arm.

If artists have left us little discussion of anything like general principles of harmony of two-dimensional tonal distribution, they have made up for it with specifications for the use of colour. The most commonly articulated goal of colour management is to unite the picture surface by imposing some consistency of colour-effect across it. There are a host of strategies, mostly either ones which seek agreement by emphasising the similarities between a range of selected colours, or ones which, on the contrary, depend upon differences. Thus one prescription was to keep the principal colours within a fairly narrow range, so that the dominant effect of the picture is golden, or blue, with complementary colours allowed no role, or only an appearance in small touches. One way to impose this kind of unity was in the choice of colour of ground. Poussin painted usually on a red ground, whereas the eighteenth-century British painter Philip de Loutherbourg chose a warm or cool ground, depending upon subject. The eighteenth-century theorist Gerard de Lairesse, on the other hand, advocates using as many colours as might be wished for, but with one dominant and repeated, as if in enamel-work, in smaller patches across the surface, to make for unity.[35] Nineteenth-century colour theories might at first glance seem to move away from that kind of unity, suggesting that the colour scheme will seem unresolved unless the full spectrum is represented. Even then, unity can be maintained by choosing consistent levels of colour contrast and intensity in the dominant colour combinations. Colour harmonies, therefore, tend to pull the picture surface together by imposing across it either similarity of colour, or a consistent degree of opposition.[36] Evidently colour changes of the kinds mentioned earlier, associated with varnish, dirt and pigment change, make nonsense of such carefully constructed schemes.

However, to appreciate fully the transforming effects of colour and tonal shift we need to add to these changes to the patterning of the picture surface the role of colour and tone on the other side of the tug of war, where they contribute to the illusions in which the surface vanishes in evocations of volume, space and illumination. Colour and tone are notoriously tricky to manage together in the Western illusionistic tradition, because the two scales are out of sync: colours in different parts of the well-known rainbow spectrum are at their most saturated and intense at very different points in the tonal scale from light to dark. Thus even the richest yellow remains quite pale (indeed, there is no such thing as a dark yellow), whilst the deepest mid-red is never much darker than a half-tone, and only blues and purples are at their richest in deep shadow. To get an idea of the strategies employed to manage the problem, consider the specification, in the explicit pursuit of harmony, by the

late seventeenth-century Flemish artist and theorist Gerard de Lairesse. Divide a composition, he advises, into foreground, second ground (middle-distance) and off-skip, or further distance. In the foreground put strongly coloured figures in a high tonal key (that is, all in quite pale tones), against the background of a shady rock. In the middle-distance put some more figures, strongly coloured, but in a lower tonal key than the foreground figures, and against a background only one step down from them in tone. In the background have women and children in pale and white draperies against light buildings and blue sky. Thus the brightest colours can be much the same in all the figures, but the contrast between each group and its background will decrease with distance:

> Now, in such a Disposition, we are enabled to perceive how each of the three Parts keeps its Distance by the Nature of the Ground behind it: The foremost, as the strongest, and consisting mostly of Light, approaches with Force against the greatest Shade; and those on each Side, tho' almost as light, yet are limited by their back Grounds, which differ but one tint from them, whereby they appear neither further nor nearer than they really are . . . Thus you may easily join Grounds and Objects in order to fetch out Harmony; and by Harmony, one of the perfections of a painting.[37]

As de Lairesse also noted, in addition to spatial effects of colour due to aerial perspective, there is also a less powerful, shallower spatial effect with saturated colours, since, other things being equal, a strong red will appear to float nearer in space than a yellow, with blue receding. This can now contribute to striking dislocations in the spatial structure of paintings of his time, with angle-edged islands of vivid blue, red and yellow drapery apparently floating over the painted surface. The effect is attractive to a twentieth-century eye, but surely a transformation when it appears in, for example, the spatial illusion contrived by Nicolas Poussin. The islands have been left stranded in their colour-saturated splendour, as softer surrounding colours have been compressed into a mid-tone range by the growing dominance of a red-toned ground, intruding through a medium that has become more transparent with age. The strongest blues are often the colours left most prominently isolated in this way.

Amongst the paintings displayed after cleaning in Dulwich Picture Gallery in 1995 is Rubens's *Venus, Mars and Cupid*, from the mid-1630s (figure 44). Rubens was fascinated enough by optics to have written a treatise on the subject, which is now lost. The cleaning has unquestionably recovered much of his concern with optical effect, and especially in the flesh painting, where glazes turn out to have been well preserved. However, as the scrupulous catalogue account of the cleaning makes clear, there has been deterioration in the two most vivid colours in the picture. Venus is pulling over her lap a drapery of the most vivid blue, but discolouration of smalt has first left it in places with a patchy greenish-grey tone, and also spoiled the resolution of the shape of the

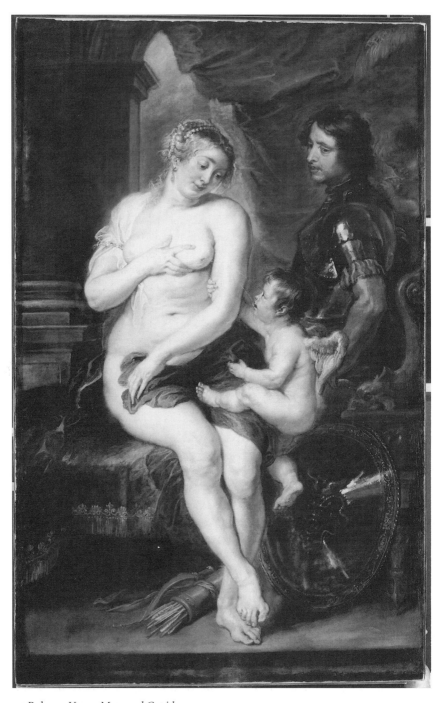

44 Rubens, *Venus, Mars and Cupid*

folds, so that, for example, it is no longer apparent that Cupid is tugging it tight in an effort to pull it off. Adjacent to it, and carrying on a diagonal emphasis across the picture imparted by Venus's arm and the blue drapery, is drapery on her couch, now a purple without the emphasis of a red lake glaze, now faded. To my eye, the intensity of the rather formless blue, where still vivid, is, therefore, jarringly isolated. The same goes for a similarly decayed blue in a Murillo, cleaned in the same campaign.[38] This is not the fault of the treatment, which has been done scrupulously, but a revelation of the kinds of problem that arise.

Not all cleanings by any means reveal problems of that kind, but enough have for painters and critics to be painfully aware of them. As Hogarth observed of colours in his *Analysis of beauty*, 'one changes darker, another lighter, one quite to a different colour, whilst another, as ultramarine, will keep its natural brightness... Therefore how is it possible that such different materials, ever variously changing . . . should accidentally coincide with the artist's intention?'[39] Ruskin made a very similar point, about changes in Turner's paintings, which he thought 'would be less baneful if all the colours faded together amicably, but they are in a state of perpetual revolution, one staying as it was and the others blackening or fading about it, and falling out with it in irregular degrees, never more by any reparation to be reconciled'.[40]

Conservation and controversy

These issues of new damage, revelation of old transformations in what are so often emotively called 'flayed' paintings, and retouchings, become very confused in the long series of controversies which have been initiated by campaigns of cleaning in major museums, themselves picking up on rows about the effects of restorations more generally since the sixteenth century.[41] The polemics are as old as public galleries themselves. The first were at the Louvre, newly opened to the public as a gallery, in 1793 and 1796, with an added edge of bitterness because the paintings concerned had been removed from aristocratic owners or following the conquest of Italy.[42] The subsequent debates retain a seriousness and political edge thanks to the suggestion that it is the good stewardship of government, in each case, that is in question. Debate revived in respect of the Louvre in 1848 and 1860, whilst a major controversy over National Gallery policy, beginning with a letter to the press in 1846, led to a parliamentary select committee inquiry in 1853. In 1861 it was the turn of the Munich Pinakothek, and though then debates died down, they were revived in 1936, over the cleaning at the National Gallery of Velazquez's *Philip IV in brown and silver*. The gallery initiated a sustained campaign of cleaning under the charge of Helmut Ruhemann during the Second World War which provoked fierce debate at the end of the 1940s. It rumbled on spasmodically to erupt again in 1962, with a public debate at the ICA in London to air the differences

between conservators, and a succession of notably waspish exchanges in the *Burlington Magazine*.[43] The National Gallery of Art in Washington, DC's policies in cleaning Rubens's *The Gerbier family* in 1973 and Rembrandt's *The mill* prompted an inquiry on Capitol Hill in 1978.[44] Recently interest has centred on the Sistine Chapel ceiling, which the scholar James Beck believes has been stripped of a toning layer of paint which Michelangelo added in dry, so-called *secco* paint, on top of the original fresco of the ceiling.[45] (This is discussed in my next chapter.) In April 1996 debate about the National Gallery's policies was stirred up once more, by the implacable foe of the gallery's cleaning policies, Michael Daley, to mark the conclusion of the cleaning of Holbein's *Ambassadors*. It would be hard to think of another public issue on which debate has erupted so consistently over a 200-year period.

There is a remarkably consistent pattern to these controversies. They are generally initiated and fuelled by a passionate polemicist. Though that word 'flayed' is often used, there tends to be confusion in press reports as to whether the accusation is that original material has been removed in the latest campaign of cleaning, or whether the problem is more that shifts in values like those described by Hogarth and Ruskin have been exposed to view. But then the establishment makes a measured response, often with some committee of inquiry, and in the end, though perhaps there are amongst these instances cases where new damage did occur, the consensus seems to remain with Wilhelm von Humboldt, quoted by Andrew McClellan in an account of the very first Louvre controversies, writing to Goethe about the supposed damage to Raphael's *St Cecilia*: All damage is thus not to be denied. I believe it is, by far, not as much as many claim.'[46]

In earlier controversies, the supposed damage was most often to the final layers of glazing, the thin, translucent layers of colour on which the richest and subtlest effects often depended. More recently, in relation both to the Sistine Chapel ceiling and in April 1996 once again over National Gallery paintings, the concerns expressed have been over supposed toning layers, which artists might have used to take the edge off the harshness of new colour. The dispute sparked by the cleaning of Holbein's *Ambassadors* in April 1996 was particularly cleverly managed by the National Gallery. The accuser, Michael Daley, was much reported, but upstaged by a television documentary about the cleaning, which dwelt on the gallery's undoubted expertise, and the computer models aiding retouching of the much damaged anamorphic skull in the picture.[47] The Holbein was a difficult painting to restore, but not a very problematic one. The extensive losses of paint to the skull made demands on expertise to which Martin Wyld, in restoring it, rose heroically. Some conservators would not countenance such a large reconstruction of vanished detail, but Wyld's intervention is readily reversible. Otherwise the paint is in quite good condition, barring localised damage, for example to a medallion, a codpiece and the

handle of the globe. The smallest hairs on the faces of the ambassadors survive, and even the often fugitive glazing of Jean de Dantville's sleeves has not faded. The television report ended with expressions of admiring support from the critic Brian Sewell, eloquently apprehensive at an earlier stage in the cleaning, and from the distinguished European conservators Giorgio Bonsanti and Jorgen Wadum. The polemic and its clever management in that case served even more than usually to mask the issues which do divide conservators.

The issue of toning down arises in two quite separate situations. The first is where a painting (like the *Ambassadors*) is in good condition, but brilliance of revealed colour prompts suggestions that the artist would have intended the effect to be toned down, subdued by time, or softened by display in low illumination. The second, much trickier, is where colour and tonal values have shifted dramatically. We will consider them in turn.

There is no doubt that dealers and collectors often toned down paintings in the past, in order to impose rather crudely the kind of tonal surface harmony mentioned above. There is a great deal of evidence that this was common in the eighteenth and nineteenth centuries. By then the eyes of connoisseurs of easel paintings of the previous three centuries were attuned to darkened varnish. New toning down moderated colour schemes, whether revealed by cleaning as much transformed, or just inappropriately bright to contemporary eyes. Collectors of the period also seem to have found such toning appropriate to make new paintings compatible with old. Constable's biographer Leslie, for example, discovered within a year of the artist's death that his *Waterloo Bridge from Whitehall Stairs* had been covered by its owner with a coat of blacking 'and that several noblemen considered it to be greatly improved by the process'.[48]

However, the historical record does not make clear at all how often this kind of thing was done by artists to their own paintings. There are rare unequivocal instances. Thus, bedevilling the most recent controversy, in one painting by the sixteenth-century painter Giampietrino, *Christ carrying the Cross* in London's National Gallery an overall toning layer of glazing oil-paint has indeed been discovered.[49] But this is an isolated instance, and not, perhaps, surprising in a work by one of the artists struggling to reconcile colour with the new procedures for shading only recently introduced by Leonardo. It seems hard to imagine that use of overall toning layers of glazing oil-paint or coloured varnish could have been very common without being detected, as this one has been, or at least without being recommended in the many old books on the practice of painting. Much suggestive evidence was put forward in support of toning in the exchanges in the pages of the *Burlington Magazine* in the early 1960s, mentioned above, but it is not easy to interpret. It certainly does not make a decisive case for toning as a very widespread routine practice. More typical, surely, is the specification for varnish on pictures in a little book on varnishing and gilding for interior decorators of the mid-eighteenth century:

'Varnish for pictures should serve only to revive the colours and to protect them, not to colour them or give them a shine which hinders distinction of subjects. That they should be dull is also to be avoided, but they should be white, light and soft.'[50] The specification suggests that the contrary practices, of using tinted and thick, shiny varnishes were part of trade practice, but not informed professional consensus. But there remains some room for debate.

There is, on the other hand, no doubt at all that some artists anticipated and welcomed the effects of time on their own work, in which case removing the softening effects of time could be said to misrepresent their intention. It is still not clear how often this was the case. There is plenty of advice of the kind in manuals for painters. The eighteenth-century portraitist and author of such a manual, Thomas Bardwell, for example, recommends allowing for darkening of greens by using them lighter and brighter than immediate appearances would dictate.[51] But there are only occasional hints that artists paid much attention to the issue, such as van Gogh's mention in a letter that crude colouring would be toned down all too much by time.[52] There is even less evidence about the extent to which an artist such as Holbein might have anticipated display in low illumination.

In the case of the Holbein, there is one piece of evidence suggesting that Holbein would not have been unhappy either with the effects revealed, or illumination of them. Martin Wyld reports in the television documentary that much of the conservation of the darkest parts of the picture had to await the summer months, since only in the brightest studio daylight could he match his retouchings of the deepest blacks. Holbein seems to have delighted in modelling in these darkest tones, of a kind anyone who has made monochrome photographic prints is likely to have become alert to, since they are amongst the indications that the full tonal range has not been lost in the printing process. Is it plausible that such rich but elusive effects would have been put into paintings by artists who expected them to be masked by toning, ageing or illumination? Can we really imagine they would have deplored conservation and display that revealed them? But artists are as inconsistent as any other group, and it would be quite wrong to assume that what may be appropriate for some sixteenth-century paintings is appropriate in all cases where what is revealed is startlingly bright.

The second circumstance in which some conservators consider toning down arises where revealed colour and tonal values have obviously shifted. The issues here are much harder. The television documentary about the cleaning of the *Ambassadors* was honest enough to touch on the differences of view on this, in connection with Titian's *Bacchus and Ariadne,* in which there have been sharp changes of both colour and tone. For a seminar in London in 1990, Gerry Hedley summarised the three broad approaches to the problems posed by such shifts, which he characterised as complete, partial and differential cleaning.[53]

The first, most prominently exemplified in the tradition established by Helmut Ruhemann in the National Gallery in London, consists wherever possible in the rigorous removal of all later additions, including any subduing surface layers. It has the virtue of involving least in the way of conscious reconstruction of artistic intention, but can leave obtrusive transformations.

The second approach, partial cleaning, has been the basis of much French and Italian practice since established in the 1950s by Carl Brandi.[54] It has recently, for example, been championed by the head of conservation at the Louvre, Ségolène Bergeon. Brandi was repeating a point made often in the past, that time can have positive as well as negative effects on paintings, leaving the restorer scope to allow for the latter by taking advantage of the former. In that tradition, it is still common in Louvre conservations for some toning varnish to be left on paintings, where it is felt that relationships have become disturbed. Thus in cleaning Watteau's *Embarcation for Cythera* small patches of total varnish removal caused 'the pale blue sky to appear too nakedly' and 'put in evidence a very strong contrast between the slightly lightened sky and foliage which had remained very dark'. These small exposed patches were therefore touched back in to leave the whole effect a little toned down.[55]

The final approach, differential cleaning, is the most controversial, since it frankly involves making judgements about artistic intention in adjustments to the tonal structure of paintings. When Constable's *Stoke by Nayland* in the Chicago Art Institute was cleaned by David Koch in 1985, a cloud beside a dark tree mass seemed too brilliantly bright, and was cleaned less than the rest of the painting, to tone it down.[56] John Brealy, formerly head of conservation at the Metropolitan Museum, was most closely associated with this approach, 'thinking of balance, balance, maintaining the picture's original unity. Everything . . . tends towards that.'[57] In the name of balance of this kind, Chiara Scarzanella and Teresa Cianfarelli advocate first a policy which, in the tradition established by Brandi, does not seek to remove more of the effects of ageing than are necessary to recover the restorer's judgement of the balance of tone and colour intended by the artist. Where pigment change, for example the fading of lake glazes, has compromised that scheme, they recommend selective cleaning of the 'patina' of age: 'a greater quantity of it needs then to be left on the parts which have lost their chromatic intensity, whilst, conversely, deeper cleaning is required in other parts, done so as to re-establish a relationship of equilibrium'.[58] This is a frankly subjective intervention, and Italian conservators often emphasise 'hypothetical intervention' as the basis of their work: the physical integrity of the object is rigorously respected, and additions are reversible and accepted as based upon a hypothetical judgement of effect.

There is a very clear gulf between good practice in the first approach, which represents the intervention as a technical matter of identifying overpaint and transformed varnish and removing them as far as possible, and good practice

in the two alternatives, which accept the intervention as interpretative. At this point the door opens to ideological intrusion into debate, and it does not hang back. Bergeon alleges that the attempt to deny history has been exacerbated by 'an arms race' between (Anglo-Saxon, we infer) studios, heavily investing in ultra-high performance gear to track down the last micron of paint.[59] She sees all this as a symptom of a division on national lines, with the Anglo-Saxons and Germans adopting the National Gallery approach, misled, she suggests, by a taste for modern art, razzmatazz and over-bright illumination. 'The older the civilisation of a nation,' she suggests, 'the more its people respect the past', and hence, she believes, the concordance between the Russians and French in preferring a more restrained approach.[60] (Whether she has in mind the only modest cultural development of us Germanic Europeans, or the dominance of brash America, is not quite clear.) But John Richardson, in his article on varnish, wax lining and Cubism, also points out differences between the undisturbed condition of paintings in the Kramar collection in Prague and those which had been treated in some American studios. 'How tawdry the victims of American beauty parlors looked . . . '.[61]

At the time of our 1970 transfer of *St Jerome*, there seemed no question but that what we were doing was right, which in retrospect reflects misplaced confidence in technology. It was the latest in good practice, and expertly done (barring our lamentable failure to keep record photographs and specimens of removed material in the museum) with the best advice. It was also a mistake, an attempt to retrieve and freeze what remained of the creative integrity of the painting in which most of its substance as an object, and with that its history, was eliminated. The focus on these questions can conceal how competent much conservation is, but no question, no conservation treatment can avoid being an interpretative intervention, and the judgements involved are not merely technical.

You might think that at least in the case of contemporary work, especially where an artist is still alive and available for consultation, these issues of intention, re-presentation and time would not arise. Not so. Neither artistic intention nor materials are stable enough even within this time-frame. Kimberley Davenport has described the case of one of Duane Hanson's polyester illusionistic figures, *Sunbather*, of 1971, one of his pieces which offer extreme realism, inevitably dependent on details of period clothing, but including magazines, tins of drink and snacks.[62] Hanson had provided indications about conservation, advising of the need to fluff up fabrics to keep the folds natural, and of the imperative need to keep the piece out of bright light to avoid fading, but it is hard convincingly to display a remarkably realistic representation of a sunbather in the aquarium-like light levels conventionally found in museum textile displays. The piece had become dirty and lost some of its props, probably thanks to the fascination of visitors with its startling realism. A perished

bathing-cap and 1970s sunglasses were found, but replacement of original early 1970s packaged items was not an option, and even carefully preserved period copies of magazines, scrupulously run to earth by the conservation team, had yellowed so as no longer to present a credible appearance. In this case, Hanson advised that what mattered was the social type defined by the consumer items. The 1970s journals *Look* and *Life* have therefore been replaced with soap-opera magazines, and the can of *Tab* with one of *Diet Coke*. What is going to happen in the future, when class categories have shifted to the point where renovations in this style will no longer be visually convincing? Since the article was written, Hanson has died. In due course, conservators and curators will decide.

These cases at least included works which were intended to survive for a time, but there have been many works, from those of Gustave Metzger and David Medalla's auto-destructive artworks of the 1960s onwards, which were not meant to last. Lynda Zycheman has described the dilemma for conservators in deciding policy for works of that kind using the example of the boxes and kits issued by the artists of Fluxus. They are transient, interactive objects, so what kind of authenticity do they offer, preserved in a showcase?[63] Overall, the dilemma for conservation is that, whatever the decision in striking a balance between original intention and history, the effect is to try to lift the object out of time. Figure 34, with which this chapter began, shows the marks of time literally being removed. Where we see them respected, as in figure 35 at Brodsworth, it is by freezing them in time. Of course, the time so frozen leaves the objects in a kind of dream-time, or limbo, in which the veil of varnish on Watteau's *Embarcation for Cythera* is discreet, and the swags of drapery in the abandoned bedroom fall in artistic arcs.

Perhaps the question is most poignant where the aim is the original condition, and most sharply posed when the original condition seems most readily retrievable. Consider vintage cars. They are in some ways more like pieces of music than objects. They are specified in blueprints, then realised from mass-produced components, which often survive as spares or for cannibalisation, and can be reproduced more exactly by a later age, if necessary, than any musical effect. Often the grossly rusted vehicle is found in a barn, the engine in a pond. Some parts are missing, or are too damaged for use, and must be taken from another vehicle, or must be remade. The conventional preference of collectors in this field is for a vehicle which looks as much as possible as it did in the showroom. But showrooms are the stuff of dreams, and showroom appearance is, if not an imaginary moment, surely one full of fantasy, and a transient one, indeed, in the life of any car owned by me, at least. The same problem applies to aeroplanes. 'How would a child know what a Spitfire is, if he just saw it in a museum?', asks an aviation curator, explaining the decision to keep these museum-pieces flying.[64] Would the children not get a still better idea if they saw the planes spitting a bit of fire at someone? Authenticity involves function,

but it is very hard to specify in which roles an object is authentic, and in which not.

The same goes for works of art returned to 'original condition'. Just when would a painting have been in this state? It is obvious that in practice there must very often have been a great difference between an object isolated in the artist's workshop, and the object as displayed or used by whoever first paid for it. The supposed moment of truth in the studio implied, for example, by sculptures stripped of paint, an artist's-eye view of the piece uncompromised by use in the real world, now seems to us very obviously a matter of taste. Is original condition ever less a matter of fashion? Putting objects into a state in which they are assumed to express the intentions of an artist, or at least the feel of a period, is often only to send them to a kind of object heaven, where they join the plaster casts of figure 27, the ghosts of artefacts. So are there any guidelines to the physical characteristics which conservation should respect? The question is not just technical, and requires the wider context of my next chapter.

Notes

1 S. Smith, 'The Portland Vase'; P. Fisher, 'The Sophilos vase'; and A. Oddy, introduction, in A. Oddy (ed.), *The art of the conservator* (London, British Museum Press, 1992), pp. 56, 169, 12.

2 T. B. Rasmussen and V. Horie, 'Etruscan incised impasto: a case of partial authenticity', in J. Christiansen and T. Melander (eds), *Proceedings of the third symposium on ancient Greek and related pottery* (Carlsberg, Glyptotek, 1988), pp. 478–85, 478.

3 B. Smith, 'Shared responsibility: welcome and introduction', in B. A. Ramsay-Jolicoeur and N. M. Wainwright (eds), *Shared responsibility: proceedings of a seminar for curators and conservators, National Gallery of Canada, Ottawa, 26–28 October 1989* (Ottawa, National Gallery of Canada), pp. 1–5.

4 J. Jokilehto, 'Viewpoints: the debate on authenticity', *ICCROM Newsletter*, 21 (July 1995), 6–8, 7.

5 G. Norman, 'No. 1 London opens doors to display Wellington Collection', *Independent* (13 June 1995), 7.

6 S. Jenkins, 'The craftsman's contract', *The Times* (3 June 1995), p18.

7 M. Kirby Talley, jun., 'The old road and the mind's heaven: preservation of the cultural heritage in times of armed conflict', *Museum Management and Curatorship*, 14:1 (March 1995), 57–64, 59.

8 C. Carr-Whitworth, 'Remembrance of things past', *English Heritage Conservation Bulletin* (November 1995), 3, 4.

9 'New era in conservation as stately pile opens', *Guardian* (6 July 1995), 9.

10 W. J. Diebold, 'The politics of derestoration, the Aegina pediments and the German confrontation with the past', *Art Journal*, 54:2 (summer 1995), 60–6.

11 S. Bergeon, '*Science et patience', ou la restauration des peintures* (Paris, Editions de la Réunion des Musées Nationaux, 1990), p. 154 and plate 2.

12 I have based part of these comments on notes made from talks given by Ashok Roy at the National Gallery's *Paintings as physical objects* study days, 'A case of the blues'.

13 D. Saunders and J. Kirby, 'Light-induced colour changes in red and yellow lake pigments', *National Gallery Technical Bulletin*, 15 (1994), 79–97.

14 Bergeon, 'Science et patience', p. 157 and plate 8.

15 H. Ruhemann, The cleaning of pictures: problems and potentialities (London, Faber and Faber, 1968), pp. 349, 350.

16 Bergeon, 'Science et patience', p. 75.

17 H. Ruhemann, The cleaning of pictures, pp. 167, 168.

18 M. Wyld and D. Thomas, 'Wright of Derby's Mr and Mrs Coltman, an unlined painting', in the National Gallery Technical Bulletin, 10 (1986), 28–31.

19 M. Kemp, 'Looking at Leonardo's Last Supper', in UKIIC, Appearance, opinion, change: evaluating the look of paintings, papers given at a conference held jointly by the United Kingdom Institute for Conservation and the Association of Art Historians (London, UKIIC, 1990), pp. 14–21.

20 Oddy, The art of the conservator, p.11.

21 C. R. Scarzanella and T. Cianfanelli, 'La percezione visiva nel restauro dei dipinti. L'intervento pittorica', in M. Ciatti (ed.), Problemi di restauro (Rome, Edifir, 1992), pp. 185–211, 202, 203.

22 S. Waldren, The ravished image, or how to ruin masterpieces by restoration (London, Weidenfeld and Nicholson, 1985), pp. 142, 159.

23 V. Jirat-Wasiutynski and T. Newton, 'Paul Gauguin's paintings of late 1888: reconstructing the artist's aims from technical and documentary evidence,' in UKIIC, Appearance, opinion, change, pp. 26–31, 26.

24 J. Richardson, 'Crimes against the Cubists', New York Review of Books (16 June 1993), 32–4.

25 R. P. Feynman, Surely you're joking, Mr Feynman? (London, Vintage Books, 1992), p. 265.

26 H. Damish, Jean Dubuffet, Prospectus et tous écrits suivants (Paris, Gallimard, 1967), p. 47.

27 Richardson, 'Crimes against the Cubists', 33.

28 V. Walsh and J. Kulikowski, 'Seeing colour', in R. Gregory, J. Harris, P. Heard and D. Rose (eds), The artful eye (Oxford, Oxford University Press, 1995), pp. 268–78.

29 A. Vollard, Cézanne (Paris, Editions George Cres & Cie, 1919), p. 129: 'Comprenez un peu, monsieur Vollard, si je mettais là quelque chose au hasard, je serais forcé de reprendre tout mon tableau en partant de cet endroit.'.

30 J. Gage, Colour in Turner: poetry and truth (London, Studio Vista, 1969), pp. 167, 168.

31 R. Wornum, Lectures on painting by the Royal Academicians: Barry, Opie and Fuseli (London, printed for the author, 1848), p. 178.

32 J. Reynolds and E. Malone, 'Notes on [du Fresnoy's] art of painting', in Sir J. Reynolds, Works (London, T. Cadell Jun. and W. Davies, 1801), vol. 3, pp. 95–189, 148.

33 Gage, Colour in Turner, p. 46.

34 R. Jung, 'Art and visual abstraction', in R. Gregory (ed.) The Oxford companion to the mind (Oxford, Oxford University Press, 1987), pp. 40–6.

35 G. de Lairesse, The art of painting, trans. John Frederick Fritsch (London, H. G. Bohn, 1738), p. 158

36 T. Armstrong, Colour perception: a practical approach to colour theory (Stradbroke, Norfolk, Tarquin Publications, 1991).

37 De Lairesse, The art of painting, p. 175.

38 G. Waterfield (ed.), Conserving old masters: paintings recently restored at Dulwich picture gallery (London, Dulwich Picture Gallery, 1995), pp. 29–32, 41–4.

39 W. Hogarth, The analysis of beauty, ed. J. Burke (Oxford, Clarendon Press, 1955), p. 130, cited in G. Hedley, 'Long-lost revelations and new-found relativities: issues in the cleaning of pictures', in UKIIC, Appearance, opinion, change, p. 8.

40 Cited in J. H. Townsend, 'Turner's oil paintings – changes in appearance', in UKIIC, Appearance, opinion, change, p. 55.

41 J. Anderson, 'The first picture-cleaning controversy at the National Gallery', in UKIIC, *Appearance, opinion, change*, pp. 3–7.

42 Andrew McClellan, 'Raphael's Foligno Madonna at the Louvre in 1800: restoration and reaction at the dawn of the museum age', *Art Journal* (summer 1995), 80–5.

43 *Burlington Magazine*, 104:707 (February 1962); 104:716 (November 1962); 105:720 (March 1963).

44 Hedley, 'Long-lost revelations and new-found relativities', p. 8.

45 J. Beck, *Art restoration: the culture, the business and the scandal* (London, John Murray, 1993).

46 F. Th. Bratranek (ed.), *Goethe's Briefwechsel mit den Gebrudern von Humboldt 1715–1832* (Leipzig, F. A. Brockhaus, 1876), pp. 51–4, cited in McLellan, 'Raphael's Foligno Madonna at the Louvre in 1800, 80–5, 85.

47 *Restoring the ambassadors* (a documentary for BBC 2), directed by Patricia Wheatley, 1996.

48 C. Rhyne, 'Changes in appearance of paintings by John Constable', in UKIIC, *Appearance, opinion, change*, p. 76.

49 L. Keith and A. Roy, 'Giampietrino, Boltraffo and the influence of Leonardo', *National Gallery technical bulletin*, 17 (1996), 4–19, 10; Q. Letts, 'National Gallery accused of ruining paintings,' *The Times* (18 April 1996), 1–2, 2.

50 J. F. Watin, *L'art du peintre doreur vernisseur . . .* (Paris, Grangé, 1773; facsimile reprint, Paris, Léonce Laget, 1975), p. 239. Il ne faut de Vernis aux tableaux que pour rappeller les couleurs, les conserver & non pas les colorer ou leur donner un brillant qui empêcheroit de distinguer les sujets; il faut aussi éviter qu'ils soient ternes, mais ils doivent être blancs, légers et doux.'

51 L. Carlyle, 'The artist's anticipation of change as discussed in British nineteenth-century instruction books on oil-painting', in UKIIC, *Appearance, opinion, change*, pp. 62–7, 65

52 J. Cage, 'Constancy and change in nineteenth-century French painting,' in UKIIC, *Appearance, opinion, change*, pp 32–5, 34.

53 Hedley, 'Long-lost revelations and new-found relativities', p. 8.

54 C. Brandi, *Teoria del restauro* (Rome, Edizione di Storia e Letteratura, 1963).

55 Bergeon, *'Science et patience'*, p. 137 and figures 7 and 8.

56 Rhyne, 'Changes in the appearance of paintings by John Constable', p. 77.

57 S. Hochfield, 'The great National Gallery cleaning controversy', *Art News* (October 1978), 59, cited in Hedley, 'Long-lost revelations and new-found relativities', p. 10.

58 Scarzanella and Cianfanelli, 'La percezione visiva nel restauro dei dipinti. L'intervento pittorica', p.192: 'sara quindi necessario lasciarne una maggiore quantita sulle parti che hanno perso la loro intensita cromatica oppure, all'inverso, pulire in modo piu approfondito le altre zone, facendo si che si restabilisca un rapporto equilibrato'.

59 Bergeon, *'Science et patience'*, p. 259.

60 *Ibid.*, p. 115.

61 J. Richardson, 'Crimes against the Cubists', 32–4, 33.

62 K. Davenport, 'Impossible liberties: contemporary artists on the life of their work', *Art Journal* (summer 1995), 40–52.

63 L. A. Zycheman, 'Is Fluxus fluxing and/or should it be conserved?', in J. Heumann (ed.), *From marble to chocolate: the conservation of modern sculpture* (London, Archetype Publications, 1995), pp. 121–9 (papers from a conference at the Tate Gallery, London, 18–20 September 1995).

64 C. Bellamy, 'Loving care propels wartime aircraft back into the skies', *Independent* (23 July 1996), 5.

7

CONSERVATION AND INTENTION

Elusive intentions

THE MOST obvious justification for all the procedures and debates described in the last chapter is so that an object should be put into a state in which its authentic meanings – artistic or historic – will be available. But do objects have fixed meanings? For the postmodern commentators of recent decades introduced in chapter 5, any intended meaning or experience imparted by the author or through historical process represents only an irretrievable moment in the life of the work. Their point of view seems to be reflected in the physical history of objects noted in the last chapter, which makes the choice of a moment in the past as a target to which the object might be returned through restoration arbitrary, if not fantastic. The author or artist, from this point of view, seems to create, but in practice can only act for the moment upon the sign systems of his or her age, leaving behind a text or object whose meanings proliferate with every later reading and treatment. Even if we reject these positions and insist that the intentions of an artist or author do have a value transcending later interpretations, that is not to say that the intention is retrievable. The inaccessibility of artistic intention has occupied aesthetic and literary commentators a good deal in recent decades, in a debate centring on what has come to be known as the 'intentional fallacy', provoked by a paper of that title in 1954 by William Wimsatt and Monroe Beardsley.[1] But the curator or conservator hoping to rely upon artistic intention as a justification need not even begin to engage such philosophical levels before running into difficulties. Intention wilts in the face of the most down-to-earth considerations.

In the first place, physical context – original or historic – is irretrievable in a museum. No artist of the past, let alone the makers of artefacts in other cultures, is likely to have imagined anything approaching the visual context of modern museums. They are assertive environments. By contrast, going not to a museum, but to Barcelona Cathedral (not Gaudí's *Sagrada Familia*, but the

mediaeval one), is a sobering experience for a museum curator of art. Every side-chapel retains an altarpiece, from the fifteenth to the eighteenth centuries. The delapidation of some of them does little to alter an effect of spectacle which the dismembered fragments of similar works largely lose, as visitors traipse past them with hardly a glance, suspended in object heaven, categorised on the pale walls of galleries. Sometimes anatomised, too. An instance that stands for many is an altarpiece by quite a rare Cologne painter, Stephan Lochner, of whose *Last Judgement* the central panel is in Cologne, the inner wings in Frankfurt, the outer wings in Munich.

The absence of original visual context is as nothing in comparison with our inability to retrieve the mental context within which a work might have been seen when first made. Just in visual terms, for example, we cannot retrieve the impact of stylistic innovation in the arts, after even a handful of years. Manchester University's Edwardian Whitworth Art Gallery was reconstructed internally during the 1960s with one of the most complete and coherent internal architectural art-gallery schemes in the UK of the decade. I first saw it in about 1969, and the effect of airy modernity was stunning. Few gallery interiors anywhere offered anything like it, and none in the UK, and certainly there remains a striking difference in style between figure 27, typical of the old galleries, and figure 45. But thirty years on it seems a sixties period piece, with its acres of hot Scandinavian woodwork, and spindly detailing on stair-rails. How much less chance we have of retrieving, for example, the first astonishment at effects of illusory space and volume in pictures. Indeed, there is some evidence to suggest that as late as the seventeenth century some people had difficulty resolving perspective and shading into a representation of volume at all, rather as later the conventions of successive revolutions in twentieth-century art seemed incomprehensible.

Our capacity to retrieve such experiences must be lessened by the spoiling effect on our visual awareness of the saturation with brilliant colour, light and reflection which we daily experience. Compare the experience of one of our ancestors in the tenth century. Unless very wealthy, she or he would have seen brilliant reflection and saturated colour rarely other than in nature. If prosperous, there might have been some treasured bright metal jewellery and weaponry around the stronghold, but no glass, no high reflective ceramic, little truly saturated colour anywhere. No wonder we cannot imagine the effect of the jewel-encrusted effigies in their shrines, and later of the great cathedrals. Even in the eighteenth century brilliance would only have begun to intrude on the everyday life of artefacts quite spasmodically, for example in the higher glaze on widely available glasswares, luxury ceramics, and brighter pigments in everyday fabrics.

Now John Richardson describes the shifts in perception merely associated with the convention of the 1950s to 1980s, that colour reproductions should be

45 The Whitworth Art Gallery, after its conversion in the 1960s

on shiny paper. He traces it to an innovation of the publisher Albert Skira, in adopting, for a popular three-volume history of modern art in about 1950, his use of shiny papers that had previously been effective in the reproduction not of paintings, but more appropriately of glazed ceramics by Picasso: 'Since many of the plates in Skira's *History* reproduced paintings that hung in a house where I once lived, I was in a position to register the effect that the originals had on eyes queered by reproductions. Face after face would cloud over with disappointment. Where were those gorgeous coach-work colours, those plastic blacks in which you could not quite see your face?'[2] Now, moving on again, we are surrounded by a daily barrage of brilliance and movement in the man-made environment, more like the trance-inducing procedures common in feasts in many non-industrial cultures than anything in everyday life during our recent Western cultural evolution. We are no longer used to focusing attention on stimuli which do not reward us with intensity and movement.

And that's just the visual experience. Suppose we want to imagine not only a visual effect, but what it meant in social or emotional terms. The inaccessibility

of context is sharply defined when the museum is not of the culture from which the objects come. Often the mere categorisation of objects masks original context. The most obvious example is of artefacts from native cultures displayed in Western art museums. The anthropologist d'Azevedo recorded a vivid account by a Liberian carver of the experience of seeing a mask he had carved come alive in a ceremony: 'I see the thing I have made coming out of the women's bush. It is now a proud man *Jina* . . . his face is shining, he looks this way and that, and all the people wonder about this beautiful and terrible thing . . . How can a man make such a thing? It is a fearful thing I can do.'[3] Transferred into the Western market or museum the object is generally displayed just for its formal qualities, or worse still presented as important only as an example of the kind of primitive art by which some early twentieth-century Western artists were 'inspired', but even where an attempt is made at contextualisation, how much can be achieved? As Larry Shiner points out, in an article urging us not to undervalue tourist art in favour of the supposedly elevated and authentic art of the 'tribal period', 'to cut African . . . masks from their costumes, wrench them out of their living context, and enshrine them in plexiglass cases for our Sunday contemplation does not strike me as an "elevation", even if we tardily paste up photographs of someone "dancing" them and a big notice explaining their "tribal" meanings.'[4]

No great cultural distance is needed for differences of view about the inter-pretative implications of refurbishment of artworks to arise. Problems can come surprisingly early in the life time of a work of art, so much so that where contemporary art is concerned, they have become increasingly a matter for the law. The issues are often effectively ones of conservation. Stephen Weil, in a study of artists' rights in the USA, mentions Alexander Calder's distress at the repainting in green and gold of one of his black and white painting mobiles, in 1958, and David Smith's pronouncement of one of his works as a ruin after unauthorised stripping of colour in 1960.[5] At the time the artists had no redress, but now artists' rights are on the agenda in a way they were not even fifteen years ago. The impetus derives from the Berne convention of 1948 and its various revisions, to which governments in Europe and the USA are signa-tories, but whose aspirations have only slowly become, to varying degrees, enshrined in legislation. Weil has given an account of the developments up to 1982 or so, following the lead of the French act of 11 March 1957, which estab-lished the right of integrity of the work of art. More extensive legislation has been passed since.[6] Just how much protection the artist gets varies. There is little more than the right to establish authorship and, if copyright has not explicitly been sold with the work, to exercise it in the UK. In the USA there is protection against destruction or adaptation of a work as well. Canadians protect even the right to object to museum redisplay, as well as a fee if display is permitted, though the provision may be revised, since currently the cost and

administration involved for galleries are likely to inhibit just the sort of display for which artists would usually hope.

But a point to note in every jurisdiction is the studious avoidance by the law of reference to intention. The criteria the courts bring to bear in judging whether a re-presentation is fitting is instead whether the artist's reputation might suffer. Woe betide anyone, therefore, who lightly appropriates the work of Bridget Riley, a vigilant protector of her work against copyright infringement even before the recent legislation. 'The Observer and Lewis Moberly,' readers of *The Observer* 'Life' supplement were advised in May 1995,

> wish to apologise to Bridget Riley, the artist, and to those who know and respect her work and who might have suffered distress and concern by our making use of Bridget Riley's 'Cataract 3', which is in the collection of the British Council, without her knowledge or permission in a recent feature entitled 'The Hard Sell' which envisaged the marketing of drugs if legalised. The article portrayed a dummy pack of reefers wrapped in a section of 'Cataract 3' and labelled 'Riley's Reefers'.[7]

There have been, by spring of 1996, two actions in the USA under the Visual Rights Act,[8] once again both involving circumstances for artists judged to be, as the act puts it, 'prejudicial to . . . honor or reputation'. The critic Hilton Kramer, appearing for the defence in one case, questioned whether the plaintiffs had any 'honor or reputation', but not whether their intentions had been preserved. If problems like that can arise within months of the making of an artwork, how reliable can intention be as the goal of conservation?

Elusive quality

There remains one other justification for the aspiration to achieve original condition. The object in that condition may not offer an authentic experience in terms of intention, but can still be thought to offer a 'better' experience, which some makers have the talents and opportunity to realise in artefacts, and others do not. The difficulty in trying to justify any practice on the basis of quality – making, collecting or conserving – is that nobody has been able to characterise artistic quality in a way that carries consensus. Even the most convinced supporter of the idea would have to acknowledge that authoritative judges in the past found quality where subsequent generations discover little, whereas in recent Western art history later generations notoriously discover quality in productions that were neglected or disparaged in their own day. It is possible to form criteria of technical competence within most conventions, but the kind of competence assessed in such a judgement can readily be met in a good copy. As soon as the discussion moves on to what distinguishes original from imitation, gulfs of disagreement open up, like those that in chapters 2 and 4 were seen to divide the connoisseurs within any period.

We cannot perceive quality other than through the filter of our own cultural and personal preoccupations. All artistic judgement is compromised by this. Hardly any artist, collector or conservator operates without some notion of quality, yet most accept that it cannot be definitively defined. During the 1980s, for example, one of the undergrowth of supposedly arm's-length financial arts support bodies in which Britain is particularly rich, the North West Arts Association, formally resolved that quality would no longer be a criterion in allocating funds, because the concept is so notoriously socially loaded and prone to become a mechanism of social exclusion. Since then, in a minor political rustle in the arts funding undergrowth, the constitution of the support body has changed, and quality has crept back on to the agenda in the newer North West Arts Board, but still eludes definition. As we saw in chapter 2, it is not just that cultural conditioning filters whatever we see, but that cultural expectation is actively projected into experience as well.

Properties of form and meaning in artefacts

As goals for conservation, intention, quality or even the freezing of historical process in time-capsules reflect the assumption that, as we also saw in chapter 2, proved so puzzling for early connoisseurs: that there is a simple relationship between the physical characteristics of works of art, their appearance to an observer, and their meaning. Some conservators do make a clear distinction at least between physical characteristics and perceptual experience, as Chiara Scarzanella and Teresa Cianfanelli do in an article on retouching mentioned in the last chapter. They discuss procedures in which paintings show substantial losses, and they explain that such damage, in addition to its obvious intrusion on the integrity of the object, often gives rise to illusory perceptual effects. The conservator needs to allow for these, but in turn can take advantage of the power of illusion in devising interventions that reconstitute visual experience whilst remaining unmistakably distinct from the original substance of the work.[9] Even here, though, the implication is that intact physical properties of the object are the focus for conservation, whilst perceptual experience must be the focus for reconstructive restoration. The assumption is still that wherever the fabric of the artefact is intact, there is a fixed relationship between physical characteristics, perceptual effect and meaning.

On the contrary, from the eventful social lives of artefacts and the shifts in our perceptions of them with time and culture it is apparent that the relationships are far from fixed. However, the link from physical properties to aspects of perceptual effect is a lot more constant than the link from perceptual effect to intention and quality. If the physical characteristics associated with perceptual effects are the focus instead of the elusive associations of authenticity and meaning, what conservation can, and cannot, preserve is easier to understand.

To see how that might work, let us set the scene by polarising views of the links between physical properties, perceptual effect and meaning in artefacts as starkly as possible. On our right, step forward as an unlikely aesthetician the Oxford scientist Peter Atkins, who (mostly) outraged the art world with a proposal in 1990 that it will at some stage in the future be possible to characterise aesthetically effective physical properties of artworks scientifically, and so generate art to order. His argument assumes that aesthetic response is associated with a special kind of physiological change in the brain, set in motion by some physical characteristics in objects: 'The initial achievements of predictive aesthetics will be the identification of the essential stimuli that conspire to induce the physical and chemical activities that are recognised as constituting response to art.' He goes on to explain that the effect might not be a response just to a single stimulus, but might arise even for visual art in some way from comparative properties of successive moments of perception. He points out that one of the explanations for the power of the golden section (whose proportions are, for example, seen in the facades of many Greek temples), is that the time it takes the eye to scan the height and width successively is in almost exact proportion to a major sixth in music. Then he speculates that perhaps we now have a much better candidate than the old golden section for the kind of specifiable physical stimulus we seek, in the mathematical patterns known as fractals: 'A single golden section may ignite a single region or circuit (in some sense) of the receptive brain. A single fractal image is *sure* to transmit as many rhythms and inevitably to stimulate any brain.' [10]

On our left, we might say, are the majority of postmodern theorists, for whom anything of the kind described by Atkins is just a power-loaded mythology: 'rejected here,' Keith Moxey assures us, 'is any notion that aesthetic value may reside in the inherent qualities of the work of art. Just as there is no truth to be found in history but only ideologically inflected narratives of one kind or another, so there is no aesthetic value to be found in the work beyond that which we put there ourselves.' [11] Mark Sagoff puts it even more starkly. The perception of a work of art may involve some special qualities of sensation, he advises us, but we are missing the point if we associate that kind of thing with significance. Discussing the difference between a painting and forgery of it, he explains that even if the two should be visually indistinguishable they belong to different categories of objects. Any similarity in the way that just looking at them 'gooses you up' is trivial, since 'the value of an artwork consists not in the tingle you feel when you see it, but in the amount it advances understanding. This requires that we study the artwork as a symbol, not that we immerse ourselves in it as if it were a bath'. Just sniffing the paint of a new forgery, he concludes, might well be more exciting in terms of sensation than looking at any painting. [12]

The gap between Atkins and Sagoff might be summarised in an analogy

between artefacts and food. Some artefacts certainly offer experiences of colour and shape that seem as direct as tastes. Even these experiences, like taste, cannot avoid being to some extent socially formed, but response to them is probably largely determined by physiology. Peter Atkins seems happy to limit the effects of artworks to something like that, and is confident that one day we will have recipes for art as for food. Of course, that would not stop artefacts from aquiring all kinds of social meaning, just as the preparation and consumption of food do. Few questions so fire the anthropologist as why some foods are taboo, whilst others are reserved for special feasts. However, in Atkins's model the intentions of most artists could reasonably be limited to what is probably the attitude of most chefs, that such social dimensions may have their place in the dining-room, but that what matters in the kitchen is what it tastes like. Intention would be very much a matter of the kitchen and the studio in this view, and its preservation or retrieval just a matter of the physical substance of the creation. Sagoff's analysis is exactly opposed. What the food may taste like may (according to him) be a matter of transient concern for diners, but for the student of intention what matter are the meanings associated with it. Neither account surely matches the experience of artworks for most people very well. Atkins's prescription makes art sound like a visual drug. Sagoff sounds like a food commentator with no taste-buds. What is sauce for the goosing up remains sauce even for a culturally contextualising gander.

A position that better accommodates both perceptual effect and social meaning is offered by Alfred Gell. His objects of study are from the south Pacific, but he addresses the way visual effect and social meaning can work together in any society. He describes the patterning which decorates canoes used in the exchanges that comprise what is known as Kula trade between certain islands in Melanesia, and explains the intended effect of these carvings, which bemuse the eye by the intricacies of their designs. Figure 46 shows an example. 'If one makes the attempt to fixate the pattern for a few moments by staring at it,' Gell notes of another design in this tradition, 'one begins to experience peculiar optical sensations, due to the intrinsic instability of the design . . . '. These ornaments were intended so to bemuse the trading partners of the approaching mariners as to place them at a loss in the subsequent bargaining. This, as Gell points out, seems a lot to ask of even the most bemusing design, and he locates a more probable source of their magical effect in the social power invested in the ownership of such an effective design, though again suggesting more complex homologies between the 'slipperiness' of the designs and concepts of Melanesian cosmology.[13] So on the one hand, much of the meaning of the object vanishes if it is described with no mention of how it is invested with power, but on the other, the perceptual properties of the design remain effective even for a viewer unaware of the social roles they might play.

Gell's account is particularly compelling because of the link it makes

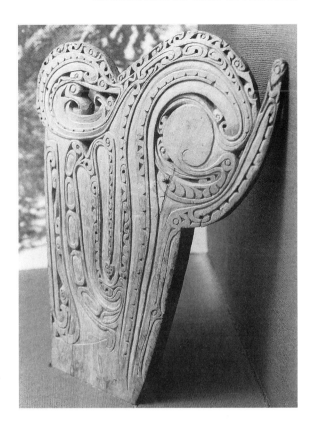

46
Ornament from the wash-
board of a canoe used in
the Kula trade, Melanesia

between the social life of artefacts and perceptual puzzles – in this case what
Gell calls the instabilities of the design – built into their fabric. Physical
characteristics that present a degree of perceptual oddness, though taking the
most varied forms, are almost universal in works of art. The perceptual effects
are to a great extent cross-culturally perceptible, but combinations of particu-
lar devices tend to be specific to particular cultures, as illusionistic perspective
and patterns of paintwork have been in European painting of the last 500 years.
As Ernst Gombrich explains in an account of the role of perceptually puzzling
devices in ornament, they usually play a role in whatever wider social mean-
ings artefacts aquire, as well as in their immediate visual effectiveness.[14] What
is more, the adaptations of the artefacts of one culture when re-presented in
another often centre on transformations of perceptually anomalous effect.
That includes the interventions of conservation, and an account of what
conservation can and cannot hope to preserve requires an understanding of the
role of perceptual anomaly in a little more detail. The physical contrivances
that give rise to it are not the site of fixed intention, but they do seem the best
focus for the source of changing meanings in artefacts.

Sometimes the perceptual puzzles and anomalies are very obvious in works of art, as in the vegetable head paintings of Arcimboldo, the seven types of ambiguity that Empson famously studied in poetry, [15] or the musical canons of Bach. An example from north-west Canadian Indian art is shown as figure 47, its central features either parts of two killer whales seen in profile, or of one bear seen head-on. No representation at all, however, can avoid some competition between perception of whatever is represented and the medium in which it is realised. Any carved or painted figure seems to offer the real presence of whatever or whoever it represents, at the same time as remaining just a carving or painting. The effect has often been articulated, for example in the description by Richard Feynman quoted in the last chapter, of his experience of looking at a Japanese painting of flowers. Here is a mid-fifteenth-century Italian commentator on ornaments in a painting of an enthroned Madonna: 'What I had seen from one point as round shining pearls and gleaming gems projecting from the base of the gold-coloured dais, appeared from another point as even smooth panels of flat pigment.'[16] In the majority of artefacts, however, as seen in figure 47, that kind of ambiguity is enhanced with more elaborate devices, though they may not be as obvious as the contrivances of an Arcimboldo. The key to these is the idea of segmentation.

Segmentation is a concept rather left over from 1970s human and machine vision research. It never quite fulfilled an early promise for engineering automated recognition, though it provides a helpful framework for looking at aesthetic effects.[17] It is most familiar in relation to language. A stream of words is

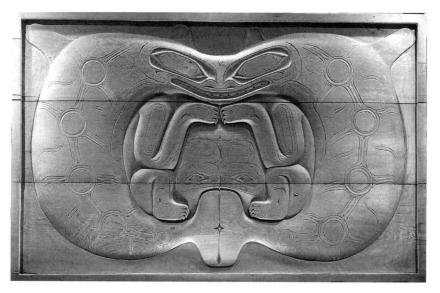

47 Killer whales or bear, carved panel, north-west coast Canadian, twentieth century

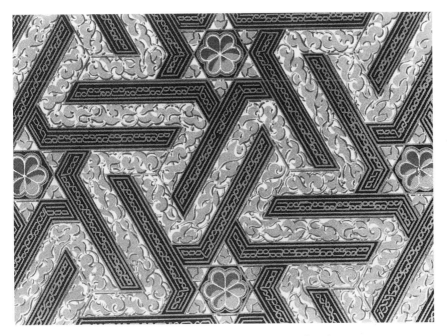

48 Decoration from the walls of the house of Sanchez in the Alhambra

physically a mostly unbroken stream of sound, yet somehow we segment it per-
ceptually into separate words. More generally in perception, we seem to
enhance just the discontinuities in the flow or field of stimuli around us that
correspond with the boundaries of chunks which make sense. Sense seems to
depend on good registration between two rather separate chunking opera-
tions, which we might call grammatical and semantic by analogy with seg-
mentation in language. For each we can to some extent specify rules which
determine whether they are 'well formed'. That is, verbal expressions may be
semantically clear enough, even though grammatically incorrect, or may be
grammatically faultless, yet meaningless. The distinction is generally not
obvious, since in our everyday experience the two varieties of good form are in
register.

In vision, the chunking we might loosely call grammatical seems to organ-
ise abstract aspects of what we see into orderly hierarchies of outlines and
occlusions, figure and ground. This visual scheme is not such an elaborate set
of relationships as linguistic grammar, but is still a remarkably stable set of
assumptions about transformations in the visual field, based on experience of
visual relationships between rigid objects under object or observer movement.
Figure 48 reveals some of the assumptions by thwarting them. It shows a design
from the Alhambra, and would remain an apparently flat design but for places

49
A scene that is evidently
not 'well formed'

at which three short line segments meet (there are six of them in this figure), suggesting corners. If these are understood as corners projecting towards us, the design develops a ceaseless instability, since it is impossible to resolve the whole scheme into a consistent three-dimensional scene. It nearly works, if every alternate corner is read as concave, rather than projecting out towards us, but then the six-point stars and detailed patterning within the straps disrupt the effect.

What the design resists is shown better in figure 49 (an adaptation of figure 4, but this time with the figure of the son of Niobe more apparent). Here again parts of the image seem locally orderly, but the whole is certainly not well formed, and the prime culprit is the single outline running around the whole image. It does three things profiles do not do in our visual experience. It encloses both space and objects within a single profile, so that they blend into one another. That is an impossibility, whereas its other offences are merely wildly improbable. In places, for example where the edge of a vase-shape and of a leg of the Niobid meet, irregular profiles match as snugly as adjacent pieces of a jigsaw, leaving no gaps, with no occlusion of one edge by another. To illustrate the third impropriety, I have taken the liberty of impaling the Niobid with a spear, since something of the kind is the inexorable fate of Niobids anyway. It adds another dimension of confusion to the spatial organisation of the scene if it is seen as one long spear. It could make spatial sense locally, as a very unlikely alignment of unusual slots and sticks, rather than a continuous object, but only as an astonishingly improbable conjunction. The point that these two figures make, therefore, is that we have powerful inbuilt expectations about what both two-dimensional profiles in images, and any objects in space that they represent, may and may not do. We expect to be able to segment scenes in to orderly arrays of separable profiles, sometimes overlapping, sometimes enclosing space rather than objects, but taking the form of closed loops.

Those rules apply even for shapes that cannot be resolved into recognisable objects, but provide a template of order on to which we seem to try to map recognisable objects from our knowledge of the world. Usually a set of recognisable shapes that make sense together coincide with an orderly array of

the edges in whatever we see, without our being aware of any alternative hypotheses, but figures like 47 and 49 seem to anatomise the process, because our awareness oscillates between alternative, incomplete segmentations of the scene.

Formulating rules of these kinds as a basis for automatic visual recognition by machines may not have fulfilled the promise it seemed to hold out for engineers of the 1960s and 1970s, but there is a case to be made that artists in many periods and cultures have hit on surprisingly consistent rules to thwart them. The thwarting seems to create perceptual play, sometimes provoking perceptions which can actually oscillate, sometimes a steadier awareness of multiple readings, which in quite mysterious ways enhance meaning, emotion and experience.

In visual art it is convenient to think of these segmentation-thwarting effects in three categories. First, the image may be semantically ambiguous, so that a part of an outline may make equally good sense as an edge of two or more mutually exclusive ways of resolving a scene, or of a part of it. Second, segmentation is often simply camouflaged, either by patterning running over both objects and grounds or where edges are broken or lack emphasis, in either case departing from expectation about grammatical rules of pattern and contour. Third and most extremely, the artist may have made it simply impossible to resolve the work into a picture or narrative of well-formed parts and wholes, either semantically or grammatically, or both. Sometimes semantic ambiguity, grammatical camouflage and irresolvabilities are combined in one work of art, but we will consider them one by one.

Ambiguity is most obviously introduced as alternative semantic readings of whatever is represented. In such works, well-formed objects can be resolved, yet individual line segments may form part of more than one such object. The best-known examples are the confections of Arcimboldo, but Picasso and Dali in this century were tireless inventors of often similarly ambiguous devices. The whole genre was extensively explored as regards Western art in the exhibition *The Arcimboldo Effect* in Venice in 1990.[18] The semantic alternatives need not even be between recognisable objects, but just between those parts of an image seen as abstract shapes forming a figure and those parts as ground.

A second set of segmentation-thwarting perceptual anomalies arises when the inherently ambiguous nature of any representation is enhanced by camouflage, an anomaly of the grammar of visual scenes, which is almost universally imposed on any representation by patterning characteristic of a graphic process. In everyday vision, variations in the pattern and intensity combinations from object to object in the visual scene help us to distinguish one part from another. Any graphic or even photographic technique, by contrast, is bound to impose over objects and backgrounds alike some regular pattern properties characteristic of the process. Arthur Laurie's macro-photographs of

paint impasto in figures 6–8 illustrate the point. The impasto patterning is evidently quite unlike any texture we would associate with hands in everyday vision, imposing on the hands instead pattern characteristics we find throughout the painted surface. Even in photographs, lens and emulsion properties impose surprisingly specific characteristics across the image, which photographers often enhance as effects of blurring or grain. Those artists aiming at extreme illusion or deception, who strive to lose the effects of this kind of patterning have been the exception. Most have delighted in the play between clear delineation and the overall effects of process patterning, in the way carried to an extreme in the paint patterning of van Gogh.

The patterns imposed across an image by artists need not derive only from graphic processes, but may be constructed on larger scales. Gombrich makes the point that we associate pattern of this kind with reduced attention, so that perceptual anomaly is subtly enhanced if the most semantically and emotionally charged parts of a scene are either more camouflaged than other parts in this way, or are repeated so as themselves to become pattern.[19] As he points out, the decoratively repeated car crash scenes of some Warhol wallpieces play on this effect.

An even more systematic urge to sabotage the perceived power of imagery to offer illusion appears where outlines and edges are deliberately broken up, rather than clarified. Effects in which the dominant boundaries of contrast in a scene do not coincide with the semantic segments are a particular feature of Western representational painting, thanks to the scope for manipulation of the represented illumination. Rembrandt and Turner revealed different extremes to which these effects could be taken. Strong lighting from the side or underside, laying a confusion of highlights and shadows over a scene, is dramatic almost by definition. Glaring sunsets and their reflections in the efforts of many a more modest imagination play upon the same effect, ensuring that the edges of highest contrast in a scene are dislocated from the horizons and edges of things represented. Abandoning illusionistic illumination, Cubist artists took these anomalies much further, since even where objects were allowed to remain coherent in their representations, patterning on a variety of scales extends across the picture surfaces, along with anomalous extended or additional edges. Thanks to the Cubists, camouflage is a not inappropriate label for all these effects, given Gertrude Stein's famous account of Picasso's amazed reaction to his first sight of a camouflaged cannon in Paris early in the First World War: 'We did that! That's Cubism!'.[20]

The third set of segmentation-thwarting effects to consider are those where artists have gone further still, and evolved artistic devices in which shapes and objects offer no well formed resolution at all. Surrealism and Cubism in the Western tradition show these effects as semantic and grammatical anomalies respectively. Surrealist paintings are usually (though not always) well formed

grammatically, but not semantically. A good deal of more recent contemporary installation art depends for its effect upon semantic anomaly as well, for example the glass igloos of Merz. Cubist paintings by contrast were often well formed semantically, assemblies on table-tops of objects typical in studios of the time, but manifestly came to depart from spatial 'good form'. The ways in which in Cubism outlines were left incomplete, or incongruously emphasised or extended, whilst the orientation of surfaces was wilfully confused and coherent figure ground distinctions eliminated, add up to a remarkably systematic decomposition of visual sense by gifted visual thinkers. (Students of perceptual psychology might note that the irresolvable faceting of Analytic Cubism seems a mischievous anticipation of the organising facets which were to play a key role in the perceptual theories of David Marr.)[21] Irresolvability is a less common device than ambiguity or camouflage, but the Kula ornament illustrated in figure 46 is another example of it. A careful look reveals it as a representation of a head, yet within it every form runs into every other.

Generally, camouflage, ambiguity and irresolvability seem equally ubiquitous in the artefacts of ancient and non-Western cultures. Camouflage by patterning imposed by the production process is as universal as in Western conventions of representation, particularly in the weave of textiles. Alternatively, creatures are surprisingly often literally camouflaged by dense patterning or interlacing. The creatures interwoven in Viking interlacing, Shang dynasty bronzes and Maori carvings are familiar examples. Geometric interlace also offers varieties of ambiguity, as the eye follows first one route through the tracery, then another. Irresolvability is less common, but to point to just one example, it distinguishes the raffia cloths of one group of the Kuba of Zaïre from those of another. As Dorothy Washburn pointed out, the dominant Bushong prefer regular patterns presenting figure/ground ambiguities, whilst the Bashoba specialise in irregular, improvised and transforming patterns which may resist well-formed segmentation into coherent sequences of figure and ground altogether.[22]

There are dangers in attributing too much importance to effects of these kinds. For a start, to what extent is the account of segmentation-thwarting proposed here culturally specific to an eye schooled in Western habits of psychological perception and aesthetics? A good example of the problems of trying to apply such notions of grammatical and semantic good form transculturally is the detail from a painting from what is now Arnhem Land in north Australia, shown in figure 50. Paintings of this kind have been extensively studied by Howard Morphy.[23] They present figures in narratives carried in densely patterned surfaces, dominated by stripe and diamond patterning at a periodicity of a few inches, finished with more detailed hatching at a scale of tenths of an inch. Semantically, we have no grounds for doubting that their narratives are well formed, if not in a sequential form of quite the kind we are accustomed to

50 Detail of the lower half of a Yolngu bark painting from Arnhem Land, north Australia

in the West. They depart from everyday visual experience, but that is no obstacle to visually semantic 'good form,' since the narratives still present objects which make sense together. With regard to what we have called a kind of visual grammar they are less straightforward. The principal features of interest would be the stripe and diamond patterning. For the most part they form a background to the figures, yet they seem wilfully to avoid the kind of consistent continuations behind the figures which a well mannered background patterning should present, and to compound their misbehaviour they reappear in panels overlaid on top of the principal objects. According to the thesis presented in this chapter, this departure from well-formed figure/ground dis-

crimination should be a principal component of the expressive effect of the image for the people who made it, as well as for viewers from the Western tradition.

From Morphy's account, however, it seems clear that the most important feature for the Yolngu is the impression of brilliance the pictures offer, which characterises them as direct expressions of sacred ancestral power. The brilliance and sacred power, as discussed by the Yolngu, are invested primarily not in the diamond patterning at all, but in the fine cross-hatching. The characteristics of the diamond patterning, by contrast, identify the social and ancestral group from which the paintings come, and indeed, as signs of identity, are often applied in life as in imagery to the bodies of people too. Such diamond patterning, overlaid with bright hatching, also, Morphy tells us, makes other, multiple references, including, for example, to 'honey glistening on the cells of the hive and the sparkle of fast-flowing fresh water'.[24] Now part of its contribution to the effect of shimmering brilliance, which lies at the heart of the meaning of the picture for the Yolngu, may well derive from the way that it also breaches figure–ground rules, which may, therefore, be as much a part of Yolngu experience as they are of ours. But if so, the Yolngu, though eloquent about other properties of the picture, do not seem to say so. The discovery by a contemporary Western eye of perceptual puzzles of this kind in artefacts of many cultures may, therefore, be to bring to bear on them inappropriate habits of Western perception.

At best, there must be variation in the extent to which we can share the experience of visual effects cross-culturally. Nobody could doubt that perceiving semantic anomalies in poetry depends upon understanding the language in which it is written, and music composed in unfamiliar harmonics is difficult to follow. Just how we hear some illusions of sound seems to depend upon the characteristic speech inflections we grow up with, so that Californians hear them one way, Britons another.[25] With vision, it seems that even so apparently stable a property as apparent size is remarkably subject to environmental formation. Colin Turnbull describes how, on a cross-country journey with Kenge, whose entire life had been spent as a hunter–gatherer in dense forest, they came for the first time to an extended view over the landscape, with nearby and distant antelope. 'What insects are those?', Kenge asked of the distant antelope. It remained unclear whether, on this occasion or later when looking at a distant boat whilst crossing a lake, which he took for a stick, he was able to accept the explanation.[26] Similarly, in Howard Reid's film of the apprenticeship of a Peruvian rain-forest Yaminao shaman, the apprentice is taken, for relaxation, to town, to see a film for the first time. Amongst many fascinating observations on the experience, he emphasises the huge size of the figures on the screen. The adjustment to the convention which we make effortlessly seems to have been impossible for him.[27] I have found myself, along with other tourists, when

confronted by the novel spectacle of the vast size of underground caverns, that the mind resists admitting their size, so that distant stalactites and stalagmites appear far smaller than their measured dimensions as related by the guides.

But neither Kenge, the apprentice sorcerer, nor I and my fellow-tourists seem to have had any trouble agreeing over boundaries round the objects which were the focus of discussion. There is no doubt that even that kind of discrimination can be tricky in the face of an unfamiliar stimulus, for example X-ray plates examined by a novice radiographer, but it does seem a candidate for the least culturally-formed aspect of perception. Though in the case of the Yolngu paintings the issue remains unclear, in other cases where an insight into the social meanings of unfamiliar artefacts is provided for us, we do seem to share with their makers aspects of their visual effects, particularly when what are at issue are the shapes which do, or do not, jump out.

It seems odd that effects like these should be as widespread as they are if they do not play some quite fundamental role in carrying meaning. They are as familiar in other aspects of cultural production as in painting and sculpture. Ambiguity, camouflage and, especially in the twentieth century, irresolvability, have also been said to be characteristic of architecture, poetry and music. Robert Venturi put oscillating, contradictory effects at the heart of architectural effect.[28] In addition to the specifically ambiguous semantic instances in Empson's famous study, rhyme and metre seem very generally to act in poetry as camouflaging patterns in ways analogous to those of graphic patterns. Nor is Empson's famous study of semantic ambiguity in literature the only one. Here is Jean-Pierre Vernant on the way that ambiguity in ancient Greek tragedy made it a forum for exploring the issues faced by citizens as they tried to reconcile myth as a basis for social cohesion with emergent notions of law:

> In the language of the tragic writers there is a multiplicity of different levels more or less distant from one another. This allows the same word to belong to a number of different semantic fields depending on whether it is part of a religious, legal, political or common vocabulary . . . This imparts a singular depth to the text and makes it possible for it to be read on a number of levels at the same time. The dialogue exchanged and lived through by the heroes of the drama undergoes shifts in meaning as it interpreted and commented on by the chorus and taken in and understood by the spectators, and this constitutes one of the essential elements of the tragic effect.[29]

Harmony in music is perhaps always a form of camouflage, because it presents coincidence in intensities in trains of higher harmonics in sound from different sources, whose lack of coincidence may normally help in segmenting one sound from another. Sloboda, discussing whether there can be said to be a grammatical basis to musical composition, gives examples of what we might call other ambiguities and camouflage, and concluded: 'Put simply, if a com-

position is totally generated by grammar it is likely to be dull; if it breaks rules in an unmotivated way it is likely to be unintelligible. The best linguistic analogy for musical composition is not so much the utterance of a novel sequence as the utterance of a non-sentence (as in poetry) . . . '.[30]

It is certainly not clear just why devices that thwart this very fundamental task in making sense of the world can be so effective. It could be that a source of their effects lies in their disruption of the timing of perception, so that they act in something like the way in which Atkins suggested the golden section might. As long ago as 1917 it was also suggested by the Russian Formalist Victor Sklovskii that poetic effects derive from the way in which such devices increase the duration as well as the difficulty of perception.[31] At the present time, very little is known of any role for timing in mental processes at all, though there have been some suggestive studies and proposals. Well-known studies associate verbal semantic anomaly with measurable changes in electrical brain activity.[32] Walter Freeman, using novel techniques based on chaos theory, has speculated that we will find oscillations in patterns of electrical brain activity when viewers perceive ambiguous pictures.[33] These are mere shreds of evidence, but interest in the role of timing in brain processes is growing.[34] For the moment, however, the vision researcher Semir Zeki, whilst speculating on the roles timing might play in perception, notes that we lack a research tool which will reveal them with any precision.[35] There is no prospect in the short term that neurophysiology will enable us to understand even the immediate effects of segmentation-thwarting devices, let alone any enhancing connection to larger meanings they may offer.

These perceptual effects by themselves do not comprise significant aesthetic experience, or figure 49 would be a masterpiece. They do, though, seem to aquire emotional charge when they are the vehicle for larger social significance. Numerous studies have discovered a rich source of proliferating meanings in perceptually anomalous effects in specific contexts. The ones associated with shifts in Western painting, whether the invention of perspective or the confrontation between Salon painting and Impressionism, for example, are familiar themes of art history. Very specific accounts relating social and personal meaning to the subtlest variations in the illusionistic effects of the paint-work of Hogarth and Chardin are proposed by David Solkin and Michael Baxandall respectively.[36] But how general a source of specific social meaning perceptual anomaly can be is brought home by studies of other conventions, in archaeology or anthropology. One of the earliest examples, which turns up in many versions ascribed to a wide range of dates in the first millennium BC in ancient Mesopotamia, suggests that the association of meaning with ambiguity is not confined to artefacts. It seems itself an evocation of a separate ambiguous experience, when the face of the demon Humbaba appeared in the entrails during divination. When the intestines are like that, the inscriptions apparently tell us, there will be revolution in the state, for sure.[37] Anthropological studies

of more recent cultures offer examples to add to those of Gell and Morphy already mentioned. The carved panel in figure 47 is probably a tourist piece, but the way in which the ambiguity it presents suggests transformation from one species to another is a widespread theme of the art of the region. For the Kwakuitl, Stanley Walens explains, such transformations in turn reflect more fundamental beliefs about the migration of spirits from creature to creature through the processes of hunting and eating.[38] David Guss gives an account that relates figure/ground patterning in the woven baskets of the Yekuana of the Amazon rain forest to deeper mythological themes in an analogous way.[39]

For some theorists the secret of the emotional punch that perceptual oddness can bring to works of art and of poetry lies in the play it offers between between whatever is represented and the language or material in which it is presented. So for Sklovskii in the second quarter of the twentieth century, the consequence of these devices, whether by disrupting timing of perception or otherwise, was a 'making strange' of the subject, in a way that focuses attention on the medium, and that he understood as the origin of all poetic effect.[40] Umberto Eco, much more recently, develops the idea, so that making strange is only the start of the process, just as it was for the canoe ornament in Gell's account. Meanings proliferate when there are ambiguities both in the meanings suggested and in the medium employed to express them, so that the receiver's attention is drawn to the medium as well as the message, and the ambiguities at both levels play upon one another: 'The message assumes a poetic function (though in this context it is preferable to call it an "aesthetic" one, granted that we are dealing with every kind of art) when it is *ambiguous* and *self-focusing*.'[41] Our knowledge of the mind perhaps does not enable us to be sure whether such detailed accounts as these are on the right track in explaining just how the link from anomalous perception to meaning is made, but their case that the link is a defining characteristic of artworks is compelling.

A difficulty that is full of implications for the role of conservation in the life of artefacts now needs to be faced. Although perceptual anomalies remain consistently a source from which other meanings proliferate, the particular perceptual effects that an artefact presents do not by any means necessarily get preserved as it moves from context to context. Furthermore, it is precisely in the process of conservation that these effects are liable to be transformed. Whether preserved, retrieved or transformed, therefore, these perceptual devices offer in practice a much better focus for discussion of the interventions of conservation and of the role of conservation in the life of artefacts than does intention.

Physical change and the social life of artefacts

Three alternative situations commonly confront the conservator required to intervene dramatically in the physical state of an object, and all can most

readily be explained in terms of perceptual play: in the first, the particular effects of perceptual play imparted to the object by its maker are substantially recoverable; in the second, there may be dispute as the effects of this kind that the object at first presented; in the third, physical change has irretrievably destroyed any hope of reconstituting first effects of this kind.

For the first situation, consider a painting like *Edmund Spenser* by William Blake, of which a detail, taken part way through removal of overpaint, is shown as figure 51. The picture had been substantially damaged and overpainted, but enough remains of Blake's paint to leave his linear effects retrievable. The perceptual anomaly in this case is the pull between the illusionistic representation and surface characteristics, but with an emphasis on linear patterning in the latter. The overpaint obscures the linework without adding much by way of compensating enhancement of illusion, because it is downright clumsy. The overpainted eye is just a lozenge, whilst the eye drawn by Blake which is emerging on the right presents both the calligraphic properties of line in which he delighted and at the same time is a remarkable evocation of three-dimensional structure. If anyone were to wish to make a three-dimensional model of this eye, there would be no uncertainty as to where to model prominence, and where recession. All this the restoration can retrieve, but only an interpretative gloss could add an insight into what such linework meant for Blake, in terms

51 A detail from William Blake, *Edmund Spenser*, during cleaning

of his own earlier life as an engraver, proud of his wiry lines, or of the burden of signification they carried at the time, by contrast with the smoky paintwork and effects made fashionable by Blake's bugbear, Joshua Reynolds. None the less, wherever the initial conventions of perceptual anomaly first realised in a work can be retrieved, as in this case, there is a strong case for doing so, not on grounds of quality, which is too loaded a term, but of visual effectiveness. In special cases the history of the object might be judged more important, but in general, the initial perceptual scheme is simply likely to be more visually effective than any adaptation of it. That is certainly true in the case of the Blake. Our understanding of how visual devices like the ones this portrait presents evolve, and our best chance of some interpretative insight into the meanings that proliferate from them, depend on retrieving them where we can.

The other two situations are much more problematic. The most contentious instance of the second situation, in which there is dispute about the particular illusionistic devices adopted, is presented by the debates over the recent cleaning of the Sistine Chapel ceiling. Anxieties have been expressed about the long-term chemical effects of the principal substance used, but the main debate has focused precisely on the issue of the kind of perceptual device Michelangelo adopted in creating the pull between illusion and surface in this case. The painting now appears in extremely vivid colours, offering a dramatic effect of relief, but in terms not so much of light and dark as of variation in colour and in the saturation of colour between foreground and background, and between surfaces exposed to light or hidden in shadow. For James Beck this is a travesty of Michelangelo's strategy, which Beck insists was to build up modelling in a way much more consistent with the appearance of the painting before cleaning, with a layer of toning overpaint, added on top of the original fresco, reducing the effect of colour to leave a dominant effect of modelling not through colour but in terms of light and shade.[42] As was seen in the last chapter, there are few problems as tricky for the painter, especially in the Western tradition, as that of reconciling colour and tonal schemes, and it was a problem of exceptional acuteness in the early sixteenth century. As John Shearman explains, innovations in modelling introduced by Leonardo had posed these problems inescapably for artists of just the time when the ceiling was painted, and it can be easy for us to forget, from the vantage-point of several centuries of experience in its management in illusionistic painting, what a puzzle it must have presented.[43] The choice of strategy Michelangelo adopted in achieving perceptual effect at the time, in other words, was probably as knotty an issue as the question of just which strategy it was is now.

Beck believes that the treatment the ceiling received stripped from it the layer of modelling, added in glue and in dry *secco* paint on top of the original fresco, on which a predominantly tonal illusionistic scheme would have depended. Perhaps the key document, reproduced by Beck, is a drawing by a

mid-sixteenth-century miniaturist, Giulio Clovio, done when the ceiling painting was only some twenty years old. It seems to show a shadow on the ground behind the foot of the figure of Jonah, apparent on the ceiling before cleaning, now vanished. This is much the strongest of a number of indications that some tonal modelling integral to the original scheme may have been removed, whether it was Michelangelo's own or, quite possibly, an earlier conservator's replacement of it, after an inadvertent earlier removal of Michelangelo's *secco* paint. Any change of that kind could represent a dramatic change in the variety of illusionism intended by Michelangelo.

In assessing what is now to be seen it is hard to disentangle the discussion of the physical characteristics of the ceiling from discussion of our experience as viewers. To me, the overall tonal balance of Clovio's study, to judge from reproductions at least, suggests no greater contrasts of light and dark than those of the colours that the ceiling now presents, and the effect of modelling and relief through colour that the ceiling itself now offers remains coherent and extraordinary. To the specialist scholar of the Renaissance Charles Hope, reviewing James Beck's book, though first indications of the cleaning looked promising, the final effect of the colouring is of Michelangelo redone by Walt Disney.[44] Even if Beck and Hope are wrong, and there was never much more tonal modelling than remains, we know nothing of any allowance that Michelangelo might have made in his colour scheme either for the effects of time, or just for the far lower level of illumination that the ceiling would have received in the sixteenth century, in comparison with its bright illumination today. In this case, unequivocal answers are now not to be expected. Michelangelo's intentions too would have extended to preoccupations we cannot share. The visual effect was only the starting-point for the meaning of the project for him, since apart from the ostensible devotional meanings of the work, the visual sense of substance offered by modelling was also bound up with a deep concern shared with Leonardo but hardly burning for us today, with the relative status of painting and sculpture. Whether illusionism dominated by tonal or colour relations better met these preoccupations is something we cannot now retrieve. All we can be sure of is that if the ceiling has been transformed in putting it into a condition that matches what Michelangelo means for the tourists who are now its principal audience, it is in an adjustment of the precise way in which it is perceptually ambiguous.

This is even more the case as regards the third situation that often confronts the conservator, in which any perceptual effect an object may at first have presented is known to have vanished irretrievably. The issue arises most often with polychrome sculpture, whether from ancient Greece or mediaeval Europe. It is easy to forget that most ancient Greek and mediaeval northern European sculpture was brilliantly coloured. The effects of these pieces when new must have been in some cases illusionistically deceptive, in every case vivid. Time

and treatment have physically reinterpreted most of them, removing the paint in accordance with the later convention that no surface variation on sculpture should intrude upon the modelling of form just by the play of light and shade. Hence, of course, the pale plaster ghosts in their sculpture limbo in figure 27.

Consider in particular the Madonna and Child brought into a painter's workshop by an early sixteenth-century nun, seen in figure 52, from a small tapestry. (It is currently available only as an old photograph, since the tapestry itself was either destroyed, or was the subject of one of those artistic *furta sacra* mentioned in chapter 1, in the chaos of the fall of Berlin in 1945.) It seems that this small carving of the Virgin and Child is about to be renovated. Somehow it does not look as though the nun and the painter are necessarily going to agonise too much about the artistic intention of whoever first carved and painted it. Indeed at the time the painting of such sculptures was at the centre of something of a power-struggle between the carvers and the painters, who sought to retain for themselves the exclusive right to colour such artefacts. On other occasions carvers might follow the new convention introduced by the German sculptor Tilman Riemenschneider, and leave the carving with a monochrome coating, but then the patron on occasions had the work coloured.[45] Whose intention should the conservator attempt to retrieve or preserve in a case like that? But it gets worse. Figure 53 shows a not dissimilar sculpture of the period, though it is German rather than Flemish. The picture comes from an auction catalogue, and the entry for this piece confirms that the flakes of paint that can be seen still clinging to it were traces of an earlier bright livery. However, in such condition, the sculpture did not approach the visual effect it must have presented when it was newly carried from a workshop, as seen in figure 52. Its environment was quite different too; a collector's house in Munich, of which a room appears in figure 54. No longer did the carving show the bright representational colours appropriate to an object of religious devotion to the Virgin Mary. Its lost details and flaking paint now signal age, and from the photograph of the collector's house we can see how it must have played a part in an assembly redolent of nationalistic faith in form as an expression of the virtues of peoples that was so much a feature of the early decades of this century. The meanings of the carving change with each new presentation, but with large shifts signalled by transformations of superficial visual effect. It is a palimpsest of intentions and meanings, that now offers no possibility of disentangling one layer from another through any treatment.

Three different sets of variation, therefore, confront the historian of art. In the first place there is the evolution of novel perceptual ways of 'making strange', such as the development of perspective, or of Cubism, in artworks as first realised. Then there is the history of the characteristic ways in which time and later practices of re-presentation have transformed perceptual anomaly, and meaning with it, as in the stripping of paint from polychrome sculpture.

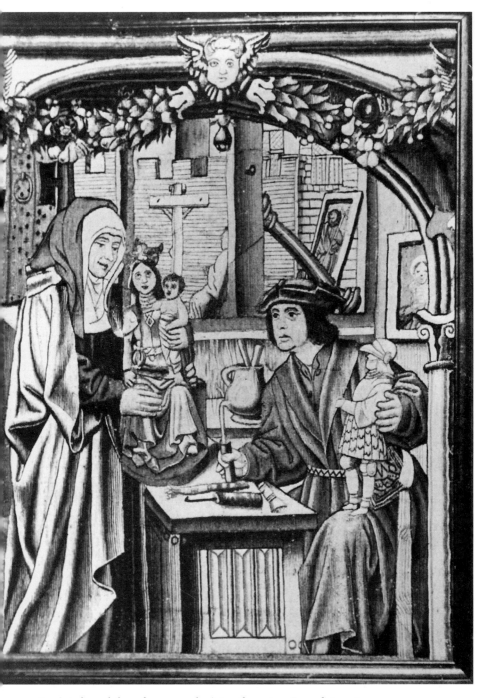

52 A painter's workshop, from an early sixteenth-century Brussels tapestry

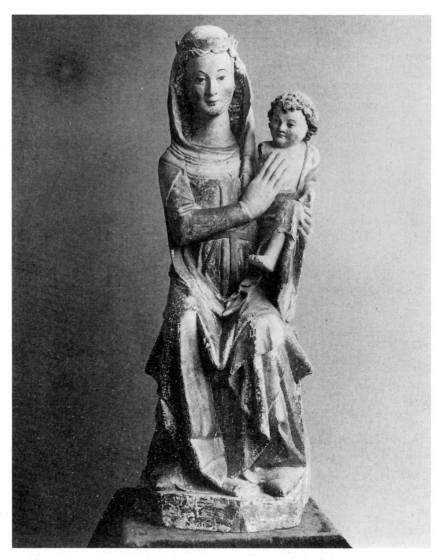

53 A fifteenth-century German wood-carving of the Madonna and Child

Finally in many monographs or major shows, such as that of Poussin in Paris and London in 1995, variation in current approaches to conservation, like the ones that characterise conservation in the Louvre rather than the National Gallery, add a third set of more subtle perceptual variations. The first of these sets of variation is acknowledged, and indeed mapped out in museum presentations. The second is only rarely presented in detail. The third is almost always passed over in silence within the museum. It is not obvious in the

permanent displays of each museum, in which the house style in conservation is presented as the model of authenticity, but it is very much on show, though never acknowledged, in major loan exhibitions.

This uneven pattern of emphasis and reticence is, of course, sustained in the name of authenticity. The idea that variation in conservation practice, within the constraints of respect for original material in the object and reversibility wherever possible, might be a perfectly normal part of the life of artworks, and one that should be on show and openly acknowledged and displayed, does not sit comfortably with the pretentions of that upstart word to absolute status. In many ways the social lives of art objects are more like those of musical compositions. In the first place there is an imaginative invention, though in this case, as the similarities between the carvings in figures 52 and 53 suggest, even the object itself may only be a variation on a theme. Every invention was realised in a whole series of presentations, first in the studio, then for a client, later for successive owners. The re-presentations are as various as performances. In some cases, as with the Blake, or with performances, if instrumentation of the date of composition and some record of style of performance

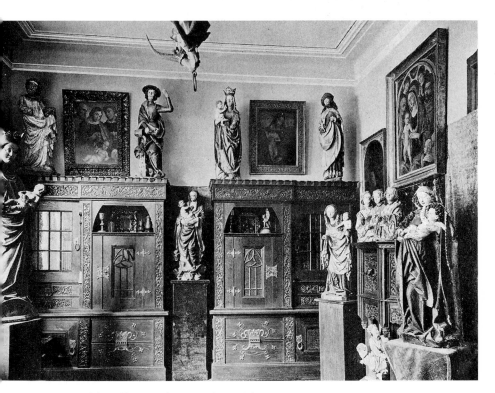

54 A corner of the collection of Dr Oertel, Munich

are available, the re-presented piece may physically be quite close to its first presentation. In others the initial invention has been radically transformed in later presentations.

Musical compositions are allowed a good deal of freedom in their social lives without this seeming to compromise their integrity, because somehow their essence seems captured in the written score. Nelson Goodman, for example, sought to resolve some of the paradoxes of forgery and authenticity with a distinction between categories of works he called 'autographic' and 'allographic'. Let us call such objects as paintings or carvings autographic, he proposed, noting that they can be forged, because an imitation can present not merely the outward form of the object it copies, but can deceptively usurp the history of production of the original object. In contrast, the physical manifestations of allographic works, those enshrined in a notation, a piece of music or text, have no single history of physical realisation, and, therefore, these, once inscribed, cannot be forged. Either way (though this was not the focus of Goodman's interest), intention and creativity seem protected, so long as the prescription laid down in notation is followed, or the physical object realised in a unique history of production is respected. The discussion certainly sharpens awareness of how hard it is to disentangle the roles of conception and execution in the meanings of artefacts, but in the end does not leave much room for fixed notions of authenticity. For allographic works, deciding which version of a notation is the authoritative one is often problematic, and performance introduces great scope for variation. As to the autographic category, Goodman had to qualify it, with an in-between category of dance and architecture, which are partly specified by notation, and had to admit that a painting too might in time become a form of notation for an image widely disseminated in reproductions.[46] Twentieth-century practice has eroded his categories even more. Moholy-Nagy recalled, in 1922, arranging for the production of five paintings in porcelain enamel by telephone, using standard graph paper and a factory colour chart as the basis for his instructions.[47] Much installation art of recent years is similarly installed from an instruction-pack. Goodman's distinction remains full of interest, but does not seem a helpful one for conservators faced with practical decisions about intention.

A view that accommodates a greater distinction between first conception and later social life for any artefact has recently been explored by Joseph Grigely. He starts from a background in literary textual criticism, the discipline which traditionally sought to distil from the often confusing disparities between manuscript versions, proofs and successive editions the authoritative text of a literary work. Often the issue is far from clear-cut, and Grigely's response is that we make a mistake if we try to enshrine the authorial conception in any definitive version. All the versions have validity, those with emendations by editors and publishers as much as those attributed only to authors.

Transfer that notion to the fine arts, Grigely suggests, and we arrive at a different view of authenticity.[48] There is, in the first place, a spectrum of extent to which any work of art or composition is a conception exclusively of its author, a specification by the market, an execution with collaborators. Then there is another spectrum, of the extent to which each successive re-presentation of the work returns to a written specification, borrows from records or memories of previous realisations, or actually incorporates physical remnants of the first realisation, more or less transformed. The lesson of textual criticism is that, whereas one might think that a piece of music, say, always returns to the score, in practice the score may exist with variations, and certainly re-presentation will relate in some way to memories of previous performances too. Similarly, as we have seen with visual artefacts, whereas it might seem that preparation of an object for display should always involve simply a return to as near its state when new as possible, very often physical transformation and changes of context make that impossible.

That does not mean, though, that in first or subsequent presentations anything goes. On the contrary, in every new presentation of a work of art, every offer for sale, performance, involvement in a ceremony or display in an exhibition, there is an understanding, often validated with specialist expertise, that certain physical characteristics make the work fit, or unfit, for the conventions of presentation currently required. The requirements can change dramatically with time and context. For example, Grigely describes a *Reader's Digest* edition of Mark Twain's *Tom Sawyer*, on sale in the USA through Safeways, from which what the editors call 'textual difficulties', which turn out to include all reference to race, have been removed to make it, in the editors' opinion, suitable for modern family consumption in a retail context.[49] Similar shifts can apply to objects. In the case of the painting in figure 50, for example, the anthropologist Howard Morphy tells us that it would have been the clarity and brilliance of the finest cross-hatching which fellow clan-members scrutinised before the work was approved as fit for its role in ceremony,[50] whereas for the collector it will be the provenance of the very same object, as a work from a 'timeless' tribal culture, which will become its most important feature when guaranteed authentic by a dealer in the Western antiquities market.[51] Should an artist be taken up by a contemporary art gallery, his or her individual identity will be what matters. Re-presentation must still qualify for fitness once an invention has proliferated into multiples. Very different criteria will have been brought to bear in judging Michelangelo's *David* fit for re-presentation as a plaster cast in Manchester's Whitworth Institute in the early decades of the twentieth century, with the head of *David* communing with his sculptural ancestors as it is seen to do in figure 27, and as the refrigerator door ornament in figure 24.

Neither of these would probably have been claimed as authentic re-presentations by their contrivers, nor would the close cross-hatching on the Yolngu

painting, nor would Safeway's edition of Mark Twain have been called authentic by those charged with vetting its fitness for presentation or re-presentation. The notion of authenticity is a special case of a culturally much more various convention that artefacts should be vetted by some competent person as fit for their roles. When the state of a work as re-presented or performed is said to be authentic, it is being deemed fit in a very particular way, that has evolved in response to the cultural context of Western life in the last three centuries. It now seems, though, that it can be a decidedly paradoxical way. It involves, as became apparent in chapter 5, on the one hand, the idea of an object expressive of values resistant to the compromises of contemporary social life. However, the compromises of contemporary social life are, as we have seen, on the other hand just what most artists and conservators in practice accommodate, in adjusting to changing notions of fitness both in the first realisation of visual inventions, and in their later re-presentations. The conservator, far from standing apart from social process and lifting the object out of it, is as much its agent as the painter in figure 52.

Notes

1 W. K. Wimsatt, jun. and M. Beardsley, 'The intentional fallacy', in W. Wimsatt, jun, *The verbal icon* (Lexington, University of Kentucky Press, 1954).

2 J. Richardson, 'Crimes against the Cubists', *New York Review of Books* (16 June 1993), 32–4, 33.

3 W. d'Azevedo, 'Mask-makers and myth in Western Liberia,' in A. Forge (ed.), *Primitive art and society* (Oxford,Oxford University Press, 1973), pp. 126–50, 148.

4 L. Shiner, ' "Primitive fakes", "tourist art" and the ideology of authenticity', *Journal of Aesthetics and Art Criticism*, 52:2 (spring 1994), 225–34, 226.

5 S. Weil, 'The "Moral Right" comes to California', in his *Beauty and the beasts* (Washington, DC, Smithsonian Institution Press, 1983), pp. 226–39.

6 The Copyright, Designs and Patents Act 1988 (UK); the Visual Artists' Rights Act 1990 (USA); Bill c-60 – amended Copyright Act 1988 (Canada).

7 'Apology – Bridget Riley', in *(Observer)*, 'Life', magazine supplement of the year (21 May 1995), 3.

8 'Court upholds droit morale', *Art in America* (October 1994), 160; 'Moral Rights on Trial', *Art in America* (May 1995), 136.

9 C. R. Scarzanella and T. Cianfanelli, 'La percezione visiva nel restauro dei dipinti. L'intervento pittorico', in M. Ciatti (ed.), *Problemi di restauro* (Rome, Edifir, 1992) pp. 185–211.

10 P. Atkins, 'The rose, the lion and the ultimate oyster', *Modern Painters* (winter 1990), 50–5, 53, 55.

11 K. Moxey, *The practice of theory: poststructuralism, cultural politics and art history* (Ithaca, NY, Cornell University Press, 1994), p. 37.

12 M. Sagoff, 'The aesthetic status of forgeries', in Dennis Dutton (ed.), *The forger's art* (Berkeley, University of California Press, 1983), pp 131–52, 151.

13 A. Gell, 'Technology and enchantment', in J. Coote and A. Shelton, *Anthropology, art and aesthetics* (Oxford, Clarendon Press, 1992), pp. 40–63.

14 E. Gombrich, *The sense of order* (London, Phaidon Press, 1979), especially 'Shapes and things', pp. 151–70.

15 W. Empson, *Seven types of ambiguity* (London, New Directions, 1930).

16 Cited in M. Baxandall, 'Guarino, Pisanello and Manuel Chrysoloras', *Journal of the Courtauld and Warburg Institutes*, 28 (1965), 183.

17 David Marr, *Vision* (New York, W. H. Freeman, 1982), pp. 35, 36, 270, 271.

18 Palazzo Grassi, *The Arcimboldo Effect* (Venice, Palazzo Grassi, 1987).

19 E. Gombrich, *The sense of order* (London, Phaidon Press, 1979), pp. 148–55.

20 G. Stein, *Picasso:* (Paris, Librairie Fleury, 1938), p. 43 'Oui, c'est nous qui avons fait cela, nous! C'est du Cubisme'.

21 Marr, *Vision*.

22 D. Washburn, 'Style, classification and ethnicity: design categories in bakuba raffia cloth', *Transactions of the American Philosophical Society*, 80:3 (1990), 119.

23 H. Morphy, 'From dull to brilliant: the aesthetics of spiritual power among the Yolngu', *Man* (N.S.) 24 (1989), 21–40.

24 *Ibid.*, text caption to figure 3.

25 S. Carlson, 'Dissecting the brain with sound', *Scientific American*, 275:6 (December 1996), 80–3.

26 C. Turnbull, *The forest people* (London, Chatto and Windus, 1961), pp. 227, 228.

27 H. Reid, 'The shaman and his apprentice', a film for *Under the sun* (Granada TV Ltd).

28 R. Venturi, *Complexity and contradiction in architecture* (New York, Museum of Modern Art, 1966)

29 J.-P. Vernant, *Tragedy and myth in ancient Greece* (New York, Zone Books, 1990), p. 42.

30 J. A. Sloboda, *The musical mind* (Oxford, Clarendon Press, 1985), p. 52.

31 U. Eco, *A theory of semiotics* (Bloomington, Indiana University Press, 1979), p. 264.

32 A. M. Halliday, 'Evoked potential', in R. L. Gregory (ed.), *The Oxford companion to the mind* (Oxford, Oxford University Press, 1987), p. 233.

33 W. J. Freeman, 'The physiology of perception', *Scientific American* (February 1991), 41.

34 John Horgan, 'It's all in the timing', *Scientific American*, 273:2 (August 1995), 11, 12.

35 S. Zeki, *A vision of the brain* (Oxford, Blackwell Scientific Publications, 1993), pp. 139, 297, 306, 322.

36 D. Solkin, *Painting for money: the visual arts and the public sphere in eighteenth-century England* (New Haven, Yale University Press, 1994); M. Baxandall, *Patterns of intention: on the historical expression of pictures* (New Haven, Yale University Press, 1985), pp. 74–104.

37 J. Black and A. Green, *Gods, demons and symbols of ancient Mesopotamia* (London, British Museum Press, 1992), pp. 17, 106.

38 S. Walens, *Feasting with cannibals* (Princeton, Princeton University Press, 1981).

39 D. M. Guss, *To weave and to sing* (Berkeley, University of California Press, 1989), p. 122.

40 V. Erlich, *Russian Formalism* (New Haven, Yale University Press, 1981), pp. 176–8.

41 Eco, *A theory of semiotics*, p. 262.

42 J. Beck, *Art restoration: the culture, the business, the scandal* (London, John Murray, 1993)

43 J. Shearman, 'Leonardo's colour and chiaroscuro', *Zeitschrift für Kunstgeschichte*, 25 (1962), 13–47.

44 C. Hope, 'Restoration or ruination?', *New York Review of Books* (18 November 1993), 4–8, 6.

45 M. Baxandall, *The limewood sculptors of Renaissance Germany* (New Haven, Yale University Press, 1980).

46 N. Goodman, 'The perfect fake', in Dutton, *The forger's art*, pp. 93–114.

47 L. Moholy-Nagy, *The new vision* (New York, Wittenborn, 1947), p. 79; cited in W. E.

 Kennick, 'Art and inauthenticity', *Journal of Aesthetics and Art Criticism*, 44:1 (fall 1985), 3–12, 5.

48 J. Grigely, *Textualterity* (Ann Arbor, University of Michigan Press, 1996), pp. 39–44.

49 *Ibid.*

50 Morphy, 'From dull to brilliant,' 26.

51 L. Shiner, ' "Primitive fakes," "Tourist art," and the ideology of authenticity'.

<div style="text-align: center;">

┌─────────────────────────────┐
│ **8** │
└─────────────────────────────┘

CURATORS AND AUTHENTICITY

</div>

What kind of experience do museums offer?

THE PREVIOUS chapters have made the case that what art historians, conservators and curators do cannot usefully be explained in terms of authenticity, but does make sense if thought of as a mapping of the production and meaning of artworks, and of something like performance in their re-presentation. Visiting a museum, though, does not feel like map-reading or interpretation. If we are engaged by the experience at all, it is because it does seem to offer some kind of special experience, of the individual objects and the minds of their makers, or of the past brought to life through documentary displays, or in reconstructions. If authenticity is, once again, no help in explaining that kind of experience, is there a better way to understand it?

One account proposes that these immediate experiences mask the deeper meaning of the displays and objects giving rise to them as signs. The point is a philosophical one beyond our scope: is language so integral to awareness that we can hardly experience anything at all if it is not mediated through a sign system? If so, according to Roland Barthes and Umberto Eco, in a culture preoccupied with authenticity, even the real becomes a mere sign of itself. When I go to New York in winter and see steam rising from the manhole covers I am overwhelmed by the feeling that I am really there again. But is this just an image familiar to me from countless films, which acts as a Trojan horse when I encounter it in the street, colouring my experience with the evoked values and atmosphere of these representations of New York? Authentic reproductions can have the same effect, like the replica hoops in the spines of the new edition of the Harvard Classics that are now cited as evidence of authenticity. In Dean MacCannell's analysis of tourism, it is only through signs like these that the tourist experiences whatever is visited at all, the authentic and the messages that it gives rise to also signalled by the aura of obvious reproductions, postcards and souvenirs that surround it.[1] For Churchill, truth was so precious that

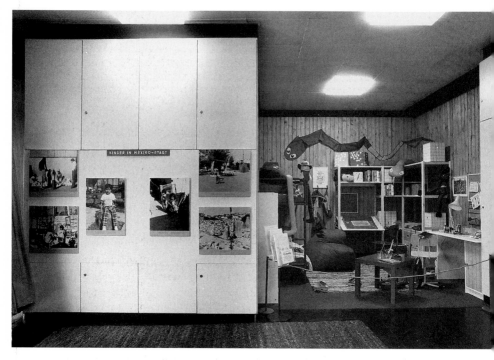

55 A child's room in Mexico City, from the exhibition *Children's everyday life in the Third World and here*, installed in the Junior-Museum, Berlin, 1982

it had to be surrounded by a bodyguard of lies, but the truths of our society need only a bodyguard of reproductions. Are all the authentic details that the art museum offers, the reconstruction of lady Fetherstonhaugh's chair-cover repairs at Uppark, all twenty stitches to the inch of them, the long recitals of provenance in catalogues of paintings, the tiny glimmers of thermo-luminescence from ceramic in the lab, mere illusions of reality and creativity? There is a case to be made that they are more than that, but it will have to accommodate the explanatory strength of the points which the semioticians have made.

To look into the question, consider an exhibition in which the artefacts were not ornaments of the lives of adults, but of children. Figures 55 and 56 show reconstructions of the living conditions of two children, one from a well set-up family, though of a minority culture in Mexico City, and the other from the slums of the same city, from a small exhibition of 1982. It was originally devised in the Anthropological Museum in Hamburg, but here is seen as I came across it, installed in the basement corridors housing the education section of the museum complex at Dahlem in Berlin. The show was called *Children's daily life in the third world and with us*,[2] and consisted of half a dozen tableaux of this

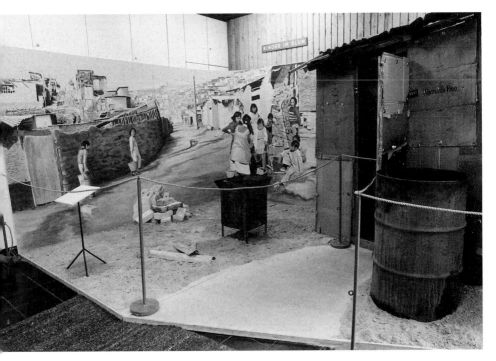

56 A child's accommodation in a Mexico City slum, from the exhibition *Children's everyday life in the Third World and here*, installed in the Junior-Museum, Berlin, 1982

kind, presenting a traditional pattern of life in New Guinea; a more Westernised group, the Ewe of Ghana; a minority culture, the Raramuri of Mexico City; Turkey, as an Islamic culture with special links to Germany; a Mexican slum, representing slums everywhere; and the room of a German child. The authentic objects and references for the pictures were assembled from museums in Berlin, Basle and Bremen, and from fieldworkers in Mexico.[3] The display was accompanied by educational notes that included quite long extracts from accounts by children in some of the different source cultures of aspects of their daily lives.

The show made a deep impression, and I was surprised, on receiving photographs of it more than a decade later, to see that it must have been far less realistic than it had come to appear in my memory. Perhaps the many details, carefully signalled as authentic, did indeed act as signs for reality, overwhelming what now appear in the photographs like devices designed to eliminate any possibility of illusion: the apparatus of museum ropes and caption stands, the intrusions of eminently institutional basement architecture, the merely suggestive painted backdrops. In retrospect there was a powerful unintended message in the display too, in the overall impression of difference

between Western viewers and the people represented in most of the display, between the children of the Third World and 'bei uns'. (In 1995 another imaginative display in the same site opposed any such assumptions: *Foreign, who is that?*[4]). However, my feeling at the time and since was that these tokens, suggestive of very various lives, did open up a heightened awareness of the lives of others that was not just fantasy, nor just the construction of my own identity through a perception of difference. Yet clearly this is not a transparent representation of reality, either. How can we describe what the curators were doing here?

As suggested in chapter 5, one account is through an analogy with mapping. Museum layouts are often literally maps of theory. For a start, most of the true serials – the reproductions and prints – are either in the basement or the shop, and as for the galleries, traditionally taxonomic displays of objects arrayed by classification are diagrammed in floor plans. Figure 57 shows an entirely typical example, the first floor of the Kaiser-Friedrich-Museum in Berlin, in the 1920s. Visitors coming up the staircase shown on the left knew for a start that this whole floor isolated and privileged Western fine art. Emerging from the staircase, they entered a chronological array, from the fourteenth century on the left to the late eighteenth on the right, Italian paintings along the row of rooms at

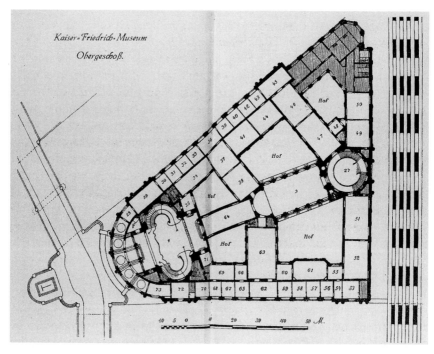

57 A plan of the upper floor of the Kaiser-Friedrich-Museum, Berlin

the top of the plan, northern schools along the bottom, with some rooms dedicated to major individuals, Botticelli in 38, Rubens in 63.[5] It is easy to overlook the extent to which mere floor plans like these can be diagrams both of theories and of the way in which they are presented.

The assumptions involved are literally mapped again in the location of museums devoted to different categories of objects within cities. You go to see works of authorial fine art in a National Gallery in a central location in a capital city, to see generically labelled decorative arts often a little further out, but to see the works of politically weak cultures you get on the Metro all the way to the periphery, to the Musée des Arts Africains et Océaniques, or, until recently, on the subway well up in Harlem to the Museum of the North American Indian. Until recently, because attitudes are changing, and, sure enough, the change is reflected in location in the city. Now Oceanic arts are in the Metropolitan Museum, Native Americans have a museum at a tourist high spot in New York's Bowery, London's ethnography collections will be rehoused in the space liberated by the move of the British Library from the heart of the British Museum, and Paris's venerable Musée de L'Homme is to be the site for new displays incorporating as well the collections of the old Musée des Arts Africains et Océaniques. Meanwhile some Caucasian artefacts have tactfully been added to the displays of artefacts from every other ethnic group in the New York Museum of Natural History, which the artefacts of most of the (non-Caucasian) cultures of the world used to share with the products of nature. In other museums individual curators are hard at work trying to subvert the traditions still only slowly being modified in these innovations, but museums are remarkably resistant to change. The apparatus of display, the cases and plinths, the hanging systems and practices, the lack of cash to change it all when it comes to installation, endow tradition with a relentless material momentum.

These spatial conventions emphasise the point that conceptually art classification is a form of mapping, but Michael Baxandall has suggested, as noted in chapter 5, that explanatory strategies applied to artworks more generally may helpfully be thought of as mapping as well. In these analogies with mapping, there is correspondence with whatever is mapped. In the case of an interpretative account, the correspondence is between statements in the interpretative account and data in archives. In a display it is ensured if the objects are correctly identified in terms of source. In each case, the map or representation can be said to be accurate or not, but always it remains map-like in being quite unlike whatever is represented, selective and conventional, and revelatory of the makers of the maps and their needs as much as of whatever is represented. Interpretations expressed as displays can also be literally map-like in floor plan, particularly if they take the form of classifications, as shown in figure 57. If a display offers a more elaborate argument than classification, the style of that too can be reflected just in floor plan. Sue Pearce calls upon a study

by Peponis and Hedin of the Bartlett School of Architecture, to demonstrate that management of just three variables in the layout of floor plans of displays so directs the route the visitor takes as to distinguish subjects presented as 'a well-known terrain, where the relationship of each part to another, and all to the whole, is thoroughly understood', from those which 'show knowledge as a proposition that may stimulate further, or different, answering propositions'.[6]

The Berlin display on childhood was map-like in these ways, with a floor plan of the latter kind. As with any good map, the great care taken over the authenticity of the objects chosen as accurate features of the subject, and with the details of the painted scenes, establishes a correspondence with the subject that can be checked. We would have been able to make predictions based upon these details, about what we would find if we went to each culture, and might have found them borne out, or not. But still this is, as the booklet that accompanied the show carefully explains, a selective representation, from the choice of cultures to represent down to the details of the scene chosen as representative, and very much one in the odd conventions of museum display. The illusion is of a transparent representation of a truth outside the museum, yet the selection and conventions are as much a revelation of ourselves as of the subject of the show.

Mapping, however, will not do by itself to explain what curators are up to in displays like these ones in Berlin. When we use a map in everyday life, we are under no illusions that it is just a map, yet this is just what museums seem to conceal in their emphasis on the 'real thing' and what we as visitors suppress when a show comes to life for us. To understand what is involved in this kind of experience, another metaphor helps, that of the frame. What the metaphor of framing accommodates, that mapping cannot, is the impression of transparent representation that the museum offers. The semiotic account of experience suggests that this is just a part of what I have been calling mapping. The impression of contact with the real, apparently guaranteed by the authenticity of objects, masks the role that they have within the displays as signs, points of reference in a mapping that is not transparent at all. Thus Bal and Bryson propose that the business of explaining and classifying art in the terms of authorship expressed in the plan in figure 57 is a more generally conceptual enframement of art, selective, and constructing the meaning of the art selected exclusively in terms of creative authorship.[7] However, there are other accounts of framing as a metaphor which allow experience of the real a deeper role.

Framing reality

The idea of framing as a metaphor for what curators do is attractive because it has so often been adopted as a device to explain human understanding, communication and experience in many loosely related contexts in the second

half of the twentieth century. It appears in the 1950s in psychoanalysis with Marion Milner,[8] in an essay on artificial intelligence by Marvin Minsky,[9] in anthropology in the work of Mary Douglas,[10] and in sociology in studies by Gregory Bateson[11] and Erwin Goffman.[12] Massimo Piattelli-Palmarini describes a role for it in the decision theories discussed in chapter 5,[13] and it is the basis of a flamboyant discussion by Jacques Derrida.[14] We are warned that framing by no means implies the same thing in all these accounts, if only by the varieties of secondary metaphor with which the metaphor of framing is explained. Thus, Douglas (in her introduction) proposes motor-vehicle assembly, Bateson uses the picture frame, but also mathematical set theory, whilst Douglas Hofstadter, explaining Minsky's ideas, prefers a nest of chests of drawers,[15] and Piattelli-Palmarini goes for tunnels. But this variety still encompasses common features: frames bracket strips of experience or data in each account, policing what is included and what excluded, but at the same time signalling the context that determines the meanings of whatever is included. Framing is the central metaphor in the analysis of context or implication.

The study of framing which best accommodates the preoccupation of curators with 'the real thing' is a sociological account by Erwin Goffman of 1974, because he takes as a starting-point the problem posed by the American philosopher William James: under what circumstances do we think things are real? A role for framing in the answer had been suggested to Goffman in part by the work of the psychologist Gregory Bateson. Visiting the zoo in San Francisco in January 1951, intending to observe communication between animals, Bateson was struck by the nature of play. He remarked that it is a special category of behaviour, 'framed' by a set of signals exchanged between participants establishing that 'this is play'. Two levels of communication are, therefore, involved, one made up of the exchanges of the play itself, the other a metalanguage of body language and facial expression, comprising the frame. As long as the frame is sustained, it performs the two functions already suggested. First, only some behaviours are permitted. Second, those that are permitted do not mean what they would mean outside the frame. This is where the shift in reality comes in. A play threat is not so much a threat as a representation of a threat in the frame of play. Bateson went on to note that a great many varieties of make-believe in social life are similarly best understood as framed forms of communication. He described pictures in frames as a kind of material metaphor for communication of this kind.[16]

Goffman, however, extended the idea of framing to experience of situations and to our presentation of ourselves more generally, and in these analyses has much to say that chimes with the experiences museums offer. We understand whatever is going on around us first as just something natural or something human and social, he suggests, but then goes on to analyse how experience of

the reality in either case can be transformed. This can happen in one of two ways, first by what he calls 'keying', for example when the experience is make-believe, part of a contest, of a ceremony, or some kind of run-through or replay, such as a rehearsal. Alternatively, the reality one person perceives can be fabricated by someone else deceptively. In each case, for example when a scene we observe is not for real but in a play, our sense of reality shifts, and if what we are watching is a rehearsal of a play, or perhaps a rehearsal of a play within a play, as in Hamlet, the key shifts again. These rekeyings Goffman calls 'laminations'. Then it gets complicated. He gives examples of laminations of deceptions, such as double bluffs, as well as laminations in which deceptions transform keys and keyings transform deceptions. Each of these transformations, in which the core reality of what is going on is distanced a step, is signalled by both physical signs – such as those in a theatre framing the stage – and social signs, such as gestures in a conversation. It is these signs that form the frame (a picture-frame is an obvious example) within which we understand a reality that we may experience only through many layers of lamination.

Let us now see how this helps us to understand representation, and mapping within it, as well as framing, by looking at figure 58. It shows, at first glance, four people at work in a slightly odd pottery workshop. The reality seems transparent. But let us first pause to note that even this photograph is map-like. As an object, an image on a page, it is obviously a very different thing from what it represents. Then, like a map, it is selective, both in what it shows, and even in the tones and colours it reveals. As a glance back at figures 12–14 will show, had this scene been recorded in infra-red or ultra-violet it would have been very different. A huge X-ray shadowgraph, if feasible, would have offered a truly novel view, but would have been no less accurate. The photograph is selective like a map too in that it engages only a certain scale of the landscape it maps, showing details a couple of millimetres wide at best, perhaps. Like a map, it is appropriate for a narrow range of purposes, in that we can imagine with it what it would be like to find our way around this scene, and like a map in that sense it is accurate. We need only briefly note that it is much harder to say what makes it look like a picture and not a map. According to one account, it is just that the mapping projections applied, along with the illumination used to select scale and conventions of colouring, are just the ones which evolution has provided us with for everyday vision; but Margaret Hagen, for one, would offer a very different answer.[17] What matters for now, however, is just that it does look realistic, although it turns out on reflection to share many of the characteristics of maps. Museum displays too, we have seen, are like this.

But now let us look at the picture as a framing of reality. Compare it with figure 59. This is not a photograph of a workshop, but of a representation of one in an exhibition, so that my framing of the image in figure 58 is not so much a question of keying, in Goffman's terminology, as of deception, complete with

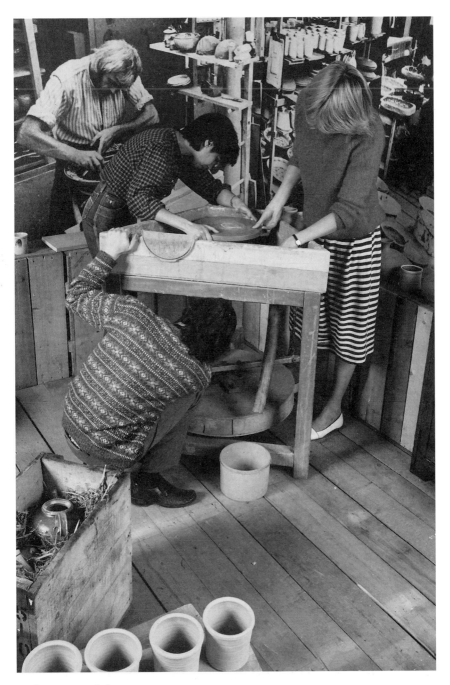

58 A pottery workshop

one figure which turns out only to be a representation, in a photograph within the photograph. In figure 59 the deception is replaced with a whole cascade of keyings. It is not just a photograph of a representation of a workshop, but of people, who in three instances are no part of the illusion intended in the display, working within it to prepare the display. So the 'real' pottery workshop takes another step back, since the picture shows only the preparation of a representation of one, including within it another representation in the form of the photograph. Goffman's term 'laminations', is a good one because each of these shifts in key is not a gradation of the perception of reality, but a whole jump. The laminations are signalled first by what the photograph masks or reveals, then by the edges of the photograph and the display area within the photograph, more subtly by the behaviour of the figures in the scene. Framing in the displays of the Berlin *Kinderalltag* show, of course, offers laminations that work in similar ways, but what is actually meant by the framing and mapping in that case, as we saw, extends far beyond just the issues of purely visual representation explored in relation to figures 58 and 59. Yet it is upon reading of these framing signals that the difference between these pictures depends, and similarly in any representation, meaning depends upon understanding framing signals. As with any map, however accurately features are mapped, what they mean depends upon how you understand the frame in which they are presented.

The pottery workshop reconstruction was part of a museum exhibition, and museums and the art they house are framed affairs. Indeed, there is a case for suggesting that part of the role of the perceptually puzzling devices that were seen in the last chapter to be so ubiquitous in artefacts lies in their effectiveness as metalanguage, signalling, like the play signals observed by Bateson in San Francisco, that 'this is art'. Within the frame of art, whatever is represented takes a step back, but is freed for associations that would be inappropriate if perceived in a everyday context. Any re-presentation of the work of art is, then, likely to involve some lamination, occasionally deception, if the presented work is a forgery, or even just includes extensive imitative conservation, always, in the museum, involving ceremony signalled by all the apparatus of the gallery.

Art is often framed by the museum architecture in the most literal visual sense, as figure 60 suggests. The celebration of authorship is what this kind of framing has traditionally privileged, whether at the level of the frame, the room or the whole museum. Consider the picture-frame itself first. 'I want the frame to be there,' remarked the French commentator of the Napoleonic era, Quatremère de Quincy, 'I want to know that what I see is in fact nothing but a canvas or an even field.'[18] The frame is first of all a sign that whatever is represented within it is not a transparent view of reality, but a keyed representation. But then within the museum the frame becomes a sign of another level of

59 Installing a display of a pottery workshop (Whitworth Art Gallery, 1983)

keying, not of the inner reality represented in the pictures, but of the pictures as objects within a history of art. In all three of the pioneering galleries of late eighteenth-century Europe in which the taxonomic approach to authorship, that Bal and Bryson call enframement, became dominant, Düsseldorf, Vienna and the Louvre in Paris, the new approach was signalled by campaigns of reframing. As Andrew McClellan explains in his study of the establishment of the Louvre as a museum, in each case, uniformity and simplicity of framing was the key, to emphasise the systematic approach within which the new ordering of authorship was to be understood. So in a 1778 engraving of the Rubens

60 The entrance-hall of the Whitworth Art Gallery, looking through to the back of the building, early in the twentieth century

room in the Düsseldorf gallery we see all the pictures in simple, flat frames, with instead of traditional cartouches, just enough by way of strictly rectangular, narrow prominences at the top, to make room for the initials 'P.P.R.' (Peter Paul Rubens), and a number.[19]

The aspiration was also that uniformity should reduce the effect of framing, so that the museum context should not intrude, but that was not at all the effect achieved. Where the idea that the artwork is self-sufficient and should be isolated from any kind of social framing persists in museums, therefore, it has not been just the museum, but the frame that has vanished, with the abandonment of frames altogether. Carlo Scarpa pioneered the idea in the Correr Museum in Venice in the late 1950s, with paintings presented sometimes one to a room, unframed, on an easel.[20] Since then both historic and modern works have been shown without frames, notably in Italy regularly in the 1950s, in the Museum of Modern Art in New York,[21] and in the Kunstmuseum in Berne, in about 1980.[22] But of course there is no escape; framelessness is itself a frame, and the trend is now, on the contrary, towards explicit contextualisation, in campaigns of 'authentic' reframing for works that have lost their original frames. Amsterdam is setting the pace, perhaps to try to make up for having apparently

thrown away van Gogh's own frames in reframing campaigns in the 1960s. Now in the Stedelijk and van Gogh Museums attempts are under way to reconstruct the framing effect he intended,[23] whilst Dutch seventeenth-century paintings in the Rijksmuseum have recently been conscientiously reframed in plain black ebonised frames, following a seventeenth-century style, rather than that of the Rococo frames in which such paintings have often come down to us.[24]

The framing of artworks in these terms even reveals in a different light the one art convention that might seem most resistant to framing. The whole point of minimalist art is that any representational or referential role is absolutely excluded, and with it, one might think, any role for framing. Framing, in fact, offers a very good definition of it: minimalist art aims to offer absolutely unframed experience of the reality of the object. Some minimalist works, like Carl André's bricks, then fall back into the orbit of framing, because they would be unlikely to command the requisite state of mind outside the frame of the museum. It must be questionable how effective any minimalist artwork would be except within a framed space of some kind.

The framing effect of whole rooms has most vividly been described by one of the current generation of artist–curators seeking to reframe the traditional authorial approach. The American artist Fred Wilson has described a series of displays which he organised in Longwood Arts Project in the South Bronx, Maryland Historical Society and Seattle Art Museum. As an artist of colour and an outsider to the museum establishment, he brings a heightened perception of the effects of these display spaces. *Rooms with a view*, his show in the Longwood Arts Project:

> exhibited the work of emerging American artists . . . I placed the work of these artists in three different settings. One room looked like a contemporary gallery, the white cube; one I redesigned to look like a small ethnographic museum, not very well appointed; the third I made to look like a turn-of-the-century room. When I placed the work in the ethnographic space, the environment really changed it. Labels stated the materials, but not the artists' names, and said things like 'Found, Williamsburg section, Brooklyn, late 20th century'. The works became exotic . . . In the turn-of-the-century space, artworks appeared to have a certain authority that they did not have in the white cube. The white cube also had a way of affecting you: it looked cold and scientific. In this modernist space, works that had an emotional intensity were somewhat diminished by all that whiteness. For me, this was a watershed event. If the work was being manipulated that much, that was the area I wanted to work in.[25]

The way in which a museum as a whole can even define what should be considered a work of art at all is illuminated in a study by Will Vaughan of the display history of the Turner collection.[26] Early displays of the Turner Bequest included only his completed pictures, as indicated in his own will, within the National Gallery. The patrons, the biography, the sketches and series of prints

all vanish, to present Turner amongst the canon of the great, Turner the academician, amongst his peers, all similarly represented at their most formal. However, as space became available at the beginning of the twentieth century in the new Tate Gallery – the national gallery of British art – taste developed for a new and specifically a British Turner, Britain's answer, indeed, first to Impressionism and later to abstraction, and admitting some sense at least of the physical processes, the sketches and studies, which lead up to exhibition pictures. Then in the new Clore Gallery of the 1980s these Turners were accommodated within a more bookish notion of total Turner, the Turner of art history, including even his less readily digestible figure experiments, underpinned by the comprehensive catalogue of Martin Butlin and Evelyn Joll. So take your pick, academician Turner, Impressionist Turner, Turner the pioneer of abstraction, socially contextualised total Turner, each signalled, in the way suggested in the last chapter, by the selection of pictures included and excluded, as well as by the selection of works by other artists on show and the conventions in which they are shown in the museum as a whole.

Vaughan pointed out that the process was even reflected in the cataloguing of the paintings, which proceeded so slowly so that the last of the categories of paintings considered to be worthy of documentation were only given accession numbers during the Second World War. Kenneth Clark recalled discovering great rolls of them, dust-covered and unlisted in remote cellars of the National Gallery. The paintings which Turner himself considered effective works of art, fit for display in a gallery, therefore, are now presented with beginnings and studies which he would only have contemplated within the studio. In the way suggested in the last chapter, but now understood within the larger context of framing, what Turner means for us (and the intentions attributed to him) shifts with changes in the actual perceptual devices selected in the name of authenticity, though in this case the framing is adjusted by selection within the museum as a whole, rather than conservation.

The advantage of Goffman's scheme as a description of our experience of works of art and displays like these is that it emphasises that at the heart of every experience there is some reality, and this is where, in adopting his scheme, we part company from strict semioticians, who would, I suspect, insist that at the heart of every experience there can only be a relationship between signs, that experience arises only out of language-like structures of meaning. Within the art museum, no less than three realities compete. One is the reality represented within the works of art themselves. The second is the reality of the history of their production that the museum presents in a documentary way, or implies. But then, competing with these two realities, which are only available in the museum as framed, there is the everyday reality of the museum and of ourselves visiting it, which may or may not be framed from moment to moment. We will consider each of these in a little more detail, noting how each

may contribute to the laminations enframing the others, but then consider how the museum sets up competition between them.

Most works of art do include some representation of a visual scene. The scene itself may either be what Goffman calls unmediated reality, like the landscape in an Impressionist painting, but, of course, it is often framed in any one of a huge variety of ways, for example if the painting is allegorical, or is an essentially documentary presentation of a historical event such as the Nativity. If in everyday life we were to come across not Rubens's painting of *Venus, Mars and Cupid* (figure 44), but this group of figures, we would be disconcerted if they were not engaged in some kind of theatrical make-believe. Even if we are looking at an abstract image, we can usually select within it illusory space, or just segmentation, which offers a perceptual reality different from that of the object itself. In conceptual installations, the works of Joseph Beuys, for example, the elements of installation make multiple reference to realities beyond the everyday perception of the materials comprising them. As has been suggested, even the artefacts that do not directly evoke a separate reality in this way at all, such as undecorated pots, or minimalist sculptures, avoid any such reference in order to emphasise their own presence. But one way or another most artefacts do offer a play upon realities separate from everyday experience.

The second variety of reality presented by the art museum, the history underlying the production of the objects implied by the presentation of the artefacts, is already familiar. We have seen how it is suggested at the level of the picture-frame, the room or of the whole museum. We should note in passing how it frames our perception of the reality represented within artefacts too. Looking again at *Venus, Mars and Cupid*, Michael Jaffé, taking a traditional approach, urges us to enjoy the revelation through restoration of the 'opulent contrasts of the soft surfaces, hair and rich stuffs . . . with the hard reflective surfaces of armour and accoutrements . . . and supremely of the nacreous tints of Venus and Cupid with the golden-brown skin, fiery and proper to Mars'.[27] For Jaffé, this aspect of the painting is selected within an authorial frame, signalled by the connoisseurial language, and is evidence of the genius of Rubens. It is just as apparent to a viewer concerned with issues of gender, but now these devices, and the critical frame that emphasises them, are distanced again. The signalling meta-language shifts to the terminology of gender studies, and the representational effects are understood through another documentary lamination, as devices through which assumptions about gender itself have been historically constructed through such paintings and their connoisseurial consumption, soft, nacreous and feminine, versus hard and masculine. Of course, in considering the gender-perception of the scene as a lamination of the traditional authorial perception, yet understanding it not on its own terms, but as an example of laminated framing, we are adding yet another lamination, duly signalled by the terminology of framing and lamination appropriated from Goffman. This

description of changing meaning in the paintwork of Rubens is rather like the earlier account of the way in which impasto aquired different meanings over time, but now it is an account that focuses upon experience rather than meaning.

For a great many of us, as we casually pass by works of art, however, neither what they represent nor what they mean enter into experience much at all. All too often, as we visit a museum, neither the reality framed within much of the artwork, nor the reality indicated by the documentary frame engage us. Instead it is the everyday reality of the museum and of the incidents of the visit, the guards debating the shortcomings of the current rota regime, the eye we are keeping out for the cafe, that dominates. As Goffman explains, the extent to which our attention and experience are in practice held by any frame varies. Frames can be broken by inappropriate intrusions. In everyday life interviews, for example, are eminently framed occasions, a bit ceremonial, but occasions for numerous re-keyings and even deceptions by both interviewers and applicant, both of the past and of the potential roles they might play if the candidate is successful. In the event of intrusion, the breaking of the frame or spell is almost palpable, as, in my own experience of interviewing, once when my colleague managed to set a huge box of matches on fire, once when, unusually in Manchester, there was an earthquake, and once when, I have been told, another colleague, in a waiting-room as a candidate, put his ear to the interview-room door to listen in to the interview previous to his own and fell through it. Frames are always susceptible of breaking in this way, as when play breaks down into real fighting. But in any frame, the experience relies on our ability to screen out some out-of-frame matters. It is, as we have seen, just on this kind of process that forgers play in setting up deceptive frames, but it is also involved in the perception of any work of art, and readily disrupted.

It is particularly so because of the way in which both the reality represented within the works of art and that implied for their production can never be experienced unframed. The whole point of art and museums is to frame them. We are all familiar with how often the unmediated reality of the museum and our presence within it breaks those frames, but they are especially vulnerable too to frame conflicts more specifically of the museum. The reality represented within the work of art and that imposed in a documentary way by the museum compete. Museums are both displays of works of art, and at the same time displays about them, in which the works can play the role of illustrations to the argument of a book. In consequence, experience of the object within the museum, at the same time as it helps to validate the historical reality, is inevitably sapped by what Goffman called the 'power of the documentary key to inhibit original meanings'. Goffman gives as an example the suppression of the humour of the comedian Lenny Bruce in an obscenity trial. Counsel for the defence requested, naturally, that the court be allowed to laugh during a playback of one of the comedian's routines, but the judge interrupted: 'This is not

a theatre and not a show. I am not going to allow any such thing . . . I am going to admonish you to control yourselves in regard to any emotions you may feel.' And so they did.[28]

There is oddly little humour in art, and so within the museum that kind of inhibition is perhaps most apparent in its suppression of just what the jurors in the Lenny Bruce trial had to focus on, the obscene or the erotic component in artefacts. It has often been claimed that the frame of art transforms the erotic, but looking at museum experience in terms of Goffman's notion of framing suggests that the usual account of the transformation, in terms of elevation, may miss a point. It is one that can be illustrated once again with reference to Rubens's *Venus Mars and Cupid,* which Robert O'Brien convincingly identifies as the *Venus* cited as a notable instance of obscenity in the trial from which the current British legal definition of the term emerged, *R. v. Hicklin* of 1867.[29] The test of obscenity as an offence, Justice Cockburn pronounced, 'is this, whether the tendency of the matter charged as obscenity is to corrupt those whose minds are open to such immoral influences, and into whose hands a publication of this sort may fall'. Paintings in galleries therefore, posed no hazard, obscene though they might be, and indeed to Justice Cockburn, 'what can be more obscene than many pictures publicly exhibited, as the *Venus* in the Dulwich Gallery?' O'Brien suggests that the judgment expresses distrust of the vulnerable masses, whilst those who visit galleries may be trusted not to be misled by such pictures. But are they safe because of the elevation of the erotic in art, or because of its suppression, in the way that humour in the Lenny Bruce trial was suppressed by the authority of the court? Traditional connoisseurs, and the clients for whom Rubens painted, were surely often very aware of the erotic content of paintings, but in the gallery the figures represented in such paintings no longer come across as flesh and blood presences. It is inhibition of experience, not elevation, that is often imposed by the museum frame, with its earnest curatorial emphasis on authorship and paintwork, let alone the stern lessons pointed out by gender theoreticians. The point is not that there is anything wrong with documentary laminations like these, but that the enhancement of meaning that they offer does tend to suppress more immediate modes of experience of artefacts, of which the evocation of physical presence is only one of the most obvious.

All this, though, is the effect when museums present their collections in organised and coherent frames. In practice few museums quite match up to the ideal of documentary lucidity and authenticity that the preceding account might suggest, and in particular the history of the institution often intrudes into our experience of any museum. Curators working in the costume gallery of the Victoria and Albert Museum have inherited a spectacularly awkward example. Within their gallery is a kind of art-museum dinosaur, a complete painted alcove by the eighteenth-century painter Paul Sandby, some 25 feet in

height and width, a relic of that era when authenticity was sought by the introduction into museums of the biggest chunks of original artistic context possible. Whole rooms were best, but such a big alcove was pretty near it.

It is now very hard to see how this huge and fragile painted lath and plaster construction can ever safely be moved again. Evidently, it could offer a background for eighteenth-century costume, but then there would be nothing equivalent for costume of any other date within the room. It is also quite opposed to the carefully thought-out aspect of costume curators wished to map in their selection and frame in this presentation. What the curators wished to stress about these costumes, the national collection of the genre, after all, was their visual effect, their artistic quality, and not their value as social documents. Within the cases, therefore, all the emphasis has been on the immaculate presentation of the costumes, usually against simple backgrounds. Just the presence of the alcove in the room has evidently been an embarrassment. It does inevitably intrude a bit, so at one time some years ago it was thought that perhaps a little furniture to go with it might soften the anomalous effect. Someone came up with the notion that rustic-style eighteenth-century chairs would be just the thing to go with the period and bucolic scenes of Sandby's murals. Since, however, the environment as a whole clearly did not present an evocation of eighteenth-century mood, what they very properly and expertly put out was a row of such chairs, a fragment of a map of the species eighteenth-century rustic chair. But this added a third convention, a third frame, to the two already competing within the room. The chairs had gone, when I last looked, and the lighting was reduced, in a heroic attempt to pretend the alcove was not there at all. Older museums tend to offer a rich variety of frame conflicts like that, once your eye for them is in.

And that's when everyone is doing his or her best, which is not always the way it is. In many a more modest museum, whenever cash or resolve falters, the history of the institution encroaches like jungle reclaiming a ruined town. Implausible and accidental conjunctions of objects, sometimes stranded when temporarily deposited in the course of some removal and then overlooked, lurk amidst a thickening litter of old fittings and service-ducts. Each generation of curators tries to leave a mark, but the result is often only to add another frame to the accumulation of laminations.

Museums as mind-machines

Museums seem so unusual, in being consistent only in the varieties of the real that they offer, that it is worth wondering what other social institutions they resemble in that respect. In contemporary life television is probably the nearest, and the screen is likely to become even more a site of competing realities if technology reaches a point where we shop, telephone, work and study

through it as well. Even now, whatever appears on the screen represents a reality as subject to deception and keying as anything presented within the gallery, but also one which has to compete for our attention within the room in which we are, or are not, watching. Museums are often identified as ritual sites, and Carol Duncan so describes them specifically because they conjure up modes of consciousness that anthropologists have called 'liminal', outside our everyday life.[30] Television is a ritual site like this too, and generally ritual itself is perhaps the other main arena in which such a variety of realities have to compete for attention with the everyday. Ritual, Mary Douglas wrote, 'focuses attention by framing . . . it changes perception because it changes the selective principles'.[31] That is certainly what museums do.

All these devices are a bit like external models of an aspect of mind. Like our own awareness, they offer a selection between incoming stimuli, memory, fantasy and dreams. We are used to machines that imitate the functions of arms, legs and hands, and even to an extent thought, but perhaps museums should be understood amongst a small set of related social practices and institutions, as machines which externalise awareness itself. Why should such contrivances be continually reinvented? Perhaps an answer lies in authenticity, not the authenticity of objects, but the kind of personal authenticity, which, it may be recalled from the introduction, is associated with refusal to compromise with the devices of social life, and has become confused with the authenticity of objects. What are the compromising devices of social life, if not just those deceptions and keyings through which, according to Goffman, the presentation of self in everyday life is negotiated? Perhaps such institutions as ritual, and now museums and television, with their multiple realities and framings, have been evolved because of the need for framed arenas in which those of us who hesitate to choose the radical way of Kurz in Conrad's *Heart of darkness* can come to terms with the paradox of the self in social life.

Framing was actually proposed by both Bateson and Milner as a component of psychotherapy, by Bateson because he suspected some pathology might arise specifically because patients misread framing signals,[32] by Milner because within the frame of the session patient and therapist could stage the transference of repressed conflict within the patient to their own relationship, the hallmark of psychotherapy in the 1920s and 1930s.[33] 'I told how I saw the frame', Milner recalled of a 1952 talk,

as something that marked off what's inside it from what's outside it, and to think of other activities where the frame is essential, a frame in time as well as in space; for instance the acted play, ceremonies, rituals, processions, even poems . . . Also the psychoanalytic session framed in both space and time. I said I thought all these frames show that what is inside has to be perceived, interpreted in a different way, from what is outside; they mark off an area within which what we perceive has to be taken as symbol, as metaphor, not literally.

If exploration of this kind is in some way helpful, perhaps it is not the elusive authenticity of objects that is enshrined in curatorial preoccupation with the real thing, but our own loss of personal authenticity.

That is speculation, but quite specific suggestions for practice emerge from the idea of museums as framing devices. One is that vivid experience depends upon minimising the conflict often experienced between museums as places for the display of objects and as places for displays about objects. In many museum displays the objects might as well be illustrations in a book, so inhibited are they by the documentary frame, and there is still room for such displays. The suggestion, at the end of the last chapter, that it would be interesting to see a show that brought out both the way in which time re-edits artefacts and the variety of approaches of conservators to the problems posed, would be such a show. However, for many other documentary approaches multi-media and the World-Wide Web offer an ample stage for presentations about objects that the real museum cannot compete with. With their aid, objects as inhabitants of Malraux's museum without walls can decisively liberate themselves, leaving the real thing behind in the gallery, where, by contrast, the objects left to themselves offer an experience with which multi-media cannot compete. In the absence of such helpful new technology, objects left to themselves were simply mystifying, but there is much more opportunity now for providing both documentary preparation and an undistracted presentation of objects, too.

There is also surely scope for much more variety in the way that objects are juxtaposed, at least in some museums. Most currently adopt a single mode, conventionally taxonomic or aggressively innovative, in a dogmatic way. Admitting approaches like Fred Wilson's, cited earlier in this chapter, does not compromise a whole museum, but helps to make it easier to experience the way the whole process is one of framing. Figure 61 is from a leaflet accompanying the display of classical antiquities, *?Exhibition*, which Mary Beard and John Henderson organised for the Ashmolean Museum in 1992, designed, as the leaflet suggests, to subvert the authority of conventional museum display. There could be more such daring escapes from authenticity.

Notes

1 D. MacCannell, *The tourist* (New York, Schocken Books, 1976), cited in J. Culler, *Framing the sign: criticism and its institutions* (Oxford, Basil Blackwell, 1988), p. 155.
2 *Kinderalltag in der Dritten Welt und bei uns.*
3 A. Kelm, *Kinderalltag in der Dritten Welt und bei uns* (Hamburg, Hamburgisches Museum für Völkerkunde, 1982), p. 1.
4 *Fremd, Wer ist das?*, an exhibition in the Junior-Museum, Museum für Völkerkunde, Staatliche Museen zu Berlin, Preussicher Kulturbesitz, autumn 1993–summer 1995.
5 Königlich Museum, Berlin, *Das Kaiser-Friedrich-Museum* (Berlin, Walter de Gruyter, 1926).

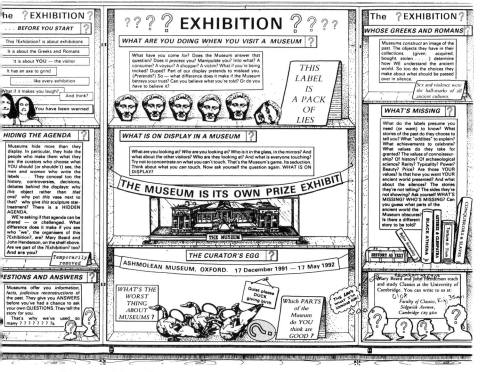

61 Central section of the leaflet accompanying the *? Exhibition*, Ashmolean Museum, Oxford, 1992

6 S. Pearce, 'Structuring the past: exhibiting archeology', *Museum International*, 47:1 (1995) 9–13 , 11.

7 M. Bal and N. Bryson, 'Semiotics and art history', *The Art Bulletin*, 63:2 (June 1991), 175–208, 180.

8 M. Milner, 'The framed gap', in *The suppressed madness of sane men* (London, Routledge and Kegan Paul, 1987), pp. 79–82 and 'The role of illusion in symbol formation', *ibid.*, pp. 83–113 (both originally published in 1952).

9 M. Minsky, 'A framework for representing knowledge', in P. H. Winston (ed.), *The psychology of computer vision* (New York, McGraw Hill, 1975), pp. 211–77 cited in D. R. Hofstadter, *Godel, Escher, Bach: an eternal golden braid* (Harmondsworth, Penguin Books, 1979), p. 373.

10 M. Douglas, *Purity and danger* (London, Routledge and Kegan Paul – Ark paperbacks, 1966), p. 64.

11 G. Bateson, 'A theory of play and fantasy', *American Psychiatric Association psychiatric research reports*, 2 (1955), reprinted in G. Bateson, *Steps to an ecology of mind* (Aylesbury, International Textbook Co., 1972), pp. 177–93.

12 E. Goffman, *Frame analysis* (New York, Harper and Row, 1974).

13 M. Piattelli-Palmarini, *Inevitable illusions* (New York, John Wiley and Sons, 1994), pp. 52–7.

14 J. Derrida, 'Parergon', in *The truth in painting* (Chicago, Chicago University Press, 1987), pp. 83–118.

15 Hofstadter, *Godel, Escher, Bach*, p. 645.

16 Bateson, 'A theory of play and fantasy', pp. 177–93.

17 M. Hagen, *Varieties of realism* (Cambridge, Cambridge University Press, 1986).

18 A. C. Quatremère de Quincy, *Essai sur la nature, le but, et les moyens de l'imitation dans les beaux arts* (Paris, impr. de J. Didot, 1823), I, p. 14; cited in J.-C. Lebensztejn, 'Framing classical space', *Art Journal* (spring 1988), pp. 37–41.

19 N. de Pigage, *La galerie electorale de Düsseldorf* (Basle, C. de Méchel, 1778), plate of the Rubens room, reproduced in A. McClellan, *Inventing the Louvre* (Cambridge, Cambridge University Press, 1994), p. 5, figure 3.

20 T. Clifford, 'The historical approach to the display of paintings', *International Journal of Museum Management and curatorship*, 1 (1982) 93–106, 97.

21 R. Greenberg, 'MOMA and modernism, the frame game', *Parachute*, 42 (spring 1986).

22 G. Martin, 'The difficulty of authenticity', *The Art Newspaper*, 57 (March 1996), 21.

23 G. Massoni, 'Van Gogh unframed', *The Art Newspaper*, 6:,50 (August 1995), 1.

24 P. J. J. van Thiel and C. J. de Bruyn Kops, *Framing in the Golden Age* (Amsterdam, Rijksmuseum, 1995), reviewed by G. Martin, 'The difficulty of authenticity', *The Art Newspaper*, 57 (March 1996), 21.

25 F. Wilson, 'Silent messages', *Museums Journal* (May 1995), 27–9, 27.

26 W. Vaughan, 'Hanging fragments: the case of Turner's *œuvre*', in UKIIC, *Appearance, opinion, change: evaluating the look of paintings*, papers given at a conference held jointly by the United Kingdom Institute for Conservation and the Association of Art Historians (London, UKIIC, 1990), pp. 85–91.

27 G. Waterfield (ed.), *Conserving old masters* (London, Dulwich Picture Gallery, 1995), cat. no. 2, p. 30.

28 Goffman, *Frame analysis*, p. 69.

29 R. v. *Hicklin*, L.R. 3 Q.B. (1868), cited in Robert J. O'Brien, unpublished paper in the archives of Dulwich Picture Gallery.

30 C. Duncan, *Civilizing rituals: inside public art museums* (London, Routledge, 1995), p. 11

31 Douglas, *Purity and danger*, p. 64.

32 Bateson, 'A theory of play and fantasy', p. 190.

33 Milner, 'The framed gap', pp. 79–82 and 'The role of illusion in symbol formation', p. 87.

SELECT BIBLIOGRAPHY

The endnotes to each chapter provide sources on detailed issues. This is a selection of the principal sources drawn upon, intended as a quick route into the main topics that may have attracted different readers to this book.

The cult of saints

B. Abou-el-Haj, *The mediaeval cult of saints: formations and transformations*, Cambridge, Cambridge University Press, 1994.

P. Binski, *Medieval death: ritual and representation*, London, British Museum Press, 1995.

E. Dahl, 'Heavenly images: the statue of St Foy of Conques and the signification of the mediaeval cult-image in the West', *Acta ad archaeologiam et artium historiam pertinentia*, 8 1978, 175–91.

J. P. Geary, *Furta sacra: thefts of relics in the central Middle Ages*, Princeton, Princeton University Press, 1990.

A. Jotischky, *The perfection of solitude*, Philadelphia, Pennsylvania State University Press, 1995, p.140.

A. R. Malden (ed.), *The canonisation of St Osmund*, Salisbury, Wiltshire Record Society, 1901.

S. Pearce, *On collecting* London, Routledge, 1995, pp. 98–102.

K. Schreiner, '*Discrimen veri ac falsi*: Ansätze und Formen der Kritik in der Heiligen- und Reliquienverechnung des Mittelalters', *Archive für Kulturgeschichte*, 48:1, 1966, 1–53.

B. Ward, *Miracles and the mediaeval mind: theory, record and event, 1000–1215*, London, Scolar Press, 1982, pp. 89–109.

Art in specific political or market contexts

A. Appadurai (ed.), *The social life of things*, Cambridge, Cambridge University Press, 1988

The Art Newspaper, passim.

W. Benjamin, 'The work of art in the age of mechanical reproduction', in H. Arendt (ed.), *Illuminations*, London, Fontana, 1973, pp. 219–253, 236.

M. Berman, *The politics of authenticity*, London, George Allen and Unwin, 1971.

S. N. Berman, *Duveen*, London, Hamish Hamilton, 1952.

H. and A. Borowitz, *Pawnshop and palaces: the fall and rise of the Campana Museum*, Washington, DC, Smithsonian University Press, 1991.

P. Bourdieu and A. Darbel, *The love of art: European art museums and their public*, Cambridge, Polity Press, 1991.

M. Bulley, *Art and counterfeit*, London, Methuen, 1925.

M. Bulley, *Have you good taste?*, London, Methuen, Ltd., 1933.

T. Cash (director), *Hidden hands: a different history of modernism*, produced for ATV by Frances Stonor-Saunders, 1995

J. Conklin, *Art crime*, Westport, Conn. and London, Praeger, 1994.

C. Duncan, *Civilizing rituals: inside public art museums*, London, Routledge, 1995.

V. Erlich, *Russian formalism*, New Haven, Yale University Press, 1981.

K. E. Farrer (ed.), *Letters of Josiah Wedgwood*, Manchester, E. J. Morton, 1973.

A. Forge (ed.), *Primitive art and society*, Oxford, Oxford University Press, 1973.

K. Garlick and A. MacIntyre (eds.), *The diary of Joseph Farington*, New Haven, Yale University Press, 1979.

A. Gebhart-Sayer, 'The geometric designs of the Shipibo-Conibo in ritual context', *Journal of Latin-American Lore*, 11:2 1985, 143–75.

J. Grigely, *Textualterity*, Ann Arbor, University of Michigan Press, 1995.

D. M. Guss, *To weave and to sing*, Berkeley, University of California Press, 1989.

P. Hopkirk, *Foreign devils on the Silk Road*, Oxford, Oxford University Press, 1984.

T. Hoving, *Making the mummies dance: inside the Metropolitan Museum of Art*, New York, Simon and Schuster, 1993.

T. Hoving and G. Norman, 'The Getty scandals', *The Connoisseur*, May 1987, 99–108 and 'It was bigger than they know', *The Connoisseur*, August 1987, 73–81.

R. Hughes, 'Masterpiece theatre', *New York Review of Books*, 40:5 4 March 1993, 8–14.

A. Israel, *Guide international des experts et specialistes*, Paris, Editions des Catalogues Raisonnés, 1991.

I. Jenkins, *Archaeologists and aesthetes in the sculpture galleries of the British Museum*, London, British Museum Press, 1992.

W. E. Kennick, 'Art and inauthenticity', *Journal of Aesthetics and Art Criticism*, 44:1 fall 1985, 3–12.

D. MacCannell, *The tourist*, New York, Schocken Books, 1976.

A. McClellan, *Inventing the Louvre*, Cambridge, Cambridge University Press, 1994.

H. Morphy, 'From dull to brilliant: the aesthetics of spiritual power among the Yolngu', *Man*, N.S. 24 1989, 21–40.

S. Muthesias, 'Why do we buy old furniture? Aspects of the authentic antique in Britain, 1870–1910', *Art History*, 11:2 June 1988, 231–54.

M. Orvell, *The real thing: imitation and authenticity in American culture, 1880–1930*, Chapel Hill, University of North Carolina Press, 1989.

Select Committee on Museums of the Science and Art Department, Report, London, House of Commons Parliamentary Papers, 1897, XII.

L. Shiner, '"Primitive fakes", "tourist art" and the ideology of authenticity', *Journal of Aesthetics and Art Criticism*, 52:2 spring 1994, 225–34.

D. Solkin, *Painting for money: the visual arts and the public sphere in eighteenth-century England*, New Haven, Yale University Press, 1994.

A. G. Temple, *Guildhall memories*, London, John Murray, 1918.

C. Tomkins, *Merchants and masterpieces*, New York, E. P. Dutton, 1970.

L. Trilling, *Sincerity and authenticity*, Cambridge, Mass., Harvard University Press, 1971.

D. Washburn (ed.), *Structure and cognition in art*, Cambridge, Cambridge University Press, 1983.

D. Washburn, 'Style, classification and ethnicity: design categories in Bakuba raffia cloth', *Transactions of the American Philosophical Society*, 80:3 1990, 119.

S. Walens, *Feasting with cannibals*, Princeton, Princeton University Press 1981.

S. Weil, *Beauty and the beasts*, Washington, DC, Smithsonian Institution Press, 1983.

Traditional art-historical methods

J. Bruyn, B. Haak, S. H. Levie, P. J. J. van Thiel and E. van de Wetering, *A corpus of Rembrandt paintings*, Amsterdam, Martinus Nijhoff, vol. I, 1982; vol. II, 1989; vol. III, 1993.

A. Burroughs, *Art criticism from a laboratory*, London, Allen and Unwin, 1939.

J. B. de la Faille, *Les Faux van Gogh*, Brussels, G. van Oest, 1930.

J. B. de la Faille, *L'Œuvre de Vincent van Gogh*, Brussels, G. van Oest, 1928.

J. B. de la Faille, *L'Œuvre de Vincent van Gogh*, Amsterdam, Meulenhoff International, 1970.

J. B. de la Faille, *Vincent van Gogh*, London, Heinemann, 1939.

H. Focillon, *The life of forms in art*, New York,1934.

C. Gibson-Wood, *Studies in the theory of connoisseurship from Vasari to Morelli*, New York, Garland Publishing, 1988.

H. L. C. Jaffé, S. van Leeuven, L. H. Van der Tweel (eds.). *Authentication in the visual arts – a multi-disciplinary symposium*, Amsterdam, B. M. Israel BV, 1978.

F. Junius the Younger, *Painting of the ancients*, London, printed Richd. Hodgkinson, 1638.

P. Klein, D. Eckstein, T. Waznt, and J. Bauch, 'New findings for the dendrochronological dating of panel paintings of the fifteenth to seventeenth centuries', Preprints of the ICOM Committee for Conservation, 8th Triennial Meeting, Sydney, 6–11 September 1987, Los Angeles 1987, pp. 51–4.

A. P. Laurie, *Pictures and politics*, London, International Publishing Company, 1935, pp. 104, 105.

A. P. Laurie, *A Study of Rembrandt and paintings of his school by means of magnified photographs*, London, Emery Walker, 1930.

J. Marette, *Connaissance des primitifs par l'étude du bois*, Paris, Editions Picard, 1961.

R. Offner, 'An outline of a theory of method', in his *Studies in Florentine painting*, New York, Junius Press, [1927] 1972, pp. 127–36.

J. H. Pollen, *Antique and modern furniture and woodwork in the South Kensington Museum*, London, Chapman and Hall, 1874.

J. Richardson, *Two discourses . . .* London, [W. Churchill, 1719] Scolar Press, 1972.

M. K. Talley, jun., 'Connoisseurship and the methodology of the Rembrandt Research Project', *International Journal of Museum Management and Curatorship*, 8 (1989) 175–214.

M. van Dantzig, *Pictology*, Leiden, E. Brill, 1973.

M. van Dantzig, *Vincent? A new method of identifying the artist and his work and of unmasking the forger and his products*, Amsterdam, Keesing, 1953.

Decision-making and the law

E. Graham, *Lord Darling and his famous trials*, London, Hutchinson, 1929.

D. Kahneman, P. Strovic and A. Tversky (eds.), *Judgment under uncertainty: heuristics and biases*, Cambridge, Cambridge University Press, 1982.

R. Matthews, 'Improving the odds on justice?', *New scientist* 16 April 1994, 12, 13.

N. Palmer, 'My toaster won't toast'; my Turner isn't a Turner, I want my money back', *The Art Newspaper* 6 March 1991, 13.

M. Piattelli-Palmarini, *Inevitable illusions: how mistakes of reason rule our minds*, New York, John Wiley and Sons, 1994.

P. Roberts and C. Willmore, *The role of forensic evidence in criminal proceedings*, London, HMSO, 1993.

B. Robertson and G. A. Vignaux, *Interpreting evidence, evaluating forensic science in the courtroom*, Chichester, John Wiley, 1995

D. Walker-Smith, *The life of Lord Darling*, London, Cassell, 1938.

Forgery

F. Arnau, *Three thousand years of deception*, London, Jonathan Cape, 1961.

D. Dutton (ed.), *The forger's art*, Berkeley, University of California Press, 1983.

The fine art of faking it, a documentary for Nova, Philadelphia, Films for the Humanities and Sciences, inc., 1991.

S. J. Fleming, *Authenticity in art: the scientific detection of forgery*, London, Institute of Physics, 1975.

A. Grafton, *Forgers and critics: creativity and duplicity in Western scholarship*, London, Collis and Brown, 1990.

M. Jones (ed.), *Fake! The art of deception*, London, British Museum Press, 1990.

M. Jones (ed.), *Why fakes matter*, London, British Museum Press, 1992.

T. Keating and G. and F. Norman, *The fake's progress*, London, Hutchinson, 1977.

A. G. Knox, 'Richard Meinerzhagen – a case of fraud examined', *Ibis*, 135 1993, 320–25.

K. C. Lefferts, L. J. Majewski, E. V. Sayre and P. Meyers, 'Technical examination of the classical bronze horse from the Metropolitan Museum of Art', *Journal of the American Institute of Conservators*, 21 1981, 1–42.

J. V. Noble, 'The forgery of our bronze horse', *Bulletin of the Metropolitan Museum of Art*, 26:6, 1968, 253–6.

A. Rinuy and F. Schweizer, 'A propos d'une peinture florentine du Trecento, une contribution à la définition de critères d'authenticité', *Genava*, n.s. 34 1986, 95–112.

S. Strauber, 'Delacroix drawings and the false estate stamp', *Journal for the History of Collections*, 3:1, 1991, 61–88, 79.

C. F. Stuckey, 'Manet revised, whodunit?', *Art in America*, November 1983, 158–77.

H. Trevor-Roper, *The hermit of Peking*, Harmondsworth, Penguin Books, 1978.

W. Voelkle, *The Spanish forger*, New York, Pierpont Morgan Library, 1978.

Conservation

Art journal, 54:2 summer 1995, devoted to issues of conservation.

J. Beck, *Art restoration: the culture, the business and the scandal*, London, John Murray, 1993

S. Bergeon, '*Science et patience*', *ou la restauration des peintures*, Paris, Editions de la Réunion des Musées Nationaux, 1990.

C. Brandi, *Teoria del restauro*, Rome, Edizione di Storia e Letteratura, 1963.

M. Ciatti (ed.), *Problemi di restauro*, Rome, Edifir, 1992.

J. Heumann (ed.), *From marble to chocolate: the conservation of modern sculpture*, London, Archetype Publications, 1995 (papers from a conference at the Tate Gallery, London, 18–20 September 1995).

National Gallery Technical Bulletins, passim.

R. Newton and S. Davison, *Conservation of glass*, London, Butterworth, 1989.

A. Oddy (ed.), *The art of the conservator*, London, British Museum Press, 1992.

B. A. Ramsay-Jolicoeur and N. M. Wainwright (eds.), *Shared responsibility*, proceedings of a seminar for curators and conservators, National Gallery of Canada, Ottawa, 26–28 October 1989, Ottawa, National Gallery of Canada.

Restoring 'The ambassadors', a film for BBC 2, directed by Patricia Wheatley, 1996.

J. Richardson, 'Crimes against the Cubists', *New York Review of Books* (16 June 1993), 32–4

H. Ruhemann, *The cleaning of paintings*, London, Faber and Faber, 1968.

UKIIC, *Appearance, opinion, change: evaluating the look of paintings*, papers given at a conference held jointly by the United Kingdom Institute for Conservation and the Association of Art Historians, London, UKIIC, 1990.

G. Waterfield (ed.), *Conserving old masters: paintings recently restored at Dulwich Picture Gallery*, London, Dulwich Picture Gallery, 1995.

The psychology of perception and aesthetics.

T. Armstrong, *Colour perception: a practical approach to colour theory*, Stradbroke, Norfolk, Tarquin Publications, 1991.

P. Atkins, 'The rose, the lion and the ultimate oyster', *Modern painters*, winter 1990, 50–5.

J. Coote and A. Shelton, *Anthropology, art and aesthetics*, Oxford, Clarendon Press, 1992.

A. Cozens, *Principles of beauty relative to the human head*, London, James Dixwell, 1778.

W. Empson, *Seven types of ambiguity*, London, New Directions, 1930.

E. Gombrich, *The sense of order*, London, Phaidon Press, 1979.

R. Gregory, J. Harris, P. Heard and D. Rose (eds.), *The artful eye*, Oxford, Oxford University Press, 1995.

M. Hagen, *Varieties of realism*, Cambridge, Cambridge University Press, 1986.

W. Hogarth, *The analysis of beauty*, ed. J. Burke, Oxford, Clarendon Press, 1955.

R. Jung, 'Art and visual abstraction', in R. Gregory (ed.), *The Oxford companion to the mind*, Oxford, Oxford University Press, 1987, pp. 40–6.

G. de Lairesse, *The art of painting*, trans. J. F. Fritsch, London, H. G. Bohn, 1738.

H. B. Maginnis, 'The role of perceptual learning in scholarship', *Art History*, 13:1 March 1990, 104–17.

Palazzo Grassi, *The Arcimboldo Effect*, Venice, Palazzo Grassi, 1987.

J. Reynolds, *The works of Sir Joshua Reynolds* (ed.), Edmond Malone, London, T. Cadell, jun. and W. Davies, 1801.

J. Shearman, 'Leonardo's colour and chiaroscuro', *Zeitschrift für Kunstgeschichte*, 25 1962, 13–47.

J. A Sloboda, *The musical mind*, Oxford, Clarendon Press, 1985.

R. Venturi, *Complexity and contradiction in architecture*, New York, Museum of Modern Art, 1966.

D. Washburn (ed.), *Structure and cognition in art*, Cambridge, Cambridge University Press, 1983.

R. Wornum, *Lectures on painting by the Royal Aacademicians, Barry, Opie and Fuseli*, London, printed for the author, 1848.

S. Zeki, *A vision of the brain*, Oxford, Blackwell Scientific Publications, 1993.

Representation and framing

M. Bal and N. Bryson, 'Semiotics and Art History', *The Art Bulletin*, 73 2 June 1991, 175–208.

R. Barthes, *Image, music, text*, ed. and trans. S. Heath, London, Fontana, 1977.

G. Bateson, 'A theory of play and fantasy', *American Psychiatric Association Psychiatric Research Reports*, II, 1955, reprinted in G. Bateson, *Steps to an ecology of mind*, Aylesbury, International Textbook Co. Ltd., 1972, pp. 177–93.

M. Baxandall, *Patterns of intention*, New Haven, Yale University Press, 1989.

J. Culler, 'The semiotics of tourism', in his *Framing the sign*, Oxford, Basil Blackwell, 1988.

J. Derrida, 'Parergon', in his *The truth in painting*, Chicago, Chicago University Press, 1987, pp. 83–118.

M. Douglas, *Purity and danger*, London, Routledge and Kegan Paul – Ark paperbacks, 1966.

U. Eco, *A theory of semiotics*, Bloomington, Indiana University Press, 1979.

E. Goffman, *Frame analysis*, New York, Harper and Row, 1974.

R. Krauss, 'Retaining the original: the state of the question', in *Studies in the history of art*, Center for the Advanced Study of the Visual Arts, National Gallery of Art, Washington, DC, vol. 20, 1989, pp. 7–11 (proceedings of the symposium 'Retaining the original', held at The Center for the Advanced Study of the History of Art and Johns Hopkins University, Baltimore, 8–9 March 1989).

M. Milner, 'The framed gap', in her *The suppressed madness of sane men*, London, Routledge and Kegan Paul, 1987, pp. 79–82.

K. Moxey, *The practice of theory: poststructuralism, cultural politics and art history*, Ithaca, NY, Cornell University Press, 1994.

S. M. Pearce, *Museums, objects and collections*, Leicester, Leicester University Press, 1992.

F. Wilson, 'Silent messages', *Museums Journal* May 1995, 27–9.

INDEX

Page numbers in *italic* refer to illustrations.

Full names of works of art or literature are listed under authors' names; names of institutions or exhibitions are under *museums, historic buildings* or *exhibitions*; names of cases at law under *court cases*, and names of saints under *saints*.